Maria von Blücher's

Corpus Christi

NUMBER FIVE
Canseco-Keck History Series
Jerry Thompson, General Editor

Maria von Blücher's Corpus Christi

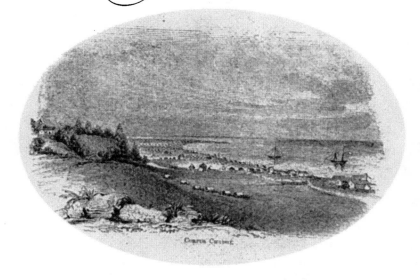

LETTERS FROM THE

SOUTH TEXAS FRONTIER, 1849–1879

By Maria von Blücher

Edited and Annotated by Bruce S. Cheeseman

Foreword by Thomas H. Kreneck

TEXAS A&M UNIVERSITY PRESS • COLLEGE STATION

The paper used in this book meets the minimum requirements
of the American National Standard for Permanence
of paper for Printed Library Materials, Z39.48-1984.
Binding materials have been chosen for durability.

∞

Library of Congress Cataloging-in-Publication Data

Blücher, Maria Augusta von, 1827–1893.
 Maria von Blücher's Corpus Christi : letters from the South Texas
frontier, 1849–1879 / by Maria von Blücher ; edited and annotated by Bruce S.
Cheeseman ; foreword by Thomas H. Kreneck.–1st ed.
 p. cm.—(Canseco-Keck history series ; no. 5)
 Includes index.
 ISBN 978-1-58544-135-8 (cloth); ISBN 978-1-60344-223-7 (pbk.)
 1. Blücher, Maria Augusta von, 1827–1893—Correspondence. 2. Women
pioneers—Texas—Corpus Christi—Correspondence. 3. Pioneers—Texas—
Corpus Christi—Correspondence. 4. German American women—Texas—
Corpus Christi—Correspondence. 5. Frontier and pioneer life—Texas—
Corpus Christi. 6. German Americans—Texas—Corpus Christi—Social life
and customs—19th century. 7. Corpus Christi (Tex.)—Social life and
customs—19th century. 8. Corpus Christi (Tex.)—Biography.
 I. Cheeseman, Bruce S. II. Title. III. Series.
F394.C78 B56 2002
979.4'11305'092—dc21 2001005015

For

MARY, BRENTON, AND KIMBERLY

Contents

\mathscr{L}ist of \mathscr{I}llustrations

Children of Maria Augusta Imme & Felix Anton von Blücher

Felix Anton von Blücher
(1819–1879)
Maria Augusta Imme
(1827–1893)

Maria Felicia
(Mary)
(1851–1918)

Julia Augusta
(1853–1937)

Carl Friedrich
(Charles)
(1856–1938)

Richard Paul
(1858–1926)

George Anton
(1861–1929)

Anna Elizabeth
(1864–1865)

Foreword

Maria von Blücher's Corpus Christi: Letters from the South Texas Frontier, 1849–1879 represents the successful convergence of family dedication, professional talent, and a university's commitment to fostering historical scholarship of its region. Foremost, this volume stands as testimony to the vision of several descendants of Felix A. von Blücher and Maria Imme von Blücher to have a book produced on the lives of their forebears based on the letters that Maria had written to her parents. These descendants—specifically Claudia Blücher Harrel, Mary Julia Blücher Jordan, Mr. and Mrs. George A. Blücher, Jr., and Gloria Blücher Alexander—brought forward the idea for this study from a sense of family pride and from an appreciation of Felix and Maria's role in Corpus Christi and South Texas. Not only did they conceive of the project, but they also generously provided its financial support. As important, they guided its progress and displayed great insight and perseverance during its completion.

Second, Bruce Cheeseman has exercised considerable editorial and writing talents. As he notes in the preface, the items included in this volume represent only a sampling (slightly less than half) of the more than two hundred letters that Maria sent home during her thirty years of correspondence. A longtime student of South Texas history, especially of its nineteenth-century ranching frontier, Cheeseman brought to bear his wealth of knowledge in selecting the most appropriate letters to give the reader an informative, comprehensive, but manageable story of the Blüchers' world. Cheeseman effectively accomplishes his role as editor, which is no small task when one considers the varied nature of family correspondence. He masterfully links these documents together with well-written commentary in each chapter.

Regarding professional expertise, profuse recognition must also be given to Arnoldo De León, C. J. "Red" Davidson professor of history at Angelo State University. In the latter stages of the project, he lent his keen editorial skills in bringing this book to publication. Professor De León's participation is yet another example of his many contributions to fostering Texas historical

scholarship. Thanks are likewise extended to Richard J. Hatch, Sr., Corpus Christi attorney and devotee of Texas history, for the courtesies he extended during the Blücher project.

Third, Texas A&M University–Corpus Christi is most gratified to have its connection to this volume, principally as the home of the letters of Maria von Blücher and as a catalyst for the book's production. As Bruce Cheeseman also points out, Maria's letters are a seminal though small part of the much larger holding formally known as the Charles F. H. von Blücher Family Papers in the Texas A&M–Corpus Christi Bell Library's Special Collections and Archives. Donated to the university by the family, the Blücher papers are voluminous and span several generations. These papers not only contain personal and business items but also the massive body of surveying records developed by three generations of Blüchers who served as Nueces County surveyors: Felix A. von Blücher, his son Charles F. H. von Blücher, and grandson Conrad M. Blücher. Maria's letters provide an example of the invaluable nature of the entire Blücher Papers. They are a significant research resource for many different constituencies.

Maria von Blücher's Corpus Christi has appeal for a broad range of people, from the most scholarly reader to someone interested simply in compelling historical literature. The viewpoint of a refined, educated German immigrant woman, it represents women's history and literature at a fundamental level. As such, the book adds an important dimension to our understanding of nineteenth-century life in a town and region of Texas that are rich in tradition and lore but in need of historical analysis and available printed primary sources.

The Blücher name has a special meaning for Corpus Christi and South Texas due to the family's many years of contributions to the area. This volume brings to life the two people and their children who first sank those productive roots in our soil.

Thomas H. Kreneck
Associate Director for Special Collections and Archives
Texas A&M University–Corpus Christi

Preface

Early on the evening of June 13, 1849, Maria Augusta Imme von Blücher sat comfortably on the top deck of the schooner *Elbe*, at a berth on the Mississippi River in New Orleans, Louisiana. A cultured and thoughtful young woman and a newlywed at twenty-two, she had just accompanied her husband Anton Felix von Blücher on a hazardous eight-week voyage across the Atlantic Ocean and through the Gulf of Mexico from her native Germany. Under what she described as a "beautiful, delicious full moon," she began to write a letter to her parents in Berlin. "The first lines you receive from me from my new home," as the letter begins, initiated a voluminous correspondence that would last well over three decades between a loving daughter in America and her parents in Germany.[1]

Maria and her husband would soon establish their residence in the new frontier settlement of Corpus Christi, Texas, arriving on Wednesday evening, July 11, 1849.[2] Here, over the next forty-four years until her death on September 28, 1893, she raised five children, suffered the hardships of droughts and Indian and bandit raids, and survived the chaos of the American Civil War and the discomfort of pioneer living.[3] Yet she endured and persevered, outstaying even the strains of pioneering that caused disharmony and unhappiness in her marriage. In the end, she saw to the development of a large and strong family with roots not only in her homeland of Germany but also in her new home town of Corpus Christi, to which her descendants became devoted and which they helped to build into today's city.[4]

Maria's letters to her parents are part of the von Blücher family's much larger historical collection (approximately twenty-six linear feet) on deposit at Special Collections and Archives, Mary and Jeff Bell Library, Texas A&M University–Corpus Christi. The original letters are in German and cover the years 1845 to 1879. Maria's daughter Julia brought the letters back to the family in Corpus Christi when she returned from Germany in 1880 after an extended stay.[5] Seventy-two years later in 1952 Maria's granddaughter, Marie Marguerite von Blücher, provided for the translation of the letters into English. Once

again the letters crossed and recrossed the Atlantic Ocean, this time to Kassel, Germany, where they were transcribed in longhand by Ernst Nolda and Willy Witzel, apparently acquaintances of the German von Blüchers.[6] In all, there are 229 letters and notes, numbering 919 pages, the great majority of which were authored by Maria. A few items were written by her husband Felix and some by associated family members. The letters document and give voice to the remarkable pioneer experience of Maria von Blücher as an immigrant from Germany to Corpus Christi and the South Texas frontier in the mid-nineteenth century.

From a privileged background, Maria was unfamiliar with and unprepared for the ongoing rigors of pioneer life. Despite her excitement and anticipation, and the sense of high adventure and newlywed love she shared with her husband, she was faced in 1849 with the prospect of leaving the familiar for the unknown. She understood that in the end there was the likelihood of not returning to Germany. Indeed, she was to experience not only the initial pains of separation but the later pangs of loneliness and isolation that often pierced her quiet hours.[7]

Maria's letters are a record of the woman's side of pioneer life.[8] They picture deprivations, cruel hardships, sacrifices, and dangers. They are not a chronicle of political events or economic developments, although they do offer insight into these areas of the frontier period of Corpus Christi. Nor are the letters a history by a keen observer or the interpretation of an insightful analyst. Rather, they stand as a personal account of the pioneer experience, described by one for whom "history" was nothing more than daily life. They provide an intimate look inside the homes and ranches, the schools and farmyards, the stores and churches of early Corpus Christi. They examine families and friendships, communities and congregations, sewing circles and social unions. Maria's is a history written through loneliness and deprivation but guided by courage and stamina. In her life she joined all of the courageous pioneer women who helped to lay the foundations of our communities.[9]

The letters also serve as elegant testimony to the role played by Germans in the settlement of South Texas. Although interest in the history of "the German Texans" has attracted a variety of interpreters from the ranks of many different professions, Maria's letters add to a solid and diverse foundation of primary source materials.[10] Moreover, as Maria points out, all pioneers of South Texas, a region best described as "a wild and vivid land," were subjected not just to the normal hazards of the frontier but to an almost unparalleled succession of special calamities: constant political and racial conflicts with Mexico;

guerrilla and Indian raids; "that great blast of ruin and destruction," the American Civil War; and a taxing setting with hot winds, droughts, prairie fires, torrential rains, and yellow fever. Moreover, all these persecutions of nature were accompanied by the scourge of man in the form of outlaws, thieves, and the "murderous and drunken riffraff of the border."[11] Those who stuck it out became Texans, part of a mythical community set apart by ordeal and survival. Texas itself became "no mere geographical expression, but a state of mind, a religion, and a philosophy in one."[12] And Maria, who survived the state's reputation of being "hell on horses and women," wrote about it with such vividness and precision.[13]

Even more important is Maria's utter frankness about the more private and uncomfortable facets of her everyday life. She is honest about such intimate topics as pregnancy, childbirth, death, and love, and not only in the euphemisms of the time. She addresses such sensitive issues as child rearing, race relations, family health questions; and, even more personal, the effects of Felix's drinking and his prolonged absences from home, which caused her eventual estrangement from her husband. This alienation also led to her gradual assumption of the management of the household and family affairs. She learned the skills of home, garden, and field; how to use and care for firearms; how to hunt and fish; how to plant, cultivate, and harvest garden crops; how to care for livestock; how to ride a horse and gee and haw at mules and donkeys; and how to work with neighbors in forging her own community. In short Maria, a former "Belle of Berlin" who had come to Texas accustomed to German privilege and a domestic life supported by servants, totally unprepared for pioneer life, learned how to be independent.[14]

One particular aspect of her European education, however, stood her in good stead for the trials she faced. As part of her education in Germany, she briefly studied piano and music under the virtuoso Franz Liszt.[15] She came to love Romantic music and the opera. After the Civil War, as Corpus Christi attempted to recover from its total economic prostration, she would help support herself and her family by teaching piano and music.[16]

Maria's life came full circle in 1874 when she was finally able to travel to Germany. After twenty-five years apart, she was reunited with her parents and extended family. Following a visit of almost one year, she returned to Corpus Christi. Thereafter, she often wrote of her desire to retire to her beloved homeland for life's end, but her familial responsibilities precluded such a move (husband Felix died in 1879, leaving her mistress of the household). As her children grew, were educated, and moved on to their own lives,

Maria lived out the last of her years in tranquility, "going on in our quiet way as ever."[17]

How was one to choose among the delightful letters that Maria von Blücher wrote to her parents—letters reflecting on three decades of South Texas history? Many of her letters were nothing more than long "laundry lists" of goods requested to be sent from Germany, reflecting the scarcity of finished products on the South Texas frontier. Constant among her requests were items like firearms, utensils, hardware, cutlery, glass, paper, and sheet music; dry goods ranging from plain calico to fine linens, woolens, and silks; notions, furniture, and a host of seeds and cuttings. Almost all of her letters contain extended discussions and interrogatives concerning her German relatives, often repetitive in endless detail. As part of the emerging German bourgeoisie in the mid-nineteenth century, Maria often wrote letters containing unbridled expressions of prejudice, particularly relating to race and class. My aim in editing her letters has been to stay faithful to her concerns and to preserve her character.[18]

And so the letters, after selection and excision, appear here with their warts, their occasional embarrassments. What I found distinctive about the collection is its depiction of ordinary life—the observations of early Corpus Christi and its environs, the ebb and flow of personal relationships, the diminution of experience by monotony and its elevation by passion. Even more important, however, are Maria's limited descriptions of the great historical events that loom behind her missives: revolution in Germany; the American Civil War and Reconstruction; and the political, economic, and social transformations of Corpus Christi and the South Texas frontier. In this wider sense, Maria's letters, taken together, draw unerringly a Texas landscape that is gone forever.

Through a judicious selection process I have attempted to retain what Fernand Braudel, the great French historian, named "the structures and drift of everyday life."[19] The book presents a representative selection of letters from each decade of the collection. As for the technical side of editing, I have relied entirely on the English translations. Translators Nolda and Witzel were as conscientious as medieval copyists, and the transcriptions are in clearly written and beautiful longhand. I did not chop sentences out of paragraphs or words out of sentences. Of necessity, however, we have, during the editorial process, altered the letters' sequence and syntax whenever we thought them awkward, unintelligible, or confusing and whenever we believed words too archaic (we switched "pyramid" to "Christmas tree," for example) for the modern-day public. Thus, while the letters are not the exact duplication of the

translated ones by Nolda and Witzel, I hope they still retain the quality of the original German when rendered in English. I did take the liberty of deleting entire paragraphs from the letters where I felt Maria's conversations were redundant. To avoid slowing down the reading and counteracting the narrative thrust of the book, I did not indicate where I omitted letters, nor did I use ellipsis points to signal deletions. My charge from the Blücher family was to provide a readable narrative. In any case, historical letters are difficult enough to read because ongoing stories are dispersed across the missives.

Finally, annotation has been limited to brief identifications of major people, places, events, and allusions when possible. Inasmuch as full source citations are given in the notes, a bibliography has been omitted. People who want to read the unedited letters may see the originals in German, as well as the English translations, at Special Collections and Archives, Mary and Jeff Bell Library, Texas A&M University–Corpus Christi.

Acknowledgments

After four years of reading and editing the letters of Maria von Blücher, it is now my turn to do the reminiscing. Many participants in the research and preparation of this book deserve thanks for their courtesies and for sharing their enthusiasm, knowledge, and talents. I owe special gratitude to the descendants of Maria von Blücher: Claudia von Blücher Harrel, Mary Julia von Blücher Jordan, George and Medora (Dodie) von Blücher, and Gloria von Blücher Alexander, who together have long nurtured the concept of this book. Moreover, they are responsible for the preservation of these remarkable letters. I am especially grateful to Claudia Harrel for her deep and abiding interest in the creation of this book and in my progress as a writer. Over the years, our long conversations about her family and early South Texas history have made the past especially meaningful. In my most trying hours, it was to her that I often turned for encouragement and inspiration.

Academically, I owe special thanks to Thomas H. Kreneck of Texas A&M University–Corpus Christi, who provided me with immutable support. His insight into the frontier period and his critical analysis of these pioneer writings were particularly valuable. I am especially grateful for his perceptive analysis of the historical process, for his unending encouragement of my work, and most of all for his enduring friendship. I also wish to thank the staff of Special Collection and Archives, Mary and Jeff Bell Library at Texas A&M University–Corpus Christi, especially Alva D. Neer, Grace G. Charles, and Jan S. Weaver. Their professional management of the Charles F. H. von Blücher Family Papers, high level of cordiality, and archival wisdom provided much insight on the details of Maria's letters.

Other individuals contributed materially to the Blücher work. For their guiding force and patient friendship throughout the writing of this book, I am indebted to Michelle Francis at the Department of History (Montreat), Presbyterian Church (U.S.A.); and Hal Keiner at the Biltmore Estate, Asheville, North Carolina. Their help extended far beyond the usual professional courtesies. George Brown, vice president (now retired) at Kleberg First National

Bank; Marty West, president of State Bank of Kingsville; and my cousin, Jerry Luccarella of Pennsville, New Jersey, provided crucial financial assistance that allowed me to complete the work. For their support and belief in me I shall be forever grateful.

Finally, my deepest appreciation goes to my family, who have shared with me the joys and the frustrations of writing. I am especially grateful to Brenton and Kimberly for their sensible advice and steady good humor, and to my wife, Mary, for her devotion to helping me with the art of living. On my humble desk her portrait, smiling, urges me onward.

Everyone mentioned was instrumental in improving this book. Any errors or shortcomings are solely mine.

— Bruce S. Cheeseman

Maria von Blücher's
Corpus Christi

I

Prussia

IN THE SECOND QUARTER of the nineteenth century, the King-
dom of Prussia under the leadership of Frederick William IV became, with
Austria, one of the two leading states of the German Confederation.[1] It was a
period of enormous social, political, and economic change, unparalleled in the
history of central Europe. For it was during this period that the great break-
through of industrial capitalism occurred, fueling an economic expansion that
produced an upward spiral of growth and prosperity. Germany now crossed
the dividing line between a preindustrial and an industrial form of economy,
and although the rural population still outnumbered the urban, the tendency
toward industrialization and urbanization had become irreversible.[2]

This in turn had a profound effect on the direction of politics. As wealth
began to shift from farming to manufacturing, from the country to the city,
and from the aristocracy to the newly rich middle class, the pressure for a
redistribution of political power gained strength. Prussian authority in par-
ticular was undermined by the struggle of artisans against industrial mechani-
zation; by the disaffection of peasants and small farmers hungry for land in an
overpopulated agricultural system; and above all, by the criticism of business-
men and university professors who ardently opposed a Prussian government
in which an aristocracy of birth rather than of talent predominated. And at
the center of this caldron of upheaval stood Berlin, Prussia's capital, with a
growing population of 615,000 and in the throes of becoming one of the world's
greatest cities.[3]

Into this world of political and social upheaval, and cultural and economic
growth, Maria Augusta Imme was born at Berlin on September 25, 1827. Un-

[3]

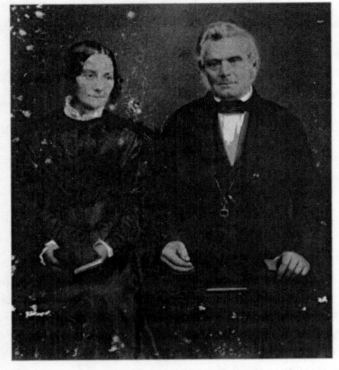

Maria's Parents, Auguste Kroll Imme and Carl Friedrich Imme.
Charles F. H. von Blücher Family Papers, Special Collections
and Archives, Mary and Jeff Bell Library,
Texas A&M University–Corpus Christi.

fortunately, little is known of her childhood. Her parents, Carl Friedrich and Marie Auguste Imme, were part of Prussia's burgeoning propertied middle class; Maria's father owned and directed a successful brass factory, and her mother handled rental property in Berlin.[4] The youngest of four children, Maria obviously enjoyed an excellent education, particularly in music and literature. She came of age in Berlin, growing up in an imposing town house at 84 Commandantenstrasse, one of the finest and most spacious avenues in Europe. She played in the beautiful Tiergarten park laid out by Frederick the Great. Her summers and holidays were spent with her extended relatives at a family-owned waterfront home at Stralow, southeast of the city in the high hills rising around Müggelsee, the largest lake in greater Berlin.[5]

Maria's formative years were spent in a world of upper-class privilege, with household servants and riding instructors, music tutors and private teachers. She developed a keen sense for German politics, joining her family as part of the liberal and moderate opposition to Prussian aristocracy. And for the remainder of her life she would follow with great interest the political affairs of her homeland.[6] At five feet, seven inches tall and a little over one hundred pounds, with jet black hair, dark eyes, and well-defined Teutonic features, the educated and refined Maria was recognized by society as one of the leading "Belles of Berlin."[7]

It is unclear exactly when and how Maria met Anton Felix Hans Hellmuth von Blücher, but her letters indicate that it occurred before his first departure for America in 1845. They obviously fell madly in love, much to the concern of Maria's family and friends, at first. For Felix von Blücher, in spite of a heritage of Prussian nobility dating back to 1214 (he was a grandnephew of Waterloo hero Gehard Lebrecht von Blücher), came to Maria's side with an unsettled past and an uncertain future.[8]

Born on November 15, 1819, at one of the Blücher estates at Poggelow, southeast of Rostock in the duchy of Mecklenburg, Felix was the son of Karl Wilhelm and Karoline Hertel von Blücher. His father was a captain in the Prussian cavalry, and young Felix learned early the lessons of fine horsemanship. However, his childhood was scarred by a series of personal calamities: his father's bankruptcy in 1828, when the family lost Poggelow to creditors and had to move to Berlin; his parents' scandalous divorce six years later; and his father's suicide in 1840.[9] These events, Maria later indicated, left Felix "cold and distant emotionally."[10]

Yet under the tutelage of an aunt, Christine von Blücher Rieben of Güstrow, Felix excelled academically. In 1838 he entered Berlin's Friedrich-Wilhelm-Universität, the largest and most prestigious university in Germany. Founded in 1809 by the scholar Wilhelm von Humboldt, the campus early attracted such outstanding thinkers as the philosopher Georg Wilhelm Friedrich Hegel and the prophet of communism, Karl Marx.[11] Here Felix studied civil engineering, law, and languages, and earned both masters (M.A.) and juris doctor (J.D.) degrees in April, 1845. He would eventually master six languages—German, Latin, English, Spanish, French, and Italian—which would later always stand him in good stead as an interpreter. At the university, a center of Prussia's revolutionary activity, Felix joined the democrats or radicals who openly demanded the overthrow of the Prussian monarchy. He edited a radical newspaper, and as a spokesman of this ideal he risked imprisonment. Early

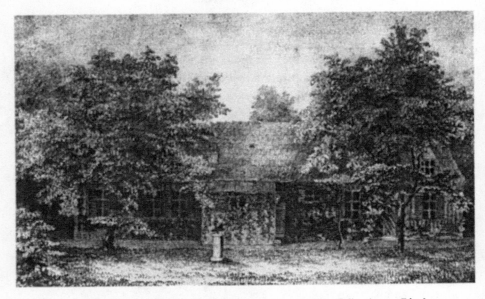

Drawing of Birkenwäldchen *(Birchforest), the home where Felix A. von Blücher was raised in the Tiergarten district of Berlin. Charles F. H. von Blücher Family Papers, Special Collections and Archives, Mary and Jeff Bell Library, Texas A&M University–Corpus Christi.*

in August, 1845, he had to flee Berlin for America. He arrived in New Orleans with only forty thalers in his pocket.[12]

Teaching German at night and keeping the books of a hotel for free room and board, Felix survived and eventually found employment as a draftsman in a shipyard. He made a wide range of contacts among the German population in New Orleans, and in 1846 joined Prince Carl of Solms-Braunfels in Texas as an interpreter and engineer. He helped the prince lay out the town of New Braunfels, acted as an interpreter in the signing of John O. Meusebach's treaty with the Comanche Indians, and then served with both the United States Army and the Texas Rangers during the Mexican War. Acting as an interpreter for both the United States military and the Mexican government, he earned what he described as a "brilliant salary."[13]

At war's end, Felix determined to return to Berlin to ask for Maria's hand in marriage. After spending "two months bear hunting and catching wild prairie horses," he left Texas and arrived in Berlin in early February, 1849.[14] Prior to leaving the Lone Star State, however, he had visited Corpus Christi, a new

settlement on the Gulf Coast being energetically promoted as "Little Naples" by its founder, Colonel Henry Lawrence Kinney. Felix and Kinney became fast friends, and Felix decided Corpus Christi would be the seat of his future endeavors upon his return with Maria.[15]

In order to reenter Prussia, however, Felix apparently had to make amends with the royal government. This he accomplished on February 13, 1849, when at an audience in Berlin with His Royal Highness, the Prince of Prussia, William I, he presented the future king (later to be the first emperor of unified Germany) with gifts from afar: "a magnificent Mexican saddle; two 'wolf-blankets'; one lasso; one pair of spurs; one horse whip; one silver bridle with

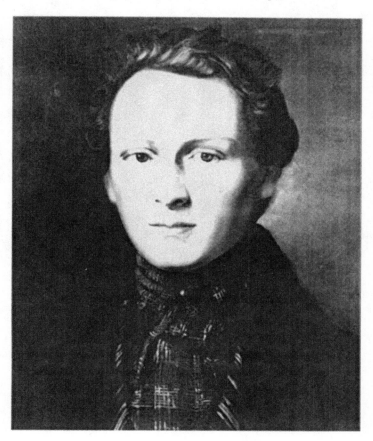

Portrait of young Felix A. von Blücher. Copy of original in Charles F. H. von Blücher Family Papers, Special Collections and Archives, Mary and Jeff Bell Library, Texas A&M University–Corpus Christi. Courtesy of Mary Julia Blücher Jordan.

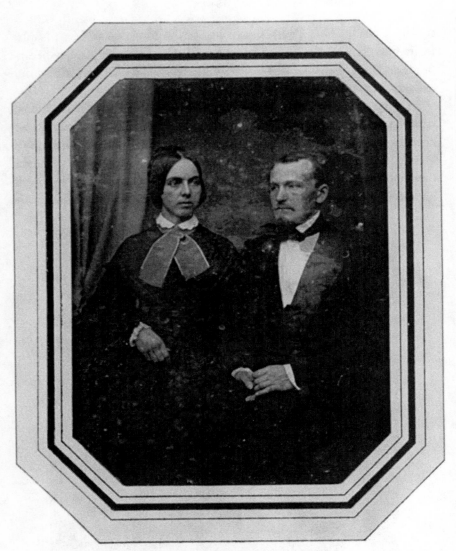

*Wedding Photograph of Maria Augusta Imme and Felix A.
von Blücher. Charles F. H. von Blücher Family Papers, Special
Collections and Archives, Mary and Jeff Bell Library,
Texas A&M University–Corpus Christi.*

bit; and one elaborate saddle blanket of striped cloth."[16] It is not known if Felix and Prince William discussed politics, but apparently his penance was successful. On March 10, 1849, Felix von Blücher and Maria Augusta Imme were married in Berlin.

They immediately departed for Hamburg to secure passage to a new life in Corpus Christi. Accompanied by two carpenters, Messrs. Büsse and Schünke, who were to help build their new home, Felix and Maria did not travel light. Six large trunks, numerous chests and bags, and Maria's beloved piano had to be carefully packed and shipped. Maria's letters describing her journey to Hamburg are filled with a sense of wonder and excitement. She described the towns visited along the way, Schwerin and Güstrow; marveled at the receptions held for her and Felix by her new relatives at the Blücher castles of Teschow and Sukow; and commented on the state of affairs she found throughout the duchy of Mecklenburg. She and Felix rode horses over Blücher lands; attended the opera at Schwerin; and observed with rapt attention the political debates of the National Assembly of the German Confederation. They drank and ate well; laughed together; and planned their future in Texas. Maria was obviously very much in love.[17]

Yet her anticipation of the high adventure that lay before her was tempered by the pain of separation. Seeing her father one last time in Hamburg shortly before her departure brought a flood of family memories into her mind. When she and Felix celebrated the Easter holiday with a sailing excursion and an Easter egg tea, she could think only of her family at Stralow. As their ship navigated the Elbe River and headed west out into the open North Sea, it is clear that Felix and Maria braced themselves with excitement and fear of the transoceanic passage ahead.[18]

Schwerin, March 19, 1849[19]

Dear Mother,

In vain did I seek a quiet quarter of an hour to write some lines to you during our stay at Schwerin. Felix's sister welcomed us so kindheartedly and has engaged our time so fully that it is often too much for me.[20] Though the events up to now have been of minor importance, I shall describe the course of the days to you a little. We arrived at Schwerin on Thursday at 2 o'clock. Because the most respectable hotel is totally crammed, we had to be content with a small room on the 4th floor; the arrangement became somewhat difficult for us. If you take half the length of our room at Stralow and the

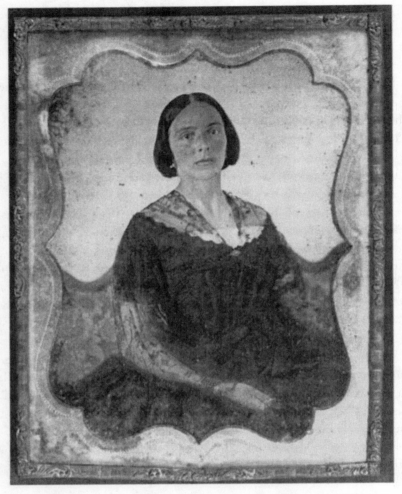

Maria Augusta Imme von Blücher. Charles F. H. von Blücher Family Papers,
Special Collections and Archives, Mary and Jeff Bell Library,
Texas A&M University–Corpus Christi.

same width, and place there 6 trunks, different seamed bags, persons, bed
tables, sofa, 2 washstands, wardrobes, stove, and chest of drawers—it was in
silent despair that we looked at each other, but the situation was too ridicu-
lous to vex ourselves about it. Up to Saturday evening we bore this fatality,
then we got the most magnificent reward, getting room no. 1 on the first
floor. We now have enough space to risk a little gallopade every evening,

which of course takes place only between Felix and myself. The slowness and imperfection of the Schwerin servants you must have experienced yourself to comprehend it.[21] My Felix is about to overfeed me. At 7:30 A.M. I polish off 3 cups of very good coffee, 6 rolls with butter, 2 soft-boiled eggs (sometimes 3), and delicious fine baked goods. We eat an excellent dinner, drink good wine at the table every day (the wine not being encumbered with taxes in Mecklenburg), then good coffee together with baked goods. Always nervous that we have eaten too much, we take a walk or a ride. The surrounding country is so beautiful that even Dresden cannot boast of the like.[22] The whole town is alongside a big lake, 5 miles wide, with nice clumps of trees and some hills adding much in embellishing the town. I have even sampled the real "Wood Castle Ale" and excellent "Berlin doughnuts." Our physical and spiritual welfare have been well attended to here.

On Friday we paid a visit to the National Assembly, which riveted our attention most agreeably for 5 hours.[23] On Sunday we were in the theater where they performed *Prince Eugene, the Noble Knight,* an opera as tedious as it is childish. The players, however, are very good, the orchestra is excellent, and the theater about a quarter of the size of Berlin's theater, but with 3 upper circles and a large Royal Box. We had a good view of everything. On the other hand we had the pleasure of being pierced by a hundred pairs of opera glasses, for a stranger is always an interesting case there, as most intercourse is with the landowners of the neighborhood. Schwerin is not a disagreeable place, only there are continual fogs and persistent humidity, which are certainly a nuisance.[24]

My darling Mother and Father, you cannot complain that my letter is not very copious. Felix, too, will soon send some lines. Thus, consider yourselves all heartily greeted. How are you all? Did you get through March 18th without excitement?[25] Unfortunately it is very difficult to get the Berlin newspapers. Take to keeping a diary so that I too can see what wonderful things are happening to you!

Visiting Dr. Wentzlaff and Marie is a great pleasure.[26] Our interchange with them is without stiff formalities. She is a very charming and pretty woman who, it seems to me, has drawn the indignation of her relatives because of this marriage. At any rate, Dr. Wentzlaff is a very clever man, but as a schoolmaster does not play a prominent part in Schwerin. They therefore have no intercourse with anybody in Schwerin, which neither of them seems to miss as the most tenderhearted relations rule between this couple.

Both musical, they have a very fine grand piano and exquisite music, as well as nice books, and from the sofa in their living room we have the most beautiful view across the big lake and castle park of a neighboring coffee house—which, however, was not built in our usual way but with columns, porticos, and a snow-white whitewash.

I am also beginning to learn English now. When in the evening we have eaten our excellent beefsteak with anchovy and drunk a glass of Madeira, I seize and diligently study the English book.

Felix's watch goes excellently well, which gives him much pleasure. As Felix wishes that in the morning I shall always wash with cold water, he went out and bought me a mighty fine washing sponge. If you could manage to send me recipes from your cookery book, you would give me great joy. The cuttings of the oranges that Father gave me on our departure are well preserved and shall be planted at Corpus Christi; I will be thrilled if they succeed.

Let me cease for today. Keep well and give my most cordial greetings to all, for it is difficult to name all whom I wish to include. If Papa should come to Hamburg, Felix will let you know where we shall take up lodgings. By the 28th, however, we certainly shall be there. Please, do try to find time to write to me, for it would give me much joy. Greet Father very, very much from me! If the sack and the bag with all the seeds from Aunt Spitz has arrived, please send it to me for we miss it in our trunks.

Give our greetings also to Felix's family when you speak to them, but do not show them this letter as I deem it "superfluous." Farewell, and once more many greetings from Felix and me to the whole Imme family circle.

<div align="right">*Your—Maria*</div>

<div align="right">Hamburg, April 1, 1849[27]</div>

Dear, beloved Mother,
On Thursday, March 29, we safely arrived at Hamburg after having had to wait seven hours at Hagenow for the train from Berlin. Unfortunately, a freight carriage had malfunctioned, and five others had then been derailed after it. How worrying these hours were, you may imagine, dear Mother, as I rightly supposed that Father might be doing the same in Hamburg (waiting).

We met each other at once while disembarking; I still thought that you, dear Mother, would be at the hotel, as I knew that for the first no ship

would leave for New Orleans and that probably a fortnight might pass, I had anxiously longed for still seeing you, and believe me that I permanently am thinking: if only Mother would also be here. How without end I enjoyed the pictures for which I say my heartiest, best thanks to you and Julius and Anna.[28] Indeed, it is difficult to decide where to begin with my thanks, for you have provided me so amply with all things. The baked goods and the gingerbread, as well as the poppy seed, and then the brilliant Easter cake gave me much pleasure; and especially your dear letter, from which I see that you are hale and hearty. I thank you with all my heart for these signs of the love you have for me and, I hope, will keep for me. I expect that we shall have to spend Easter time still at Hamburg, whereupon the nice cake will ensure a really festive day.

Now, my beloved Mother, let me tell you something of our Mecklenburg trip that will certainly interest you. So: On Tuesday evening we arrived at Güstrow, a little town 8 miles from Schwerin, where we were received by two domestic servants of Mrs. von Rieben, a 60-year-old Aunt of Felix's (his father's sister).[29] The Aunt welcomed us most lovingly and amicably; a delicious supper awaited us, the kind the Mecklenburgers' hospitality requires. Felix's Aunt is a very active, tall and robust lady, rather like old Madam Clar in figure and as humorous as she. Right away I felt as if she were an old acquaintance. There we stayed on Wednesday and till Thursday at 10 A.M., when we started for Teschow, promising to revisit Aunt on the way back.[30] She loaded us for the trip so amply! For instance, she gave me a nice roller cushion for my neck, a very fine porcelain flacon, two large table cloths of linen, a big silver needle, two lace needles with several pins, and several lace patterns, and she also taught me how to use them. She loves my Felix very much, but has an irrevocable hatred for his mother, which, according to the claims of the other family members, seems to me much justified.[31]

On Thursday after a four-hour drive we arrived at Teschow, where we were also very warmly welcomed by the whole family. Felix's Uncle is a man in the fifties, very, very tall and a little robust, of most noble appearance and manners; his wife, the second, is in her early thirties, very well educated and amiable, witty and cordial; and in this the younger sister, Louise von Dewitz, who is very rich, carefree and sprightly, is in no way her inferior.[32] Gustav, the eldest son, is owner of an estate and came to Teschow on Friday morning, as did the younger son, who came from Halle, both of them very nice young men.[33] Two little daughters of 7 and 9 years as well as a governess, 4 chambermaids and 8 servant girls, huntsmen, and other servants make up

the inhabitants of the castle. Even at a prince's home in Berlin, they perhaps scarcely have an inkling of such a household; the most splendid and elegant dinners, fine carriages with 4 horses in front with a huntsmen, etc., are indispensable there. They went to so much trouble that I quite decidedly declined a chambermaid. Louise always came three or four times while I was dressing to send me someone for assistance. Felix and I occupied 2 very fine rooms on the first floor, furnished in royal luxury. The same was the case at Sukow, the ancestral castle of the Blüchers, where we drove for dinner on Sunday; and if our departure had not been firmly planned and fixed for Monday, we should have had to stay there.[34] I can assure you of one thing: it is not possible to treat a person with more love and distinction than I was shown from all sides.

At 9 o'clock we met for breakfast, where we sat together till 10 o'clock, then took a look around the world of this castle: garden, livestock, rural buildings, dairy, creamery, fruit-loft, etc., etc. I toured everything with Uncle, Louise and Felix. We scared up several lambs, 19 young hens, tiny chicks just a few days old, swans; everything imaginable is there; you cannot picture all this abundance. I also watched someone churning butter from scratch. On Monday I took a ride with Louise Dewitz, who is an excellent horsewoman and as such has acquired some fame in Mecklenburg. Uncle has magnificent horses. My horse was led by Gustav, and Felix, too, was at my side. We began slowly and ended up a trot. Oh, that was splendid! All of them are so infinitely fond of my darling Felix and greatly appreciate his knowledge.

The other day Aunt related to me how badly Felix's mother had acted—the fine estate that Felix's parents had owned has been ruined through her negligent management.[35] Felix's father's 9 brothers each received an estate and 23,000 thalers, and they have been happy and become very rich people, distinguished state officials in Mecklenburg.[36] Of 26 brothers and sisters, only this one, Felix's mother, ended up badly when her affair with Kill-Mar began.[37] Aunt also related to me how she had let the children *starve* and suffer great want and *hunger* in order to devote herself to her own pleasure. When she divorced their father, the children were dreadfully maltreated.[38] Well, you can now see why the Kill-Mar does not show herself in Mecklenburg, and that I must lavish upon my Felix the love he has always been denied. But you all, too, must love him very much, won't you?

I am not able to go on writing as it is already very late and as I feel rather fatigued! Good-bye till tomorrow, and give my love a thousand times to all,

all, etc., etc., very heartily, just don't forget anyone, and tell them I shall be writing soon. Did you forget the recipes? Farewell!

Your—Maria

❧

Hamburg, in the ferry-house
April 10, 1849, at 11 P.M.

Beloved Parents,

The designation of the place and the unusual hour will no doubt have alerted you that we are on the point of beginning our further journey. Felix has found a very good, large, and almost new ship called the *Elbe,* and has signed a contract for our passage under very favorable terms. My dear Father, you can rest your mind about Felix not taking sufficient care. Like Julius, he is the soul of caution. Mr. Büsse and Mr. Schünke will go by the same ship, but between-decks, which makes a great difference.[39] As there are not many saloon passengers, we each got a private cabin. Our things have been safely taken aboard. Felix has been kept much on the move, as he wished to be present as much as possible.

I should like to have written a lot more to you, dear Mother, but it has been impossible, for the day before yesterday Felix signed, and there still remained much for me to do, as the holidays had prevented little errands and purchases, and it was not possible to complete them before; [they had to be done now] in case we should go to Le Havre or Bremen, which would have been useless for this.[40]

As there was easterly wind till this morning, such a quick start could not be considered, but suddenly toward noon today Felix came and announced that very favorable wind had begun and we would be taken in tow with the steamboat. I still needed to buy some things and then packed without interruption till 8:30 in the evening; of course I had to pack Felix's things too, as he had to attend to much more urgent matters that he could not leave to other people. While I am writing Felix is occupied with taking our trunks aboard, which requires much time. In Hamburg, everything is so troublesome. At the gate they wanted to investigate all our trunks, fearing we might be exporting dutiable goods, which of course caused a great delay.

How I thought of you, Mother and Father, and all our household, over the holidays; you certainly were at Stralow on Sunday! My Felix, to remind me of our Stralow parties, had hired a very fine sailing boat, had then fetched me, and with the finest wind we had a very agreeable sailing party.

On the second holiday, we had been invited to a party at a merchant's house; there at 10:00 A.M. we took a walk with a great company to the Elbe River, west of Hamburg, and saw the fine hothouses, etc. Then we went back to our host's house for tea and eggs at 3 o'clock in the afternoon.

Every day on the ship I shall write something to you and send it to you at the first opportunity! I was not able to answer the letters of my dear girl-friends—give them my best love and greet them *all, all* many thousand times from me! I thank you very much for the recipes! You would do me a great favor, my dear Father, if you would inform Aunt of our departure, and if you should see any of Felix's family, greet them many times! It will be only a short time now that I remain anywhere near you, but in my thoughts we will surely be together often! Be of good cheer, my dear, dear Mother, and I hope we shall yet see each other again! You must pardon me if this letter is insufficient in every respect, but the greatest haste and, at the same time, fatigue will make you pardon me for not having sent you something more complete.

Now farewell and often remember me who will not be granted to hear from you so soon! Give my love to all, greet my brothers and sisters many times, all from your

—*Maria*

[P.S.] Felix begs to greet you a thousand times and sends you farewells! I am much alarmed that he does not feel quite well, which is not surprising given all the running he has had to do; he is very hoarse!

Farewell! Maria

2

Passage to a New Land: America

FOR EIGHT LONG WEEKS the *Elbe* plowed across the Atlantic Ocean, through the Straits of Florida, and into the Gulf of Mexico and the Mississippi River to arrive at New Orleans on June 7, 1849. The passage was as horrendous as Maria had feared. Just three days out to sea the ship encountered a severe storm in the English Channel and the "first steersman" was swept overboard. During the second week of the journey a fever ravaged both crew and passengers, claiming a young girl, who was then "thrown overboard." This burial at sea horrified Maria. She wrote that "such a simple way of burying a person never occurred to me; even the memory of it is highly disagreeable."[1] Their travel companions Büsse and Schünke, who berthed between-decks by contrast with Felix and Maria's first-class accommodations, suffered terribly from seasickness and fever. Powerful thunderstorms across the Gulf of Mexico flooded even the saloon cabins and "bathed" Maria in rain water. All of this occurred on top of what Maria called "a vessel badly organized beyond all comprehension."[2] Yet she persevered, proudly relating to her parents that "I have not been seasick and am feeling hale and hearty."[3] Moreover, she was amazed at what she saw along the banks of the Mississippi. New Orleans and the "Americans" captivated her.[4]

In 1849 New Orleans was in the throes of explosive growth, full of vibrancy and river commerce. The city's population totaled 116,375, swelled by German and Irish immigrants who had begun arriving in large numbers earlier in the

decade.[5] With the advent of the steamboat, the wealth of the American continent was carried down the Mississippi and spread out on the levees and docks of New Orleans. In rural Louisiana and across the Deep South the plantation system was at the peak of its success, gained through slave labor. Commerce on the Mississippi River and prosperity on the plantations caused a flood of gold that had New Orleans rated the fourth port in the world: total river and international trade in 1849 were valued at almost $82 million.[6]

This enormous trade brought merchants (and smugglers) from around the globe. French, Spanish, German, Irish, Mexican, Creole, and American merchants competed ruthlessly against one another. The city was already renowned as "extravagantly gay."[7] Royal Street was lined with gambling houses. Canal Street was filled with magnificent mansions. Theater and opera flourished. There were balls every night. The Mardi Gras festivities had begun and were growing more lavish every year. Indeed, the city was already famous for the art of high living, as it is today. And of course bankrupts, escaped criminals, army deserters, gamblers, whores, and swindlers all helped to set the tone, as did thousands of settlers and vagrants from all parts of the United States who were passing through the city heading west to the goldfields of California.[8]

Maria could scarcely have chosen a more appropriate city for her first view of the American experience. Like other European observers, she was astonished at the industriousness of the Americans and at how often and how much they ate.[9] She saw slaves for the first time and endured the heat and humidity. She came to meet many of Felix's earlier German acquaintances as well as several of his Texas friends. She was proud that her husband was so well known, and she listened attentively as he and his friends told tales of their Mexican War days. She continued to study English, not yet having quite mastered it, and spoke mostly French with her husband. As Felix scurried about making arrangements for the voyage to Corpus Christi, she busied herself adding household provisions to their trunks and repacking her piano.[10]

Maria's letters from New Orleans capture this vibrancy, rawness, and newness. Yet it is doubtful that her experiences in this great American city prepared her for the next leg of her journey. Although New Orleans was vastly different from Berlin, it was nonetheless a metropolis with a high degree of culture. No such claims, however, could be made under any circumstances for the new settlement of Corpus Christi and the wild South Texas frontier.

Maria and Felix departed New Orleans on July 3, 1849, in a "little schooner" and cleared the mouth of the Mississippi at noon the following day.[11] She was aghast at the cost of this excursion ("We had to pay $25 a person and $74

freight!"). Heading southwest across the Gulf of Mexico, the eight-day voyage turned out to be a nightmare. This time Maria was seasick the entire trip, and the vessel stuck fast on the bar at the entrance to Corpus Christi Bay. After lightering to a coastal boat, which also ran aground for several hours, Maria and Felix, their carpenters, trunks, furniture, and piano arrived at Corpus Christi on Wednesday evening, July 11. Here, together, they began to build their life "at the place we were striving for."[12]

Corpus Christi in 1849 was the domain of Henry Lawrence Kinney, described as a "hustler in the wilderness," who had founded the settlement a decade earlier.[13] It was not yet legally incorporated as a town, nor had it been surveyed and platted. Although it had gone through a boom during the Mexican War, at war's end Corpus Christi had quickly reverted to its status as a haven for smugglers engaged in illicit trade with Mexico.[14] At the time of Maria and Felix's arrival in 1849, Corpus Christi had some 550 inhabitants scattered among 151 dwellings, including one free black, 47 slaves, 112 men stationed in a frontier army unit, 30 farmers, 97 herdsmen, and 39 laborers.[15] The population was predominantly Mexican American, with new arrivals coming from Germany, Ireland, England, and Scotland. The town's basic wealth stemmed from trade with Mexico and from the livestock of the Nueces River Valley and the vast Rio Grande Plain. Great herds of cattle, horses, sheep, mules, and goats would eventually nurture the town's economy.[16]

The visible manifestation of this wealth was a series of imposing houses standing high above the town along the forty-foot bluff rimming Corpus Christi Bay. The first residences and the business district had been built lower down near the shore, but the town's showplaces viewed the bay across the roofs of the business buildings. These well-built houses of the few, however, formed only an elegant facade; the area immediately behind them on the plains to the west consisted of small Mexican *jacales* with thatched roofs and dirt floors.[17]

Surprisingly, Maria embraced the harshness of this frontier settlement. She was at first delighted rather than dismayed by the surrounding wilderness. She of course had the advantage of being taken in immediately by the town's leading families, as Felix was already well known to Kinney and others. Her letters describing Corpus Christi in its formative period provide new primary sources on the town's early development. She threw herself into helping Felix establish their homestead and into learning the duties of a pioneer wife. Her letters reflect the newness and excitement of it all, and she provides vivid descriptions of the abundance of nature that surrounded her.[18] The endless drudgery

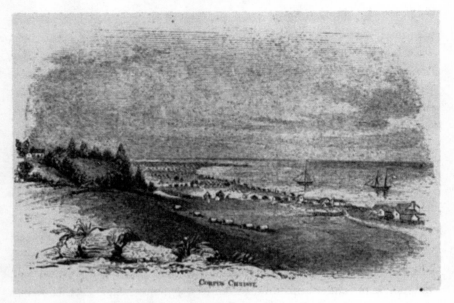

Corpus Christi, Texas, ca. 1845. Special Collections and Archives, Mary and Jeff Bell Library, Texas A&M University–Corpus Christi.

and labor of pioneering and subsistence living, the dangers and harsh realities of life in South Texas, and the never ceasing loneliness and separation from family and friends were yet to come. For Maria, it was all too new.

New Orleans, June 13, 1849

Beloved Parents,
The first lines you receive from me from my new home are as unsatisfactory as the last from Hamburg; our departure was so sudden that I had not the time or peace to write to you in detail, beloved Parents. We safely arrived at New Orleans on the 7th after 8 weeks of fighting the tribulations of a vessel badly organized beyond all comprehension—but she was the last to undertake this passage to America (under a neutral flag). You may perhaps form an idea when I say that during the thunderstorms we had in the last week, all day and all night, the rain came through to such a degree that despite placing canvas, mattresses, 3 woolen blankets, etc., in the uppermost berth (in Felix's bed), my face was nevertheless soon bathed with heavy drops and

by and by the rest of my body in rain water. On our arrival I felt much alarmed to find such bad news from Germany and that even our beautiful Dresden had to bleed.[19] Though I did everything I could to procure exact news about the state of things at Berlin, still it was not possible. God willing, however, you escaped every danger.[20] I have been especially concerned about the health of my dear, good Mother. Don't forget to write to me as much as possible of how you are.

I have not been seasick and am feeling hale and hearty, though yesterday evening at 9 o'clock it was 99 degrees in the shade. The next letter shall contain an exact description of my voyage, which you will find by no means dull. We are lodging here at Contis Hotel, which is managed by Germans who nursed Felix with great care during his illness. America is of course a country you don't easily forget once you have been there. I can't imagine anything more beautiful than the banks of the Mississippi, which are occupied by the finest plantations, if not the healthiest. For two days you steam alongside them as the American steamboat passes up the river, which for the most part here is as wide as the Elbe, passing the finest trees of the most wonderful fresh green color unlike anything we know at home. The owners' houses are palaces, the gardens having high oleander trees, orange walks, etc. The trees, entwined with forest vines and Spanish moss and under which here and there an alligator lies in the sun, are heavenly to look at.[21] Tonight we had a delicious full moon over the Mississippi, so beautiful that I have been sitting on the deck the whole night long. I only regret that you, my dear, beloved Parents, could not see and enjoy these beautiful sights with me. You cannot form an idea of the elegance and the gracefulness of the Americans. The schooners going by are surpassingly neat and elegant. The sailors are almost all handsome men with long black hair and mustaches, wearing fine white shirts, white or black trousers, gleaming shoes and broad round straw hats. The customs boats with their white sails and canopies, perhaps the size of Felix's boat, look more like elegant toys than like something created for use. Every workman is neatly clothed with white day-shirt, straw hat and white or black trousers.

Life is quite different here in every respect from that in Europe. Every morning at 5 o'clock there is a market in big vaulted halls, or rather it takes place from 2 o'clock A.M. to 12 noon. At 5 o'clock nearly everyone goes there to look at the slaves or to have coffee and *beignets,* etc. At 8 o'clock there is breakfast at the hotel, where all imaginable hot meals are served, also including fruit like bananas, pecan nuts, grapes, raisins, almonds, apples,

melons, peaches, etc. Everything conceivable is set out there, and then there is coffee with fine cream and perfectly fresh butter. Oranges are extremely cheap and juicy. All day long they drink ice, seltzer water, red wine with sugar; they don't drink anything without ice. Ice by the pound costs ½ cent, 100 cents making a dollar. At 3 o'clock is dinner, when once more the table is laid with 100 things. From 6 o'clock they again go out![22]

For my part, I have only been in the street twice in eight days, on Sunday to have a look at a wonderful garden in our neighborhood, which is a little larger than our yard but provided with the most beautiful flowers, shrubs, and garlands of vine. Figs and grapes dangle most invitingly! The garden is around a circular terrace, in the center of which rises a little fountain. There we ate ice cream, which is cheaper than at home.

We have made a very agreeable acquaintance in our hotel: Prince Paul of Wittenberg, the famous natural explorer, now devoted to Felix.[23] This old gentleman might have been of great advantage to us, as he is traveling with an old servant in order to find, if possible, a place to settle. It concerns me that he wished to stay with my husband, but who knows whether during his journey something else besides Felix may appeal to him more. He has with him the finest instruments for land surveying and measuring distance, which is very advantageous in Texas, and provisions for 3 years. He has already been here once, about 10 years ago, and then he went to Egypt; he has visited in all parts of the world. He is also a medical man, having gotten his medical degree from Stuttgart.

Felix is very sad that he lost his fine horse. The son-in-law of our hostess, who was well acquainted with Felix, had boarded it. During that time, the wife died, and some weeks later the husband and youngest child; the eldest daughter, a 2-year-old child, is now with the grandmother in our hotel.

In a few days, I hope we shall start for Corpus Christi. With Felix's assistance, Mr. Büsse will build our house. Schünke does not seem to me reliable for work. Then we have with us Herr von Winterfeldt, who was also with us on the ship and has renounced his position as lieutenant in the military because of the state of things in Germany.[24] His father is a very rich landed proprietor near Mecklenburg who gave him a fair amount of capital. But at Hamburg, he had the misfortune to become acquainted with a man who stole his purse. After he raised the alarm, that gentleman was found and indeed was recognized as a miscreant in possession of stolen passports and letters. The purse the gentleman received back, but only a little of the money. Herr von Winterfeldt is a very educated respectable man.

I shall send this letter that I began on the ship at our departure for Corpus Christi. I often feel sad when I realize I cannot hear from you soon, as I think of you so much! Remain all, all in good health and remember me in good times and bad. My good Mother, give my love to my dear brothers and sisters, relatives and friends, greet everyone! My Felix sends hearty greetings; it is rotten that he has to be out in the great heat here all day long. But it can't be otherwise if we wish to leave here soon.

Darling Mother, I am quite cheerful and content, but would be more so if you were with me and could enjoy the natural bounty with me. Farewell! Remember me often, as I do you.

Now farewell, my beloved Parents, and keep dear

Your—Maria!

New Orleans, July 2, 1849

Beloved Parents,

You are sure to be highly astonished now to receive another letter from New Orleans, where we had hoped to stay for only few days. Unfortunately, the season is not favorable for passengers from this town to smaller places, for the great business traffic does not begin before November. In summer everybody goes to the seaside retreats in the vicinity, which can be reached in 6–10 hours. Here the atmosphere is now hideous and stifling, and it is only because for 4–5 days I have not been out at all, or at best have been sitting on the balcony in the evening, when the heat is not unbearable for me.

Today our things have been taken to the ship, to sail off to Corpus Christi with us tomorrow. We still had to get a dreadful number of boxes and things for the construction of the house: furniture and household utensils, ploughs, carriages with endless items for transport, provisions, etc. And the freight is so expensive on the American ships that we can estimate $20–30 expenses. I had to repair my piano anew and pack it, which cost $8. Felix bought a very fine saddle for me, which I enjoy very much. The principal thing I lack is a *tame* horse.

The emigration to California is so important that almost no weapon can be bought in New Orleans.[25] The steamboat that formerly used to go regularly to Corpus Christi was bought by a group of young people to take them to California. In our hotel there is a lady with 2 children who wants to go because her husband has gone to California.

Captain Hughes of Corpus Christi, an old acquaintance of Felix's, is still

[23]

lodging here.[26] He has nice land on the Nueces. My husband proposed that he sell the land to him. In the beginning he did not quite agree. In spite of all his efforts, however, he could not get ready cash, so he agreed and has now sold Felix 1,024 morgen for $350 and will come along to Corpus Christi in order to deed it to Felix.[27] We shall now move there, and Felix will later sell the land he bought from Kinney, as it has no wood, unlike the new one. The Captain is a very amiable man with one hand, the other one having been shot off by the Red Indians. Up to now he has occupied the position of land surveyor for Corpus Christi, i.e., he has to enlist workmen and conduct and deliver the surveys, which is a very profitable position. Felix is a great favorite of all his former acquaintances, as I see from the fact that they have all come to see him as soon as they heard he was here. It gives me great pleasure when the gentlemen, like Captain Hughes, Mr. Bettinger, and Felix, are sitting on the balcony remembering with delight how they were together in the war and reminiscing and laughing about the dangers and vexations. These two gentlemen are also great admirers of Texas and the prairies. I am often very glad that Felix has such amiable acquaintances here, are all of them honorable and for the greater part older gentlemen.

It is very peculiar for me to hear other languages and German almost not at all, as I cannot yet speak English, though I can understand it quite well. So we always speak French, which is very agreeable to me.

I now thought it better to write another letter. For it might perhaps not be delightful for you, dear Mother, to read about what happens on such a ship. I don't know whether I have already written that during a storm in the English Channel the first steersman fell overboard. We had been on the sea for only 3 days, and this of course did not bode well for the voyage. The whole crew got sick, and between-decks there were fever and all kinds of diseases. A young girl died of tuberculosis in the 2nd week of our voyage and was thrown overboard 12 hours later. Such a simple way of burying a person never occurred to me; even the memory of it is highly disagreeable. The steward or waiter, who also had a berth in the first cabin, got the nervous fever but fortunately got over it. Mr. Büsse and Mr. Schünke, too, have been sick. Mr. Büsse is well again, while Mr. Schünke, though out of danger now, is nevertheless still suffering much. A doctor and medicine are expensive beyond all measure. A small bottle of medicine is $1½ to $2. Herr von Winterfeldt, fearful of falling ill, has gone to Galveston. Whether that was wise will soon be clear.

By the way, we have not been made destitute by Felix not receiving the

money he was promised; it is not of importance.[28] For he got his inheritance paid by his mother, although of course only 2,500 instead of 4,000 thalers. I myself also had nearly 800 thalers in ready cash. Thus you can well calculate that we are not destitute. On the contrary, I have the pleasing prospect of not getting Felix's mother for a neighbor in Texas (I hope!). Felix has cut off every correspondence with them. Yes, my dear Mother, it has often sorely grieved me that you talked to others so long about Felix's circumstances and in this way thought to learn more about him. This was offensive for Felix and myself; you often conversed with others in the back room for more than an hour. Still, I did not say anything about it before as my husband did not fear the judgment of others. If he was of easy mind, it was because he had done enough to fulfill the engagements he had undertaken. And believe me, though the people who allowed themselves to make judgments about Felix may have had the advantage of money (by no means acquired through their diligence), they did not have the character and wisdom of my Felix. I should like to see many another arrive in New Orleans with only 40 thalers, as my Felix did earlier, and whether he would succeed in getting along honorably as he did. Not according to his own accounting but through others do I know how much I possess in Felix. When he first arrived here years ago, Felix gave German lessons all evening, every evening, from 9 to 11 o'clock, for which he got paid in cash, and during the day he kept the books in the hotel where we are now lodging, getting free board and lodging for it. If I had not one pfenning I should not be in the least afraid at Felix's side! I was very glad when we arrived and Madame Müller, the mother of the hostess of the hotel, welcomed me with open arms and said at once: "Dear Blücher, isn't this she for whom you so often sighed, and this is well she who presented you the book you always had lying beside your bed during your illness?" Of course I looked at Felix much surprised, but when he nodded his head in affirmation I was contented. The Prince of Wittenberg started off last Thursday, a week ago. I wonder if he will come to Corpus Christi later on.

Felix hopes by Captain Hughes's and Hennings's intercession to get the post of Hughes. This is the man who surrendered to Felix's administration the rest of the land that my husband did not buy, and if Felix can sell it for him, we will have the advantage of a good sale. For cattle breeding, Felix will take a Mexican family along with him to tend the land, by which I shall at the same time get a great domestic help. My husband bought a number of washtubs, 6 for $3, and a number of washing troughs, 4 in all. As a gift he

presented to me a large chest, ½ dozen chairs, and a cane-bottom armchair, which I enjoy very much. In return I have presented him with 1 dozen stockings and a dozen cotton visiting handkerchiefs. Very graceful, isn't it? I unpacked my chests and found my brown woolen dress with the silk stripes quite moldy, my red traveling case seriously damaged by rain; fine new shirts, the finest stockings, fully a dozen have been damaged so that I cannot wear them. The laundress has rubbed large holes in my real chambray handkerchiefs; you must know that they wash everything with soda and on wooden washboards. I felt awfully vexed; it was to no avail whatever. At the same time washing is so expensive. A day-shirt is 10 cents. They have no mangles, and everything is ironed with a box-iron. The black women are all of them *Ferkel,* sucking pigs![29] You can imagine that we have already needed washing to the tune of almost $20. Dresses—up to now, I have only had 3 skirts washed, 2 from the ship and one from here. My husband, however, must change 2–3 times a day, day-shirt, trousers and coat, everything. He has two linen coats. As he must run all errands, because I must not go out in the heat, it is also natural that on his return he cannot remain like that.

I beg you, my dear Mother, to send at least the music I left behind. How I long for a letter from you; please do not let me wait so long. How are you all? I wish I could have this question answered as often as I have it in my mind and say it. Anna and Julius and Malchen and Edward, as well as the children Carl and Auguste, are all still alive and well, aren't they, just as I hope you are yourselves, beloved Parents.[30] Remember us sometimes, but only in the good sense—that is what I wish with all my heart. They did not always treat me justly, but I can well pardon them that, though it grieved me, as my Felix loves me very much and therefore does not speak of it. If only either Pauline or Bertha would come, how very glad should I be. For I love them all so much and so often remember them, my dear friends, all together. I greatly regret that Malchen with the children and Bertha Schmidt did not get themselves daguerreotyped; I should have been infinitely glad.[31]

My dear Mother, please send 5 thalers to me for my birthday so that I can buy a horse and a cow. A bill of exchange on a good Hamburg house is as good as ready cash here, payable on demand, or whatever it is called! Felix thinks you may fear we need it or may be in want; but it would give me great joy if I could raise cattle and make a little profit from it. For then I would be risking nothing but the loss of a few thalers, if a cow should die.

Just now my darling husband has returned from the ship and has brought me something very pretty, i.e., a gold dollar, a new sort of coin in America.

It is very disagreeable here that one cannot work or write with a light burning because then thousands of mosquitoes swarm around you. And in the morning it is so hot in our room that I was not able to write much to you. Beloved Mother, please tell all who remember me and ask about me that although I am not able to greet each individually, I nevertheless have not forgotten any of them and my thoughts often return to my dear acquaintances in Europe. Fare right well, and greet my dear brothers and sisters a thousand times from me; some lines from them would also please me. Will write from Corpus Christi!
Farewell!

. . . *Blücher*

Corpus Christi, July 14, 1849

My dear Parents,

At last, after long delays, we have arrived at the place we were striving for, and I must admit that I never deceived myself on anything more than on Corpus Christi. I expected to find nothing but a miserable den of wretched huts, instead of which I already see from the ship the pleasant houses glittering, some near the shore and some on the heights.

Now, you must not think you can reach this blissful land without trouble. On Tuesday, July 3, toward evening, we started from New Orleans in a little schooner; a big towboat assisted us and 2 big ships down the Mississippi. At noon the next day we put out to sea. I expected to get off as well with the seasickness this time as before; unfortunately however, I was sick—desperately for 4 days and somewhat less severely for 5 days. I could neither eat nor drink anything and barely closed an eye for 8 nights; because of the bad air in the cabin we had to stay on the deck, confronting rain in the night, etc. The steamship *Fanny* used to go to Corpus Christi regularly once a week; she steamed off to California a few days before our arrival. We had to pay $25 a person and $74 freight! With greatest difficulty we reached the Bar on Saturday, but had to hold off for 16 hours as it was not the right point. The following day, or 2 days later, we had to wait for 3 hours, and then at last we got over the Bar. The captain signaled for a pilot, as it is very flat there, but got the answer via others that the only one was drunk. So they tried their luck themselves, and so it happened that we soon stuck very fast. We stuck

till Tuesday, when a boat came from Corpus Christi and took us and our things aboard. Now, we meant to be there in 4 to 5 hours, but instead this boat also stuck fast, and so it was only on Wednesday evening that we reached Corpus Christi.

There I found a better arrangement for unloading the ships than anywhere. It is a big wooden bridge and pier bearing a railway with a goods van. In this manner the things are delivered to the owners well and undamaged. My husband at once found an acquaintance at the ship, a German named Ohlers, the wealthiest merchant from Vera Cruz, with whom Felix had previously stayed.[32] He settled at Corpus 9 months ago, and since then you can find everything in Mr. Ohlers's store. His store is close to the beach. Walking directly upward from there you come to his house. He possesses 2 fine massive houses. He at once took us to his house, where we were very kindly welcomed by Mrs. Ohlers, his wife of about 28 years.[33] She recognized Felix immediately. Her husband got all our things fetched and brought to his warehouse. They have the most elegant house fitted up in oriental luxury.[34] There are 2 floors and 8 rooms in the house. It is situated wonderfully, the view offering all the scenic variety you could wish. In front of the house is a very nice garden with the most magnificent roses, white pomegranate trees shaped like Christmas trees, oleander trees, resedas [white brush]; a range of all kinds of fine trees can be found there. In the evening a strong scent of vanilla wafts from among the oleanders, the wild plants almost more beautiful than the cultivated ones. The walks in the garden are strewn with fine red and white shells. The staircases are planted with oranges. The gallery in front of the house is bordered with a very fine iron railing over which are hung beautiful colored rugs. Enough—from afar you can recognize the comfort of the owners. The women here do not lift a hand all day long; they sit in rocking chairs, taking their ease, or lie on the sofa, or take a ride or drive to their plantations. There are 6 or 8 well turned-out ladies, and I never saw such fine and elegant grooming as here. When we are at home in the evening, Mrs. Ohlers and I lie in a hammock of vanilla hemp fastened to the columns of the gallery. She is a merry, somewhat vain and very lazy lady, but a very good-hearted being. She speaks German as well as English and Spanish. Attending her she has a Mexican, a nice young girl with magnificent eyes, and 2 black women. People live well here in every respect. At the table stands a black woman with a mighty fan of peacock feathers, shooing off the flies. I rarely saw such elegant silverware in Berlin.

My dear Mother, you will realize that I do not write this from pleasure in these things. I only wish to calm your fear that I might have come to live among wild and rude people who are foreign to the necessities of our life; on the contrary, I never have found such a complete household as here. They uphold etiquette very sternly here, only is it just the opposite from Germany. For I must not pay a visit to a lady before she has made a visit to me. It is very tedious for me, as all of them speak English or Spanish. I understand almost all that is spoken, but speaking myself is not yet the right thing to do. Mrs. Ohlers is a very fine horsewoman. Today, I shall accompany her to their plantation; she on horseback and I in her carriage. Here they do not walk 2 steps on foot, always driving!

You are sure to be highly astonished to hear that Felix bought a house from Kinney with Corpus Christi's best-managed garden for vegetables, fruit, and potatoes.[35] There has been a gardener there up to now who has cultivated these things for sale. It is a very small house with 2 large rooms, but situated pleasantly on the hill and with a wonderful view of the sea; very big thick trees are there, very fine fig trees, etc.[36] The area is also near the artesian wells Kinney is about to get built. Felix is away with him to inspect the land on the Nueces. In any case we must delay moving there for some months as the Red Indians are in the area and there is a military post close by, causing much excitement.[37] Traveling takes strange forms here. Felix was with me at the store to see about the chests when Kinney sent a saddled horse and inquired whether Felix would accompany him to Casa Blanca.[38] This borders on our land on the Nueces. Felix took a shining new hat, put on Mexican trousers, spurs, got on horseback, said farewell to us in a hurry, and rode off! I expect him back by Monday, for he started out on Friday quite early in the morning. Until our house in Corpus Christi is rendered clean and nice, I shall stay with the Ohlers. I occupy a very pleasant room on the first floor. There is a charming view from my window. I fully believe there is no healthier climate than here. The heat is never excessive, and every evening there is a strong sea breeze, often beginning as early as 2 o'clock in the afternoon. The Ohlers, too, have a plantation on the Nueces, but only 5 English miles from the town. There they keep their cattle, goats, sheep, oxen, horses, etc. They maintain but one cow at Corpus, giving sufficient milk for their household, and every morning they buy fresh butter. If you have a bit of land here, a little house and some cattle, you need not have much cash. My husband has taken his money to Kinney for safekeeping. I am his treasurer. He hands me the receipts, notes, bills, dollars, and

during the whole journey I was hampered with handling the money. In New Orleans, we bought still more provisions, as Felix did not know how things had altered here. We therefore have no opportunity to spend our money.

How often I think how happy Father could be if you were here. For it is a magnificent seaside resort, i.e. fine bottom and fine water where we bathe. Then the angling—we in Germany have no idea of it. When the ship stuck fast, two gentlemen set out fishing lines and in a short time, perhaps 8–9 minutes, had caught 28 catfish.[39] I myself caught 7 fish, but I found it tedious managing the rod. They bait the hook with a little bit of bacon, nothing else. They are very tasty fish with tender flesh. Some that they caught were perhaps a hand's breadth longer than this sheet is high. But if you do not know this kind of fish, it is very dangerous as on either side and on their back they have spines in their fins causing nasty poisonous wounds. So it is not easy to kill them. Were there such a wonder at Stralow, I think Father would buy two fishing licenses.

Yes, dear Father, if you could make up your mind to surrender the business to Carl and come here with Mother, Anna, together with F. and Julius and his wife! For, believe me, once you recover from the voyage, you cannot find a country in the world more blessed and healthier than here. There is a little church here, 3 doctors, one of whom is paid by the town and is said to be very clever. All you need is the chance to travel freely, which the blockade did not permit, as few ships were at Hamburg. And then take along as little baggage as possible, because most of what you drag along with you as torment can be got here. Felix often says you would surely be well pleased here as there is no comparison with Stralow, where Father so likes to be. I believe so firmly that you will come that I will advise Julius to take up his English language studies thoroughly. The only thing against which one has to protect oneself is the hot sun on one's head. You must never go out with your head uncovered. In New Orleans two men who had been with us since Hamburg tumbled down dead because they were out in the heat of the street all day long.

My dear Parents, do not judge my writing and the style of my letters harshly, for it is not easy here to write undisturbed. In the evening and by night you cannot do anything because of the gnats, and during the day I am not always my own master. I got on especially badly with this letter; I had been writing the whole morning, and when I finished, the thin paper flew up and wrapped itself round the wet pen so that the words could no longer be read. I at once flung it aside and began this one, when 2 ladies came to

pay their respects. Thus I finished it but on Sunday in all haste as a ship was about to depart.

My dear Mother, you would be much astonished to see me now. The recent seasickness affected me so much that I grew still thinner than I was already, and so sunburned that I look much like a Mexican in color. To complete my misfortune, I am losing my hair beyond all measure. But as I don't want to feel vexed at it, I got it cut off by Mrs. Ohlers and do not wear my hair any longer than Julius once did. Twice a week I get the German newspaper here from Galveston. But it produces such untruths that I long to hear from you whether there is peace now in Berlin and how business matters are proceeding.

Beloved Parents, you cannot say that I write to you too little; on the contrary, I often think I write too many letters, as the postage is very high, and the arrogance of the Americans also shows itself here. For they say: who writes a letter to a free citizen, also pays for the letter.

Mrs. Ohlers has given me a little tame fawn of 4 months out of joy because I presented her with something that the others cannot boast, i.e., my colored wax tapers. It is true they were dear presents to me from you, but as she found them so nice and as I must be very grateful to her, to be sure, for the amicable reception, I at once parted with them. It is very grand here now. There are 2 fine hotels in the town, regrettably for gentlemen only. Never do ladies put up there. But that, too, will perhaps soon change.

Felix plans to use our little house later on as a kitchen and storehouse as soon as another one has been built for us by Büsse & Co. Since New Orleans my husband has paid for everything for these gentlemen and hopes they will thus be obliged to him. It is much enticing to know that once he gets to work and his skill at carpentry becomes known, Mr. Büsse will earn $2 a day.

I must now cease at last, otherwise the boat will sail off. Give my greetings to all our acquaintances, brothers and sisters, and friends. Farewell all of you and often remember

Your—Maria

Corpus Christi, October 30, 1849

Fondly loved Parents,
I had the great pleasure on September 29th of receiving long-awaited letters from you. Above all they comforted me as to your health. We still are in

Corpus Christi and probably shall stay here for some time, because Felix got the position of district land surveyor, a rather remunerative but also very hard one. Now he has been 14 English miles from here for 2 weeks, where Kinney intends to erect a new town, to which a hundred families will come from Galveston, to whom he will give free land and cattle.[40] As soon as even a little of it is settled, the rest of the land will double in value.

Outside the town we inhabit a very neat little house, which through Mr. Büsse's assistance has been much improved in appearance: by large porches on 2 sides, and canopies in front of the other doors, connecting the useful with the graceful. We have only one very large room with an adjoining kitchen of the same size. In Germany they would think it impossible to content onself with so small a house, but here, where one spends the greatest part of the day in the open air, it is sufficient. Mr. Büsse has a wooden shed in our garden that is his bedroom and workshop. I have no servants at all, this being superfluous as I can preside very well over my little household. Cooking I do for 3 persons only, for the most part only for 2, as Felix cannot come home for dinner even when he is surveying in the neighborhood. It is the custom here that gentlemen do all the shopping. In the town there is a butcher, baker, etc. Mr. Büsse procures meat, and Felix gets milk from our Mexican neighbors. I think dear mother that you perhaps do not have as agreeable a notion of our habitation as the reality. For everything is bright and airy, which renders it delightful for me. The house is situated in a garden of 12½ German morgen, where we grow vegetables and flowers.[41] Moreover, I have quite a stock of cattle, 6 pigs, 27 hens, among them 7 that I bred myself, and 2 big Turkish ducks the size of our German geese. Besides, Felix got a wonderful English horse from Kinney, for which Kinney had paid $200 in Mexico—a magnificent, tame animal which I, too, am riding. It is a roan horse. As I never go out, for it is finest of all in my garden, I sometimes fetch the horse and take a horseback ride in the garden. It is very agreeable that we have no costs for upkeep of all these animals. The pigs seek their food in the chaparral and only come home in the evening. The fowl eat beetles, etc., and melon seeds and grains our garden produces in plenty. We sold melons to the tune of $2 to $3 dollars a day almost until September. The prices here cannot be compared with ours in Germany at all. For example, I have a Mexican washerwoman who appears at 8 o'clock in the morning with 3 children. After breakfast she begins washing; at noon, her husband also comes, and after dinner washing goes on still till 3 o'clock, then it stops. If there is some wash left, she comes

Painting of the first Corpus Christi Blücher Homestead. Charles F. H. von Blücher Family Papers, Special Collections and Archives, Mary and Jeff Bell Library, Texas A&M University–Corpus Christi.

the following day; but she understands washing only, nothing else. She has no idea at all about starching and ironing, which I like to do myself. For this she expects $1½; however, she has had to content herself with receiving from me $1 a day.

Several birthdays have now passed, when I was more piercingly conscious of the distance lying between us than ever. In order to offer at least something to my beloved Father, I sought fresh flowers for a wreath that I hung above his portrait, and every hour, every moment, I thought of earlier days. My birthday here passed quite without a trace. After I reminded Felix of it, he brought me a fine bouquet of flowers and an excellent big watermelon. In the evening I went to bed at 7 o'clock as we had had several nights of severe thunderstorms and northers. The thunderstorms are extraordinarily severe and long lasting here. Though at this time of year we often have 84-degree heat (now at noon it is 71 degrees), the air is much purer and more endurable than with us in Germany at 68 degrees. I get warmly dressed in the

evening even at 75 degrees, to such a degree does the body become accustomed to these high temperatures.

A great number of rattlesnakes live in our garden. In the very first days of our sojourn here Felix shot a rather big one with his rifle. We had one living in a jar for a while; while digging, my husband saw it and held it fast with the rake till I fetched a jar, into which we made it creep. Last Sunday I was alone and saw such a snake sunning itself on a bundle of shingles. Some paces from it lay an axe, with which I at once dispatched it from life to death. The other day in the kitchen I opened a bread bin and there was a snake lying close under the cover. Though it was in the bread bin and in the kitchen, Mr. Büsse shot it dead!

From New Orleans, we brought along very fine wheat flour, with which I bake every day. No man can die of hunger here, for the hunting and fishing are indescribably productive. Often when boys from the town go fishing, they later drive around and offer fish as presents. Thus the other day we received immense red fish; we only took 2, as they can feed 4 persons well for several meals. The flesh is most like that of perch, of most agreeable and finest flavor. Each red fish was more than an *Elle* in length, and at the same time they are thick and broad. It is the same with hunting: wild ducks, geese, prairie chickens, quail, jackrabbits, snipe, and doves are shot in enormous numbers. My husband went out for an hour the other day after dinner and brought home 53 wonderfully fine snipe. As it was absolutely impossible for us to polish them all off, we distributed half of them to the pigs, mainly of course the shot-damaged, less fat, and smaller ones. It was a fine supper indeed. Mr. Schünke having been fired some time ago because of his stinking laziness, Mr. Büsse and Felix got them plucked, singed, and disemboweled—in the garden of course. I receive game and fowl in the kitchen thus dressed out. Another time they brought me a live quail, which unfortunately at once flew away again. On a walk before breakfast, which is taken at 7 o'clock, Mr. Schünke one Sunday hunted up 4 jackrabbits, 1 quail, 1 prairie chicken, 1 snipe, and 2 very big tortoises, all of which made an excellent soup and stew. From this you can well see, dear Parents, that even gastronomes can find much to their taste here without great expense and with little exertion. I have been trying my hand at shooting at targets but do not yet hit quite surely. The other day I shot through a barrel from 20 paces, but this has been my best effort so far. The gentlemen have also shot hummingbirds and egrets.

Reading in your letter of the various alterations to your home, I can well

imagine that many an inconvenience has ceased for you, dear Mother, now that the work is complete. I was as glad about the news that both apartments have been let and hope the arrangements are satisfactory for the longer term. I was astonished and greatly alarmed at news of the cholera and that death has already claimed many a victim from among our acquaintances. Thinking of cholera affecting my dear relatives, I should so much like to have you here where you would be safe from that dreadful disease.

All the boys in town love to catch wild horses and perform little races, at which the other day Kinney's nephew got 3 front teeth knocked out as he tried to hold the lasso with his teeth. Even grown-ups do not manage this, much less than a nine-year-old boy. Felix has received a trumpet from an old Ranger friend, so perhaps he shall gain some musical talent. My husband urges me to play the piano as often as my time permits, but my music collection has remained in Berlin and the piano has become so bad that it affords me little pleasure. And to tune a piano here costs *$15!!*

Beloved Parents, write to me very, very often and also very much about how things are at Stralow and how you are doing, enough for me to imagine I am still with you. My old fat dog is still living, I hope?[42] Take good care of it so that it would not look miserable if I should come to Berlin right now. I do not know at all how I should feel to live again in a town where everything is so narrow and dark. Here everything is so green and beautiful as far as I can cast my eye, and in the chaparral there are the nicest walks you can imagine. Tall, thick trees are festooned with the most magnificent and exuberant creepers. At a little distance from our garden is a small creek with such wonderful places on its banks that when Felix took me there for the first time, I was brought to a standstill, quite enchanted. Acorns, too, there are in great numbers.

Dear Mother, each hour, day by day, the desire rises in me to see you again as soon as circumstances will allow. When I am talking to Felix about you, he always thinks I do not enjoy being with him here and I must be tormented and longing to be back in Germany. But my husband takes great pains to earn our keep, sparing no inconvenience or labor. I am often saddened to think that for weeks he has to lie in the open at night in spite of rain and wind, and must suffer being ravaged by mosquitoes, so to speak, then work all day long without proper meals. When he comes home, he has so much to do immediately that the other day I had to dictate English land papers for copying till 1 o'clock at night; and he was obliged to sit and write like this for 3 days as if nailed to the spot. You surely suspect that Felix may

be too lazy to write to you, but this is by no means the case. On the contrary, he loves you from all his heart, and when we were reading your letter, beloved Mother, he wept like a child, perhaps remembering the unpleasant relations with his mother, who has not fulfilled a single one of her promises. However, thank God, Felix was not destitute after all this. When he delivered the papers he had translated and copied, he was paid $31; and $8 dollars for one hour of land surveying. I am now less anxious about the future than at any other time; for the way Felix is paid here, and given our small expenses, something can be laid back for later days.

Keep me much in your love, so that I shall always be glad and cheerful! Give my love to *all, all* friends, relatives, and acquaintances a thousand times from your

Maria

Fond greetings from my Felix!

Corpus Christi, November 29, 1849

Beloved Parents,

In all haste I write you these lines, only a few hours before the departure of our next ship. On November 12 we received the letters, and with great joy I saw that my dear brothers and sisters did not forget me altogether. And as for the pancake mix, I wish a good meal. For Felix's birthday I baked the pound cake, which turned out very well and tasted no less good. My dear Felix enjoyed it very much and even wished a repeat of it, which indeed followed in the form of a coffee cake and other baked goods. My husband's birthday was spent in special pleasure and joy. Mr. Büsse had not given up his plan to serenade Felix. For this purpose, he crept under the house early, with trumpet in hand, from which he poured forth terrible notes from beneath the spot where Felix's bed stands. Then began the production of the pound-cake and a dish of pickled herring salad, then followed the gift of a big chest, in which were two other chests, in the smallest of which were 25 good cigars from me and a carbine pistol from Mr. Büsse.

My dear Father, you write that you would have liked to present me something as usual on my birthday. But as trifles might not help me, I will patiently bide my time. My beloved Father, I should reproach myself in the extreme if you should have to toil in your advanced years to support your children! Be assured that I lack nothing, absolutely nothing. I have to care for my household and am well occupied; but I certainly am not in any want.

If by any remark of mine you might have come to the suspicion that I am in want of anything, you may quite calmly lay aside that idea. Here, as everywhere, with great means you can make great enterprises; and Felix is young, healthy, and very active and will certainly not fail.

As Christmas is now so near, I do have a wish to bring forth. Dear Father, might it be possible for you to procure for my husband a needle gun together with cartridges, which would be of great advantage for him and cannot be got here at all.[43] I beg you cordially for it if it would not be too much trouble or be too expensive. Send such a one to New Orleans c/o Magner and add some boxes of copper-lined percussion caps. By this you would give me great joy as I might much more calmly watch Felix riding away when he has to spend long times very far from here in the greatest wilderness. Such a weapon would be a great terror for the Red Indians because it can be loaded so quickly. Pardon me this request and be sure that nonfulfillment of it will not make my heart angry at you for a moment.

Felix has now returned home, and he has been *very rough* toward me, for which reason you had better not send a rifle (you must know this is intensely annoying!).[44] We hope to have a second house at Christmas in which I am to get a room for myself. We shall also have a Christmas tree, apples, nuts, and oranges for Christmas. I hope the cholera may be ended now without having claimed additional victims. As for the political tidings, Felix is very glad to hear something, though last time it evoked his deepest regret about unfortunate beautiful Hungary.[45]

So must I cease, and I greet and kiss you a thousand times in my thoughts, wishing that you may spend the holidays happy and healthy and that you might close the old year remembering me and might keep me as warmly in your hearts in the new one.

Fare right well!!

Give my cordial regards to my dear brothers and sisters, and my Aunts and Uncles, and to all, all acquaintances.

Maria

3

Early Corpus Christi: The 1850s

ALTHOUGH PROMOTED FAR AND WIDE by Colonel Kinney as the "Naples of the Gulf," Corpus Christi grew slowly during the 1850s, following boom and bust cycles like those in many frontier settlements.[1] The first half of the decade brought significant growth, fueled by offers and rumors of cheap land, agricultural abundance, and trade with Mexico. Kinney's land agents, working mostly in Europe, enticed new settlers from England, Ireland, Scotland, and Germany. Corpus Christi was incorporated and platted in 1852, was named the Nueces County seat, and held its first elections for a mayor and city council. The organization of government likewise sparked development, as city hall and county courthouse brought their factotums: lawyers, official, clerks, and of course the assorted "peddlers of influence."[2] To protect the town and its environs from Indians, hide peelers, mustangers, and assorted roaming cutthroats of the frontier, a company of Texas Rangers mustered to patrol, assigned to headquarters at Corpus Christi.[3] The boom became official late in 1852 when the United States Army established a military depot and frontier troop station. Government contracts and payrolls now supplemented the town's livestock and shipping economy. By 1854 the population had doubled to twelve hundred inhabitants, and plans were being formulated to solve the town's most pressing problem: the inaccessibility of deep water over the Aransas Pass bar. The young city allocated fifty thousand dollars to dredge the bar and deepen the channel.[4]

The boom, however, was not tenable. After the Corpus Christi company of Texas Rangers was disbanded in March, 1853, depredations attributed to Indians, brigands, and renegades increased. Yellow fever decimated the town in 1854. And the unending clash of cultures, economic division, and racial cleavage between Americans and Mexicans prevented true prosperity. The two groups willfully misunderstood and despised each other, with feelings often inflamed by an array of historical resentments and mistrusts. The bust came in 1857 when the army abandoned its post and depot for removal to new headquarters at San Antonio. Business came to a standstill, and stripped of lawful protection, Corpus Christi stood at the end of 1859 forlorn, with an uncertain future.[5]

Maria von Blücher rode this ebb tide with resourcefulness and ability. Her life, however, was far from easy. Although her husband achieved success in his many varied occupations, his lack of capital precluded financial independence and wealth of the kind she had known in Germany.[6] There would be no life of leisure. Instead, for Maria, life entailed the endless drudgery of housework and homemaking. Her letters repeatedly underscore the recurring theme that home and hearth meant workloads heavier than she had ever imagined. Housework consumed her time and energy. She put in long hours cooking, cleaning, sewing, laundering, and gardening. In addition, she took on the responsibility of keeping Felix and later her children healthy. With calm deliberation, she used the little medical knowledge she had to treat ague, malaria, cholera, hepatitis, smallpox, and yellow and typhoid fevers, along with day-to-day scrapes and bruises. She always assumed the major burden of nursing and caring for the sick. Indeed, many of her letters read like a nineteenth-century medical primer. These endless hours of backbreaking toil left Maria little time for rest and leisure: "God, how often I have longed for a rest!"[7]

Pregnancy, miscarriage, stillbirth, and successful childbirth all came to Maria during the decade. Her daughters Mary and Julia were born on January 14, 1851, and January 6, 1853, and her sons Charles (Carl) and Richard arrived on February 10, 1856, and March 20, 1858. In between Maria suffered at least one miscarriage and also experienced stillbirth of a son.[8] Although child rearing added greatly to Maria's burden at home, the children brought love, humor, lively companionship, and later helping hands to her labor. Her letters are filled with unconditional love for and pride in her children as well as timeless parental concerns about education, health, and character. She also writes frankly and honestly about the trials of raising children, the endless demands placed upon her, and the frustration and often deep depression she faced daily as an

immigrant, wife, mother, helpmate of her husband, homemaker, and house-keeper.[9]

As Maria worked day in and day out to supply the basic necessities of life, she grew more confident and independent. At first, the heavy work load seemed almost unbearable; it was physically exhausting and emotionally draining.[10] Over the decade, however, she learned to abide the drudgery and monotony. Indeed, she developed a certain fortitude and resilience that enabled her to withstand the privations and overcome the hardships. She helped her husband support the household financially by selling eggs, melons, milk, and produce from her garden; taking in piano students and teaching embroidery; and even selling family heirlooms, her favorite horse, and her beloved piano in times of need.[11] Her marriage to Felix, however, slowly deteriorated into an emotional abyss.[12]

Felix's successful career as surveyor, civil engineer, interpreter, and land agent, and his attempts at ranching and farming, kept him away from home for months at a time. Business took him away even at Christmas and he missed the births of two of his children.[13] Land rich and cash poor throughout the decade, Felix continually had to work to support his household.[14] All of it apparently took a serious toll on his relationship with Maria, who had to depend more and more upon the generosity of her parents in Berlin for support. Although Felix and Maria clearly loved each other and their children, they grew apart. By the late 1850s Maria candidly told her parents: "I am convinced that if Felix could live free and myself among my family, both of us should be better off. . . . I have already become accustomed to managing the household independently. . . . I am more quiet and content when Felix is away and I am alone with my children."[15]

Maria's thoughts and letters, however, often border on the hypochondriac, for she was in many ways better off than most in Corpus Christi. Always aware of her class, she was contemptuous of almost everyone and everything she encountered. At times her pen was vitriolic.[16] Yet her caustic superiority masked what were at times good-hearted generosities. Her racial biases notwithstanding, she was a complex, well-educated, and strong woman and was not quite as particular about the conventionalities of her life as the standards she imposed on others would suggest. How else does one explain the aristocratic Maria von Blücher, who routinely slandered Mexicans as "lazy, dirty, and unclean," sneaking off into the town's "Little Mexico" to visit an old Mexican woman friend to share cigarettes and a drink of tequila?[17]

Maria escaped toil and drudgery in other ways less worldly than the occasional use of alcohol and tobacco. She embraced the great outdoors, taking

immense pleasure in horseback riding and gardening.[18] Reading always intrigued her, and her favorite writer was the French author Alexandre Dumas.[19] Music likewise enthralled her, and she relished her limited playing time at her piano ("For the pleasure I have had in playing the piano I should exchange for no other").[20] And she did enjoy Corpus Christi society as a "person of rank."[21] Her pen often displayed a sarcastic and biting sense of humor, particularly when describing her children and the pitfalls of child rearing.[22] As a mother she was a stern disciplinarian, but she made sure her children always had a Christmas to remember.[23] All in all, her letters provide remarkable insight into the human experience in Corpus Christi during the 1850s.

Corpus Christi, February 20, 1850

Beloved Parents,

On Sunday, February 17, I received your dear letter. I, too, had to wait three months. You dear ones may well imagine how eagerly we longed for news, as Christmas fell in between and I was not given the pleasure of hearing anything from you. I am pleased to hear that my letter arrived on Christmas Eve; I had scarcely ventured to hope that it would reach Berlin by then, as the letters are picked up here once only a week and then must first go to Galveston. Later, yet other impediments arise, as the steamers transporting mail start from New York only every fortnight. If something is just one hour late, it first lies there for two weeks. Fortunately, everything arrived in due time. My good, dear Parents, be assured that we did not think of you less than you of us! Felix and I were quite alone at home on Christmas Eve. Toward evening, when my husband had stopped work, we sat quietly side by side, and Felix told me amid stifled tears that he had intended to present me with a tray I wanted for my silver goblets and nice sugar basin. Though he had searched for one in all the stores, he had not been able to find one. In return I told him that I had been no luckier than he and had not been able to hunt up in Corpus Christi cloth for a woolen overshirt, which would be useful for measuring work. We were content that each had thought of the other's wishes, and thus the evening passed by like the rest. Christmas Day, too, we spent quietly at home, and on the second day we went to the Ohlers for one hour in the afternoon, and then the holidays were over. By the way, Christmas and New Year are celebrated brilliantly here. At the Ohlers there was a big soirée on Christmas Eve. But we preferred being peacefully together; so in our minds we were in your midst every moment. On New

Year's Eve Mr. Schünke and Mr. Büsse were with us. But as both seemed preoccupied with thoughts beyond this little circle, it was very calm and quiet with us. At 11 o'clock we parted and went to bed. Moreover, I had a violent toothache, which bothered me continually with only slight respite until some weeks ago, when it reached a terrible intensity. Then it ended in a violent diarrhea, which compelled me to stay in bed for several days. My poor Felix has had great trouble cleaning the rooms, making the beds, cooking, washing, and nursing me, which he did with indefatigable care. At night he has sat up with me and then he has worked all day long outside at building the house. It's a pity our new house has not yet been finished as Felix has had to wait eight weeks now for lumber because of low water.

Some of Felix's German guests have therefore been obliged to go to the Corpus Christi Hotel, where they are quite comfortable and well attended. The American practice is that lodging and dinner, breakfast, and supper are all included in the price. They have a hot meal first thing in the morning at 8 o'clock, just as in the evenings. Dining à la carte is not known here in any hotel; this is done in the restaurants, where for a dime you can eat and drink as much as you please.

Life is now quite different at our house. Mr. Büsse has prepared our kitchen garden. He has laid out a very nice flower garden for me. Moreover, he has made several bird cages. One of them has a trap, in which we have already caught three fiery red cardinals. They are charming creatures the size of blackbirds; they have a similar bill but also a big crest on their head and great, wonderful black eyes. To my great dismay a sack fell against the door of the bird cage, opening it and setting my prisoners free. But I shall get others, for they flit about in our garden in immense numbers, even below the porch, just like the hummingbirds in summer. At times I accompany the men when they go out to collect cactus or catch butterflies and beetles. I go hunting with them too. Snipe and thrushes are present in enormous numbers, and jackrabbits are plentiful. Every week we have jackrabbit pie at least once. What rank as expensive meals in Berlin are the cheapest here. The other day Mr. Schünke shot *9 hares* in 1¼ hours and would have got more had he not already had enough to carry. We have not bought meat in several months. We are well acquainted with some Mexicans; we are kind when they come to see us, while the Americans almost always treat them contemptibly. When the Mexicans kill wild cattle, we get so much meat that we often dry some of it. Usually they bring the fillets and some other good cuts besides. An old Mexican woman came to see me the other day.

When she went away, she drew a very nice silver ring from her finger and presented me with it. The following day she sent me a big plate of little cakes and every morning she sends a big pot of milk and the finest meat available. I also go to see her at times, to smoke with her a cigarette which she prepares for me and herself begins to smoke, also to drink a glass of liqueur, etc. Altogether I have contact with some very nice people, among whom are 2 Germans. Mrs. Ohlers sometimes comes to fetch me in her carriage, as does Mrs. Noessel, whose husband has the hotel.[24] We then undertake very agreeable carriage drives. These good ladies as well as Mrs. Meuly always provide me with cakes and such things.[25]

Dear Father, you write that if we wanted things or could sell them to advantage, you would send them. Indeed there are many things for which one could get threefold or double the price in return, but that would also cause you significant outlays. For example, a double-barreled gun that costs 15–17 thalers in Hamburg can be sold here for 30–40 dollars; 40 dollars equals 55–57 German thalers. But, dear Father, I will be fully satisfied if the request in my last letter is fulfilled, and if, dear Father, you should perhaps already have sent away some of the things requested, my most cordial thanks for them in advance. If not, pardon me when I beg my good Mother to send some wooden kitchen utensils, for rolling pins and wooden scoops are invaluable here. In the American households, pigpens that they are, they do not know cooking things of that kind—and pots and pans all the less!

You ask, dear Mother, how my things got here. On the whole rather well; at any rate nothing would have been damaged if the ship had not been *too very bad.* The mattresses in particular got wet and rusty, as did the bedsteads. My red trunk got totally soaked and a great many things in it turned moldy, as the water continually dripped through the ship. My piano had been extremely badly packed; thus it suffered much. The outer cover has rotted off my music chest. The big trunks and their contents, however, remained perfectly fine. Of the things in the big trunks and in the little chests only one glass was broken, which nevertheless I regretted greatly as it was spun glass. Our good mirror survived too, and as I have a very nice bedroom, the mirror hangs there. Once more I thank you for it, my dear Father!

Our bedroom is wonderfully cheerful and airy with 2 windows; the floor and deal boards are varnished like the windows and doors. In two corners finely worked small shelves have been installed where our toilet-set and stands are, as is the custom here, big porcelain wash basins with very nice

water jugs, soap caskets and brush caskets, all fitting together. At another corner stands my little toilet glass. Below it are white curtains; for the windows, too, I have made and trimmed linen curtains. You dears can now surely imagine it. Otherwise, there is nothing in the bedroom but the beds and two chairs. All in all, it is very nice, and I feel glad when I enter it. We have discovered that the mattresses are much smaller than the prescribed measure; there is a good hand's width missing in their length and breadth. Yet that can be altered. My little old mattress, however, is still better than our new ones; nevertheless, everyone envies us these.

I wish I could be in our family circle for the approaching celebration of your silver wedding! But that cannot be. Perhaps the future will bring us happy times when we can be together! It pleases me that Hermann Blücher sees you, and Felix will write to him soon.[26] And it seems you are in constant touch with Aunt Rieben by letter. I believe she takes the most cordial and sincere interest in our fate. Felix will also write to her, and I shall add some lines.

Much is now being done here for the security of the settlers. Yesterday a corps of regular troops arrived here and are pitching their camp in the neighborhood to purge the region of Red Indians.[27] It is advantageous in every respect as the commerce in the town will be improved. For the chief commercial traffic indeed goes by land, as Corpus Christi Bay is too shallow and flat to allow big ships in. With the population not yet very great, there is not yet an abundance of marketable goods here. But this will increase every year, and secure sales prospects are needed. Indian corn is the chief crop grown here, producing the best yields. Our field, too, is seeded with Indian corn. Two Mexicans ploughed it for us with a yoke of oxen, our small horse, and a mule. Most of the lemon, almond, orange, apricot, peach, and vine seeds have already sprouted, and every day more and more are shooting up. Though we have had very strong northers and a slight freeze, yet all is already bright green and fresh. Our house, too, will soon be surrounded with greenery, which pleases greatly. Scorpions are immensely numerous about the place, but we learn to live with them. They are admittedly disagreeable to me. But the idea one has of them in foreign countries is worse than the reality. You write, dear Father, of means against rattlesnake bite. I do not believe they are all that dangerous. For we had in our garden a horse that had been bitten by such a snake yet still ran for some distance. It is true that it went lame and its lower leg was much swollen. Felix had the wound washed with spirits of ammonia and warm water and then ban-

daged. After some days the beast was sound and as quick as before. Felix has already caught two big rattlesnakes with his hands, one of them in our garden.

Because of our garden, I left my little dog for some time with Mrs. Ohlers. There it ran about free, also going into the chaparral, where the dogs of a man living here tore it to pieces. You may well imagine how the news afflicted me. The same dogs have already done much damage here in town, attacking calves, etc., etc., and yet nothing can be, or rather nothing is, done or said to this man. Justice is awfully insufficient here. You would be astonished at the curious domestic animals they have here. Mr. Noessel owns a tame tiger which Sñr. López, our Mexican, caught and sold to him for $2.[28] It is a magnificent beast and also understands very well how to suffocate hens and pigeons.

I was overjoyed to receive so many letters from my friends and relatives. But my dear friend Bertha Schmidt will now certainly live a very sad and lonely life. Her letter is so shot through with pain and suffering about the loss of poor beloved Pauline that it made me uneasy for her. Like her, I am deeply saddened over what we have lost. You, dear Mother, know best how much Pauline has meant to me.[29] I would not have believed that our separation would be so painful. I should very much like to fulfill Bertha's wish to send a copy of the only existing portrait of our Pauline, but it is not possible here at present, and to send the picture to New Orleans seems to me too great a risk. Its loss would afflict me painfully. I should have to consign it to the hands of strangers. Yet there is a possibility that a daguerreotypist will come here. Mr. Noessel is very skillful in producing such pictures, and only a few months ago he sold the equipment for it. For several years he maintained himself and his family this way in Mexico and New Orleans. Whether he would be interested in trying to render Pauline's likeness from the portrait I cannot be sure, as I do not really understand the art.

Certainly you will see Bertha soon; greet her with all my heart. Now all of you keep very well and remember me and write to me often. Give my cordial greetings to my dear brothers and sisters and all relatives and friends who ask about us. Farewell once more and keep dear.

Your—Maria

Corpus Christi, April 13, 1850

Beloved Mother,

Today a year ago, on April 13, was the last time I stood on German territory and soil! Just as I wondered then what the future would bring for you, I anxiously wonder what your letter just received and most eagerly awaited will report to me. I cannot deny that I felt great concern for my beloved Father's health when I saw Julius's seal, and was gladder than ever to hear that all, all of you dear ones are fine. The letter was an extremely long time coming. For from Feb. 4 to April 13 is more than 9 weeks, and often letters take no longer than 4 weeks to reach here. And so that you, beloved Mother, shall not have to wait too long for an answer, I sat down at once to begin a letter. But I don't believe I shall be able to finish it today.

First of all, dear Mother, I must tell you the apprehension I have been feeling since our last letter that Father may perhaps be angry at Felix for declaring his wishes in such an open, frank, and straightforward manner; he may have gone somewhat too far in that. I had begged for a needle gun for Felix's use. That Father could not get such a gun fills me with regret, as its rapid loading capability is the greatest advantage here. I entreat Father very much not to be angry at him, as Felix told me that he wished to reimburse Father for any cost, as he could have profited greatly from selling the gun. This week he was offered land worth $160 for a pair of pistols and his gun. But as he cannot be without weapons, and as these are very good, he of course had to give up the bargain. The surroundings here are very, very insecure because of the Red Indians. On the other hand, in town you can live without the slightest fear, as they seldom venture to attack a house. The Red Indian does not place his life in danger without pressing reasons. And, whatever books and your apprehensions may suggest to you, be reassured that I have nothing to fear for myself. It is true that I have trouble with the knowledge that Felix is out in the hinterlands for weeks. When he was away last time, the week before Easter, I got up in the night and paced to calm my anxiety. This is probably unwarranted and due to unfamiliarity, as the American wives laugh at me when I ask whether they feel anxious about their husbands' lives being in danger. But for me, this has been a constant from the outset!

At the end of your letter you write that you could not see me in my house in this life! If I could conceive of the idea that I should not be allowed to see you again, beloved ones, and share a hearth with you, I must think myself very unhappy! Beautiful, immeasurably charming as nature is here, every

beauty makes me sad if I am to enjoy it quite alone. My only company in
Felix's absence is Mr. Büsse, who patiently shares my loneliness and does all
he can to render it less painful for me. But you will surely understand,
beloved Mother, how little he can do to replace my family, friends, and my
husband. I have cut short almost every intercourse with the rest of the
people here. Mrs. Ohlers is the public paramour of Col. Kinney, and his so-
called wife is shunned by all because of her low descent.[30] Mrs. Belden is the
most honorable lady but too old for me to wish in the least for closeness
with her.[31] Felix of course is not shocked at Mrs. Ohlers's affair and often
goes there in the evening as well as to Kinney and Mr. Gilpin, an unmarried
American.[32] The most ignominious aspect of the Ohlers affair is that Mr.
Ohlers, because of his pecuniary relation, tolerates the affair with the
Colonel and even favors it! I often imagine how happy and fine it would be
to have my house near you. Yet I banish the idea as quickly as possible as for
the moment at least there can be no thought of that.

It affords me great pleasure to plant and sow in *my* little garden. It is a
pity that of the German seeds, only a few have sprouted—three kinds of
flowers, nothing else. If we had brought the seeds along in a tin box filled
with coal dust and soldered up, they probably would have kept better. For
coal draws in humidity and bids it there. Aunt Rieben sent me such a kind
letter in which she declares her wish to receive a lock of my hair or some
other trifle from me. If you, beloved Mother, want to do me a favor, send
her a copy of Felix's and my daguerreotype; it would certainly give her much
pleasure.

Who possesses little, yet must still always lose of that little? I had 4
cardinals and a dog, which were my greatest pleasures here. Some days ago
my little dog drew from the corner in the kitchen a poisoned bit of bacon,
placed there for exterminating the millions of mice. I came upon him as he
was swallowing it and at once tried everything but to no avail, and in an
hour he was dead. Two cardinals flew away, one died, and the fourth, which
was already quite tame, was disemboweled but not killed by a strange cat, so
that I begged Mr. Büsse to kill it. My little friends have now been buried.

I hope the dreaded days have passed without further troubles and that
there are prospects of order being fully restored. I do not hear anything at all
about Europe except the tidings that reach me from you. Felix, it's true,
reads the English newspapers, but you know he does not place much stock
in circumstantial information. You ask whether Felix is still so gloomy. On
the whole, less so; only he cannot get over the loss of the money promised

to him, and that is why he is so out of sorts. But his frowning has completely ceased. His lamentation is constantly the same: "Why do I not possess millions?!" Mr. Büsse and I usually cut him off by an equal exclamation, for we have heard this so often that we also begin to be vexed at not possessing the said millions.[33]

I also would beg you, dear Mother, if possible, to learn something more precise about how to get a dirty straw hat in order again and about the nature of the wooden form or press, etc., as here it will be necessary to do that myself. Our house and garden are growing finer every day. Before my room I have a charming veranda with a trellis, and I will plant different creepers at the columns. It is built in the style of the Swiss cottages, and extraordinarily large and fine deer antlers have been placed in front. Our Indian corn is also looking good. The other day two pigs were minded to break into our garden. Realizing this, Felix ran for his pistols and thrust his hand through the window. Having stopped one pig, he tried to take the other one with the same hand but tipped the hammer so that the gun went off. The ramrod was in it. This and the ball scraped Felix's arm and wounded it not a little. If the pistol had been angled differently by a ¼ inch, ball and ramrod would have gone through his body. Instead, they fortunately went into the ground. I was standing close to my husband. You can well imagine how terrified I was on observing Felix's arm wound. At any other time Felix is so infinitely careful with every weapon.

Much as I have to do in my own household, I have nevertheless had to make a skirt for the old Mexican lady. You can imagine that I reflected long on how to begin the thing. Yet I accomplished a very fine skirt. It is a delicate lilac woolen cloth with silk stripes, just like mine. She bothered me for ages to do her this favor. The yarn she furnished was the finest but consisted of a roll of *green thread*. I felt obliged to open my reserve box for backup supplies. She has her sons taming a horse for me, and she often gets a pony fetched from nine miles away on Sundays so that I may take a ride. Other times she comes to visit me. When her husband is here in town, they come in the evening. If I had more to do with Americans, perhaps I should be able to speak English rather well already. Indeed I understand it, but I am still mediocre at speaking it. I chiefly practice Spanish. Every evening I study a little and am able to speak it rather well. I now have one more domestic, an old Mexican; he gets $10 a month, eats with us, and is very, very diligent in our big garden. There he keeps everything free of weeds, cares excellently for the horses, and waters all the vegetables and flowers

every morning and evening on a very, very large piece of land. He hauls the water up the hill from the pond. I don't know whether I have already written to tell you that we no longer have our big American horse. Felix gave it back as it ate a good deal of corn and this is rather dear here, while a Spanish horse, like our Trakehner, can be maintained very well on grass alone.[34] I am not proving very successful with my poultry. No hen has laid eggs in 6 months. We have therefore already killed some of them. I guess they have become too fat. If it might please you, dear Mother, I shall send you some of the nuisance animals in alcohol at the first opportunity. I already have several rattlesnakes preserved in alcohol, but I've been doubtful about whether they would interest you and therefore I ask you about it.

I am greatly saddened about the outbreak of cholera in Berlin.[35] Just come here to me—here you will be safe from it. How glad I should be if you came here. I should love to yield my whole house to you. In 4 to 5 weeks you could be with me if you came by steamer, only the voyage would be some-what more expensive than ours was. How did Father manage during the cholera epidemic last year? I hope more peacefully than 2 years ago!

Here everything has already come on a lot. As long as a month ago, we were eating good new potatoes, i.e. such as those in Germany. Round-headed garden lettuce is ready in January. The lettuce has already gone to seed, and the second sowing will be soon. Green peas and carrots we have had already. Cucumbers and melons are in bloom. In front of my house I have a fine lawn with fig, orange, and pomegranate trees and rose bushes and a magnificent aloe. Moreover, the house is no small matter. The house and porch together are 32 feet long.

If dear Mother, you should still have some of the pieces of music I left behind, I beg you to find out whether a Beethoven sonata is among them, which I must absolutely have forgotten. Should you find it, please keep it safe. Perhaps one day a good man will be found to bring it along, one who will *not* deliver it up for sale!

For today, beloved Mother, this must be enough, as it is evening already. I intend to hand the letter to one Mr. Jorden, who starts tomorrow for his native country, to get it to London, whereas I could otherwise send it only next week.

So farewell, give my love with all my heart to my brothers and sisters, relatives and friends, and keep dear—

Your—Maria

Corpus Christi, June 26, 1850

Beloved Parents,

Though not yet having received an answer to my last letter, I cannot
hesitate any longer over writing to you. First, let me present my congratula-
tions on your silver wedding anniversary; please do write to tell how things
go that day, so that after the event I can fully relive the celebration in my
mind.[36] The second impulse for this letter is that I think you will like to
hear that Felix's journey has ended and about his return. We were separated
for more than a month, during which time the prattle of the townspeople
about my beloved husband's return tormented me still more than all the
care, work, and trouble that I, too, had much of in the meantime. On the
13th, Felix came back from his excursion, sound and lighter by 20 pounds, in
rags and rather dirty, but he had discovered a good short route to Paso del
Aguila. He had almost left off eating, and with great pains I have now fed
him up a little. Unfortunately, this journey caused him tremendous expense
and did not yield so much as a penny. It was a sacrifice for the common
weal. I am just contented that he has returned.

Dear Parents, you will surely have become accustomed to always being
troubled with new requests from my side. This time, too, I am true to my
evil habit and inconvenience you again with commissions and expenses.
This errand is admittedly somewhat strange and ridiculous—but to me of
special advantage and great importance. Please try to get a pair of Welling-
tons for Felix, which I will present him from you on his birthday. It is
impossible to buy good boots and shoes here or at New Orleans. A pair of
coarse, quite ordinary leather shoes, which the gentlemen here wear, cost
$1½–2, i.e. up to 3 thalers, and if they then hold out so long as to survive two
trips across our garden, you must thank God for this miracle. You doubtless
think this is exaggeration, yet I can firmly assure you that it is so. Felix owes
frequent chills to his poor footgear on surveying as well as during garden
work. I know that I certainly cannot give him greater pleasure than through
this present. I should not trouble you were it not that I remember the
kindness and love you have shown me so often. Yet, I have not arrived at the
end of my wishes but would like to solicit from you for me, too, a pair of
house shoes or morning shoes, as you would call them. For good footwear, I
do have one pair of low boots. Not so when it comes to house shoes. I had
two pairs, and these I have worn to shreds because of the heat. Yet I am still

wearing them as I possess no others and am too thrifty to give 3 thalers for a miserable pair of glued shoes. Stockings I do not wear at all in this heat, except occasionally when going to town. The heat has been considerable for some time already. By 8 o'clock in the morning it is already up to 93 degrees in the shade. Indeed, it sometimes becomes a chore to be at the fire in the kitchen the whole morning. But one does become accustomed to heat.

Now I come with the suggestion dearest to my heart and that would give me immense and inexpressible pleasure: that you, dear, beloved Parents— and if it is impossible for both of you, that one of you—pay us a visit here. It is not so utterly impossible to contemplate that I must banish all thought of your coming, as you will understand if you consider that my love for you and my ardent desire to see you and speak to you allow me to see past all the difficulties that might get in the way. Felix and I talk almost continually about how you, dear Mother, would fare here and would be happy with us, in our beautiful garden and in all this magnificent nature. And how Father would be delighted with angling and catching sea crabs. You could then also satisfy yourselves as to the state of my health, if our dear God preserves it. I think that even with all possible care devoted to me, my well-being would be less sound in Berlin. With slight exceptions, the perpetual old malady with my heartbeat has almost totally disappeared. I live a very regular and moderate life, with due measure of exercise and sleep. At 9 or 10 o'clock I go to bed, always sleep wonderfully till the next morning at 5 o'clock, when after a moment's hesitation I get up.

Mr. Büsse has become a great inconvenience in our home. He has turned into a low fellow with a very vile character, who makes a practice of bad-mouthing Felix to me and telling lies no reasonable man can believe. Despite having shown him the door several times, I have nevertheless kept silent to Felix, whose absence thrusts this loathsome companion still more closely upon me. Lying, too, is his business. Felix has turned him out several times already, but that does not bother him. In spite of that, he remains quite free and easy in our house. He is as dirty in his person as without a sense of honor, evidenced by the fact that he does not finish the house though he has already demanded as payment the piece of land on which he built himself a house and laid out a nice garden. For some *8 months* he has been working on a little room for me, but Felix still has to help whenever time permits. When it will be finished God alone knows!

I hope that the apprehension of a general war has been buried and that everything with you may be as peaceful as here. The newspapers write that

the king has ordered the barracks to be fortified but nothing else disquieting now.[37]

Our garden and the chaparral are completely overflowing with game and wonderful birds. The trees are alive with birds' nests, with cardinals, and birds that look like parrots, green jays, red and gray doves, blackbirds with red breast and head as well as immense numbers of hummingbirds; and cottontails often sitting side by side in rows of 20! A Berlin amateur sportsman would probably think this is a big lie, yet it is so. Half a mile away from here our Mexican the other day found 5 wolves, and tied them to take along but had to kill them because of the horses. Flamingos, too, are here in profuse numbers, rose colored ones. Felix shot several and they tasted very good. Pelicans come here, rafts of them, which people boil for oil as these birds are very fat. There are butterflies the size of your hand, with the most wonderful colors. I kept some fine beetles, but the mice ate them. Those beasts as well as a kind of black cockroach are so troublesome here that you cannot save anything from them. In the chests my linen is gnawed away. Overnight I left a fine cambric handkerchief lying on the table; next morning it had been totally ruined. Garments—everything is eaten.

Inconveniences of that kind and degree cannot be found in Germany. I feel great pleasure and anticipation at the idea that we shall get plants of European kinds of fruit. Here you can get no fruit at all except figs, melons, and oranges. At New Orleans, however, you have the greatest choice. We have some vines with bunches of grapes in our garden, but they are poor, thick-skinned fruit. I have had many mulberries here, and once got a whole pail full of blackberries, which delighted me very much. I now understand quite well that when something is available, one does not want it in great quantities all at once. I feel this about potatoes, grapes, and wine as well. The sweet potatoes are quite good, though I still prefer ours. They are also grown here. Last fall Felix could not get any for sowing, and wine as a luxury has been banished from our house. I should probably never have a great desire for it if our water were cool and refreshing, but it is always lukewarm. We cannot get water refrigerated locally. One has to fight many nuisances here. For example, I have been moving about from one place to another to write this letter. You can hardly bear the flies, gnats, and the heat in any room. Outside, on the other hand, it is so windy today that everything flies off. It is not easy to write a letter here, as in Berlin.

Dear Mother, you wished to have my itinerary in a letter, but it was so long that I tore it to pieces and threw it away. The journey was not rich in

events and nor did I see especially much. The only change was what the sea offered us, and that is little. I have already written of how we passed by the coasts of France, England, and later Santo Domingo and Cuba, and of the impression that the first traces of American industry made upon me, and about the beauty of the shores of the Mississippi. Together with the delights of the journey, I had also to remember its bad aspects, and these, I regret to say, predominated. Would it be possible for you perhaps to procure me a lock of the hair of my beloved friend Pauline? I shall guard it as a jewel. The memory of her loss still affects me as mightily as if it were only yesterday that this terrible blow fell. I think of you often now that you are at Stralow, remember all the traditional amusements, and ask fate whether it will lead me to you once more before I am totally Americanized and have all genteel sensibilities choked off. I hate the Americans here with all my heart. I do not mean to judge the whole nation by these few people but am speaking only of those around me.

Dear Parents, I have some small matters we would greatly appreciate your sending: a bit of good rhubarb; as well as Morrison pills, one or two, which cannot be had here or at New Orleans; various wire tacks, also not to be had anywhere here; and a little soldering iron, for things like tools are very bad and extremely expensive here, besides the fact that you have to buy them from New Orleans.[38] Perhaps you can send me some scented candles to drive away the ghastly smell that the wind pushes into our house from some dead horse in the neighborhood. Even though this does not happen often, it is always very unpleasant, and one wants to strew everything with laurel leaves, which are not known here. With the next letter I shall send along some seeds of the so-called Texas star, a scarlet-red, star-formed creeper, wonderful, with fine featherlike leaves. Unless it's too much trouble, you may want to try some seeds and let Papa try them too. I shall then write about the best manner to grown them. When they come up and blossom, they will certainly please you so much that you will want to use the seeds again.

Give my love many times to all acquaintances and friends of mine. Write to me very often, and have a wonderful silver wedding night. Many greetings to Aunt Rieben.

Maria

Corpus Christi, September 27, 1850

Dear Mother,

Don't be astonished that I am sending separate letters to Father and you, but I have some little questions to bring up to you that I did not want to write in communal letter! First I must calm you about the many apprehensions you pronounce in regard to my health and habits. I must avow that I indeed cannot imagine writing such a disconsolate letter as to produce the impression you have come to that my life with Felix is neither happy nor agreeable. On the contrary, as I wrote during my husband's absence, one could only suppose that without him life is neither happy nor agreeable. It is natural that I was very dejected and disquieted by Felix's absence, because it was a dangerous enterprise. In addition, perhaps as a result of a cold, I had caught an indisposition that exercised a sad influence on my mood. I hope my later letters have set you entirely at ease. Moreover, I can solemnly swear that however advantageous it might appear from the outside, I would not welcome a change in my situation if it might separate my husband and myself. And I think the same can be said of him, to judge from the care he bestows on me. In fact, it cannot be helped that he must be away from me often and at times for a long period. You know every man wishes for good progress in his affairs. The more promising things are in our case, the more frequent our separation. And believe me, the conditions as regards the Red Indians will certainly turn favorable, so that my husband will be able to build on our land and can then at once give up the surveying business. It was saddening and painful for Felix and me to read of doubts about our relationship. I don't wish anything more anxiously than that Father and you, beloved Mother, should visit us to convince yourselves that even if we don't live in abundance, yet we are infinitely happy and content with each other, a circumstance enhanced by the prospect of having a baby in the New Year, which is the cause of my various questions.

Up to now, thanks be to God, I am quite hale and hearty, to which my regular mode of living with due exercise surely contributes greatly. You doubtless know, however, that I am not in the least well informed about dealing with little children, and your advice would be useful to me, as I am loath to be stranded without your guidance. There is a young German woman here with whom I became acquainted with more closely some time ago. She has told me about the local way of clothing babies, which seems to

me really most disagreeable. Immediately after the birth, the baby gets a little linen cloth wrapped around the body, a little shirt, if winter a thick red woolen petticoat, and a dress. Then it is laid on a pillow with the mother in the bed. If it is very cold, she has a big woolen blanket to wrap around the legs of the child. I am not pleased with this manner, and I remember back home we wrapped the baby in a longish covering and cut the corners round, which pleases me much more. I don't know whether this is the custom in our family too. Here everything is so free and easy that one scarcely knows what to do. And is it not unwholesome for the child if the right covering is not made clean and dry? This German woman referred me to an American woman whom I should like to look after me in the first days. She has had eight children herself, and as I was told by Mrs. Meuly, she makes a doctor dispensable. Mrs. Meuly herself had the woman. I should very much like you to write to me as soon as possible with your opinions about these matters and what linens are necessary for this little being.

You regret that I have no female domestics. It would often be of great service for me to have help. But it is impossible to get anyone. Mexican women never work more than they have to, and only when it is vital to support their households. American women of the servant class prefer to stay in a big town, and there is no American at all in service here. A German girl came here 6 to 8 weeks ago and at once had 6 to 8 offers of work. She chose the one where she probably got the highest wages, and I heard from her mistress that she had arrived here several weeks pregnant. This one I should have liked to have had, if only I had known about it. My husband promises he will see about getting another young German girl to lend me a helping hand for a while. Mrs. Meuly is a really nice woman aged 20, who got married at 15, but who besides is awfully, dreadfully silly, no, stupid at times, and has the disagreeable habit of arguing with everything and everyone. You can barely imagine it. She visits me sometimes, and I go to see her. You advise me not to break up the relationship with the Ohlers. But I really cannot persist; for the woman has by now arrived at the lowest degree, her husband having been there a long time already. Believe me, it is better that we do not associate with each other.

Today is Sunday, and on awakening my first thought is: now my dear, beloved Parents must certainly be at Stralow. I have always had a very soft spot for this place, and thinking of you there also evokes reminiscences of Stralow. It is a great pity that you had such bad weather this summer, depriving you of some of your short time of summer pleasure. Is Father still

such a passionate angler? With his yen for catching fish and big sea crabs, he would find rich pickings here, where one need not wait for the creatures to be hungry or wonder whether they will bite or not. The other day, Mr. Büsse brought me two immense fishes, especially very, very broad ones, called "sheepshead." They are extremely delicate and fleshy and almost without bones, having only a backbone; nor have they much in the way of guts; the whole is flesh. The back fins, however, consist of big spines. On preparing one I skewered the upper side of my finger. This happened nearly 2 weeks ago and still it is swollen and inflamed. The Mexicans think these spines poisonous. But I think it will heal without further developments.

If you came here now, the garden would not make a very favorable impression upon you; everything has dried up. Half of the crop is lost. Fortunately, Felix was unanimously reelected surveyor, thus this income at least will continue. Sometimes my husband is ill-tempered; for all the work with his land has been in vain. Our Mexican is a strange fellow, who although employed never misses a fandango and dances half the night. Moreover, he is not in the least young! Like the greatest part of this nation, he too is strange. He knows how to handle horses, nothing else. And Mexicans love to eat sugar and cake with such passion that they sell their things for this. During the greatest heat of the summer, 93°, he wore a thick coat, claiming the mosquitos might otherwise bite. Then, at his wish, I gave him a comb. Now he spends every free moment combing his hair! Things are much better now that Mr. Büsse is no longer at our house, and we are on quite a good footing with him.

You express the wish to have a floor plan of our house. I begged Felix for one ages ago. But he wishes that our house should first be finished on the outside at least. And then you will receive one as soon as he can make it. My little room has now been finished and is very nice and cheerful. Let me describe it to you somewhat. It is 12 feet high and 12 feet wide, 13 feet long, and has a ceiling of white cotton cloth, as no boards could be bought, a floor of fine joinery and less finely worked rough wooden walls, which, according to Father's promise, will soon be wallpapered. In the middle of the north wall there is a door to Felix's room; to the right of it hangs my little book-shelf adorned on top with trinkets; on the left side is a shelf for displaying ornaments. On the west side, in the northwest corner is a door to the bedroom, then my piano, and above it a picture of Stralow and one that Ette painted. In the middle of the south wall a door leads to the little porch, now quite densely overgrown, as is our entire house, with Texas stars alive

with hummingbirds buzzing around like bees. From my bed I can watch and enjoy them, especially in the morning. They are not timid and come so near that the other day Felix got one by its tail. To the left of the door are family pictures—you and Julius arranged beside my bookshelf. The east side has 2 windows facing the veranda and front garden, with the nice mirror between them. I have long intended to have a little table here, but now there is not much wood to be had. I made pretty red curtains and covered the sofa with the same fabric. Initially I considered selling this cloth, but it pleased us too well. For $2 Mrs. Meuly bought the bronze boots, which had already suffered damage through neglect and which I therefore disposed of willingly. Thus you get an idea of my room and little house.

The day before yesterday was the 25th. I hope you did not wholly forget the day. We also celebrated it a little here. Felix presented me with a piece of jaconet for two everyday dresses; very fine dried peaches; and chocolate, which I am sorry to say, if one does not buy it oneself in New Orleans, is made here of burned flour, starch, and sugar, and is very expensive—I baked a cake with it. I also received from Felix a big, long wished for wardrobe and linen press made for me by Mr. Büsse. Mr. Büsse came for breakfast at 7 o'clock and brought me a wonderful oleander bouquet and a fine, sturdy bridle of the kind I have so far lacked (I am only sorry that it must long rest idle before I can use it). And then, imagine, a plate full of apples he picked up here somewhere. Though at New Orleans infinite masses of fruit can be bought, and very cheaply, almost nothing can be got here. Mr. Büsse stayed with us all day. In the evening we ate partridges and chatted quietly till 9 o'clock; then the festivities were over.

You surely laughed heartily when I wrote of baked plums, but imagine the heat here and no fruit except melons. Any dried or preserved fruit is a real refreshment, and here you cannot always have even that. Dried apples, pears, plums, or cherries, or whatever they be, are a real treat. I prefer them to the local butter, which is always close to melting because of the great heat. We have now rented a cow, which is milked by our Mexican. My husband has not yet found an opportunity to buy a good, tame cow. You inquire so eagerly after our Mexican, Domingo; he is indeed still with us.[39] As there is nothing to be done in the garden now, he has been away several times to shoot deer, generally for 2 days, and on last three trips he shot some twenty deer, some of which he brought here for us, and then he sold the rest for the hides, from which breeches and overshirts are made. He then brought along wonderful big turkeys, which are really excellent. We

have here in profusion prairie chickens, jackrabbits, snipe, quail, and turkeys.

The other day, Domingo fared sadly, the poor devil. Seven (7) English miles from here he rides to a water hole that the deer frequent. There he turned the two horses loose to graze, and he went looking for game. The water there had already dried up; for we are still longing for rain. Growing thirsty and finding no water, the horses quietly departed, heading for home, where they arrived on the third day, on my birthday. Domingo came back, found the horses missing, and tracked them this way and that for 1½ days without eating or drinking. At last he came upon an arm of salt water, where the bay reaches inland for 3 miles and has been staked out with poles. There he saw the horses proceeding right out in the middle of the water. At first he intended to go after them, but at that moment he collapsed. He then lay down by the water, and tormented by an awful thirst, he resolved to drink salt water, which of course made him totally ill. The following morning my husband sent out another Mexican to seek Domingo; the man found him near dying and still drinking salt water! He gave him bread, coffee, etc., which of course was very welcome, and also plenty of good water and a new horse. Domingo arrived safely but is still ill.

My fine dog recently went out through the gate; I at once hastened after him. Yet before I was able to open the gate, he had already eaten some of the poison that the tramps and gamblers spread out everywhere. And after a 2-minute fight and struggle, the most faithful and excellent guardian of our house died at my feet, right at the garden gate!

You would be much astonished to see me in the morning in my Mexican garb, which, however, is necessary in the kitchen because of the heat. It amounts to nothing but a shirt, fastened with buttons. I now regret that I brought along only a ½ dozen of them from New Orleans; but here clothes are made like that, all of them! So: shirt, petticoats, and light, very light cotton skirts without waists! I could have made excellent use of my old clothes here!

You write so anxiously that our money might attract thieves. But that need not be feared, as up to now we have had only small sums for safekeeping. For Felix's chief work has been for Col. Kinney, and he has settled accounts in lands. Then, too, my husband has had great expenses for boards and lumber to alter and improve our house. It is very annoying that people here have almost no money and of course do not even pay for work. Now,

however, two companies of soldiers are coming to Corpus Christi, whereby the town will probably grow somewhat more prominent.

Belatedly, I beg again you to tell me what kind of bed the little child's must be. Feathers are shamefully expensive, even in New Orleans. I therefore resolved to take feathers from our pillows, as indeed we do not need all of them, and in the summer none at all except those pillows of horses' hair. I got Spanish moss fetched, which is quite like horses' hair, for a little baby mattress. But as to the child's other bedding, I am not informed and await your advice as quickly as possible.

I now have a new faithful companion in the household, and an excellent keeper. A new dog I received from Felix, who got him when he was at Eagle Pass. He is only 5 months old, very watchful and aggressive, and never goes away from the house or out of our garden. He has become very devoted to me and will grow very big and strong. Throughout this morning he has been lying next to the fireplace. He is now Felix's, Domingo's, and my darling. Greet my fat old dog at home. Farewell! May God preserve you safe and sound, beloved Mother! Stay dear

Your—Maria

P.S. With this letter, dear Mother, you finally receive a little drawing Felix made for you of our house.[40] Explanation of it follows. The aspect is from the front garden. On the right side of the house are our two windows, the door between them. This is now Felix's room; formerly our only room. The line of the roof shows how far the old house stretched. The two windows to the left of the entrance under the little veranda are my room. The little corner of a building you see to the left is our Mexican's house with adjoining horse barn; until Mr. Büsse's departure, this was his workshop. You can't miss the very big tree, pride of our establishment. I wanted Felix to draw in the horses to complete the picture, but he would not include these kickers. I therefore send you a separate picture of them drawn by my own hand.

To the right of the house we live in is a big shell cistern, and at the right-hand corner of the drawing is our henhouse with the adjoining poultry yard. The railing leading at an angle from the cistern to the henhouse separates the front garden from the big field of Indian corn, melons, and pumpkins with our fine fig trees. To right and left our house is surrounded by a very large garden, which is missing in the picture, as I guess our house is Felix's chief focus. The fenced space in front of the house is a wonderful lawn, just

as we have on the left, where the dots on the drawing represent the rows of fig and orange trees. To give you a complete idea of our dwelling, also missing are the creepers that festoon our whole house, the veranda, and the henhouse. On the veranda you really would not see anything but a tall mass of flowers with a small opening. The plants, Texas stars, reach far above the deer antlers. In the foreground you see a yucca, which indeed is very, very beautiful and is planted around with rose bushes. Behind the veranda would be our bedroom window and then the kitchen, making up the back of the house. Now you are fully equipped to find your way around our home. I don't know whether you, dear Mother, have wished a more detailed drawing of our fields and gardens. I think when this Mr. Hofrat comes here and brings along the daguerreotype apparatus, it will be possible to photograph that quite exactly.

At last the rain urgently needed has come, the day before yesterday, and has been beating down furiously with little respite. I think we in Germany cannot conceive of such rain! The water pours from the sky in torrents. Our big cistern was completely dry and the rain filled it in but one night, and it is by no means small: 8 feet deep and 12 feet square. As you can imagine, we are rather isolated when it rains.

I am sorry I did bring along dominoes. Last winter my husband and Mr. Büsse played excessively with my fancy little dominoes.

Our Domingo has not yet recovered from his hunting expedition, though he is better than in his first days back. We are safe and well, thanks be to God. Tomorrow we shall get two cows from Colonel Kinney, which delights me. I have no other news to report, because nothing much is going on as far as I know. And I guess it has been about four weeks since I have been out, as I prefer being in our house where it is cool and more pleasant than in town.

My dear Father, I must remind you of your promise. I beg you very much to come to us, and you will make our joy quite complete by bringing our dear, good Mother along with you. I should not have ventured to hope this, but now that you speak of it yourself, I have almost no peace, thinking of it all the time and awaiting you daily. So do not make us wait too long!

Now farewell, and greet all my dear brothers and sisters very cordially from us. Felix sends you the most heartfelt, best greetings.

A thousand and thousand kisses—From your

Maria

<div align="right">Corpus Christi, January 24, 1851</div>

Beloved Parents,

Miss Mary Blücher's [ink spot] first letter.

The last letter you will surely have received not long ago, and this one follows it *without my having received any lines from you.* I wrote recently supposing I could no longer be so active. Indeed it was so. On Tuesday the 14th, at the last strokes of the 12 o'clock chime at noon, a little daughter was born to us. Though we had very much wished for a little son, I could not love such a one more than my little girl. As it would make only a few days' difference, I thought it better to leave you in the dark till I and Miss Daughter could write to you together (the ink blotch above being made by her finger) that you must not be alarmed about my health. All went well after I had endured 10 hours nearly going mad. My poor Felix had great trouble with me. Everything was so unfortunate. The two Mexicans, Domingo and Juan, had started for our land at the rancho quite early, and my washerwoman, who was to come to us at the time of my confinement, was busy in an American house in the first two days, so that Felix was alone with me and in those 2 days found himself obliged to see to everything. At the beginning I had no idea how to deal with the little babe, yet this, too, quickly resolved itself. She nurses properly, cries little, and is sturdy and fat. As you cannot see her, you shall at least know that she has great blue eyes, dark brown hair, and a fine pale skin with narrow little white hands and feet. When she had just been born and was crying, I said if only Grandmother were here, she would certainly cover the little angel with kisses. In the neat white jackets she looks charming indeed. Since Wednesday noon I have been up again and am feeling quite hale and hearty. The old Mexican woman cares for me and keeps everything clean and in good order and also knows how to cook very well. She is the only Mexican woman here who knows how to work and does work.

You will surely be so kind as to inform the relatives and acquaintances of the birth of the little one. Just now Felix has so much to do, copying out land papers, that he cannot get to writing letters at all. I should so very much have liked him to write to Aunt Rieben. If only I could visit you with my little one when she is a little bigger, and then could spend Christmas with you, what sights she might see. At first she will not see anything but our house and garden, for now I can no longer think of going away. The

poor little one will perhaps not be overly well attended when I have to do other things that take priority. As I never read the newspapers here, I am completely ignorant of what is happening in Germany, whether war still looms or how things have ended up. If war should come to our family, I cannot imagine that you would support the king's violent measures or remain aloof from such atrocities.[41] Do try in time to sell your property and leave Germany with Mother. Even if you sell at a loss, you will still have enough to be able to live well. Go anywhere. In America you can at any time invest money at 8 to 13%, provided you do not deposit it with one of the good Germans running about in America by the thousand to relieve their arriving countrymen of every last pfennig. If you feel antipathy to Texas, go to the north of the United States, say New York or Cincinnati, etc. There they say one can live very well. If you do travel, go as comfortably as possible by steamer. You'll win back the greater expense it causes, and nothing is more discouraging and depressing than a bad voyage. You probably wonder at having me speak this way and may find it arrogant that I give you advice. But you will surely pardon me when you take into account my most fervent disquietude about the preservation of lives so dear to me. One year spent in America always matures one to some degree. Unintentionally, one becomes a politician, and politics is often the topic of Felix's and my conversation. The elections, too, now interest me. For if the person elected is favorably inclined toward our area, he will look after its interests, and our property will increase in value more and more.[42] My dear Mother, you are so very anxious about the long distance from the town. For the present, I do not think of moving to the rancho at all, as there are so many bugs there, and if we should move there it really would not be a big change. For the rancho is only 2½ German miles [one Prussian mile is roughly 4½ American miles] from Corpus Christi and only ½ a mile from Nuecestown, and farmers live and grow crops along the whole route out there. Don Domingo and Don Apollonio are still working out there as before. We did not make a very plentiful crop, it is true, but a good crop of Indian corn. I should very much like to see the rancho. So far the rancho continues to carry high costs without the least earnings; for the Indian corn reaped must remain for sowing and be used to feed the men until the next harvest. Then only a few bushels will be left; and always there are expenses to face. I am still teaching Mexicans various things. Juan is learning to write. Our Domingo the other day took a deer from a panther

and enjoyed it very much. Every day 400 to 500 deer come to the water holes on the rancho, and people subsist on coffee, deer meat, cornmeal, and pumpkin.

It is impossible to mention by name all those from whom I would love to hear! So greet all the dear ones from me ten thousand times. Felix charged me with many greetings to you. Fare very well and write to me soon.

Your—Maria

Corpus Christi, October 26, 1851

Dear Parents,

On October 4 I received your missive of August 28 and should have liked to answer at once had I had the time. My little babe, thanks be to God, is safe and sound and is growing in size, strength, and understanding. Since two months ago she has been pulling herself up alone and now she is beginning to walk. She goes along with one hand held and also hands herself along from one chair to another if they stand close together. One tooth is already quite distinctly visible and will soon break through without difficulty, I hope. The little one has legs like the corner posts of our veranda, and she is now more than 3 feet in height. The black hair has become fair, and the beautiful blue eyes have turned brown. The weaning is a big drama still pending, for she does not like eating at all. The other day Felix held her head and hands, and I held her legs and the rest of her body, and she was thus forced to drink some milk, amidst among formidable crying and thrashing. I can only give her thin cereal so far. She is still bathed daily and now wears breeches with her little shirt. She looks like a little street boy: toddling about barefoot the whole day. You write, dear Mother, that you would like to see her in her soft little moss bed, but her cot is by no means soft. At night she lies naked on a sheepskin between me and Felix, and in the daytime she sleeps on the floor. I wish to make her as tough as possible. We have been testing how many taps she can stand. After a ¼ hour, the red stripes where each finger was can still be seen; this is an amusement for her, and she laughs, quite amused at it. When she falls, she laughs.

Indeed, my little Mary is developing more and more very day. Who will undertake piercing her ears and her vaccination against smallpox is still very uncertain.[43] Before I forget again, the rod is missing from the package you sent, which I regret greatly, as no day passes without the little one getting a

whack, and for want of the rod, the end of my riding whip must serve. I greatly fear spoiling her, and I do not know how I can break her of the naughtiness of continually wishing to be held.[44]

Even now, while I am writing, I have her on my arm. You therefore must excuse the untidy writing. I never thought so small a being could cause such a great deal of trouble and work. Every day I must wash and iron for her, for she often needs *14* changes of clothes a day. Despite Felix's taking great pains, it remains impossible to get a servant. My washerwoman stays only till noon and gets ½ a dollar a day, and that is a lot. But Felix still has too many expenses with the rancho to buy me a black girl. For a girl of about 12 years costs at least $300 at New Orleans. Our Mexican workers receive $10 and provisions each month; so this, too, is always a great expense. Our Mexicans, Juan and Domingo, are however infinitely diligent and skillful. Moreover, Felix gives them such plentiful provisions and treats them better than anyone else does here: 3 lb. coffee and 5 lb. sugar a week, ample corn for bread, rice, and then he kills wild game for them so that they have meat and fat in abundance. Except for the inconvenience of these expenses, our lives are happy and cheerful, barring the thought afflicting me that things with you in Germany now look rather bleak and poised for war. If worst should come to worst, just come and join us!

Felix sends you his deepest thanks, dear Father, for the great joy you have given him by sending the fine needle gun. The gun more than meets his expectations. I almost lost my horse at the rancho. He was attacked during the night by a panther that mauled him around his neck and head. He had been hobbled (his forefeet tied together so that he could not stray too far); nevertheless, the horse kept the panther off. Upon going out to round up the horses in the morning, Juan found my poor horse like that. But Domingo nursed him well, and he is now sound and fat again. Felix took his new gun, gathered several men, and went out to the rancho. They encircled the place where the attack had occurred, scouring the brush till they found the offending panther (which betrayed itself by snarling). Felix shot him dead. On the adjoining rancho are a great many sheep, hence the presence of the panthers. They have already torn 32 sheep to pieces, but numerous panthers have likewise already been killed, and they will surely be driven out as the region becomes more inhabited.[45] They do not attack people. In the Zoological Garden in Berlin there are two specimens of this animal. They are gray and are very difficult to see in the thickets. Felix's gun shot very well.

An old German gentleman named Schätzell, aged 70 years and having lived in America and Mexico these past 56 years, has settled here.[46] Felix already knew him. He is an immensely rich man, and has a grand structure being erected here for his residence. He is unmarried and uses a great part of his money to help other people out of trouble and to give presents. The other day he sent us a barrel full of the very finest flour, which of course was very agreeable for us. Mr. Büsse has now been engaged for $2½ a day to build his house. As a result, working there he can make splendid money in 3 months, and in view of these expected earnings, I have told him he owes me $20 for past room and board. And, hoping he keeps his word this time, I have spent that amount on a nice stove for my new kitchen. I still need $50 to stock my kitchen. If you would advance us this amount of money, we should thank you for it from the bottom of our hearts; for we cannot put much aside and save as yet. The rancho, its land, the men, and the agricultural implements needed, such as ploughs, etc., have cost us a good deal, and for this plot of land in town we still owe $100. But if we harvest a good crop, we will save. Up to now the weather has been promising, and there are 10 acres of late Indian corn in all its glory on the rancho.

I read with great regret of the ruin of the Croll art establishment.[47] I am glad you saw the paintings of America beforehand. And if the artist rendered the beauty of Mississippi shores even in some measure, you must find my rapture as natural as looking at the reality. So you got our house painted again. By now the greenery must already have grown up again; what color is the house? Here we have painted our house with white oil paint. The fine big orange and fig trees shown on Felix's drawing have now disappeared, I'm sorry to say, not a single one of them remaining. I hope Father and Julius may go to London for the grand exhibition, and I should not take it amiss at all.[48] If we had the wherewithal, we should also do so. This is a splendid venture, which will bring England considerable advantage.

The day before yesterday I was disturbed by a violent thunderstorm, wind, and terrible hail and rain. The shingle roofs dry out so much in the heat that at the first strong wind and rain, they generally leak somewhat. This time the storm and rain were so violent that the bedroom and the kitchen were suitable for bathing. Felix's room and mine are protected by little shutters.

I have written this letter while suffering a violent toothache that has been with me for several months with only brief respite. I think it to be rheumatic, for Spanish fly and a foot bath help me achieve some relief. One of

my ears (or rather behind it) has become quite red from Spanish fly. This terrible toothache is really tormenting me. It resists even creosote. My head swims with the pain. You can certainly not complain of my writing too little. Now fare very well and greet all relatives and acquaintances a thousand times.

Very fondly loving you—your—Maria

Corpus Christi, November 2, 1851

Beloved Parents,

Once more I entreat you not to give up the plan to come here, where you will be safe from revolution and anarchy. Indeed, dear Father, I beg you fiercely to extricate yourself as soon as possible from the rotten conditions in Germany, for sooner or later a terrible storm must certainly break loose. For if one does not live alongside it every day, but hears only now and then of that base administration and how the people are being treated, truly every upright mind revolts. If only you could see the English and American newspapers, which relate the facts without reserve, freely and openly, and what future they prophesy for the Germans, you would find it natural that I am vexed at the thought of you dears suffering such a time. Felix has been on the verge of writing about it, but he thrust down the pen, as he is filled with fury about that shameful government. I know, dear Father, that you are a thoroughgoing royalist and do not avoid saying so on occasion. Please, just do not say it, for the German people will and must win the upper hand, and if you stay, it will be to the misfortune of our family.[49]

The Americans (the United States) and the Texans are now endeavoring to deliver Cuba from Spanish dominion, and yesterday a ship with volunteers started from here.[50] At 10:30 I heard their cheers when they embarked. I have not heard about conditions in Germany since your last letter but do hope the threat of war will not arise again. As to the book about Texas, it delights me that you found my opinion confirmed in many respects. It appears that Corpus Christi will grow into to something grand, as a major military depot is soon to arrive and a month ago Col. Kinney announced great festivities, like horse racing and bull fights, etc., for next May.[51] Mrs. Kinney is a society lady who dresses only in silk and drives along four-in-hand with 4 magnificent roan horses.[52] In spite of all her invitations I have not yet visited her, as her house is continually full of strangers, and I do not find pleasure in that. I am not giving up hope that you will still come here.

So far Felix has not returned. He has been away nearly 6 weeks on business for the German Emigration Association and I assume will stay away even longer.[53] He is advising them about the most suitable land to purchase in Texas, for which he is best qualified thanks to his position as a surveyor. We have already planted our garden again, and I guess I shall soon have some cabbage for our kitchen, and I see my shallots looking wonderful too. I got all that done in Felix's absence, and he is bound to be very agreeably surprised. I also have a big pot full of magnificent aged cream cheese, which is in danger of beginning to spoil. It is high time that my Felix came home!

Father's letter of July 12 inquires urgently after the act of baptism. But as there is no church here and priests come only from time to time, my little Mary has not received any other baptism than ours. I must confess that it is not agreeable to me to have her baptized by a Catholic person. And as it is the custom here to have the children baptized only at an advanced age, I wonder whether we should not wait till we eventually go to New Orleans to have her baptized there in our faith. I shall wait and see how I might like the next priest to arrive. In New Orleans the children are generally baptized at the age of 10–12 or even older.

My life here is so monotonous, for my existence consists of these ordinary occupations: (1) morning—washing (2) morning—ironing (3) morning —baking and cooking; afternoon: nursing and feeding the child; evening— sewing and writing; night—sometimes sleep when it pleases my little one, but fortunately this is mostly the case. Today at 4 o'clock, Mr. Noessel came to invite me for a little carriage drive. This was only the second time I have been out in 5 months. We drove to his house. There we supped on fresh butter and real *fatherlandish* old cheese, the like of which I have not seen for 2 years, and red wine. He gave me a cheese for Felix as well. Then we had a carriage drive of a ½ hour and I was at home again at 6:30. Fine weather, some wind, 86°.

Dear Mother, you asked about my delivery, and to reassure you and dismiss your apprehensions concerning my delivery and health, I will give you more exact details about it. On Monday evening, Jan. 13th, I felt very unwell, went to bed at 10 o'clock as usual, and slept calmly till 2 o'clock, when I awoke because of violent pains, which increased from minute to minute. Nevertheless I got up at 6 o'clock, aiming to cook breakfast for Juan and Domingo, who had already saddled in order to start for the rancho. But I had to give up those intentions as I felt faint, and I lay down on the sofa

until Felix and Mr. Büsse had taken my bed into my room, which is more spacious and higher than is our bedroom (and furnished with a stove). Then I lay down in bed, and Felix wanted to fetch the midwife. But I did not wish to stay alone, and as Felix, too, was anxious, he sent Mr. Büsse to fetch the woman. Mrs. Schmidt, however, was not at home, as she had been called away a few hours before and was a considerable distance from the town. Mr. Büsse went there, and fortunately she had just finished there and then came to me toward 10 o'clock, stayed with me till 2 o'clock, when after having received her $10 fee (and some whiskey), she left in all haste. As I felt extraordinarily well, neither incapacitated nor weak, I nursed the little one, though Mrs. Schmidt was of the opinion I should surely have to wait a few days before I had milk. For this is always the case with the nervous American women, and she could not imagine that it might be otherwise. My little babe drank with great ease. She then remained in my bed, and father, mother, and daughter vied with one another forthwith over who could sleep most peacefully. When I got out of bed on the ninth day, I looked better and healthier than I had ever looked before. I hope you will now be quite calm.

Felix is still away measuring land for the German Emigration Association. He told me straight out that he is by no means inclined to revert to being German, as he puts it, as he has become an American citizen only with great pains. I too like it best; for as to climate, Corpus Christi is the healthiest and most agreeable place in Texas, and I should not like to exchange it for another place, which would be necessary if Felix went to work for the association. And we would also have to give up the rancho, which is now finally shaping up into very fine order, with fine grapevines and nut trees, fences, pens, corrals, etc., together with three log houses: one each for Juan and Apollonio and the third for Domingo and his wife, as he is now going to be married. Next time Felix will send you a plan of our land so that you may see exactly where the trees, water, hills, and houses lie. He has also already drawn a plan of a large house, which he will build there for us later.

When Felix was away with Colonel Kinney for two days several months ago, a young Mexican came and annoyed me with insulting remarks. As I did not have a pistol at hand to teach him good manners, I quickly called Mr. Büsse, who ushered him out. When Felix came home in the evening, he at once found the fellow and, accompanied by 2 Americans and 2 Mexicans, brought him to our house, where I confirmed that the man had not removed

himself when I ordered him to do so. Then he was tied and 100 lashes were administered, and his knife was taken from him and broken, which is equivalent to removing on officer's sword. Then Felix notified the judge, after which the man had to leave town in a hurry. In this respect the Americans are noble: if a lady is discommoded, there is stiff punishment. And that is as it should be, for otherwise I could not be calm for a moment when Felix is not here; hence they are on their guard. Among the Mexicans here there are only very, very few good ones. The rest live by stealing and gambling. But the good ones are always kindly received at our place, and Felix cures them with great care if illness befalls them.

Some 50 horses were recently stolen here in a single night, including two from our rancho. Felix at once mobilized a company of soldiers and they were away for two days without seeing anything, as they had a very bad guide who lost the trail. Fortunately, our horses returned here the next day, freshly unsaddled and in a sweat. To a Mexican his horse is his one and all. It is supposed to be the work of Don Elochio Zamora, a notorious horse thief who hides out in the chaparral thickets between here and Brownsville.

Last week, poor Domingo cut through some veins in his arm, right above his hand, with his hatchet and would probably have bled to death had he not jumped on an unsaddled horse and ridden to Nuecestown a ½ hour distant when he felt faint because he was unable to stanch the bleeding. From there a messenger came in the night to Felix to fetch the necessary supplies and remedies. Domingo was unconscious for a long while. My husband, who to his greatest dismay now weighs 173 pounds and is developing a portly belly, has had 2 big boils on his back but has healed up again now.

A letter has just arrived from Mr. Magner saying that the chests you sent have arrived at New Orleans. A thousand thanks and greetings to all brothers and sisters and their children and all the rest of my acquaintances. Now fare right well and write soon.

Very—Maria

Corpus Christi, March 1st, 1852

Dear Parents,
Corpus Christi is now celebrating festivals upon festivals! On Dec. 2 and 3, during Felix's illness, a great hunt was held for bears, panthers, jaguars, deer, bobcats, wild boars, turkeys, geese, etc. Some 60 persons partook in it and

inundated Corpus Christi with game. On the third day they arranged a great dinner. I kept a list of the game killed so that you might get an idea of how crowded the surroundings are with animals. The register, however, got lost during Felix's illness. The chief hunter brought in 65 ducks, 9 deer, 18 turkeys, and 11 geese after only two days' hunting. Numbers of snipe and quail were not announced. Big ox carts fetched the prey. On the first day of the festivities there was a great ball, which we did not attend. People living here are much caught up in all this, do not go to work at all, borrow everything from well-off persons, and never pay them back. The ball cost one lady her life. She had been a *widow for a year* and had 5 or 6 children. She was about to be married again at New Year. She danced herself half to death, then caught cold and got erysipelas, from which she died.

Dear Father, Domingo immensely enjoys the clock. But for safety's sake it has been hung in our house because it is a very good one, and Domingo cannot yet do well at winding it. A very disagreeable event has occurred here. Our fine, fine big dog would often go into the street and bark vigorously at passersby. I went to town one day and the dog was outside the fence, where he was annoying a man by barking. The man shot at him and hit him in both eyes. So now he has been blind since November. It is scarcely apparent now, admittedly, for he accompanies me everywhere, though he has grown yet more aggressive.

Should you receive this letter only a long time after our sending it off, I should not be astonished, for the mail boat was stranded somewhere near here without a crew, and there are probably no other boats soon. So a hearty farewell to you all and just write *very soon.* Many greeting to all dears and a thousand kisses from

—*Your Maria*

Instead of a letter my little Mieze sends you a little curl![54]

Corpus Christi, May 1st, 1852

Cordially loved Parents,

For nearly 3 months I have been without news from you and now I suppose a letter from you to have been lost, and therefore I will hesitate no longer with mine. All of us are well, thanks be to God, our little Mieze sturdy and fat and in high spirits. Some weeks ago I got her vaccinated against smallpox, and of 3, two have come out very well. For two months now, I have barely seen Felix at all. He has been away all of the last 6 weeks,

and he is measuring and surveying the town and is occupied from 7 or 7:30 in the morning to 8 or 8:30 in the evening. At noon he comes home for a ½ hour to dine, and in the evening he goes to bed exhausted at 9:00.

Corpus Christi is gradually filling with people and animals of all kinds: jaguars, bobcats, bears, panthers, bullfighters and bulls, cocks—(cartloads full, their purpose being fighting, the chief pleasure of the Americans)— circus riders, fast runners, German girls, and barrel organs. It vexes me that the women of our nation sink so low here. For the prizes Col. Kinney has bought magnificent and most valuable silver things, worth many dollars, all the objects very tasteful, such as: a big silver coffee machine, big water jug, bowls, all inscribed with Col. Kinney's name as donor and the date of the festivities; dozens of knives, forks, and spoons, the boxes bearing similar inscriptions on silver plaques—all in all, an immense number of items. Kinney has also bought a steamboat, which transports the new arrivals promptly off the big schooners in the harbor. All speak and think: Festivity. I shall stay away from all performances, as Felix expects to have so much to do during the fair.[55]

I have long been expecting some letters from you, beloved Parents, and I hope you are all safe and sound. How much I should like to see you again; no day passes by without my speaking of it, and no hour without my thinking of it. I should so very much like my little Mary to spend Christmas with you and the whole family. I find much pleasure in my little rascal. She walks all over the house and is into everything. The day before yesterday and yesterday we were visited by Hungarian fugitives, followers of Count Kossuth, two most interesting persons to whom Kinney, by the by, has presented 1,000 acres of land. As for the other fugitives, as soon as they come here, up to 10,000 acres have been promised them. The Hungarians now here are certainly known to you: Uihatzi, former governor of Komarom, and his friend Pumusz.[56] Perhaps I have spelled and written the names wrongly, but this is how they are pronounced. The first is an older, kind man, not tall, with a long, long white beard and wearing a Hungarian officer's uniform; the other is a tall, nice man with fair beard. Both of them speak German well. They were much moved when they spoke of their native country and called it the richest and finest country in the world. They seem, incidentally, to be short of funds, as between them they have traveled 1,200 miles on foot. As the older one told us, a cheap saddle harmed their horse and they could not afford to buy even a cheap horse. As I was writing this, they reappeared. Felix says you may not tell anybody that he is helping followers

[71]

of Kossuth, and that he gave the Hungarians some cigars, for it might cause you trouble with the police. They are frank with Felix and talk politics long into the night. Felix is aware of their limited means, and he will give them as much as is in his power.

My cow still provides us with milk, but it will certainly soon run short. In all Corpus Christi, drought has already depleted the grass, and our pond too is already half dried out. The town's artesian well is always being dug, dug, and dug. The digger, however, gets $2 a day and free board and lodging in Kinney's house. This fellow thus has plenty of time, has indeed been digging 4 years already, and always says, "In a fortnight there will be water!" May God keep him with us for just two more weeks!

Tomorrow the Mexican I have in the house leaves, too, to celebrate the festival. I am not at all sure how we will fare. For these fellows are really too awful, lazy, and unclean. If we did not have the rancho, I might already have two black people.[57] For recently, Felix has been earning quite well and has presented me with a doubloon, worth $16. Though I keep all our money, I prefer having some pocket money as well. You see, I am cashier and book-keeper. Around here we keep precise track of expenses, receipts, etc. And all this trouble before I can even get a washerwoman! Last winter I had to give washing a miss for three months, unable to do it myself because of rheumatism. If only we can do well with Indian corn this year, we will probably come out all right.

The festivities have commenced and are proceeding mightily, music and dancing everywhere. There are also races every day, and some of the valuables have already been distributed as prizes. Every evening there are circus performances, and land auctions in the mornings. Felix has his hands full, and I have all this through hearsay and have not yet been in town at all. Now there is a tent with ice and refreshments every few yards in town. Iced lemonade is what I fancy and request; it is agreeable. They say there is very mixed company everywhere. Felix will go with me to the bullfight, and I am indeed curious to see it. Every day new fighters come in.

I now have a new servant who seems to be very good, and at least rather clean. All the pots are clean and shining; all is swept clean; he polishes spoons and teapot, etc., every day without being asked. I cannot begin to describe how sweet and funny our Mary is. The heat here is already so great again that the little one is clothed only with a little knee-length smock and a pair of shoes, and at night she sleeps quite unclothed. She still has 6 teeth only. Her food is very plain, but she is sturdy, fat, and very robust. She does

not have cereal and the like; milk, white bread, at noon a soft-boiled egg (her favorite dish). Bread she does not like especially but favors water and oranges. Her father's passion, reading, she will probably also succumb to later; for she now sometimes stoops for a ½ hour over a written or illustrated page, looking attentively at the letters. An old album is now her reading matter. Do greet all relatives and friends a thousand times and write me very much—once more a thousand greetings and kisses

From your—Maria

Corpus Christi, November 20, 1852

Dear loved Parents,

It seems I am never to begin my letters but with the complaint about your not writing! Since September 10 I have again been quite without news from home, which surprises me now when I have been hoping to hear something about the shipment of the chests from Bremen, so that Felix might take steps to get them sent here from Galveston. For I am very keen to receive the winter supplies speedily, as we have already had some northers. Is it really so difficult for you to write?

On October 20 Mr. Schünke started from here to travel to Europe. We sent his trunk to Galveston for shipment, and along with it I packed a nice jaguar skin and some egret plumes for you, dear Parents. The really fine, large skin I had written to you about was sold just eight days before, and not for $25 but for only $12. The good man felt no one would pay such an excessive price. The skin I sent is quite nice, but unfortunately not the largest or finest in quality. I found a damaged spot on one ear, but I had no choice, it being the only one here. Yesterday, I asked a gentleman from Mexico to procure me another really good one. If he sends a nice skin to Felix soon, I shall send it to you with a bag that Mrs. Belden gave me for you so that you may have a sample of the hand-woven textiles produced by the Mexican women. It is the same kind as the big Mexican rugs. I don't know if the egret feathers will be useful. Should this be the case, I beg you, dear Mother, not to let them lie unused.

From all my letters you surely recognize how little credence I give the hope that you might really come here! And how should I indeed? You scarcely even write! And in truth my time is as restricted as can be, but I do not neglect to send you my news from time to time. I can hardly find time to sew. With much difficulty I found time to make Felix a winter waistcoat

he needs, which was his birthday gift. The days are so short now, and our Mieze keeps me constantly busy as I must always be on the lookout and rounding her up from the far corners of the garden. I can never sit still for an hour and sew.

At least I am more comfortable in my home now, in that I am no longer cold. We have two good fireplaces and I can go to the kitchen through a closed warm room. Our rooms are now papered, as are the fireplaces. However, so much is being built here that no carpenter is to be had. And Mr. Büsse cannot be persuaded to do it; he mends some rifles but he will have nothing to do with continuous work. A month ago I ordered a little table for the child, as she always sits at a chair to eat, and this is not appropriate. But he does not complete even this trifle. And Felix gave him boards to use, so want of lumber is no excuse this time. Felix has diligently done the carpentry, and the room between the living area and the kitchen is better than the first. He has also built a good stable. Our livestock has increased by a little hog that Mieze got for a present from Mrs. Meuly. My little girl will soon get a little property together. I save all the milk money I make for her, and when it reaches $10, I will buy another cow.

Before I forget it, I wish to tell you, dear Father, that when you see the maker of the needle gun, please procure as many more as possible. For Felix keeps his firearms like dolls, elegant and clean, and he is overjoyed with the needle gun.

Mrs. Ohlers has rented her beautiful house with garden, furniture, and all conveniences to the colonel of the soldiers now stationed here for $100 a month, and she now resides in a little apartment in town. She no longer has social intercourse with anybody, and her position is not very enviable. She has fine horses and carriages from Kinney, black servants, and every possession conceivable but must use these for herself alone. Her husband, as you must realize, is of no account. What they now have is mostly hers, and she can do with it as she likes.

Mrs. Kinney and her eldest daughter went to their plantation some weeks ago. I think she finds things tedious in Corpus Christi. But now that a government depot has been moved here, there will certainly be more traffic.[58] In the time we have been here, the town has increased and improved so immensely as to be unrecognizable compared to when we first arrived. Every week, 3 to 4 new houses rise, and the workers are in such demand that Antonio has left us, as another pays him $1 a day.

Before this letter reaches you, Christmas and everyone's birthdays and

New Year will probably already be behind you; so we should be sending best wishes for the New Year! Who knows what kind of Christmas or New Year we shall have? My birthday as usual did not pass unobserved. But I did not even have dinner with Felix, who was gone. I spent the evening quite alone. In the afternoon, Mrs. Kinney's daughters, Louise Love, and Rebecca Britton all came to see me, amused themselves for a few hours with playing ball, etc., and that was that. But I was not left empty-handed. For some days before, Felix had presented me with 4 town lots and building sites that he bought for me from Kinney, and now I am a landowner![59] Up to now their value has been $300 to $400, but prices have been rising for some time as in the town itself, the lots have almost all been sold and built upon. Then I got a nice gift from Mrs. Webb, who sent me 2 magnificent white turkeys, and I hope that in the spring I shall have some more. Mr. Büsse brought me fine flowers; the baker had made a cake which he gave Felix at a very low price. Our Antonio, too, brought me his share, which pleased me extraordinarily, not the thing so much but the attention. He presented me with a bottle of very fine Malaga.

There is so much noise here that I cannot go on writing, as Felix is quarreling with a man about land affairs, and I cannot keep my thoughts together. To all my greetings; Felix and my Mieze greet you a thousand times.

Your—Maria

(Belatedly) In addition I want to let you know that the old Mexican Doña Carmel is again washing for me and will probably be my nanny for the *Miesbock*.[60] This will mean one less difficulty, for she is very kind and clean: only (according to Felix) she has a tongue like a mudslinger or sailor.

Corpus Christi, January 20, 1853

Dear loved Parents,

This time you can reproach me for having made you wait an excessively long time for a letter. This letter was delayed because on January 6, toward 4 o'clock, another little daughter was presented to us. Thanks be to God I am now quite well and running my household again. I should have liked to write you sooner, but my eyes were so affected that I was not allowed to read nor write nor sew. The cause is perhaps sewing by candlelight, which could not be left undone as my household requires sewing a great part of the day.

I was still up and about till 1 o'clock, which the midwife had recommended to me this time as more appropriate than lying down. Then I had her fetched. This little creature came into the world with much more difficulty than our Mieze, and her birth might perhaps have taken even longer had the woman not told me that if she were not born immediately, she would die. I have now gotten over it and will not torment you or myself with the memory. It was a difficult labor, and the baby took a pummeling. Her forehead and head were covered with dark blue bruises, and from her nose across her forehead was a big, big swelling, which, however, disappeared on the second day. The baby is longer than Miesbock was though much less fat; but, thanks be to God, she is visibly gaining weight. In the first three days I was miserable and unable to nurse the little being. The little one also had and still has a kind of thrush, little pustules in her mouth. To treat this I continually apply: borax, honey, and syrup water. I had an old Mexican woman assisting me, and this one has stayed with me a fortnight; a very good woman, but unclean and disorderly like her whole race. Unfortunately, Felix was so busy all the time that during the 9 days I was in bed, I neither saw him nor spoke to him. Sometimes he had to write land papers half the night; every evening he had to go to Kinney's. And thus my Mieze is my only companion, and often troublesome company. The many visitors were more fatiguing than enjoyable. Mrs. Kinney presented the little one with a nice agate cross on a chain. As I write this scarcely legible letter, I am rocking the cradle with my left foot.

The crate fortunately reached us on New Year's Eve. The schooner had been here since 2 days before Christmas but was not unloaded until then. We might very well have had it on Christmas Eve. The Bremen ship had been sailing so extremely long that we thought she had perhaps been lost at sea—from Sept. 20 to December 5, on which day she arrived at the bar at Galveston. As in all the earlier crates, we have again found all we wished for and other delightful things in it. Pardon me if this time I restrict myself to saying many thousand and most heartfelt thanks in general. In the next letter the details will follow. Felix wishes to thank you again for the gun, with which he is thrilled, for according to him and Mr. Büsse it is excellent. Miesbock is chiefly very glad of the jester and Noah's Ark, and the other toys I have tucked away for the next time. The winter supplies and things are utterly welcome, especially the stockings and shoes; they could not have come at a better time. Felix always means to write to all as well as to his Mecklenburg relatives, but he has become so absolutely a businessman that

I have lost him for myself and for all the rest. Sundays or holidays he now declares as nonsense and he just keeps hard at it.

The ground oats and pick-me-up did me proud, and I also got a great boost from a glass of jelly. From the 6th day they gave me some spoonfuls a day, and I drink a cup of chocolate a day for extra energy. Above all, however, I thank you for sending the insect powder. For 4 days after the child had been born, I awoke in the night with sharp stinging pains and found my body covered with swellings; soon I saw that I had been lying in a regular ant hill, the ants having come for breadcrumbs that had fallen into my bed. Get up I could not, and it is to this insect powder that I owe the children's and my deliverance from the terrible tormentors. I sleep accompanied by my offspring; Felix has yielded his bed to Mieze and lives fully in his office. On Tuesday he rode away again for several days, and today I expect him back.

Indeed I must close without expressing my pleasure about the charming clothes for me and for the child: jackets, hats, caps, and the umbrella for Mieze. The skirt and the silk bodice fit excellently, and I only wish the silk bodice had sleeves, as the old ones have been thoroughly damaged by perspiration and contrast much with the new cloth. The red shawl is magnificent too! But if I go into detail I shall not finish this.

Mr. Seyler, who arrived here on December 5th at 7 o'clock in the morning with 75 cents in his pocket, also delivered a little package, for the contents of which I thank all as fondly.[61] Mr. Seyler is a very good-hearted young man, only he does not yet seem to me ripe for Texas! Without a cent in his pocket, unable to speak a word of English, he plans to go back to Berlin in a year's time as a rich man! Felix, however, has found him work for $2½ a day and maybe a later job for $1½ to $2. But at the same he is never content and says so; thus he surely would never get on here. What was he thinking of in coming to Texas?! For I can firmly assure you that he is not able to make himself understood in the least, and now, Oh God!—he complains about there being no confectioner's shop; no Bavarian public bar on Sunday evenings; no balls over the holidays! How can that be endured, he asks! Yes, and at Papa's there was always wine at noon—not so with us; on Sunday champagne and nut tarts—nor that with us! He should have come here with us in the beginning; he would have been well and truly astonished. Now enough of that; it will eventually become clear whether he is worth his salt.

Many thanks for the feather bed. I can't tell you how heavenly it is. I no

longer dread the northers! For the first two nights I slept with joy (indeed!). Felix has grown very envious, and I shall gather feathers so that I can perhaps make him one next year.

Christmas we spent peaceably and pleasantly at home with Christmas tree, etc., and only Mr. Seyler could not properly enjoy so *calm* a Christmas. Do write and tell me how you spent Christmas. I wished you a happy New Year in my last letter, and I now repeat it. On New Year's Eve your package arrived, so we had a great fete, and on New Year's morning the baker brought us excellent Berlin doughnuts.

I do not yet feel entirely well. As for the birth of the little one, you will surely be so kind as to announce it to all the relatives and interested acquaintances; for Felix cannot be relied upon to do so. When will the day come that you, now a dear Grandmother, can give my little beasts a fond kiss? Much as you write, I do not believe you are coming. Our Mieze is such a sparkling, healthy child. When Mr. Seyler entered our home, she was just dancing and singing to herself. On seeing her for the first time, he remarked: "My God, how flourishing and healthy that child looks!" This Texan seedling is not fat but has flesh like iron; rain and northers matter little to her; she always strolls about out of doors. When the little one was born, she sat at my side on Felix's bed and did not leave me in the 8 days of my lying in. She showed immediate affection for her little sister from the very first moment and rocks her cradle with rare dignity, warms her long cloths and linen at the fireplace, and is altogether very occupied helping me. She is only two years old herself! And when there is too much milk, she still likes to drink her fill at her mama.

I am enclosing an advertisement from the New Braunfels German newspaper. Again you can see from it that Corpus Christi is by no means so bad. There are now two bands here (one military); some 40 men in one, nearly all Germans, and almost every evening there is music in the public square, and wonderful music indeed. When sitting on our veranda we can hear it quite distinctly. Weather wise, it is very different from with you. On New Year's Eve, it was 86° with magnificent moonshine; on New Year's morning, 32°—a bitter difference!

I am so tired that I can write no longer. So a thousand greetings to my dear brothers and sisters, relatives, and friends, and to you many kisses from our whole little family. Only do write very often to your

Maria

(Excuse the extraordinarily bad writing!)

Corpus Christi, October 20, 1853

Dear Parents,

Your last missive of August 4 I duly received on Sept. 24. You have again gone a very long time without news from us, and I have been constantly bothered by the thought that you feel apprehensive on our behalf about yellow fever, which has this year caused unheard of devastation (worse than in living memory). Galveston, Indianola, New Orleans, etc., enough, in the whole area people have nearly died out. But Corpus Christi, thanks be to God, has been quite fully spared, a new proof of the wholesome influence of the fresh sea breeze.[62] I kept all the newspapers with the weekly reports, but they are not at hand just now. I intended to send these to you as proof of my statement. A single lady died here from it, but she had embarked at Indianola on Thursday hoping to recover here, and she died one hour after her arrival. This was the only fatal case in Corpus Christi. By the way, it is said to be most peculiar that persons who fled apparently healthy from afflicted places fell ill in healthy towns and died from the yellow fever. In New York, especially, the disease is said to have spread not at all except that persons *from foreign regions* bearing the contagious matter died there.

My last letter, I guess, was written during Felix's illness. That same evening I had to send for the military doctor, who gave Felix 10 g. quinine and 10 g. blue mash (quicksilver) in the evening; at 2 o'clock A.M. 10 g. quinine; at 5 o'clock A.M. ditto; after which the fever finally broke and let up, and he thus gradually recovered. He lost 55 pounds and was scarcely recognizable. How he is now I cannot tell, as he went off 6 weeks ago to Eagle Pass with General Smith of the troops here in order to dig wells along the route in case war should break out with Mexico.[63] Eagle Pass is the frontier fort between Texas and Mexico. He is being rather well paid for this work. His contractual agreement with the government goes on and on and designates him Major Blücher, etc. He commands a column of some 30 wagons, conducting the work under his direction at his own pace. He has spacious, comfortable equipage with 6 mules and a driver for his comfort; *gets paid $5 a day;* and has a Mexican servant he selected but who is paid by the government, good provisions for himself, and a full range of servants and a riding horse. He is making a map, for which he is paid extra, etc., etc. If such an offer were made to any man in Berlin, one would fear it might make a fool of him! A young man accompanied Felix, traveling just for

pleasure. This fellow died on the way. I don't know any details about his death, as Felix did not write; the news came with a pack train from Eagle Pass to Mr. Belden.

While Felix has been away, I have had great trouble with the children, even having to fetch the doctor. First the little one was ill, and as the doctor said, she is about to get her eyeteeth though she has only 4 incisors. The big one is getting molar teeth and has had no high fever along with that, though for some weeks she has had cholera-like attacks every other night, without stomach ache but only vomiting and diarrhea, from 11 in the evening to 2:00 o'clock in the morning. All day long she has been feeble, though not otherwise ill. What chiefly alarmed me was a kind of angina cough that she had 3–4 times in the night. The doctor gave me an expectorant that I should give her in case of great alarm and heavy mucus accumulation in the throat. The angina has been and remains my horror, and if anything exists that can replace the leeches according to Dr. Henschel's opinion, do send it to me.[64] For several children have now died of it again here. It is probably attributable chiefly to the autumn air after the great heat, for it is still hot enough, only at times we also have rain. Though the younger one's teeth are not in yet, they are about to break through. She is quite well again and has not lost weight but is still the thick skittle—still much fatter than the Miesbock was—with big blue eyes and fair hair. Taken by the hand, she already trots about a little. The great Mieze is growing fast and is now fit and in good health, still with flaxen hair and black eyes. For your comfort I can now tell you that I have a maid and servant, a German peasant girl, young, nice, and robust, for $9 a month in pay. How would such a girl feel, coming from Germany where she would be paid so little, if she immediately received $10–$15 a month here? She has been in my house for several days, and Felix does not even know it.

October 27. There has been an 8-day delay with my letter, as last Friday morning, when I had just sat down to write, my Felix, my husband arrived from Eagle Pass. I hope you will forgive me for not continuing to write that day. He arrived safe and sound and much sunburned. You must not be angry that Felix does not write at all. I have often reproached him with that myself, though I understand it very well. At other times it was always the greatest pleasure to me to fill up with letter writing as much time as ever I could spare from my household chores. Now, however, even if I have time for it, I do not always feel inclined to it or am too distracted to gather my thoughts properly. How much more must that be the case for Felix, who has

to talk, draw, and calculate all day long. When he has finished that, he of course is not in the right mood to write a gay, cozy letter. Just consider what our household costs, and that we are always getting on and saving something, too. On top of that, Felix's illness—(and when the little one was born, having the Mexican woman also cost a lot)—meant nearly 3 months continually in bed and a fourth when he could not yet earn anything; then a Mexican at the rancho, who gets $15 a month; the girl at $9; then we procured a carriage and one more fine mule this year, dug a well, built rooms, etc., and Felix must earn all that with his head and hands. And it is his wish that if possible I shall not do anything at all. I firmly believe that I am very unjust to be astonished that Felix does not ride out or take a walk with me. For his thoughts are continually on work, and he allows himself but little rest. Perhaps you think it ingratitude that he does not even thank you when you send him things. Yet, it is not so, for he often says, "I know I ought to write if I could find time and leisure." Today he spoke of how useful the brushes and colors you sent him have been in making the large map of the Eagle Pass route.

My beloved mother, you speak of the journey hither with pleasure and sorrow. I have reflected on it much and talked about it to Felix but am always doubtful as to what to write about it. For I need hardly assure you further that it is our greatest wish to see you in our midst. But I should always reproach myself, if you, beloved Mother, should suffer any health effects from the journey. As soon as you arrived here, it is my firm conviction that the climate, tranquility, etc. (and most of all the exercise) would do you an extraordinary amount of good. I am not able to judge your present state of health so far as to know whether the passage on a comfortable steamer might affect you too much. Seasickness is often avoided if you lie down and remain in a comfortable position until every uneasiness has passed. At any rate I certainly warn you against traveling alone. I will not write more about it, so that you are not moved by persuasion from my end to ignore what the doctor says about it. I even think it my duty not to make any further demands on you, my dear Father, as you shall not perhaps leave Mother for our sake in the event the doctor thinks it more advisable not to undertake the journey. If you could travel with Mr. Schünke, that would be a great advantage, as he speaks English.

It appears one will soon no longer be able to say that one is from Berlin; for our worthy countrymen are seen in a very poor light here. My eye trouble continues. My eyes are very easily affected and then ache. According

to your advice I shall find a set of spectacles. Felix is already amused at the very prospect of seeing me wearing them.

Dear Father, one thing has greatly afflicted me: that you gave up our home at Stralow. I always expected to stay there when I eventually come to see you. I have nothing against Treptow, but I always felt uneasy there. Taking a walk in the park for an hour is very nice; but living there never pleased me. Now I miss two dearly beloved things: my Pauline, and my snug little Stralow room. I cannot imagine that you were indifferent about moving from there. Your new little home must be remarkable, when it has only 7 rooms. You should know that here in our garden the castor beans you sent have grown so large that we use the leaves for umbrellas. I now have a great, dense clump of such trees, 20 feet and still higher, near the chicken run, casting fine shade for the animals.

Felix is not at home. He is now delivering the map, which has turned out so well that people have asked him to make copies so as to avoid sending the original to the general, as it might suffer on the way. Felix entirely agreed; for his pay continues until he has delivered what is required. For that, however, Felix gives himself by no means enough time but works from early morning to late at night. Today he will receive $270; this is the better part of what he earned during the journey.

My servant girl is entirely worth her pay; for in Felix's absence I saved $11½ in washing and ironing money. Elizabeth washes every Monday and the following day she irons, and she does her work quite well. She also helps me sew the children's things.

It is growing dark, and I must finish. Just write very soon. Many fond greetings to all family members and friends. Farewell! Yours,

Maria

Corpus Christi, February 22, 1854

Fondly loved Parents,
On January 2 I received your dear letter dated November 25, and I have long been planning to answer, but things keep on cropping up. Now, however, my conscience pricks me too much—as Felix says—and if possible I will clear away all obstacles in order to finish a letter by Sunday. The crate you sent arrived on December 26. However, as the ship probably was not unloaded quickly, there was a delay till January 23 before we received it. We should not have gotten it even that fast had General Smith not seen it on

the steamer—from Galveston to Indianola—and himself had it brought along for us. General Smith is the commanding general of the United States troops here, and his things enjoy the fastest dispatch. Above all we both send you the most heartfelt thanks for the picture, which really is so excellent as to outstrip any I ever saw. And if I had the chance to send you excellent pictures of my children, we should not spare any cost to get them made. I think I need not aver that the memory and the wish to see you again as soon as possible has been more vivid than ever in me. This wish has intensified so much with the possession and sight of the picture that I have begged Felix to let me travel home by autumn. We often speak of it, and of course I always bear in mind that such a trip would keep me away from my household for a year, and there are still more important apprehensions— whether the children would safely stand the journey or might be overcome by some children's disease at the onset of rough weather. Now, let us see what time will bring!

To return to the crate! The objects you listed have all arrived in good order. They caused the greatest pleasure to all of us! I especially thank you for the charming petticoats and dresses. The dolls, you may easily imagine, gave the children infinite pleasure. The gingerbread has contributed much to the general pleasure. Felix found the raspberry jelly incomparable refreshment. And as always, thanks a thousandfold for the various medicines, vaccines, knives, forks, spoons, medallions, etc. I wanted to save the gold thaler you sent along. But one Sunday a ½-year-old filly was offered me for sale. I bought it for the children for this thaler and think they will have more pleasure from the little creature than if I had preserved the thaler for them.

As I have not written to you at all since Christmas, I will report how we spent the festival. Up to Christmas Eve everything seemed very promising. Mr. Büsse had put up the Christmas tree; and two miserable things scarcely deserving to be called dolls had been gift wrapped. I had killed a splendid turkey and was hoping for a very merry holiday. Then suddenly at noon of Christmas Eve, Felix again came down with a fever; so, too, on Christmas Day and on the following day. In the evening, it is true, the fever receded, yet he did not feel well and was scarcely able to eat and drink. He had the fever about 3 or 4 times. After having been well 2 days, he at once rode away again on December 28 for distant measuring work. On January 21 he returned and, as expected, had suffered fever on the entire trip. On the 23rd the crate came, and on the 25th he already had the fever. Dr. Turner, another

excellent military doctor who replaced Dr. Jarvis, gave Felix some pills, whereupon the fever left him.[65] All this winter so far, Felix has had very much to do and most of the time he has been away.

On January 2, we had a (great) big revolution here in Little Mexico. On the bay there is the town, and partway up the hill is Little Mexico. Parallel to the town on the hill are the Mexicans' huts, the last of which borders our fence. On New Year's Eve the Mexicans had a fandango, which is an event frequented only by the most disorderly sort of Mexicans and Americans. The government wagon drivers and soldiers were there that night, too, and a quarrel began, whereupon the Mexicans as usual drew their knives. And though the Americans took flight and had no weapons, the Mexicans stabbed one, thoroughly butchered him, and wounded four others. One died the following day. The owner of the house where the fandango took place is named Blas Falcón.[66] His wife had arranged this festival despite his forbidding it, and he has had to pay dearly for it. Don Blas, you should know, was away surveying with Felix. On January 2 the affair was scheduled to be legally examined, and the criminals called to account. But of course these thieves and murderers had at once stolen horses and had long since made their escape. And the rest, as they are all equally bad, pretended not to have heard or seen anything—all of them! The soldiers were so angry about the crimes going unpunished that at noon of the same day [Jan. 2] some 30 men took up arms and began searching the Mexican huts, not of course proceeding legally or properly. That morning I had received your letter, and full of pleasure, I wished to celebrate the day a little and took a short walk with my big girl Mary. I was sitting in Little Mexico with my old Mexican woman friend, in her house, when suddenly the mother of the young Mexican boy who is now helping me mind the children rushed in and said: "Where is Andrés; where is my son? They are killing all Mexicans and burning everything!" Indeed, I looked out and saw three houses in flames already, and the soldiers shooting to right and left. Toward our fence they stood, warning everyone not to try to quench the fires, as they would shoot down all of them. As I had left the boy Andrés with the little one alone at our home, you may well imagine that I got quite a fright, and to get back to our house I had to pass this whole band. So I picked up the child and ran straight home, and just as I entered they shot a Mexican down only 20 paces from our fence. As the fire was spreading further, the officers rode up at a full gallop and intervened. The soldiers gradually retired, but they swore to come back again. Of course the entire Mexican rabble at once moved to the

town with bag and baggage. In the evening by 6:00 o'clock there were no more living beings in all the houses in Little Mexico. It was only eight days ago that they became inhabited again. Up to now the citizens have conducted civil night patrols and thus prevented further crimes. In spite of that, on the evening of the 14th, on Mary's birthday, they burned down the house bordering our fence, which as aforesaid had been vacated by its owner at the time. It is difficult to determine whether such conflicts will recur from time to time.[67]

Aunt Rieben again wrote me a most cordial letter. From all I know of her, the sympathy and love she shows me really come from her heart. I also can tell you that in each letter she speaks of you with greatest love. It is much to be regretted that Felix is not more susceptible of proofs of love; otherwise he would certainly maintain his correspondence more. For he has the good luck to have very excellent relatives. His two uncles in Mecklenburg are as cordial and amiable as Aunt Rieben. I shall give up advising Felix to write to you or to Mecklenburg, for he proposes doing so a hundred times and yet never carries it out. He never used to know the pleasure of being treated kindly and tenderly. So he of course does not grasp the need to open his heart to his friends and let them know of his affection in writing. We so often talk of you and of the possibility of meeting again, and Felix remains of the opinion that conditions in all Europe will develop so that you will perhaps come here against your will. It would be really sad if the Turkish affair should evolve into a general European war.

Among my acquaintances here I have sustained a little loss. After 3 years of war with each other, the Kinneys have finally realized that they will never be able to make peace, and Mrs. Kinney has gathered up all her goods and chattels and departed, not scuttling secretly away but with the full consent of her husband.[68]

Corpus Christi is now advancing rapidly, and there is no longer any comparison with the time when we came here. Major stores have been opened, but in spite of that no umbrella, i.e., *no good umbrella,* can be found here, and ditto for jaconet. The other day Felix drove around with me for an entire afternoon, but we returned without success. After nearly 6 years of confronting summer and winter here, my umbrella has at last split, and Felix wished to have a good one again. But we found only quite miserable things. Felix commissioned Mr. Gilpin to bring me *a very good one* from New Orleans, where the gentleman goes in 4 weeks. Now let us see!

We found only imitation jaconet; I did not buy that, of course. The other

day Felix made me a nice present of a *big, fine* new cooking stove, just arrived from New York, with many good pots. Our house has also been newly whitewashed and now looks much more cheerful again, and for manner of building here, our house and garden are exceedingly beautiful. I am completely surrounded with greenery.

Finally, I beg you, do greet all relatives and friends many thousand times from me and do write to me *very, very soon!*

My fat rogues are safe and sound and well fed. The little one now has molar teeth coming in and is somewhat uneasy. They know exactly who Grandpapa and Grandmama are and kiss them often and fondly. The big fat one wishes to go to you Grandpapa; you shall give her apples and knitting needles, she says, and take a walk with her. She already makes attempts at knitting with hairpins. As to sewing, she has already achieved attaching buttons. The little fat one is a funny little monkey, *still* much larger than the Mieze was, and already beginning to speak. If only you could see them running about in the garden, each seizing a big tomcat by its collar.

Now farewell very fondly!

—*Your Maria*

Corpus Christi, June 28, 1854

Dear Parents,

I received your last missive of May 4 on June 6, and I was really happy to hear from you again after such a long, long, time. You should know that yesterday Felix did not come to the table before 4 o'clock and then with such a beaming face that I knew he had again had a little drinking fit. I do not know whether I told you last time that this has long alarmed me, and only the Red Indian troubles shoved the memory of it somewhat into the background. A courier between here and another military post was so afraid of the Indians that he cut his mission short, returned, and arrived here in the night toward 11 o'clock. He then notified the government office that the Indians had attacked him, and as these couriers have the best horses, he had escaped them—which was not too difficult. But he reported that they were only three English miles away and had resolved to storm Corpus Christi. The news was brought to us from town in the middle of the night, for you may well imagine that all was in commotion, as the Indians had caused plenty of trouble in the area before. I must say that from the beginning my

husband, and also other men, as I later heard, found the matter hard to believe. Felix nevertheless loaded all his firearms for my comfort. Mr. Büsse also came to us. He was not without *great apprehensions*. We all lay down, but you may well imagine that, for my part, I did not spend the first hours in quiet sleep. The general had at once sent a military detachment to find out whether the Indians were really present or if it was rumor—as was later confirmed. I must confess that I am terrified of the Indians, principally because of Felix—when he is out surveying, an encounter with them would definitely be his ruin. After this uneasy night had passed, when I expected every moment to be frightened by their horrible yelling, I began a letter to you with the prayer to send as soon as possible a mail-shirt for Felix; they use these in Mexico against the Indians. They are well tested so that no arrow nor ball can pierce the mail. But I fear you might perhaps be need-lessly disquieted. On Monday Felix will start for a survey very, very far away, where there were Indians on their last trip. My two big dogs were then my hope! Unfortunately, Felix had to kill the big black one (kind of a New-foundland) as it was biting the other. In spite of calomel, mites had infected his ears and head. I was infinitely sorry, but there was no other choice.

Yesterday evening we received other sad news, that a young German named Frank Abbe, who had lived with Mr. Büsse and sometimes took me out for a drive, was drowned during a work trip. He was a horse dealer. While driving his horses across a river that was anyway quite swift flowing and that had been swollen enormously by three weeks of rain, he was swept away.[69] It was a bold move to depend entirely on the horse, as Abbe could not swim at all! Seeing and hearing all this, one might grow thoroughly uneasy. I must avow that I always feel greatest apprehension for you in the cholera season. This year our rains were admittedly late but more frequent and ample than ever before, so that our pond and a big water hole we dug for the horses inside our fence are completely filled. I don't know whether this weather might favor yellow fever, etc. I hope to God that Corpus Christi may be spared as usual. For a while I took a drive with the children every day—our present Mexican is rather a good driver—but for about a month, though there have been some fine days, I have not been able to take a drive, to the children's great dismay. The inconveniences indeed are never ending! Last evening they brought Felix news that our remuda had been stolen by Cecilio Balerio, a noted horse thief and trader. Among them was my pretty chestnut mare; so probably she is gone, along with the rest.[70]

Dear Father, I hope the war troubles are not looking worse for Prussia. I

am constantly alarmed for you and our relatives. Otherwise, Germany's revolution might not really come amiss. I can't begin to tell you how pleased Felix was at your just indignation concerning the English ambassador, as Felix often thought that you might find acceptable many actions of the Prussian government that he considers great absolutism. I often think that the foul conditions may perhaps drive you to us, and it is not without apprehension that I think you might not like it here. For you are accustomed to so many things one could not have here for all the tea in China, —i.e., a cool glass of pale Berlin beer! The heat of summer is present, but not the cool pale stuff!

Should you, dear Father, be willing to send a crate this autumn, I still think it better to send it to New Orleans instead of to Galveston, as between here and Galveston for the past two years there has been no *direct* communication. Address the crate this way: "To F. Belden & Company, Corpus Christi/care of/ H. L. Stone & Co., New Orleans." I summoned Felix to write to you himself, but he took it very amiss; he said he had "no time to write." He is sometimes very strange and base. He always has his head so full of business that he is half crazy.

I should be very glad to receive a drawing of the Treptow house so as to be able to imagine myself there. I shall close now and begin other letters calling for attention, for I must necessarily finish up today. I have suggested that Felix take his meal elsewhere today, for I don't want him bothering me. So for the present farewell! I kiss you

Your fondly loving—Maria

Corpus Christi, November 24, 1854

Fondly loved Parents,

This time you had to wait a while for news from us. Unfortunately, illness has prevented me from writing. For more than two months now I have been ill, some of the time in bed, some of the time up. At first I ran a high temperature, which receded after a week but left me feeling extremely weak. Eight days after that, Felix rode away for a survey. You should know that on the morning after Felix's departure, Mr. Büsse brought me the news that Dr. Turner and his eldest daughter had suddenly died of the *yellow fever* during the night. I was on very friendly terms with the family, and Dr. Turner was my doctor![71] Just as he told me that, I caught the fever. Felix was now away and I quite alone with the children! This hampered me greatly, and unfortu-

nately Felix stayed away 3½ weeks. As a result of the unusual rain in the summer and the prevailing sea breeze being absent, we had burning sun and heat, so that troublesome fevers arose here too this year. Yellow fever appeared in the streets where the water had no outlet, thus producing contagious matter. Up here on the hill nobody fell ill with it. As cause of my fever the doctors state: overexertion and exposure to the sun. The least exertion revives the fever; I never shiver or feel chilled before an attack. I am already so weakened by this little bit of writing that I must pause!

I received two letters from you in August and September, the latter of which also contained some lines from Felix's mother. Her letter to Felix contains nothing much: nothing at all! Empty words of her affectionate loving mother's heart (and very tenderly composed). Yet nothing about how unjustly Felix's mother behaved to him, no reasons as to why she withheld the money from him. But I now suffer the consequences of that baseness, for from the beginning we lacked the means to keep a domestic. And this has been among the many things that have gradually worn out my body— along with the changed climate, much work, being shut off from all family intercourse, not going out, having no distractions, enough, enough; in short, the totally changed mode of living—which all resulted from our limited means. For in this country 100 thalers more is a great difference, but to have or not have 4,000 thalers is an incalculable advantage or loss. Thank God we have made our way by our own effort, and made it *well*. That Mr. Kill-Mar claims he never meant to misuse Felix confirms that he is an impostor and a rogue. Felix, however, begs you, dear Mother, to keep up friendly exchange with them, as such a rapprochement between you might be favorable to him in perhaps getting the rightful inheritance he is owed.

The crate you were kind enough to send us has not yet arrived, and perhaps its arrival will still be delayed a little. The crate seems from the bill of lading indeed to contain hundreds of things that are impossible to procure here. I wish to thank you with all my heart for the ample gifts you provide us, and I am very impatient for their arrival.

The children and Felix are very well, thanks be to God, and my old man is growing pretty fat. I must indeed look funny between my husband and the children—Felix extraordinarily well fed, and the latter downright cylinders. Yesterday I received my Christmas gift from Felix, with which he has indeed greatly surprised me, consisting of: three chairs, a rocking chair, one table, and one wash stand or toilet table with white marble top. All the pieces of furniture are extraordinarily finely worked and lacquered in sky

blue, adorned with flowers and rich gilding. A long time ago I saw these pieces of furniture; I was then quite enchanted. I forgot to mention that they include a very pretty towel rack or stand. I really was totally delighted when they all arrived.

I have now prepared a medicine that a Mexican woman advised me to take, as the two doctors I had after Dr. Turner's death refused to give me anything because they said I was too weakened. I now take rhubarb in the evening with a maguey syrup, which I prepare myself as fortunately we possess such a maguey plant. Besides ours there is only one other here. In Mexico they use the plant to make the renowned mescal and pulque. Now one doctor says, "yes, yes," if only he had known I could get the stuff here, for it is the best! It has indeed begun to restore me.

I must stop now as I am flagging. Greet ten thousand times all who are dear and affectionate to me! I have just realized that even this letter will arrive after Mother's birthday. Therefore let me finally add my sincerest congratulations to you, dear Mother, and I always pray to God that he may grant you lasting good health. I wish all a Merry Christmas and New Year! Many greetings from Felix! Farewell!

<div align="right">

Your—Maria

</div>

❧

<div align="right">

Corpus Christi, January 24, 1855

</div>

Dear Parents,

We received your December letter at the beginning of January, and I had long been awaiting it. I regret very much that Carl has been so sick, and it is a singular coincidence that we both keeled over at the same time, only with the difference that Carl had tender nursing and good doctors, which I lacked. Not even a domestic had I. But why burden you with this distress. When Felix came home, things were much better. I hope Carl may be restored with God's help and be his old self![72] I am more or less back on my feet but tire easily and am not fully back in action. My husband has stayed with me until now. But as the temperature keeps recurring and will perhaps continue to do so for a while, he started on Monday, first to Brownsville and then to Camargo and Roma (Mexico), and he will probably stay away for some time. After having lain ill 2½ months, I am minded to travel to you. There I would certainly get proper nursing and be sure of good doctors and rest. God, how often I have longed for a rest! But I could not escape needing to watch over the children, and the Mexicans we have in the house

never cared whether I needed or wanted something. When that was the case, I had to shout through three rooms toward the kitchen, and it sometimes took me ½ an hour to attract anyone's attention. I surely shed more tears in that time than in the first 20 years of my life. But don't worry about that, for heaven's sake; indeed, I did not die from it.

While writing I am sitting at the window looking for the crate that has yet to arrive. Because of low water, only two schooners have been here since December. On Monday evening word arrived from the merchant Stone that our crate was in the schooner *Esther Burr,* which came in on Saturday. Since that time I have been sitting waiting for it to be unloaded and sent to me. Eight lighters have come in a dozen times with cargo, and the crate still is not yet among it. It really is a test of patience!

I am now planning the arrangement of my garden, which I have had enlarged. It really is a pity that the remaining five acres within our fence lie uncultivated because of the horses, but pasture is indispensable for them. How did you spend Christmas? Mr. Büsse was with us on Christmas Eve. We hung the Christmas tree with sugar cakes, but there was not anything else. On that occasion I drank to your health with my first glass of champagne in Texas.

We had hoped for the crate, but in vain, though it had been at New Orleans since the beginning of December. The businessmen are utterly careless out here in the hinterlands. Mr. Belden tells me that ordinarily Stone used to be a very punctual man. But—our bad luck—a short time before the arrival of our crate, his wife ran away with another man, which is said to have deranged him much. Since my illness I have suffered constipation beginning at the stomach and running across the left side of my body, just as hard as stone. Cupping, mustard poultice, Spanish fly, and pitch plaster are the remedies I have tried. They have not only been unsuccessful but have worsened matters. The Americans call it "fever cake," the Mexicans "spleen swelling." Now, thanks be to God, it is gradually disappearing.

I shall probably stop this letter short, for I received the crate yesterday evening; I did not finish unpacking it, and today I am running a fever again from the joy and excitement, and writing is awkward. I cannot begin to find the right words to thank you for such ample supplies and gifts. It is all so beyond my expectations that I have been beside myself with delight and emotion. The children are swimming in happiness. The five dresses and hats surpass all you can see here! The shoes fit excellently well; indeed, today's miracle is a pair of felt shoes, for there can be nothing more comfortable.

The little shirts, small clothes, and petticoats, everything is so charming; the little ones are half crazy with joy. Felix's things are all excellent, and I can still see his delight. It is impossible to mention every single thing and express the pleasure it gives.

Forgive me for stopping my letter here, but I am feeling very low, and the mail will start at noon, and I should not like to make you wait eight more days. Don't be disquieted about my indisposition, for heaven's sake, for it is quite trivial. So once more my deepest thanks for your love and devotion

Remember with love—Your Maria

P.S. The children send many thanks and kisses to the dear Grandparents! "Dear Grandparents: We thank you a thousand times for the nice things." Your little Mary (xxx) & Julie (xxx)

❧

Corpus Christi, April 3, 1855

Fondly loved Parents,
You must surely suppose we have died, so long have you not received any news from us. But things have been such a muddle in the house that you must pardon this delay. When I last wrote, workmen had begun to paint our rooms, mantelpieces, etc. with oil color, and they have been at it so very long that I have been obliged to keep the children in the dining room for nearly fourteen days, and that with the house always full of people to feed. Then I set to ironing and have been ironing continually for *14 days*. For from the beginning of my illness the linen lay unironed in the chests. Then after six weeks' absence Felix came back from Mexico, and when he is at home there is much more to be done. And on March 24 toward 9 o'clock in the evening, as a result of an alarm, I had the misfortune to be delivered prematurely of a dead boy. On Friday the 23rd, in the afternoon, Fat One (Mary) fell while holding a knife she had secretly taken out of the work basket and, in falling, thrust it in her mouth. I almost passed out when I saw her lying before me bleeding. I at once washed her with vinegar and water and then saw that fortunately, she had hurt only her lips and chin, which have already healed up without any scar. The next morning I fell ill, and as Felix had to be in court all day long as an interpreter, I had no chance to lie down until he came home at 8 o'clock in the evening. He immediately went away to fetch the midwife, and in the meantime the baby boy was born. After that I at once felt much better physically, but Felix and I grieved deeply and wept sorely that we had thus lost our little son. Today is the

tenth day. From the third day I went from room to room and lay down on Felix's bed all day long. From the fifth day I have been up and about and have felt better than while in bed.

This time you are not getting a letter from Felix. He really is so exhausted that I am often frantic with rage. Here no person at all can begin anything without Felix's advice and assistance. When court is in session, every ½ year, he doesn't even have time for dinner. At every case he must give his verdict. If ever he does not appear, the sheriff hunts high and low for him! Not one of the attorneys or judges, I gather, has sufficient command of the Spanish language as to be able to read and write it properly. Hence they summon Felix, who at once reads out the old Spanish land deeds in English, saving much in time and expense. It's just that Their Honors, etc., are very lax about paying. A Mexican to whom Felix gave good advice that secured him 4,000 acres gave us a cow and a calf in payment as well as a big China cock and hen of the Shanghai breed. In the evening when Felix comes home from court, he sometimes has to write half the night. Saturday was the last day of court. He was at it writing things up the whole of Sunday and deep into night, until 12:30 in the morning. Yesterday (Monday) likewise, and at 11 o'clock at night I was still dictating to him so that he could finish more quickly. And this morning he rode away with some men to select land for them on the Nueces, and Mr. Belden has already been awaiting him on his rancho for eight days so that Felix can go with him to San Antonio, New Braunfels, and Austin to conduct land affairs for his clients. So he will again stay away a long time. Felix, you must know, always tells me less time than he will really be away. For example, he said four weeks on this trip, and I took a bet with him that he would probably be gone six weeks. If I win, he has to give me $3; if I lose, I must make him another waistcoat.

You should know that Felix is now very corpulent, and I think stouter and much heavier than Father. Felix danced about with happiness over the contents of the crate; the mathematical instruments made him utterly happy. The pistol I told him was mine, as he already has five or six of the best: Colt's Navy pistols. For $50 he bought a Sharp's patent rifle, which is even simpler in construction and faster to load than a needle gun. He really cannot write to you at present, though it might perhaps not seem so for one who can find so much time for business. Even while bidding farewell to me and the children, he was still concluding a land negotiation. By the way we can be glad that we received our crate on the *Esther Burr*, for following four

ships were stranded at the bar near San Joseph Island. All big ships stand off there in order to unload for lightering, as they cannot get as far as Corpus Christi.

In the future you will perhaps receive a package from us, for Mr. Noessel intends to start a daguerreotype salon. He expects his equipment on the next steamer. He gave up his hotel and has arranged a studio for daguerreotypes. You then shall receive a photo of the children and our new domestic. I want to warn you in advance so that you will not think him to be an orangutan—he is in fact the best Indian I ever saw (this is a tame Indian!). During my illness he cooked good food for Felix and made me good coffee and good chocolate. Felix has often expressed his wish for us to be rendered in a daguerreotype. It may seem ridiculous to you, but I should myself like to have it. We enjoyed the drawing of the Treptow house immensely and only regret that we cannot have such a house built here for want of bricks.

Father, you probably misunderstood me when I wrote of the money. I meant exactly what I said! It is by no means my intention to squeeze money from you by hinting, certainly not! If I were in great need or might ever be, I should frankly ask: "Can and will you help us?" The matter is simply this: Felix and I have often spoken of the advantages of capital here, whether it be great or small, and we discussed whether Papa might embark upon such a business here, as you certainly are a very well-off man. I took up the idea and wrote to you of it, knowing that Felix has sufficient property in land to stand security. I took up the idea all the more readily as my greatest wish is that Felix may give up the office of surveyor. I hope you may now be reassured that you need not trouble yourself anew to provide us with money. Again, many thanks for the ample supplies and gifts in the crate. The crate itself I shall use as a bathing tub. Near our gate Felix has already dug a second well, which contains sulfur water. This water has been used successfully as a draft and for a bath against liver complaints and boils, including infirmities of long standing.

We have often gone visiting at Noessel's in the evenings. I happened to be called upon to play the piano, after not having played seriously for almost six years, and Noessel suddenly discovered that I am an *eminent* talent! As a result they invite us nearly every day, and the other day my young Misses received an invitation to a ball. But I did not risk going or taking them. They say here the Russian emperor is dead—if that is the case, what course will the war take now?[73]

Much to his dismay, Felix now weighs 180 lb. American weight; he has

quite a paunch! Again, and once more, greet everyone you can and keep on loving your children in Texas! Farewell!

<div align="right">Your—Maria</div>

❧

<div align="right">Corpus Christi, May 29, 1855</div>

Dear Parents,

The time between arrival of letters always seems to me awfully long, and I will not make you wait so. Though it is already 10 o'clock in the evening, I have begun to write. Above all I wish and hope that you are all safe and sound. We here, too, are quite well, and I hope now to maintain my own health better than in the last year. You, dear Mother, so hope of a journey for me. I should make it if the means to travel with the greatest comfort and a maid for the children were at my command. But alone with two children, and sure of seasickness to boot, it cannot well be done, no matter how anxiously I wish it. Felix virtually lives elsewhere, so it would make little difference in that respect. By the way I am now quite well and have an excellent appetite. I have totally given up drinking coffee, as tea agrees with me very well. Only one thing is disagreeable to me. After the fever my stomach became swollen and I think it to be weakness in the bowels or stomach muscles. If I wore a well-fitting girdle it might perhaps abate. The children are growing pretty tall and at the same time remain equally sturdy. Felix is ever richer in blessings and earnings and will soon be the very epitome of a rich landed proprietor.

Have you sown and worked over everything in your garden? The drought here is again so extraordinary and terrible that everything has dried up, and already we have to buy all our drinking water. The last good rain was in December. A new doctor has joined the troops here; these military men are mostly very good doctors. He comes from New Orleans, where he is said to have healed the governor of Louisiana of the yellow fever in fourteen days—which reportedly cost the said gov. *$5,000;* this, it is said, he had to pay directly to the doctor! This new doctor wrote and sent to New Orleans a medical prescription for me, which he insists will restore me forever from the fever. We shall see![74]

June 2nd. I had to pause in order to make some new trousers for Felix, as he had to go away again on business. He started out tonight. The dresses, hats, gloves, shoes, etc. from your Christmas crate have been to my excellent advantage of late. There was a big soirée at Major Chapman's to which we

had been invited.[75] Though Felix was not here, I attended nevertheless, and I should not have been able to go had I not received your dresses. For here the invitations always come only the evening before or even on the same morning. One has no time at all to make any arrangements because of this wanton habit of sending invitations out for such festivities only three or four hours before. So the gloves, too, were utterly welcome. In Berlin they would not be able to comprehend that even in the foremost and most dignified establishment, as Major Chapman's is here, a ball could be held with only two pairs of gloves in evidence. Each excuses herself to the next for her bare fingers, as in all Corpus Christi not one pair of gloves can be bought. So when your crate came, I went forth proudly in gloves! Only the notables of Corpus Christi were there, and judging by the luxury, one would not have believed one was in Texas. Each person, of about fifty in attendance, was presented an individual silver nutcracker. Only champagne and fine wines were served. I should certainly have been wonderfully entertained, if not for the fact that after two hours I had to go home because of feeling unwell. The Chapmans might be the wealthiest people locally. Here a man can quickly double his property, as the taxes are not as in Germany. For example, the taxes on our entire property amount to perhaps $6, at a rate of 15 cents per $100. You must truly wonder!

I have taken up horseback riding again, and I drive out in the carriage every day with my children for an hour in the evening, pulled along by our old mule. Indeed, we are now living as people of rank, although Felix goes his way, and I go my way with our children. Felix now gets $5 for each of his maps (thanks to the fine case of mathematical instruments from dear Father), and no one could work more neatly or carefully, or could handle things with more precision, than Felix does with all his scientific instruments and firearms (pistols, rifles, needle guns, shotguns, etc.). Felix goes to town early in the morning, before the great heat begins, and he comes back only very late. Often he takes his supper at 10, 11, or 11:30 at night. The nights are wonderfully beautiful here now, with a full moon by which I sew without further lighting. The military band sometimes plays until 11 o'clock and later at Major Chapman's or General Smith's, by which making agreeable entertainment for us. The other day Felix even tried to teach me a Scottish waltz on our lawn in front of the house!

Nothing much further has happened here except that we read in the newspapers that Col. Kinney has married an exceedingly beautiful and very rich girl in New York.[76] Mrs. Kinney is still in Galveston, and we conduct

steady correspondence. Farewell now, and give my greetings to the whole family. And excuse this shabby writing, but I am writing in a hurry, late in the evening, and still with a thousand interruptions. The children each send a tender kiss. (And Doña Feliciano comes washing tomorrow!)

Keep on loving—Your Maria!

~&~

Corpus Christi, November 5, 1855

Fondly loved Parents,

About ten days ago we received your letter dated Sept. 14. I have often complained before about you making me wait so long, but this time it has been longer than ever. In the meantime you must have received two letters from me. And as I did not wish to write before having received a letter, you will also have three months between arrival of this and the last. Many thanks for the cabbage seeds!

Mrs. Kinney was here last month for fourteen days, and I spent several days agreeably in her company. She invited me to spend the winter or at least some weeks with her at Galveston. But I cannot think of that at all. She hopes very much that in April next year I shall go with her to Europe. Probably not so because of my companions, for the children would certainly be too much trouble as a trade-off for my easing her way with the languages. But as agreeable as her personality is to me, such a journey would meet neither your nor my wishes. She lives only for pleasure and is rather committed to this, and for her, to spend a week at Treptow would be to suffer the torments of hell. She claims to be just the right age to have "fun." Even before setting out here, she wrote to me that Felix should in any case prepare himself for my being away.

Now, some months having passed since the conquest of Sevastopol, have you heard if Hermann, Felix's brother, returned safe and well when so many fell victim?[77] What if Lady Kill-Mar knew that it was even in the New York newspaper that her son joined the English foreign forces and was accepted *with pleasure and great expectations?* Are the Kill-Mars in Berlin again?

The children have acquired a goat, which is so attached to them that it even accompanies the children when they take a walk. The goats here are smaller than ours in Germany, not bigger than a sheep. The children's livestock holdings are already significant and remarkable. They possess: 23 head of cattle, mostly cows, some few young bulls among them. Money invested in cows doubles every year.

Felix has received a permanent position managing the land formerly belonging to Kinney to ensure that no timber is cut illegally, which brings him $50 a month. About two weeks ago, Felix was in bed for some days with fever, which still recurs now and then. On the whole, however, fall is rather favorable here, and there was little illness. The children, thanks be to God, are healthy and growing like the mushrooms. Mary is extraordinarily tall for her age but not very inclined to learn reading or writing. She knows how to knit, sew, and string pearls, dust, wash, etc. Some days ago the little one, Julie, fell on an iron shoe scraper and got cut just between the eyebrows, and her face is so swollen that she looks terribly deformed at present. Our children are so innocent and natural, as they are completely confined to themselves at our home most of the time. I prefer them never to come in touch with the other children here, who roam the town like wild cattle. Mary and Julia even speak their own language, a mixture of Spanish, English, and German.

I always regret that I have little of interest to tell you, as we are really so short on changes and events worth mentioning. I calculate that this letter will arrive around Mother's birthday, and let me add my wishes for your well-being: "Health, ease, and *repose*," and as always the hope creeps in that perhaps next year we shall celebrate this festival together. Felix sends fond greetings, having charged me with this before he rode away. To all many greetings!

Yours, Maria

[Attached to preceding letter] November 1855
My dear Mother,

As this letter contains little to delight you, I thought it my duty to add some words for you, as I wish with all my heart to be able to convince you that I am devoted to you with the same unchanging love but nevertheless cannot neglect the care for my children. It is no straightforward matter to give someone who does not know the conditions here a true picture of our position. Felix has certainly come to be regarded as an important person in Corpus Christi, as his intellect and education are superior to those of many. But people have their own opinions about the outward position of a man. To give their wives the comfort and appearance of being a lady, they mostly sacrifice good name and honesty and indulge in all kinds of swindling. Now, as Felix has done his utmost to get us ahead strictly with hard work and,

instead of using his gain for superfluous luxury, has on the contrary employed it to augment our property, it is therefore nearly impossible for me to enjoy the comforts of a social life, as this would be in constant conflict with our means as regards house, dress, etc. For to join in the enormous pomp of these ladies would result in infinite debts in New York, which are then settled by ½ or ¼, as with others. It is thanks to your care that on the few outings I do undertake, I can appear matching up to expectations. On June 10 we were at a wedding involving the most fashionable family, at Mr. Bee's.[78] My yellow dress served me excellently well, and you completed my ensemble with white gloves, hat, etc. Just a week earlier on June 4, I was at a Mexican wedding. Don Alvaro Pérez's daughter, 15 years old, got married, and it was a magnificent wedding. Nearly all of Corpus Christi was there.[79] Felix and I had positions of honor as *padrino* and *madrina,* just as at our baptisms we have godparents. We led them to the marriage ceremony, etc., and with regard to their conjugal relationship we have more rights than their parents. The custom is to address those persons always by these titles. The young couple call Felix Padrino and me Madrina, and we call him *ahijado* and her *ahijada.*[80] Felix gave the young man a pair of pistols and I gave her some silver spoons, for which they presented us with one of the most magnificent Mexican rugs, handmade, a $50 value. We and the couple's parents are *compadre* and *comadre,* which is always how we address one another.[81] This year we had five balls in the best private houses, Major Chapman's, Captain Fullerton's (2) and Mr. Belden's (2), as well as some children's parties. But I went to only four and the weddings. I wore my black dress at the wedding, the old red silk one saved me on another occasion, and the new one I wore at the last event.

I now take a horseback ride every day, which seems to do me good and which I will continue as long as possible. Since October, except for six hours of drizzle, we have had no rain. The cattle are dying of hunger and thirst; the ground splits open everywhere five to six feet deep and one foot wide, such that many a route is impassable. The work on our new rancho progresses apace. Mr. Müller lives there and works it; he built a good house on it and keeps his and our cattle there.[82] The land belongs to Felix, and when they sell cattle, the proceeds are divided in half.

I wrote to Father that I wished to acquire a decent house. I must therefore first give you an exact description of our present house. You have the drawing of the old house: in front there are 2 rooms of 12 X 13 feet and 18 X 12 feet, the smaller one my little room, the larger one our general bedroom;

behind it 2 wooden rooms; behind them a dining room, small but built of rough lumber; then the kitchen. In line with this house stands the new one, begun and planned out in good proportions, so as to yield a fine house when means allow. So far there is only a room with unpapered walls and a roof without a ceiling, but of the best material (wood), with a nice veranda in front. And everything has been whitewashed. Just to finish the inside of this room, which is Felix's office, $50 would be required, and to turn it into the intended decent home for us, at least $700 or 1,000 thalers would be needed. Our household, together with the men, who get $1 daily, costs $2,000 to $3,000 a year. Felix must work hard to afford that, and although improvements are continually made here and there, there is no prospect of much being left over as net gain; what had already stacked up, $500, has been spent to build the office: It surely is the most natural wish to have the place where one spends the greatest part of one's life, as I am not a fan of going out, at least a little agreeable. Possessing a sofa is a luxury I know only in the homes of others. Therefore I cannot be silent about how anxious Father has been for the "comfort and setting up" of my brothers and sisters, while I am always to have "patience, patience"—I who could certainly use more comfort. Felix's picture is now in hand, and we shall send it at the next opportunity.

Fare cordially well! And write soon! And not angrily, for don't be angry at your

—*Maria*

❧

Corpus Christi, January 16, 1856

Fondly loved Parents,

First of all I wish you a "Happy New Year." We began it sleeping and gave it little thought. Christmas we spent very cheerfully. The children got the Christmas tree adorned with little sugar dolls, etc. Mr. Büsse presented both of them with dark blue silk dresses, and I had bought such playthings as could be had here (awfully poor things and especially *no dolls*). Their delight was enormous. So far the crate has not yet arrived here, nor have I heard whether or when the ship arrived at New Orleans. Time indeed stretches out when one is expecting something. As soon as I hear of the crate, you shall be advised.

The cholera must haunt you horribly. Year after year it spreads such devastation in families. I have thought so ardently of returning to Germany

in order to give the children the chance of a good education, but I would always live under the apprehension of losing them sooner there than here. And if perhaps I should still have more children, journeying will become ever more inconvenient and my existence here not more agreeable. Felix is away from home more and more and has only one pursuit: riches and a position in the world. As these two things have little attraction for me and domestic joys are unattractive for him, I am convinced that if Felix could live free and myself among my family, both of us should be better off.

Since New Year Felix has again been at San Antonio and Austin. The Democrats of Corpus Christi elected him ambassador *without payment* for an assembly that meets today at Austin. This appeals to his vanity. So he starts for God knows how long, takes a servant, three horses, and not a little money, lives in the best inn, etc. It seems he could not care less what happens here as he left me quite alone, and I shall probably have the baby before his return. Disregarding whether the expenses suit him, I have this time hired a Scotswoman, who has been with me since the 10th, when I again caught the same fever as last year: three times only, thanks be to God. The woman who is with me is of a decent family. She does not do any housework but prepares the table and sometimes irons, but she is an excellent seamstress and has proceeded apace at sewing the children's linen, as I have not yet been able to make anything at all. She lives in the expectation, as I suspect from her comments, that I shall go to Europe and take her along as a nurse for the children. The girls now have a difficult time speaking three languages at home. For yesterday I again hired a Mexican boy for the housework. Both my little girls speak Spanish very well, less German, and least English. But I hope they will learn all well soon.

Since Christmas winter has hit hard here. We have had very cold weather almost without a break since then, and whatever was coming up in the garden has perished. Our cabbage crop was frozen.

My letter will probably be brief this time, as I see and hear ever less of what happens in the outside world. A matter that occupies people in Corpus Christi intensely is currently before the court. You should know that the rich old German Peter Schätzell, who died here 1½ years ago, did not leave a family (wife or children), and according to the statement of his administrators there is no last will and testament. Now, a good German cobbler turns up with his family in order to take possession of the important treasures, landed estates, etc. of his uncle. All of a sudden people find themselves wanting to swear under oath that there was a will, in which they

were all more or less remembered; and they now accuse the administrators of having destroyed the will in order to gain authority over these riches, etc. Each party has now retained attorneys, and the issue is very uncertain and probably dependent on the craftiness of the attorneys. Mrs. Ohlers, too, claims to have been denied $10,000. As the man bequeathed me scarcely a thing, I can very quietly await resolution of it all.[83]

Besides that, everything chugs along as usual. There is much building and expansion in Corpus Christi. We even have an icehouse under construction, and when it is finished and in operation, it will be an enormous improvement. There is a smokehouse, too, offering wonderful smoked meat not inferior to the Hamburg meat.

The other day at my instigation Felix talked to the local schoolmaster about instructing our children here at home, as I certainly do not have the time to devote myself to it *seriously every day*. He says, however, that we had better wait until Mary is 7 years old. He also is of the opinion that the children will learn faster then and without disadvantage for their health. In spite of the cold and wind, the children stand at the garden gate awaiting your crate. There is a big schooner from New Orleans lying at the island, and it is possible that this one has the crate in its hold. As Felix is not here, I will not get word of it until they send it to me. I so often think how Berlin must have been decorated, and if you have an opportunity you should send me little illustrations of the city and its embellishments.

Last night our best mule sprang over the fence, and I do not yet know what has become of it. But I hope it has safely joined the other horses. Now farewell from all my heart, write very soon, and just beg my dear friends and brothers and sisters to write to me as well. Adieu!

Your—Maria

Corpus Christi, February 22, 1856

Cordially loved Parents,
The delivery of young Major Blücher came on February 10. The said descendant was born at 2 o'clock in the morning. As I expected, Felix did not come back, which afflicted me greatly as I had told him that I should be confined between the 6th and the 12th, and he promised faithfully to be back. Everything is now safely behind us, thanks be to God, and I am back at my usual occupations. I was nervous that I might not recover so quickly, as on the 2nd night I was suddenly seized by diarrhea and violent fever, and

I feared infection, as I was afflicted with the most insupportable pains and am even now not quite free of them. My boy is a beauty in size and weight and has so far shown a very amiable character. The Scotswoman I have in the house, has unfortunately proved a mere cipher, incapable of performing any tasks but good needlework, and I had to send for a Mexican woman to make me a bowl of soup.

I cannot write at length, for which reason you are getting only a short letter. I beg you to announce to all the arrival of my boy. The girls are safe and sound, thanks be to God, and pleased that they now have a brother. As for the crate, we have not yet received it, for which Messrs. Eaton & Henderson of New Orleans are at fault. After the crate had been in New Orleans for a month, they informed us that they were not able to get it through customs, and as the papers were in a "foreign language" they thought it best to move the crate over to another house. Now, after his return, Felix has written to a German outfit, Kramer & Comp. of Bremen, to take the matter in hand with the promise that if they carry out this commission promptly, all our future shipments and banking affairs shall go to them. These good people will get big ideas if little business.

Here in Corpus Christi things fare rather badly; the army depot has been removed, all property has become valueless and sales are impossible.[84] In consequence there is no activity in land affairs and no surveys are needed, and the prospects are very depressing.

My little prince is crying; I shall write more to you soon. Fare cordially well!

<div align="right">*Your—Maria*</div>

Felix sends many greetings and the children send many kisses.
Our impatience for the crate has now reached a pinnacle.

<div align="center">Corpus Christi, August 1, 1856</div>

Fondly loved Parents,
I have not been able to write to you for a long, long time, and I hope you will find it natural and forgivable that my little prince engages me so completely. My boy is tremendously heavy, strong, and alert and makes the finest progress from sitting to crawling. I also think he will soon get four teeth, which can already be felt through his gums. My son is named Charles Frederick, and I wish with all my heart that like you, my dear father, he may be active and vigorous.

We finally received the Christmas crate on June 6. Amazingly, everything is in good condition, and as ever, there has been great, great joy at its arrival. Everything of the best quality and fitting so exactly and meeting our wishes as closely as it possibly could have had we selected it ourselves. Felix, the children, and I thank you with all our hearts! Felix has again been in San Antonio and Austin for two weeks and will still be away several weeks more. I wish Felix could rather have said, "I set out for Germany 14 days ago!" Mr. Schünke has returned to Corpus Christi and has settled as a cigar manufacturer. He came to see us one Sunday and told us much of Berlin, of the luxury, shortages, and poverty.

Aug. 23. I did not mean to forget this letter, but with three children in the house, Felix gone away for God knows how long, and incompetent help, I return to it only now. From your last missive I see that you do not give my resolution of coming home in the spring much credence; and yet I considered it more seriously than ever. It's just that my fears for the children's health hold me back. And often I think how here my children have fine cows, increasing year by year, and after fifteen years they could supply each with a good start in life that might dissolve if I were to journey away. For Felix does not concern himself about this at all. Only the future will tell.

Mrs. Kinney is here for a visit from Galveston, and the day before yesterday my children and I spent the whole day at her mother's house, which is a ¼ mile from our place. She is quite keen to pay for me and the children to return with her to Galveston. This of course I cannot do, but I wish it were possible as here in Corpus Christi times grow continually worse. Felix is already considering a change of residence, because in all Corpus Christi probably not $2,000 can be found. As a result no business can be done. Therefore, in view of the bad times here, I bother you once more with a letter pleading for Christmas gifts and needed supplies. I really beg your pardon for this with all my heart, my dear Father, but if you had been in Texas 7½ years, you might perhaps also wish for certain things. My dear boy is again cutting more teeth and is very out of sorts. The girls are asleep. Farewell!

Your—Maria

Next time I shall also send you a package, albeit a miniature one!

Corpus Christi, November 1st, 1856

Cordially loved Parents,

I must frankly admit that I am hardly in the mood for writing today, as a violent toothache and the devil of a swelling—i.e., fever, swelling in my neck, breast, and right arm—has kept me pacing these past four nights and days. I have had the pains for eight days, but in the past four an abscess seems to be forming. And as nothing at all, indeed nothing in the world can be procured here, I shall have to wait, in patience or impatience as the case may be, for progress and recovery. Not a single *half raisin* or *fig* or a suggestion of ground oats or linseed can be had here. Such circumstances really tempt one to run away. But I received your last letter with your kind offer to add something to the money that Aunt Rieben is sending us. At any rate I should prefer you to procure the necessary things, as for the same money that would give me three times more and *much, much* better and more reliable good things than here. And your crate is always the joy of a whole year. Three weeks ago now I let the Scotswoman, Mrs. Dunn, and our Mexican go, and I perhaps caught this rheumatic swelling while washing or in the kitchen at the fire and then out in the wind. Felix is healthy and hefty and will probably go to Austin and San Antonio again in 14 days. The girls are hale and hearty and wild as can be. My son already takes little steps along the chairs, is now getting his fifth tooth, and when six months old weighed twenty pounds in his shirt. I shall no longer be able to write much, for I am suffering what I can only describe as mental anguish. All day long I am on my feet and hard at work, and then at night I must walk about carrying the little one, as he is suffering with a tooth—*it is not easy.* Felix now sleeps in his new office; thus I cannot even call him if I need him. Yet I hope this, too, will pass, and days free from sorrow will come again.

Please tell brother Julius that I shall write just as soon as I feel a little more human, and I thank him for his kind offer to come here and help, which I may perhaps soon have to accept. Tell him I can offer him my "palais royal," which—though it lacks stables as yet—boasts 15 horses and 3 mules at our disposal, 25 cows for rustic charm, and 19 bulls for bullfights. My table is not especially distinguished, and my cellar has room for much wine. The mosquitos bite me so much that I jump more than I sit. Therefore I close with the best greetings to all relatives and friends. Farewell!

Your—Maria

Corpus Christi, March 8, 1857

Beloved Parents,

On February 15 I received your last missive of January, a fortnight after the arrival of the crate, which arrived here quite unexpectedly on January 30. As ever we went through its rich contents and surprises with great joy, and I will abstain from mentioning anything in particular, as everything is as desirable as it is tasteful; except that I must say the dolls are the *non plus ultra* of all seen here hitherto, and of course they made the children very happy. To sum up, I will tell you that we all spent a happy, contented day and felt the sincerest thanks in our hearts, probably more than I can ever do in words.

Pauline Horn will leave Corpus Christi on April 1, for her wishes can never be realized here. She is a girl skilled at work but not patient with the children, and that has often placed us at loggerheads; nor do I think that it was her wish to serve here as a domestic, as she brought along with her neither an apron nor a simple dress fit for the purpose but only fine clothes, etc. Whether she intends to go to Germany I do not know as I believe that her first priority is to find a *rich* husband!

With us here everything is much as before; we are all well, thanks be to God, and the children are growing up. My son excels at naughtiness. My dear Father, you wish Felix to write a book about Texas. I talked to him about this again, and he wishes to write to you himself with his opinion about this. He thinks it might be time-consuming work that may yield no return. I now have to cut this short as an unexpected visit has shortened my writing time today. Farewell and keep in your love

Your—Maria

N.B. Following are a few lines from my husband Felix!
[Corpus Christi, April 25, 1857] Beloved Parents—You will probably be astonished to see a few lines from me at all. But my Maria writes so often and in such detail that it becomes difficult for me to add anything that might be of interest for you. My affairs engage me very much and are progressing steadily, even if slowly. I continue constantly acquiring more property in the form of land, which increases daily in value. Laying by *ready cash* is not possible for the moment, and our expenses rise daily as our family grows. Besides, we are living as well as people of the same rank in Germany,

even though not in abundance, and if several enterprises turn out well for me, we shall become independent in some years. All I lack is the capital to make my enterprises more extensive, yet I hope I have the most difficult phase behind me if only I remain healthy, for which there is every prospect. I have now begun a new, larger rancho, and next week a wooden house will be sent out there on two wagons. Our stock of cattle is increasing slowly but visibly—in short, we are doing so well that we cannot complain of our fate. And that is good enough.

Many thanks for all the things you are always so kind as to send me. Everything you send is so much better than one can get here that it fills the inhabitants with amazement, and I use it all and guard it with great care. If I were to write a book about Texas, I should indeed not lack material. However, if I were to do justice to writing a book, it would claim my time for at least six months, and that is not possible now. For today, farewell and remember your son

—Felix A. Blücher

❧

Corpus Christi, July 18, 1857

Cordially loved Parents,

"God spare me from my countrymen!" is Felix's prayer, morning, noon, and night; and after dealing with the insolent demands Pauline made upon us, I agree. Felix has not yet returned from his journey, and yesterday I heard he had gone to Mexico. Whether it be so, I do not know. This means he was here for the celebration of July 4, and on the 6th he went away again. On the 4th there is the greatest celebration: the Independence of America. Far from holding back, Corpus Christi does its utmost for this day. The festivities began at 11 o'clock in the morning, opening with thirteen cannon shots fired by our resident Captain Müller. The first shot came at midnight, at daybreak there were 13, at 11 o'clock 13, 1 shot after each recital, some shots at the beginning of the dinner, and at sunset again 13 (the number of original states). My children were allowed to participate in such public festivities for the first time. Felix took them in the morning to the courthouse, where recitals and songs lasted until between 2 and 3, when the whole company set out on a parade, the dignitaries on horseback in front, then the schoolgirls, whom our girls joined, then the boys, and after them all persons present. Right in the worst heat of the day they had to parade about a ½ hour from the courthouse to the city hall, where a meal was

served, of which the children partook too. Felix came home, and Mary and Julia stayed there until 5 o'clock in the custody of "Uncle" Büsse and "Uncle" Schübert. I had no suitable dress, therefore I remained at home, as I have worn my yellow summer dress three times in a row at great festivities. If possible, I shall procure a good white dress and keep that one for all summer activities.

So, to come back to July 4: what stories the children now had to relate! As they speak three languages, mostly Spanish and English, less German, the tales were all the more droll. Mary at once began: "Mr. Lovenskiold read aloud, then they kicked with their feet (here people stamp their feet to applaud), and then Uncle Müller fired the cannon." Mary is already almost 4 feet tall, as tall as girls up to 12 years of age, but her speech is often still hesitant. Then they related what a fine dinner they had had: roast suckling pig. Julia immediately wagged a finger, pointing out: "No, Mama, I tell you it was a dog!" And the reports went on that way. As the facilities are too restricted for large crowds, it is the custom at such occasions to have dinner standing up; first the ladies, as the gentlemen assist, and when these have gone, the gentlemen. Julia now declared that she did not eat without a chair; and Mary asked, most astonished, "Whoever laid the table? They had indeed forgotten the napkins!" As a treat for me that day, Mr. Büsse brought some ice, and we spent the afternoon over a good iced tea. After supper the gentlemen went to the ball, the children and I to bed. They were so exhausted that they no longer had any thoughts of the ball.

I still take a ride on horseback every day from 6:30 to 7 o'clock. The children are already passionate little horsewomen. Mary rides just as well as I. Riding on horseback is my greatest pleasure. As long as I can ride, I never go to town. On July 5, Sunday, we had a large riding party. Often we ride along the bay, and sometimes the horses go into the water up to their knees, letting the waves roll up their legs. I confess that this simple, straightforward life has great charm for me. After nine months of drought, we had 2½ days of rain that has made everything burst forth in great green splendor. Unfortunately that is not enough; ponds and cisterns remain empty.

On the first Monday in August an election is to be held, and Felix is therefore always dashing about. [August 8]—I am sorry not to have sent these lines to you before but resolve to write you a few words today, which I hope will not arrive too much later. The election passed on Monday very calmly. Felix's opposition party had put up another candidate during his absence from here. In spite of his absences, my husband got 106 votes here

in Corpus Christi and his opponent 29; and at the other polling place Felix got 84, his opponent 2. So he remains in the surveying office. Felix and the children send a thousand greetings, and I close in haste.

Your—Maria

Corpus Christi, December 11, 1857

Cordially loved Parents,

I still ride horseback every day with Felix, Mr. Schübert, or our Mary, who rides as well as any woman, and often when she is riding with us in the field, she has Julia before her. My horse is the darling of all, and one can sit on it as calmly as on a sofa, scarcely feeling any movement even it goes fast. You will certainly have read already of the great calamities in New York, and God knows whether, as a land agent, Felix too will be stranded with more than $600 of a $1,100 contract still to be received from his client.[85] Since September neither money nor letter has arrived from the man, despite all communications from Felix. This would be a hard loss for us, as my husband has no more assignments for a long time. For the businesses in Corpus Christi are still the same: nothing, nothing at all to do and no money! Raw hides that used to bring 15–17 cents a pound in cash now bring at best 8 cents in credit, which is tough for the stockmen and rancheros. However, two big schooners have already come into Corpus Christi by the dredged canal, and there is now a direct passage between here and every other harbor, whereby greater traffic can be expected. One ship has twice taken horses as cargo to be sold at enormous prices in New Orleans, making those here increase in value; horses that once cost $20 are now worth $40.

We still have not seen anything of our New York money, and our Christmas will not turn out very rich. Mary, or "Fat," to use her usual family pet name, is now an excellent and fearless rider. I should have liked to give her a nice saddle for Christmas, which Mr. Noessel had ordered from New Orleans for his 17-year-old daughter. Horse, riding habit, everything had been received, and now she does not have the courage, and so he will sell the saddle for $20. But I have no money to spare now. You must know that here no ladies' saddles can be had in the stores, and they are enormously dear.

With us everything is much the same; Felix goes his way and I go mine, with the children. For a year Uncle Schübert has been our evening companion almost daily and he is teaching Mary to read. Now seven years old,

Mary is only slightly smaller than I and nearly as tall. She is very diligent at reading. I demand very little from her mentally so that her health does not suffer at such rapid growth. Julia is small and the boy medium and, thanks be to God, well again and on his feet. He speaks extraordinarily well but only Spanish and is the pet in the house. Greet all relatives fondly from me! A fortnight or three weeks ago the mail steamer ran aground, again, at Galveston, and it may well be that our letters have been lost.

<div style="text-align: right">*Your—Maria*</div>

Fond kisses from the children and greetings from Felix!

<div style="text-align: right">Corpus Christi, March 27, 1858</div>

Dear Parents,

I send these few lines to let you know that at one o'clock in the morning on last Saturday, the 20th, my dear Maria was safely delivered of a healthy boy. The mail starts in a ½ hour and we have no time left to write. My wife and I join in sending you all our best love. More next time.

Love in friendship

<div style="text-align: right">*Felix A. Blücher*</div>

<div style="text-align: right">Corpus Christi, August 5, 1858, 10 P.M.</div>

Truly loved Parents,

At last then! This is how I hear you exclaiming, and you have every right. For five months have passed when I have not written to you. But having four children and no servants is enough to fill up days and nights so that there is scarcely time left for eating and drinking. We received your last letter of June 15 in the middle of July, and I was quite astonished that the arrival of my little Richard surprised you so much, as I wrote in September or so to tell you that at the end of March I was expecting an addition to the family. Perhaps this letter was lost. Although I have had a servant for only one month since January 1st and have been working in the kitchen and doing the washing at 90–106°, I can assure you that I am very fit and well. Our poor "Thick" or "Fat," Mary, is of course worse off, for all day long she must help, and her only recreation is that sometimes she goes riding on horseback. Nor have I given that up, and when I have a washerwoman I take a ride in the evening for a ½ hour. Otherwise I could not endure such uninterrupted work.

We had an extremely hot and windy summer with such ample rain in May that 20 more acres of corn were planted on our rancho. However, it has since been so enormously hot and dry that the harvest is doubtful. Times are still bad here and money is not to be found. No payment has yet arrived from New York. Felix started for Mexico on Saturday, and Mr. Wardwell (the New York debtor) was in Corpus Christi on Monday but at once departed that same night on hearing that my husband had documents and invoices delivered to an attorney to file suit against him here. But Mr. Wardwell rendered himself as invisible as possible, and it was only from me that Judge Neal heard he had been here. Money has been very short for us, and a fortnight before my delivery I had not yet procured anything for my little one. With joy—and with great sorrow—I accepted a proposal from Mrs. Meuly to buy my piano to have her eldest daughter instructed. I did not reflect on her offer long, for my piano was no longer of any use, and it brought me only $35 in cash and $15 in things from the store. I likewise sold the necklace I got for a wedding present, for $14. To have 30,000 acres of land and no money!! I have often told Felix he should teach us to eat grass and send us out to pasture!

In spite of money being so short I got myself daguerreotyped twice and threw away much money, for the pictures are of no use whatever, and I will not send them to you. You will already have received Felix's portrait by now, I hope. It too is only mediocre, as the men have awfully poor equipment here.

After several years' absence and having divorced his wife, Colonel Kinney has arrived here on a visit, and in consequence of this there were big banquets and balls, in which of course I could not take part.[86] Felix is almost never at home and spends most of his time with the attorney Mr. Lovenskiold.[87] He eats and drinks there, works there, and everything. I no longer bother him about that, for I am sure it would be futile. I am feeling so exhausted that I shall cease. Farewell, give my most cordial love to all who can be greeted, and do soon write to your

Maria

P.S. The children send a thousand greetings and kisses and are happy with their dolls. Charles has now become sturdy and strong and talks most delightfully. Richard is already teething and is the nicest of our children. The other day Felix, Uncle Schübert, and I rode to the bay on horseback and amused ourselves with a shark.

Corpus Christi, November 6, 1858

Cordially loved Parents,

We are all hale and hearty, thanks be to God, though Corpus Christi has been surrounded by yellow fever on every side. Fortunately, we have had severe northers since Nov. 1st, which might have interrupted the epidemic somewhat if New Orleans, Galveston, Indianola, and Brownsville had had them to the same degree. In Corpus Christi there has not been a single case of illness. No special troubles have prevented my writing, yet my work and the little ones require all my time. Mary is a tall girl and it's a shame to have to put her to work so young. Yet you can certainly understand that when she sees to the little one, I have more than enough to do with the time. Mr. Schübert remains her teacher. Every day that I can ever do without her, she goes there for reading. She learns with great difficulty, yet she is skillful at writing. Julia learns through play and is as sharp as a tack.

Christmas will soon come, and God knows what it will bring us. For I cannot make anything for the children, nor have I money left over to buy a thing. Felix has had rather a lot of work, but the payments are all still pending. We have had such a terrible drought that our cattle are again suffering for want of food and water, and a good rain would be a great blessing. Now and then I still ride horseback. And that is all the recreation I have, for Felix has sold the carriage.

[November 17] The other day while writing I was interrupted by the little one, and only this evening could I return to it. For a full two months now I have had a very bad finger. Despite this I have had to do all the work, but with weeping and gnashing of teeth. One evening I just tumbled down senseless with pain, and two nights after that my arm and hand swelled up so much that at 2 o'clock in the morning Felix was forced to cut off my wedding ring. With poultices of cactus leaves and cauterization of the infected flesh, the finger has now healed up again. For two months I had an open wound! Now, after nearly three months, it is only stiff and painful.

The children are feeling very sad that there will not be a crate this year. But it can't be helped; the bad years are generally very bad. Felix and the children are sleeping around me, and I think I must also get some rest, for I don't usually manage much. It is very cold, by the way. Since Nov. 1st we have had severe cold.

Let me hear from you soon and tell me about all dear friends and

relatives. The girls are captivated by playing forget-me-not, would love to have the chance to learn to draw, and are eager for a little package from Berlin. Once more greet relatives and acquaintances a thousand times and soon write to your

Maria

I had the bad luck to lose one of the fine new cambric handkerchiefs, which has afflicted me very, very much.

Corpus Christi, February 20, 1859

Dear beloved Parents,

Happy New Year! I received your dear letter dated January 4. Just as with you, in our family nothing much has happened except Christmas. As always, we celebrated Christmas as best we could. Uncle Schübert and Uncle Büsse were with us. The old Christmas tree was decorated again, the dolls that were in the last crate were dressed up again, each child received a trifle as a present, and that was all. Felix and I, too, had Christmas gifts this time. Felix received from all of us a wonderful silver bridle, between $20 and $30 in value, and I was presented with baked nut macaroons, on which we all feasted. Then we had our roast turkey for supper as always, and that was all. Thanks be to God we are all well, and that is the main thing.

Winter has so far been extraordinarily mild here, and we have needed fires indoors only a few times. Everything is already green here and the vegetables available are those we get in May and June in Germany. But very often the cold comes later and does much damage. Felix is almost always away from home, and despite that he can scarcely earn what we need, as there is little money around and he must most often take land as payment. In Corpus Christi there is no longer any work for him, and I think he does best going to Brownsville, where there is much business traffic and money. I shall not go there, at any rate, for yellow fever rages there every year worse than in New Orleans. Corpus Christi is a blessed place in that respect. Yellow fever ravaged communities all around us last fall: Indianola, Galveston, New Orleans, and on the Rio Grande, and here no person has fallen ill. We have not heard anything from Felix's parents for ages, and we do not even know whether they are in Berlin or not.

On our rancho, Müller will sow corn or perhaps has already done so. Pray God that we make a crop. Our cows continue to increase, and their milk

greatly bolsters our household income. How much a household here costs one can scarcely imagine. I have calculated that with four children, if we eat only meat, which is very cheap here, with coffee, tea, sugar, candles, soap, bread, and butter, I need 95 or 97 cents a day, which is $1 minus 5 cents. Now add clothes, shoes, corn for hens and horses, and the expensive wages if you have help, and you may well imagine that if business is not good, we will have no rich haul. My horse has had colic, and I have sent it to the rancho for a while so that it may have better pasture. Mary and I thus lose our only pleasure, which is all the harder as the boys make the house a complete hell, the big one (Charles) with willfulness and rage and the little one (Richard) by screaming. I do not believe that in the whole world there are three such children as Richard. Often I think he is not a human creature at all but a Satan. The other day old Büsse said if a snake bit Richard, the snake would die, as it would not be as poisonous. Now imagine all that work and no time without a crying child on your lap or arm; no night without being awakened 5–10 times, often to sit up the whole night with him. He is by no means ill or weakly, however; on the contrary. He runs about everywhere, dashes up and down stairs like the others, but is continually in a bad mood. I use a horsehair cord on the big one, Charles, which breaks the skin and draws blood at a hard blow. But even this scarcely tames him!

I can indeed say that because of the children I should like to live in Berlin, as here their education is being totally neglected, and I cannot redress this evil in the least myself. Now, finally, there is a very good lady music teacher here. If "Fat" were a little more advanced in her schooling and I still had my piano, I should certainly get her taught to play the piano. For I should exchange the pleasure I have had in playing the piano for no other. And I should also like her to learn drawing, which in my opinion is a really feminine and interesting pursuit. I instruct them in needlework myself, and the two girls already know how to quilt and hem very nicely. You have asked about the news of the Indians in Texas and said you were very alarmed. But I must tell you that I had not heard of it before your letter, and upon closer investigation I learned that Indian disturbances had taken place 900–1,000 miles from here.[88]

Now I come to a very important point in my letter, namely your kind offer to send us things again. As I have been so overwrought with the continual bawling of the little monster, I forgot what I wanted to request. Now, after four hours of wrestling with the little one, I have at last succeeded in getting him to sleep, and I will use these quiet moments, though my eyelids are also drooping. I accept with great joy your invitation to send us the things we

hope for, hesitating only for fear that all this will be a nuisance and a burden to you. Thus, I shall note on a separate sheet what I mainly lack, and the list is not short. You may then choose what is convenient to send.

I am really very glad not to be present when you, dear Father, receive my "little" wish list. You will crown your kindness by sending something for Uncle Schübert, for he is so generous to us. He likes my husband and has great affection for the children. And please get an ordinary chess board for Uncle Büsse, who also does many a thing for me. And I can never do anything for them.

Fond farewells, and greet all friends a thousand times.

Maria

Corpus Christi, August 22, 1859

Dear beloved Parents,

I have unfortunately not been able to get letters to Berlin regularly this year. I received your dear letter of May 18 in the middle of June, and I should have liked to answer at once but was prevented from doing so by another very sore finger. Of course so much work is left undone when I am ill that once I improve, my hands are really full, especially as I take care of the washing and ironing myself. It is hard work. But I now prefer doing that myself than having lazy Mexicans in the house with half a dozen of their dirty children, and then still having to pay $1 a day besides.

The happy prospect of a crate keeps us all in joyful expectation, as you may well imagine, and I only hope and wish with all my heart that we soon shall get news of it. You have again gone to great expenses and have favored all of us so amply, and my letter must have appeared to you rather insolent.

Felix has given up his office in Corpus Christi and is now surveyor at Brownsville, a worse nest of yellow fever than Galveston or New Orleans, and there he lives all the year round. Felix is not afraid of yellow fever, because he has had it. On Thursday the 18th he left to move his office there. In that district he expects to have much to do, as for several years there has been no surveyor there. Here anyone who does not have the capital to open a store or keep cattle must take some civic office, which keeps many men away from home for months. But for Felix, staying away has become habitual. I am more quiet and content when Felix is away and I am alone with my children. For when Felix is at home, he is ill-tempered most days, saying I must not bother him and complaining that the children give me so

much work and trouble. And this makes matters no better but only more disagreeable; we can never have meals at a predictable time, etc. I have already become accustomed to managing the household independently. Uncle Büsse and Uncle Schübert are my factotums.

The children now go to Sunday school. Here Sundays are kept so strictly that many people do not even buy a loaf of bread. Especially the Irish. School is from 8:30 to 11 o'clock and then the sermon runs until 12:30. How the children stand that in the heat I really do not know. This much, however, is certain—they very much enjoy going there and have already made good progress in reading. The heat has been insupportable here this year, and in recent days it has been 106° in the shade, which you must agree is an impressive and almost intolerable heat. The corn crop, on the whole, has not turned out as well this year as we initially expected. The rain has again been late and scanty. However, the farmers are now growing a significant amount of cotton here, and cotton of excellent quality.

Here things chug on in the old way. Since we parted with the piano, we are short on lively entertainment, and you might consider favoring me with a barrel organ. That way we can all have music with no need to learn how to play it! After school the children sit around so drearily on Sunday afternoon. "Fat" then rides in the evening while the little ones lounge about. And I regret not having thought sooner of asking you for some little society games, as the children might then stay out of the sun and amuse themselves quietly. A great joy I have had: Col. Kinney found our finest white cow after she had been gone two years, with a charming calf at her side. Some people at San Patricio had her and were milking her.

One thing I intend to procure for myself, and I am already saving for it, is a good sewing machine like a Wilson & Wheeler, acknowledged to be the best.[89] You probably remember the imitation diamond earrings and brooch that Papa gave me. These Don Pérez sold for $25 in Mexico, and I had sold them to him for $12, which I am holding as founding stock for the sewing machine. The $130 is quite a sum; but dollars saved here and there, now and then, are stacking up.

It is getting dark and I must end. Fare very, very well! And please do write to me soon. Greet all relatives a thousand times. As soon as I hear about the crate, I shall let you know it at once. For the present take our sincerest thanks.

Your loving Maria

P.S. Many kisses from the beasts!

Corpus Christi, November 20, evening, 1859

Cordially loved Parents,

What surprise and joy, what magnificent gifts you have bestowed on us! The crate arrived on Sunday afternoon the 6th, and I must try in vain to describe to you our happiness and that of the children, to whom only you can offer such bright days. I beg you to accept the sincerest and most deeply felt thanks from all of us and also to convey these to all relatives, friends, and acquaintances who had a share in sending it.

One affair dampened our joy to a degree, i.e., the disturbances at Brownsville. I do not know whether your newspapers report it. First, the occurrence in itself is very sad; and second, it totally disrupts our good prospects for this winter and leaves us worse off than ever. First the yellow fever quite upset all our calculations and now the insurrection. But let me keep to the point. A Mexican, but a Texas citizen, named Nepomuceno Cortina, of one of the richest and best educated families of Brownsville, has taken up with a band of good-for-nothings, and they attacked Brownsville to take private revenge upon persons who opposed him. But, as is usual in such cases, innocent victims fell, and the affair turned into a siege with all the consequent misery. Brownsville was almost deserted of people because of the fever. There were no troops. So the few inhabitants were abandoned. For three months already this sad drama has been playing out.

Cortina now has 500 men, has occupied all the entrances to Brownsville, and has opened all the mail and thereby interrupted every communication. From all the neighboring places volunteers have been summoned to help and have marched off; 20–30 set out from here. In our area they have taken the precaution of requiring every Mexican not resident here to declare and hand over any weapons.[90]

You can surely imagine how hopeless our prospects are. Here we are with 30,000 acres of fine land, goodness knows how many head of cattle, fine horses, etc., and we have not one dime in our pocket. Felix has advertised a great part of his land for sale. But who will buy it just when one has to sell? But do not be concerned over all this. We have already undergone very hard times quite often, and I only wish Felix had been able to save enough to buy me a good sewing machine. But it is not so, and I must do my best. I work without pause from morning to night: I wash, cook, scrub, boil up my own soap, make candles, churn butter when I have enough cows, make cheese, and mend and darn and tailor for the great and small of the family through thick and thin. And when I occasionally run to town every three or four

weeks to make necessary purchases, then I am a lady. Yesterday I washed and today I starched and ironed, etc., and it is already 11 o'clock, and I must at least finish this letter tonight. Let us still hope for a happy and cheerful meeting someday! Again farewell!

Your—Maria

4

Civil War

THE YEAR 1860 proved fortuitous for Maria von Blücher. Her husband found employment and success in Brownsville, which had rebounded economically from the Cortina revolt of the previous year.[1] Felix's surveys brought him a new client list of the most powerful entrepreneurs, merchants, and landowners in the Lower Rio Grande Valley: Charles Stillman, Henry Woodhouse, José San Román, Francisco Ytúrria, John Young, and a host of others became important connections.[2] Moreover, Felix cemented his friendship with the veteran steamboat operators Richard King and Mifflin Kenedy, whose Nueces County lands he had surveyed in 1853 and 1854. They advised him that in their opinion Corpus Christi would surpass Brownsville as a transportation center and that they would soon be investing large sums of money in the Nueces country.[3] And on December 5 at Galveston, Felix finally received a portion of his long disputed inheritance from his grandmother's estate.[4]

The amount of money was not specified, but it must have been substantial. For Felix immediately contracted for the building of a "new house," and he provided Maria and the children with Christmas gifts richer than ever before.[5] Even more important, Maria and Felix seem to have reconciled emotionally, and a son, George Anton, would be born October 3 the following year.[6] With the noise of carpenters working on her new home competing with the melodious notes of her "magnificent" new piano, Maria looked forward finally to continued prosperity and happiness. As she and Felix closed 1860 with a Christmas "never before celebrated as noisily," Maria had no reason to suppose that the way of life she chronicled to her parents would not continue.[7] Her radiant outlook, her familiar and now richly promising world, however,

would be swept away by "that great blast of ruin and destruction," the American Civil War.[8]

The Texas Secession Convention met in Austin on January 28, 1861, and voted to secede from the federal Union. When a secessionist ordinance was presented to the voters a few weeks later it was approved by a vote of 46,129 to 14,697. Nueces County voted for secession, 142 to 42.[9] Unlike many German Texans, Maria and Felix, who had close ties to the pro-secessionist establishment in Austin, aligned themselves politically and ideologically with the Confederacy. Indeed Maria, with minimal realism, became something of a local "fire-eater." She wrote to her parents: "We are justified in saying: God is with the South! . . . Maybe the North will totally break the South. . . . But make us submit voluntarily—never!"[10]

Felix entered Confederate military service as a major in the engineer corps, helping to design and build fortifications up and down the vast Texas coast.[11] Small fortifications were built at the approaches to harbors at Port Lavaca, Indianola, Matagorda Island, and nearby Harbor and Mustang islands. At Corpus Christi, embankments and earthworks were thrown up on the bluff and at the bay's edge. These bulwarks, though their flimsiness ought to have been cause for despair, actually inspired confidence. In the defenders' minds (and Maria's), the justice and invincibility of their cause would prevail. In fact, any battle would be decided by superior manpower and firepower. Ignorant of the destructive capacity of steam-driven warships fitted with rifled cannon, the defenders of Corpus Christi mounted a battery of two old smooth-bore cannon—an 18 pounder and a 12 pounder—and "gaily prepared for the coming conflict."[12]

Surprisingly, Corpus Christi was targeted by the Federals early in the war. Early on the morning of August 13, 1862, a bold and aggressive Union lieutenant, John W. Kittredge, came ashore under a flag of truce and demanded the town's surrender. Denied this, he announced that he would bombard the city and gave the Rebels forty-eight hours to evacuate women, children, and old people. At daylight on August 15 the Confederates ended the truce with a salvo; Felix von Blücher fired the first shot and successfully directed the subsequent fire that drove off the Union gun boats. Early the next morning Lieutenant Kittredge landed thirty-two sailors south of the Rebel fortifications and advanced on the defenders, which consisted of local volunteers under Felix and four companies of the Eighth Texas Infantry under Maj. Alfred M. Hobby, who easily repulsed the attack. Corpus Christi was proclaimed throughout the state as the "Vicksburg of Texas."[13]

Maria's letter of October 5, 1862, provides a vivid description of the evacuation and battle of Corpus Christi. Yet in spite of what the town's newspaper proclaimed as a "Great Victory!" Corpus Christi remained blockaded and vulnerable to Federal attack. And when Union forces returned in larger numbers in 1863, the citizens of the town, now faced with starvation, offered allegiance in exchange for food and protection. Corpus Christi remained "a divided and stricken city for the duration of the war."[14] Maria described her hometown as "abandoned by the friend and not yet taken by the enemy."[15]

Maria hung on desperately through the war. The Union blockade, a severe drought in 1863, and a frigid winter in 1864 brought almost total economic collapse and famine.[16] Maria's letters document in detail the suffering of the populace, as she chose to stay in Corpus Christi to protect her home and property from Union confiscation. Only with the aid of her parents and relatives in Germany, who managed to get supplies and money to her past military lines, did she persist. The war scattered her friends like chaff in the wind. She observed death and loss of property; her world simply "vanished."[17] She had to concentrate on staying alive ("I had to sell many of my things to get by") and protecting all of her and Felix's worldly estate for her children.[18] To that end, she rejected an offer from her father to pay for her family's return to Germany and likewise her husband's demand that she relocate with him to Mexico. Perhaps because of this, Felix abandoned her and remained in Confederate service, seeing extensive military action in the Lower Rio Grande Valley, as the Rebels under Rip Ford's legendary "Cavalry of the West" campaign redeemed Brownsville from Union control in 1864.[19] During his absence she gave birth to a daughter, Anna Elizabeth, on August 26, 1864, only to watch in horror as the baby died from dysentery "in cramps" on October 1, 1865.[20] And yet through this chaos, her letters also reveal a daily life she attempted to "make normal." She especially worried about her children's education: "I regard the time during which this war left our children deprived of all instruction as *irreparably lost*, and I *fear* it will influence them for the whole of their lives."[21]

Maria remained ideologically committed to the Confederate cause until the bitter end: "I believe that if ever the North is victorious, the last man from the South must have fallen. And of the immeasurable riches of this country nothing will remain but ruins and fallow fields useless for the white man. Lincoln has stamped his name with infamy through the Emancipation Declaration!"[22] As the Confederate Army on the Rio Grande melted away in May, 1865, Maria's aspirations withered, and she faced hopeless poverty. Neverthe-

less, she steadfastly refused to give up hope: "God has always cared for us so wonderfully that instead of losing heart I am feeling more and more encouraged . . . as by much experience I have come to the firm conclusion that the events seeming vexatious to us mostly turn out for the best."[23] Determined to save the Blücher lands and to remain at home, she managed to ration meager food and clothing supplies carefully among her family and friends ("I have known how it feels to have to maintain a family without having the means").[24]

With her modest wealth and southern institutions destroyed, and her needs so great, she had to open her home to occupying Union troops. Necessity probably drove her at first, but she came to see by early 1866 that the Yankees were not a gang of grave robbers dressed as soldiers. Indeed, she came to depend on a number of Union officers who settled in town after the war, while Felix, always the adventurer, crossed the border to join the French Imperial Army under General Tomás Mejía in Mexico's civil war.[25] For almost three years, from late 1863 to 1866, she rarely saw or heard from her husband, whose abandonment of his wife and family was virtually complete.[26] Moreover, Felix's war experiences apparently left him a broken man in health and spirit, and he returned to Corpus Christi in September of 1866 in the throes of alcoholism and depression.[27] It is clear from her letters that this time her marital relationship with Felix came to an end. As a decade of Reconstruction politics commenced in Corpus Christi, it would be the unending love of her parents and relatives in Germany, along with the help of loyal friends in town and two Union officers (one of whom became her son-in-law), that helped Maria rebuild home and hearth in South Texas.[28]

Corpus Christi, March 8, 1860

Cordially loved Parents,
On Saturday, March 3, I received your letter dated January 31, and I had already long been awaiting it. I sent a letter at the end of November, I guess, which must have arrived in your hands at Christmas or New Year's. It contained our thanks and details about the arrival of the crate. The gold dollars in it were untouched.

Felix has not yet been back. Tomorrow it is three months since he started off. Since January 5 I have not received any word from him, but I heard from someone that he is again at Brownsville. My dear Father, you are so ready to look after Felix's interests, yet I again beg you urgently, let the whole company there go to the devil; do not even spare them a glance. Felix's

portion of the inheritance from his grandmother amounts to 21,138½ thalers, according to Kill-Mar's letter, which sum has always been and remains in the hands not of Kill-Mar but of Herr Normann of the council of justice at Greisswald. And he must be content with that, even if they deprive him of the rest. Felix charged me with writing to Kill-Mar—if a letter should come from Hermann [Felix's brother] or him. But I do not wish to have anything, anything in the world, to do with them. What Felix will do I don't know, and I shall also probably not be the first to hear. For Lovenskiold is his advisor and administrator. Felix is infinitely generous, but too disorganized to draw profit from his property, and at the same time too indifferent about cultivating closeness with his family and making them happy. I should already have left long ago, had I had the means. For I really cannot regard myself as other than an administrator or landlord's agent for an absent master's property. If there is anything at hand, it is at my disposal; if there is nothing, Felix is the last to worry about it. Felix has immense quantities of the finest, most exquisite land, and if only we could eat grass, we would be well off. I am by no means unhappy under such independent conditions, and I believe on the contrary that they suit my character better than does dependency. Yet, confronted with having to live alone, I might have chosen a more sociable and more advantageous place for the children. I am thinking of taking on a young girl as a governess for the children and having them instructed in the basics. A female educated in the *seminary* here would probably not to be able to take them farther than that. The children have great desire and aptitude for drawing, and I beg you very much to procure the Berlin systematic school of drawing book No. 1, "Beginnings of Drawing," by Wilhelm Hermes.[29] I sometimes practice drawing with them.

Our "Fat" [Mary] rode horseback to Nuecestown the day before yesterday. Mrs. Littig came to see me on Tuesday morning with her sister, and in the evening they all rode back in the moonlight.[30] I don't think that females in Germany could risk riding twelve miles unmolested, while here you often see ladies riding quite alone on horseback or in a buggy. Uncle Schübert will drive up there with Julia in a buggy on Sunday to bring them home.[31] Mrs. Littig provides me with excellent butter.

Our winter has been like yours. We had cold and ice as never before, and now spring has come. All the gardens have been worked over, sown, and planted. Unfortunately, though, they are all deprived of their finest ornaments, the orange, peach, and oleander trees, etc., the unseasonable frost having killed every last one, and likewise the fig trees.

On February 1st I received $50 that Felix sent me from Brownsville, and a hen laid the first egg of this year at our place; and in the evening came the second of the big steamers that run continuously between here and Indianola, bringing each week 300–600 barrels of freight and never less than 15 strangers, last time bringing 23. Thus she keeps things lively enough here; if she can just persist, costing $30 a day to run.

I beg you, dear Mother, to see whether you can procure for me the book *The Doll* by Carl Müchler.[32] It is the nicest book for little girls that I ever saw. Finally, once more my sincerest thanks for the money that you sent for my benefit. Now farewell, greet all my old friends a thousand times. The children send many kisses and each a little wild flower. Write very soon to

<div align="right">*Your—Maria*</div>

<div align="right">Corpus Christi, May 26, 1860</div>

Cordially loved Parents,

Felix came back from Brownsville on March 10, and his first words were that now he would fulfill his promise to me and that I should travel home, especially as he would probably stay away from home this whole summer. I was very glad of it and the following day immediately began to get myself ready. Felix gathered information about the ships from Galveston to Bremen, and we received news that on April 10 the barque *Fortuna* would start. But it was already April 2. Felix at once went to Galveston to make the necessary arrangements, and he suspected that the *Fortuna* would not set out so soon. But she did sail on the 10th, and as she crossed the bar she collided with another ship, broke her masts, and suffered significant damage. She then returned to Galveston and reimbursed the passengers their passage.[33] Felix now says that no ship will start before the end of June or July, all of them to be loaded with cotton, and that in his opinion, arriving in Europe at that time of year they will get there might be dangerous for the children. Passing from summer here to fall in Berlin would not be advisable. Felix considered all the possible children's diseases and this largely induced him to put off the journey until next spring.

Felix wanted to send you full power of attorney and authority, dear Father, but I was decidedly against it. Kill-Mar is an old rascal, and the less one has to do with him the better. Felix has already been away from home again for more than a month, and I expect him back today. He has given me a great surprise to console me for my *nonjourney*. A fortnight after he went

back to Brownsville, a magnificent piano and first-class sewing machine arrived from Galveston; the former with wonderful sound and excellent workmanship; and the latter of the first and best kind and name: Wheeler & Wilson. The sewing machine cost $135 in Galveston, and when opened, the cover forms a surface for work basket, etc., and is richly adorned with rose bouquets, inlaid with mother of pearl. The piano cost $275 at Galveston from Kauffmann and Klaener. It was made by Julius Blüthner in Leipzig. Since the arrival of these things I have not yet seen Felix at all to tell him of my surprise. The sewing machine sews wonderfully from the finest cambric to the coarsest cloth. In just two hours I made a whole suit (trousers and jacket), with nine buttonholes and buttons made by hand. That it is a great, great help for me, you may easily imagine. In a Berlin newspaper I read of sewing machines that make buttonholes and that overcast seams. Such machines are not known here, and it would interest me greatly if you could send me a bit of cloth with such work. My machine has a seamer that overcasts the seam and stitches right on the edge, so that it looks much like hemming work.

Mr. Schübert gave me this view of Corpus Christi for you, taken in front of our house from the hill that rises from the foreground of the picture. Our house is of course not in it, as it was behind the camera. No. 1 is Belden's estate, which is situated directly between us and the bay, showing his home and warehouse. #2 is the City Hotel, which you can see with a magnifying glass, and you will also find #3, Meuly's home. #7 is California House and #8 the house of Dweyer, who went bankrupt and then bought a *hacienda* in Mexico with money obtained by swindling, and sent his wife and one child to Ireland for a visit; she left three children here. #9 is the home of the Catholic priest. The picture shows scarcely a 5th or 6th of Corpus Christi, and the pretty views are missing. On either side of the view are nice houses on the hill. Had he taken the picture from the wharf, he would have had a pleasing view. Perhaps I can send you a better one.[34]

You must excuse my poor writing, but I am always in such a hurry, and I write so rarely that my hand is quite unsteady. I can tell you nothing new. Things are much the same with us. The children are well and disappointed that nothing has come of their journey, as the idea of traveling by steamer charmed them. Our Richard is a most lovely boy, cheerful and boisterous and talking so well. I must confess that frankly I was afraid to undertake such a journey alone with the children, as I get so seasick, and who would then attend to the children?

We have not heard from Kill-Mar again, and I wish you would ignore him, for he is nothing but an old hypocrite. Nor have any of Felix's brothers or sisters written.

Just now I came from the cow pen. My fine white cow that was lost for so long has been bitten in her udder by a rattlesnake and looks appalling. I think you will find it right that I submitted to Felix's wishes to give up my journey for this year. For had I insisted upon it, he would have kept his word. But I thought if anything happened to one of the children, it would probably be regarded as my fault.

Now fare cordially well and write soon . . . to your

Maria

Many kisses from the children.

P.S. Mary has been away from home for eight days for the first time. She has been with Mary Littig, and Uncle Schübert and Julia brought her back in the buggy. My horse, on which Mary had ridden there, ran away from the Littigs' place and turned up at home a week later. Mary sometimes rides with Mr. Schübert to the Littigs on Sundays. There and back is 30 miles. You may imagine that she is not weak!

Corpus Christi, December 26, 1860

Cordially loved Parents,

Christmas has passed again, and never before was Christmas Eve celebrated as noisily as this year. Felix was here, fit and well, and Mr. Büsse was back in our midst. Thus it was a real festival for the children. In presents, too, they have never had as rich a haul as this year. Uncle Büsse made Charles a toolchest with a complete set of carpenter's tools, and he made Richard a boat, not a toy but a real one, which has already taken its maiden voyage on the pond. Büsse crafted both things finely and accurately. Uncle Schübert had a big drum for Charles and for Richard a big trumpet and other toys. The girls each received from him a fine brooch and from Uncle Büsse nice chenille shawls. From Papa they got two dresses each and many other trifles. I received a nice dress from Felix and a very nice clock from Uncle Schübert. On December 5 Felix was paid out some of his inheritance, and from Galveston he ordered me richer presents than I have ever been given. I got a very nice cut-glass table set, with six

bottles for vinegar, oil, etc., which are always on our table; English plates, a fine saddle, an extraordinarily good lamp, a silk umbrella, and a new kind of patented flat irons, in which the glowing coals are placed inside and the irons have a chimney and draft valve so that the iron maintains uniform heat for two hours, often longer; a fine cooking stove; and a new washing machine. So you can see that I did not come off badly.

In September all four of the children got the measles, which this year broke out with great violence, for the first time since I have been here. Had they caught the disease earlier, I should have been distraught. As it is, I am quite calm, though not without plenty of trouble and exertion. Yet it is not so severe in this climate. We had no doctor or medicine except an elixir with licorice, etc., and only lemonade to drink. Charles was worst off, for he got whooping cough as well and this meant suffering, of course. Richard has not had whooping cough at all. For Charles, though, after the measles receded, he quickly got rid of the whooping cough. The best means they have found here against it is to keep the children cool and bathe them with cold water. Applying warmth always made things worse except for linseed poultice fortified with tobacco and placed around the neck. I gave them nothing but mustard poultice, foot baths, and enemas. It is curious that none of the other children had it. From the bottom of my heart I am glad that you have all been well, for it is miserable to be dealing with patients.

I shall soon dismiss my Mexican girl. She has been with us since June but is still as just she was on the first day. She cannot even make a cup of coffee, nothing at all. As long as I supervise her closely, we manage; but if I should fall sick, it would be worse than having nobody.

Mr. Schübert is now in Mexico to make a deal for a major sheep purchase. He will now also move to our rancho, together with Müller. Sheep are the best business here, better than cattle.[35] Schübert has sheep, Müller breeding knowledge, and Felix land; each will take a third of the proceeds. Our Mary would well fit in at the rancho. She can milk and is not afraid of cows.

Please procure two first-class *saddle blankets* for a person to whom I owe much gratitude and who in the past year—when I was sick and Felix was gone for three months, leaving me with only 5 thalers at home—provided me with everything needed in the house without my ordering it. He is our baker, whose customer we have been these ten years and who brings us bread in the morning. Then I have a private affair concerning you, dear Mother. I will need another baby cap, a shawl, and little hat. I wish I were mistaken.

[127]

It is already 11 o'clock, and I close herewith. Fare very well and write very soon.

Your—Maria

With kindliest compliments! Yours faithfully,
Felix A. Blücher

Corpus Christi, February 19, 1861

Cordially loved Parents,

Texas, too, has now seceded from the United States, and people's opinions about the future of the southern states differ widely. Some think that they would form a more effective republic on their own and would establish direct commerce and traffic with Europe. Others fear war with Mexico, Indians, and excessive taxes. So far everything is as before.

I still beg you to ask Dr. Henschel what I can best do for a much swollen gland under the arm, which is painful and persistent and accompanied by a continual pain in my breast. The more pronounced the swelling of the gland, the more the pain in the breast diminished, and I now feel nothing but inconvenience when exerting the arm. Yet I should like to know whether I should use a dissolving ointment or what I can do.

You, dear Mother, wrote last time that you would like to come here. What indeed could please me more! But I know that such a journey would involve great discomforts and being deprived of the comfort that has become a habit for you. As regards health, I am convinced that you would feel very well here, for it is without doubt a healthy and agreeable climate. It is very difficult for me to write about this subject. For to summon you urgently is too risky, and to dissuade you against my heart's desires is very difficult for me.

Greet many times all my old friends. Fare cordially well and let me hear something from you soon.

Your loving—Maria

Corpus Christi, May 11, 1861

Cordially loved Parents,

On April 22 I received your letter, my dear Father. I did not answer sooner as I wanted to wait for Felix's return from Galveston, where he was at that time. On shipping a crate, we can only say that we must wait until we reach an understanding with Bremen. I can assure you that not the merest

difference can be observed *here*. I don't like what I hear of how things are at other places, like New Orleans, Charleston, etc. The Indians at once fell upon Texas again when the troops of the United States were withdrawn. They succeeded in slaying 23 people, among them Poly and her husband and child.[36] You will perhaps remember that Poly stayed at our house for several months last year with her baby daughter. But after that the Indians were defeated and driven back, with the loss of some lives and all horses and prisoners.[37]

Felix has received his money from Kauffman. He will try to set matters straight through Kill-Mar as far as possible. I am pleased that you had nothing to do with that at all, dear Father, for several more rounds will probably still be needed. Felix is now eagerly busy building the new house. And if only I could get a servant, I could not wish more comfort. The children are safe and sound, bungling through their learning. Felix brought along fine carpets and curtains, etc., from Galveston for the new house.

Greet all family and friends a thousand times from me and do not forget

Your—Maria

P.S. N.B. Write to me very soon, as it seems likely that in August a blockade will begin, and whether mail will get through is in question unless prior arrangements are be made to dispatch it from New Orleans.[38]

Corpus Christi, October 5, 1862

Dearly beloved Parents,

Best love to you all! I have not heard from you in eighteen months, and I doubt whether you ever received my last letter, which I sent in June last year. Thank God we are all hale and hearty, and my youngest son turned one year old the day before yesterday, October 3rd. He is walking and has four teeth and is the cutest and best, as the youngest always is.

War now has completely cut us off from all communication with the outer world. Gold and silver are things known only by name. We have nothing but paper money that is valid only in the Confederacy. Times are hard for all families. Clothing cannot be bought at all, except if anyone is fortunate enough to be able to send silver to Mexico to get some. Perhaps one person in a hundred is so lucky. There are no shoes at all, and it was good fortune that I had two hides of good leather from which I myself make shoes for our family. Mr. Büsse made me tools as good as possible. I have resolved to wear out all my dresses before giving $26 for plain white

calico to make dresses for myself and the girls. Calico now costs $1 a yard. The worst and toughest hardship is the lack of flour and corn. About a month ago the last flour came to $25 per 100 pounds. A bushel of cornmeal is $6; one pound of coffee, $1½. People might be willing to pay that if only they could get it. Felix bought himself a pair of shoes for $8 and a pound of soap for $1½.

Corpus Christi has been in a state of siege since June, with more than 700 men and soldiers in the place.[39] On August 15 we had Yankees visiting; there were 7 boats. On Tuesday the 12th in the evening, they came for the first time and anchored about 2 miles away but in front of the town, after having captured one of our boats and after our soldiers had burned 2 other boats to avoid allowing them to fall into the northerners' hands. The following morning Capt. Kittredge came ashore with a white flag and called for surrender of the town. As this was of course refused, he announced that bombardment of the town would commence in 24 hours. After negotiations he extended that time to 48 hours. Then you should have seen the migration of people! Felix was not in Corpus Christi and returned only on Thursday, whereupon I packed up some clothes in all haste. And on Friday morning at 3 o'clock Mr. Schübert came with 2 buggies, designed for 2 persons each, and took us to Nuecestown to Mrs. Littig's, where I stayed with the children for 14 days. From ¼ of a (German) mile from town and for 4–5 miles along the wayside, one saw one household after another loaded up. In one place there was a big mattress on the grass, and four most charming children were jumping around on it. In another place breakfast was set out on a neatly laid table and the family was sitting in rocking chairs as comfortably as at home. The only inconveniences were lack of water and the great expense of transporting things. That much aside, no one seemed to be making much of a fuss about the migration. On Saturday morning between 4 and 5 o'clock I was standing in the courtyard with Mrs. Littig when we heard the first booming of cannon, and thus it went on until sunset. A gunboat and 6 other boats fired on Corpus Christi with 32 and 24 pounders, using shells filled with sulfur and gunpowder and solid round balls or shrapnel shells with 24 small balls (about the size of a Borsdorf apple). They flew merrily over our house, into our field, and through our fence but did not do any harm at all. In our yard the children found a shell 13" long, a similar one 10" long weighing 26 pounds, and one of 24 pounds, 9" long, all of them unexploded; careful opening showed them to be filled with sulfur and powder, and one had a full 32-pound round ball. The greatest misfor-

tune was that the commander, a goods merchant chosen by his soldiers, was absolutely incapable and irresolute; despite having had three days to prepare, they had no battery and only two guns, 18 pounders. Felix and a young man, Bill Mann, volunteered to build a battery and defend the town. At first the good man did not want to permit even that. But as it was essential to do something, the permission was given, and a small battery was erected below the town close to the bay shore, which Felix, Bill Mann, and ten volunteers defended with the two cannons. Sunday was a day of rest, and on Monday before daybreak 30 Yankees landed with cannons to take the battery, attacking from the rear. They were protected by the guns on their boats; in spite of that, they were knocked back without achieving anything. In the afternoon Felix fired 30 shots, which holed the gunboat and put an end to the affair. The boats hastily withdrew, with the loss of *one* man on our side and one slightly wounded; a ball rolled from the deck of the battery onto the man's head. Fourteen days ago, Capt. Kittredge again ventured hither and then our men succeeded in capturing him with 8 men. He was escorted to San Antonio. General Bee was here from San Antonio, after everything was over of course, and brought guns, and horse-drawn artillery has also arrived. Felix was appointed major of the engineer corps by General Bee in order to erect the fortifications here. It has done most people good to emerge from the dreadful inactivity produced by the war. This double victory has filled everyone with new courage, and there is no thought of succumbing or giving up as long as any man can bear arms. All men from 18 to 35 years have already been called up, and they say that the next draft will go up to 45 years.

A great number of houses were shot through and through; two cows were killed, and a Newfoundland dog had its head torn off by flying shrapnel. People who were near the places where the shells exploded say bits of fence poles, etc., were driven into house walls with incredible force. Fortunately nothing was set on fire, though this had been the clear intent of using sulfur and gunpowder. The Yankees fired their shells across more than three English miles.[40] When the little one was born we hired a black woman, who proved extraordinarily good on this occasion, and I am sorry that I cannot reward her for it to some extent.[41] She remained in the house during the bombardment, and she watered and milked the cows and calves while the balls whizzed past her ears to right and left. She cooked for Felix's acquaintances during all the time that the wives were away, and fought with the soldiers who robbed all the houses. All the hens were killed except ours. I lost three cows, which were possibly killed; this, however, happened far away

from the town. I wish you could send me cobbler's awls and thread and cobbler's wax. Mr. Noessel scampered off with his family in good time and lives at Matamoros, Mexico. Mr. Schübert and Mr. Büsse are safe and sound and send greetings to you and their families.

We of course have never heard any more about the crates or what became of them. It was inexcusable that they went to New York. Father should have taken the advice given to him at the embassy for what it was: the advice of a fool who believed in the impossibility of a rebellion against the mighty North. One must not go to the enemy for good advice.

I must finish. The gentleman who takes this letter to Matamoros is waiting at the gate with the carriage. If you wish to try to write, you can send a letter to George Noessel, Matamoros, Mexico.

<div style="text-align: right">Your—Maria</div>

<div style="text-align: center">Corpus Christi, December 26, 1862</div>

Dear Parents,

A little more than two months ago I sent you a letter. Whether it ever reached your hands I shall hear with time. I then wrote in haste as the gentleman who was willing to take it to Matamoros for me had his carriage waiting at the gate. Yet you will have seen enough there to get an idea of how things are here. Taken together, everything has grown rather worse. The prices of provisions here have been driven to such heights as to sound fabulous. Lincoln's proclamation declaring all black people free after January 1st made it necessary to call up whoever is able to bear arms. All men from 18 to 50 years have now been drafted. Felix has been away from home these three months. He is at Port Lavaca in the engineer corps and it is difficult to say when he may be able to return. The natural consequence of all the men being soldiers is that no field is tilled, and soon neither flour nor corn will be for sale, and anyone who cannot live on meat must starve. At Brownsville, which is now the only port serving Texas for imports, you can no longer buy anything for paper, as they can no longer buy cotton for paper. So anyone who has no silver can absolutely no longer get anything. And had it not been possible for Mr. Schübert to go to Matamoros and bring us 195 pounds of flour and a little coffee, like many others we would have tasted no food other than beef for a month, as hens and turkeys are skinny for want of food as it is not possible to get them food. One bushel of corn now costs \$10–\$12, and Mr. Schübert says that farther inland a bushel of corn already costs \$20–

$25 (our corn or maize for you is Turkish wheat). A hundred pounds of flour costs $60; one pound of coffee, $2; one bottle of whiskey, $15. There is no [white] sugar, the last of it having been sold; brown sugar is $1½ a pound; a pair of shoes, $12; a pound of tobacco, $3½. Mr. Schübert bought Felix ten yards of blue checkered shirting, $40; every ready-made shirt, $20; a pair of black trousers, $40; a dozen eggs, $3; one pound of butter, $1½; one quart of syrup, $1¼; a quart of milk, 25 cents. Everything else is in proportion. You can well imagine that I do not buy nor have I bought any clothing; I stitch up all the old rags and keep the children as presentable as possible that way. My own linens are scarcely worth washing, yet getting new ones is very unlikely. Mr. Schübert has already sacrificed on our behalf $100 of the silver and gold he had, and now the question is what will become of us? He has debts outstanding, but no one can successfully be asked to repay money at present. We ourselves still owe $150 to the carpenter who built our house. But there is no silver to be had, unless one is trading in Mexico. The government pays in paper only. It was my intention to come to Europe with the children this spring; but it is most unlikely that I can get the money together. I offered my piano for sale for $250 in silver, and all our cows, but it is not possible now to think of converting anything into cash. All my hope turns to you then, dear Father, that you might be able to procure for us $100 or $200. I know that you have no business but only a certain income; whether this allows you such an expense I do not know. Thus I can only beg you to borrow such a sum for us, and the repayment will not be impossible as soon as this war concludes. At present I am not in a *desperate* situation that might move me to entreat you for it; rather it is my conviction that every week, perhaps every day, the shortages will increase, and the only hope is to have means in hand to buy food from Mexico. The French are now turning to Matamoros and that too might in turn worsen matters for us.[42] We have not yet heard about the crate, and you may well understand that its contents are now invaluable to me.

Today is Christmas Monday, but I need not tell you that Christmas passed unnoticed. The children each got a slate from Mr. Büsse as a present, and Uncle Schübert brought along gowns for the girls from Mexico. That settled it for our Christmas. It is not a shortage of food that renders every-thing so expensive but the speculation of the greedy money-grubbers. But they will find their comeuppance, then the rest will take heed. Mrs. Ohlers is at the head of these speculators in Corpus Christi. On the whole most people are willing to suffer to the last to win victory and independence.

The other day eight of our soldiers again took two boats from the Yankees in Corpus Christi Bay and killed three Yankees, who were buried here.[43] Captain Ireland and Captain Wilke were our leaders.[44] They were in a small boat reconnoitering Corpus Christi Pass. Realizing that they were being pursued by two launches (the Yankee blockade bark was near the mouth of the pass), they landed and lay in ambush until the 25 Yankees were near enough. Then they fired, killed three, wounded the officer, put the soldiers to flight, and then returned to Corpus Christi—all safe and sound —with the Yankee boats, three dead, and a great number of excellent arms and provisions. Capt. Wilke paid me a visit some time ago and told me that formerly I had been well acquainted with his sister, who is dead now, but who had sent him news in Austin at the time of our wedding. He is a school-fellow and classmate of Felix's. I cannot remember his sister and the only possibility is that we were together at the Griebens. Please ask Julius whether he can help me with recollecting this.

The Noessels have moved to Matamoros, as I told you in my first letter, and in case you did not receive it, let me repeat: address your letters to me c/o Mr. George Noessel, Matamoros, Mexico. When you write, I beg you to include one or two vials of variola vaccine if possible, as smallpox is always present in Mexico and now also among the soldiers. My two youngest boys, Richard and George, have not yet been vaccinated. If you can raise money for us dear Father, it will be possible to send it only via Matamoros, and I think it best by the German consul. Which of the two is the official consul I do not know, but the firm is Droage, Oettling and Co., located in Mata-moros.[45] I am concerned to provide for myself in time, for Schübert's silver is at an end and there is *no* chance to get silver now. Besides, I fear he will have to enter military service. Up to now he has been exempted by General Bee by virtue of his business "acumen." This new draft is by the governor of Texas, and it is very doubtful whether he will be exempted.

In Corpus Christi, as also in other places, they have held concerts, performances, etc. at the hospitals. At one I played the piano, and yesterday I received an invitation for another on Jan. 14. But as in the course of the last eight months I have played only perhaps three or four times, I shall probably not do so. On January 14, Mary will be turning 12 years old: she is already nearly as tall as I am but more vigorous and stronger than I was at 12. If only she would maintain better posture; I wish I could get her a brace with a plate at the back.

How are Julius and Anna, etc., etc.? You may well imagine that I am

anxious to hear of all relatives, special acquaintances, and friends, as almost two years have passed without my having received news from you. I hired the black woman for another year, for $15 and a garment a month, which is very cheap. Everyone must pay $25–$30, but she told her master she did not want to leave us and that she was content. Besides, her services are now invaluable for me. She is fearless, resolute, and stronger than many men I know; she also has a devilishly sharp tongue and natural common sense, too. I have seen her lift a cow by the horns and pull it out after it fell into a ditch in front of our house during the night and was quite unable to move. Alone, she drew it out and settled it in a comfortable place. The cow died nevertheless.

Greet all, all a thousand times from me and answer very soon. Farewell!

Your—Maria

Mr. Schübert and Mr. Büsse send you cordial greetings. From the children many thousand greetings and kisses. Excuse the bad writing; I am writing late in the evening, and my hand is quite unsteady from want of exercise.

Corpus Christi, July 10, 1863

Dear beloved Parents,

On May 4 I laid hands on your long-awaited letter, and the same day I received via Mr. Oettling $250 in gold, which came like a heaven-sent blessing as it enabled me to get provisions sent from Brownsville, the only place where provisions are in stock as it is situated on the Rio Grande and is three English miles (½ a German mile) from Matamoros and has imports constantly coming in from Mexico.[46] The only inconvenience is that one must use gold or silver, and Felix's pay is of course in Confederate money (paper), where $6 in paper is worth only $1. Felix has just been posted to Brownsville and in government carriages he at once sent me 200 pounds of flour, 50 pounds of coffee, 100 pounds of sugar, 30 pounds of starch, a little crate of dried apples, vinegar, candles, shoes, shirting, sole leather, one length of cotton, and one piece of colored skirting, so that I am now provisioned for some time. Mr. Oettling wrote to me that if I wanted to journey home, he was charged with covering the cost. Nothing could be better for us now than for me to be in Germany with the children, and I therefore at once wrote to Felix. He agreed completely. But the costs of such a journey for a large family are immense, so that only in the case of the most

dire emergency can I make use of your kind offer, my dear Father, especially as I have already received such a considerable sum. As soon as I am somehow able to do so, I shall indeed reimburse you. For if the war ends victorious for us, property in Texas will double in value. For the moment one cannot realize anything. At auctions made necessary by legal proceedings, things are given away at half price.

Felix's pay is $250 a month; but once reduced to real market value this is a little more than $40, which is not sufficient to cover the costs for him alone at Brownsville, where everything has climbed to enormous prices, as Mr. Oettling probably informed you. Washing a dozen items of linen costs $1½ or $9 in paper money. Everything else is commensurately high—a pair of shoes for the children, $3 silver; for Mary, $5; one pound of tea, $2½ in silver; one pound of coffee, $½ in silver; etc. If I should wish to travel to you, I should necessarily have to make preparations as regards linen, which is now not feasible.

Felix has been away from home one day short of nine months, and two hours before he arrived here from Brownsville, a steamer came from Matagorda bearing Col. Sulakowsky, a colonel in the engineer corps, who has taken Felix away ill to build forts at Aransas Pass, Corpus Christi Pass, and Paso Cavallo.[47] One day before he intended to travel home, Felix had an attack of yellow fever, which kept him at Brownsville a month longer. The journey here provoked a new attack, and on the second day after his arrival they took him to the steamer from his sick bed, in Mr. Schübert's buggy, because they have absolute confidence in his knowledge of the surroundings. His ambition is all that kept him going. God knows when he will now return. Since he became a soldier, he has lost 35 lb. of fat; I wish I had it for roasting. Two days before Felix's departure from Brownsville, on June 26, our crates arrived in Matamoros, and with God's help they will be here soon. The quartermaster, Major Russell, will transport them here in government wagons.[48] They should reach us from Brownsville in eight days. Felix might have waited for them, but sometimes it takes weeks before they can unload the ships, as such an enormous number lie off Matamoros.[49] Felix brought along $11,000 in government money destined for paying of his workers. Had it been me, I would have made them give me $2,000 in gold at Brownsville for the workers and would then have bolted and returned to Germany on the same ship. Perhaps it is good luck that the crates arrive only now, as we are in need of the things now more than at any other time. Mary, however, will probably scarcely find anything to fit her. She is almost

as tall as I am and as broad and heavier. The regimen people have in
Europe, shutting children into a schoolroom from their youth and totally
breaking their health, is unfortunate. When they are nine or ten years old
they will still learn as much. Mary has super stamina compared to the
others. In the morning at 4:30 A.M. she prepares the coffee while the black
woman is at the market, and sets up the dining room, and at 5:00 A.M. she is
in the cow pen, where each calf is her doll. Since Felix's arrival there are
horses here again; now she is completely happy. He gets government forage
for three horses, and his two clerks each get it for one horse, so that the
horses are all in good condition and they can ride on horseback as much as
they desire.

We are justified in saying: God is with the South! We have had such a
superabundant harvest this year that if it weren't for the speculators, every-
thing would become cheaper. I just bought green ears from this year's *second*
corn crop. Hundreds and hundreds of wagons laden with cotton are being
sent from Corpus Christi to Mexico, where they exchange it for provi-
sions.[50] And if I only had enough shoes and clothes for the children, I
should have no complaints. Mr. Schübert has stood by us and cared for us as
best he could. So has Mr. Büsse, although he is near rotting with dirt, etc.
Upon the arrival of your money I settled part of our debt to Mr. Schübert,
and I was very glad I could. Just now he brought me a case of vermicelli,
which is a good extra in our provisions. The children are all hale and hearty.
The little one is not yet talking; you do not even know his name, although I
thought I had told you. It is George Anton. His papa, too, had forgotten his
name, and the two do not yet know each other. Mr. Noessel is still living at
Matamoros, and we are in correspondence. Here in Corpus Christi nothing
of consequence has happened except that yesterday the Yankees burned two
ships laden with cotton at Mustang Island, a few miles from here.

Vicksburg has not yet been taken! Today the news arrived that New
Orleans was taken back by the C.S.A. soldiers![51] We hope it may be so.
Dear Father, my heartiest congratulations for your coming birthday. May
heaven permit you to enjoy many more, healthy and happy! This is what we
all wish with all our heart.

Maria

P.S. Mr. Taylor, Felix's clerk, today sold his worn boots for $55, three boxes
of blacking for $5, and one new hat for $15, which gives me the sum of $75
Confederate money.

Corpus Christi, October 29, 1863

Dear beloved Parents,
On July 12 I sent a letter to you through Mr. Oettling. It is doubtful whether you ever received it. Therefore, I announce the happy arrival of the crates. Words cannot convey the perfect happiness their contents brought after such extended waiting and deprivation of anything but the most basic needs. A thousand, thousand thanks to you and all the dears who have supplied us so amply. The things in the big crate are in excellent condition. The smaller one, however, showed some signs of dampness; but except for the orange blossoms, nothing had been spoiled, as even the plums were preserved as if freshly packed. I guess we can be very satisfied to find everything still in good order after so long a time. Once more, many heartfelt thanks for your great kindness.

The articles that enchanted all Corpus Christi were the dolls! I cannot describe to you the sensation these caused. On the afternoon of the first Sunday after their arrival, I had no fewer than eleven children crowding to hold "the babies" for a moment, and the children thank you from their innermost hearts for the great joy you have given them.

I must also tell you what the poor crates went through. On July the 26th they landed at Matamoros, and they were transported to Brownsville for shipment to Corpus Christi. Droage, Oettling and Co. have a managing clerk at Brownsville, who ships all D.O. & Co. goods from there. This young man committed the unforgivable blunder of sending our crates to Austin (220 miles from Corpus Christi) and sending us the things destined for Austin, which arrived here on August 24. I'll pass over the ghastly scene of bitter disappointment. Felix's clerk, Mr. Taylor, a very agreeable gentleman, offered to go to Brownsville to find out about our crates. He took a carriage and six mules and at Brownsville heard that they had gone to Herr von Biberstein in Austin. Mr. Taylor came back, hired an ambulance wagon, got two government mules, and Capt. King gave us two mules, and after three days he set off for Austin, where he arrived on the same day as the crates—which had been forwarded from Brownsville by ox wagon and had passed within five German miles of Corpus Christi. But all's well that ends well. We fortunately have them in hand. When Mr. Taylor drove into our courtyard, he shouted a loud "Hurrah for home!" and his hat came flying right over the mules and in among the children, where it remained undis-

turbed, for everyone's eyes were focused upon the crates. While they were being unpacked and all was a tumult of enchantment, Mr. Taylor came to me and said with deep emotion, "Madam, this is the happiest moment of my life. I never expect to see a happier one." I made him a present of one of Felix's pipes, and a saddle blanket, and for his willingness to expose himself to the inconveniences of these travels. To give you a better idea of Mr. Taylor, let me describe him: he is a little taller than Julius and somewhat fatter, and he has an imperturbable good humor![52] This blunder cost D.O. & Co. several hundred thalers (paper), but that cannot be helped.

Felix is now at Sabine Pass. But he has a boat for his own use in his position as major of engineers, he has already been here twice for several days, and I expect him any day as I informed him of the arrival of the crates. I cannot give you any news of the war. When 100 Yankees are killed, 1,000 fill their places. Yet I believe that if ever the North is victorious, the last man from the South must have fallen. And of the immeasurable riches of this country nothing will remain but ruins and fallow fields useless for the white man. Lincoln has stamped his name with infamy through the Emancipation Declaration! Felix has 500 black men under his command for the construction of fortifications; every 25 black men have their white overseer.[53] Our black woman is still with us, all gracious energy in running and ruling the household. I made her a present of colored fabric that many a lady here would be pleased to have. Having received all the fine things from your crates, I did not want to leave her empty-handed.

We get by through everyone giving a hand, especially the children. Mary gets up before daybreak, sees to the hens, then goes milking with the black woman when she returns from the market. Julia prepares the coffee, and when I come down and have washed and dressed the three boys, she gets everything ready for breakfast, fresh butter, etc. We wash, iron, dye, make soap, make indigo from a shrub (which is a curious procedure), and burn our own lime from shells. All this takes up a good deal of time. I give piano lessons to young girls; in exchange, their mothers help me with sewing as I do not wish to accept payment from them in cash (which no one has in any event). I indeed thank you from my innermost soul for having provided me with instruction in music, as it is not only a source of the greatest pleasure here but has also given me a certain superiority over the womenfolk, which is invaluable under the circumstances. For an American lady says: "No true lady must work!" As cultivation is their greatest and only concern, while I combine the useful with the agreeable and have always have felt and shown

an immense indifference toward their company, they do not rightly know what to make of me, and they think it best to treat me with respect and esteem, and the liberal gifts from your end contribute to enhancing this. For the American parents do not send anything, as far as I know, or feel the need to bring joy this way. Even a trousseau is a thing unknown.

I should like to keep you informed about the prices here for food and articles. But I must note in that regard that a sad but inevitable inconvenience has crept up on us as a result of Europe not recognizing the Confederacy, and this will lead to its ruin. This is the worthlessness of the paper money. One dollar ($1) in paper is now worth only 10 cents in silver. All goods come from Mexico; abroad our money is not even accepted. Everything hinges on hard currency! Whoever does not have it must pay 10, 20, up to 30 times the true value. You can well imagine what misery results from this as the soldiers receive their pay in paper money. The only way to get around this is to restrict our necessities. I regard the time when this war has left our children deprived of all instruction as *irreparably lost,* and I *fear* it will influence them for the whole of their lives. Charles is now nearly eight years old, and it is not possible for me to get him instructed anyhow, anywhere. Felix speaks of perhaps wanting to take me to Mexico, but I think as long as there is a chance of retaining our property it would be foolish to abandon it, as he and I have worked hard enough for it. Should the Yankees be victorious, his property would be confiscated. If this misfortune should come about, at least I cannot reproach myself over having lost it for the sake of my personal comfort.

Greet all brothers and sisters and aunts from me many, many times, and I wish all a richer Christmas than we shall have. Fare very well! Remember us and write soon. Give cordial good wishes to Felix's Aunt Rieben!

Your—Maria

N.B. Tell brother Julius if he wants to read a good book that will give him a precise understanding of the standpoint of North and South: *Planter's Northern Bride* by Caroline Lee Hentz.[54]

Corpus Christi, March 16, 1864

Fondly loved Parents,
At the end of February I received your letter written in September. You can imagine how glad I was to receive it, as I have not had any news from you

since May 3 last year, except that Mr. Oettling wrote to tell me that you, beloved Father, were willing to pay the passage for me and the family if I wished to return to Germany. How much we should have liked to answer this call had Felix not fallen ill in Brownsville and prevented it at that time!

Later I again packed things up and arranged for a carriage and everything necessary for the voyage, and then I changed my mind. First: Felix's resignation from the military was not accepted, and I should have had to undertake the tour to Mexico alone at a time when the routes were unsafe. Second: I should probably have had to wait several months in Mexico before I found a Bremen or Hamburg ship. Third: I did not wish to come without possessing at least some of my own means, even if few. The expenses of five or six children are not insignificant, as I know from experience, without even a cent being spent for their education. We have had a hard time here; I can truly say famine. But I am nevertheless under my own roof, and thanks to your kindness, I have many good things that I can sell by and by to survive. Acorn coffee without milk, moldy flour, and bacon are our daily fare.[55] To add to the calamities of war, we have had a drought such as I have never experienced, and cattle and sheep are dying of hunger in such masses that it is not difficult to count 10,000 a day on the Nueces River and in the creeks. The animals are so worn out that when they go to the water they get stuck fast in the swampy banks and slowly die there.[56] Such distress seems to surpass human understanding. But when need is greatest, God is nearest. I have found new friends in these hard times and kept old ones, so that I remain optimistic. Mr. Schübert is no longer with us. He thought he could boss us around, and one master is enough for me. Felix was sent away on Dec. 3, and I have not heard from him since. Phyllis (my black servant) is true to us in all distress. The worst is that when I packed up my things, I gave away a good deal that could very well have been useful to me, especially all the baby linen. But all in good time. If I can sell our house and otherwise keep going, I shall set out to you by the end of this year. I sent word to Mr. Oettling to ask whether you would be willing to send me another $100 so that at the time of my delivery in August I shall not be completely destitute. I am in anguish that once more I must beg for your help. But who is master of such conditions?!

I hope to send these lines you via New Orleans so that you may receive them more quickly. Your answer, please, send to *Oettling*. The Federals sometimes pay us a visit; but there is not yet communication between here and New Orleans or Brownsville. Open letters like this one are sometimes

expedited by the kindness of these *visitors* (Federal soldiers). As I have no political news to report and am content to hear from you and our family, I think our correspondence will not face obstructions. Everyone here has his sorrow, poor or rich, and I can indeed say that wherever I look, all conditions inside and outside our family teach me patience, resignation, and to be content with my own fate. All our children are healthy and unconcerned about bad times, thanks be to God, and Christmas itself did not pass without pleasures, even if quite small.

I have only a short time to write to you and must close so as not to miss this opportunity. For I cannot say when I may find another one. So farewell, write *very, very soon* and let me hear as much news as possible. One fact I will still mention. Mary is now 13 years old and is as tall as I. The children kiss and greet you a thousand times and are eagerly looking forward to the time when they can be united with you; and they never tire of hearing about the Treptow garden, of the flowers and fruit trees in it, which sound wondrous to them. For they never see fruit besides apples, oranges, and bruised peaches, except for canned fruit sent from the North, and even that has not been seen for the past three years. Delicate canned vegetables of that kind come to Matamoros from Germany, and I ate the finest asparagus and green peas, etc., at the farewell dinner party our friends gave when we were to depart for Germany (which we never did).

Once more fare cordially well, greet who ever may be greeted, especially Aunt Rieben, who seems never to forget us despite her great age. Remember with love

<div align="right">*Your—Maria v. Blücher*</div>

<div align="right">Corpus Christi, May 10, 1864</div>

Cordially loved Parents,

Thank God we are all well, and though I can no longer flash a single cent around, we do not lack the food we need, thanks be to God, except flour. We are now restricted to cornbread, and after the great cattle plague we only very seldom get meat, which is given to me at no charge. Schübert presented Julia with 10 lbs. of coffee, and I got 20 lbs. of sugar on Felix's account, so that I have not suffered want. Of course butter, milk, vegetables, etc., are luxury articles that we no longer know. Nevertheless God has always cared for us so wonderfully that instead of losing heart I am feeling more and more encouraged. I had to send Phyllis, my black woman, back to

her master, which has loaded me with an immense burden just now. Mary unfortunately feels the burden more than I, as she is vigorous and healthy, while I can no longer manage any work.

I wrote to Oettling inquiring whether he was willing to advance me $100 on Papa's account, which I wanted to use to get provisions sent to me. Last week I received the answer that he was not authorized to send me money and could do so only at your instruction, dear Father. As by much experience I have come to the firm conclusion that the events seeming vexatious to us mostly turn out for the best, I thought that this time too it was perhaps to better advantage, unless you are weary of supporting me continually, that you send me needed articles of clothing from Germany, as they can be bought there about *20 times* more cheaply than at Matamoros. As crates arrive each time that the Yankees pay us a visit, I guess the commanding officer would mount no obstacle to allowing any family to provide itself with needed articles of clothing. Please therefore send things via New Orleans, which might possibly be faster. Should any changes occur here as the months go by, I guess it would always be possible to communicate via Oettling.

On March 28, Felix was here for a few hours to fetch his last things and papers, and after that he seems to feel he has left his house forever. He had carriages with him and was resolved to take us along with him, but every house that is forsaken is totally demolished within two to three days, and I could not face throwing away all this to go off to an unknown destination.[57] For I cannot go to Europe until I have in hand at least some means of my own, which will be feasible as soon as I can manage a sale of what remains here. But that is impossible for the moment. I feel increasingly driven to go to Germany for the education of the children. They are all growing up without getting the learning they need; for I can give them so little instruction. My time is divided between too many essential chores. I had begun to give piano lessons again; for this I got our dresses made. But upon Phyllis's departure I had to give that up also. Mary plays a little but has had no instruction for months.

We have never before had a year as unfavorable as this. So far no rain has fallen to do us any good. In spite of the drought all has greened up, for nature cannot forget spring.

It is astonishing how my strength and energy have diminished in the last three years. Though I don't feel any pains, my vitality fades visibly. We have an excellent doctor here. He gives me no medicine at all or only very

seldom, because he thinks it may weaken me further. On his first visit he recognized the same problem that Dr. Henschel pronounced about me: enlargement of the blood vessels of the heart and nervous debility. He recommended the richest and at the same time lightest diet and perfect repose as the only means for me to feel well; I should not eat any meat but ample vegetables and *fruit*. Vegetables I have not tasted for several years, and fruit—we scarcely know the word here. Three years ago in Galveston Felix got me two dozen tin cans of green peas and asparagus, which came from Bremen and were excellent. These were the last vegetables set before for us. And how much repose can one have when one has to care for five children! We must depend entirely on ourselves. A black woman now costs $20 a month, and even if I had the means, I would not hire one under the present circumstances.

In these hard times I have met many persons quite agreeable to me. Among them Mrs. Ziegler is a cordially good woman of entirely unpretentious manners and always ready to be obliging to others. I quite truthfully say that without the Zieglers, I would have found it difficult to get by.[58] Though his political opinions do not quite agree with ours, it has never excited any animosity.

If you, dear Father, should decide that you can send me some things without privation for yourselves, I will specify on a separate sheet what I need most. Being now the caretaker, if not also not the supporter of the family, I am obliged to go out more than has been the case in the past fifteen years. Thus among all the other items detailed on sheets nos. one and two, I beg you to send me some new fashionable patterns.

I have made an intimate acquaintance in a young woman, 18 years old, named Mrs. Frost.[59] She has had the advantage of an excellent education and is diligent and skillful in embroidery, at which she is unsurpassed. Though they have three black women in her family, Mrs. Frost seems not to be idle for an hour. However, she has already had a sad experience in her life. Though only 18 years old, she was forsaken a year ago by her husband, who sides with the North and demanded that she sell her black women, go to the North with him, and face a very uncertain and surely miserable future. The three black women had been born and raised in Mrs. Frost's family and are much attached to her. She positively refused to sell them, and then one morning he had gone, disappeared overnight, set out secretly to Mexico. Out of the kindness of her heart she embroidered me a pair of white trousers for the little one, George, which are wonderfully pretty. My

Mary, though as tall as I, is still a complete child, and likes playing with dolls more than anything else. Mrs. Frost is now making Mary and Julia many nice clothes for their dolls, and for this they are devoted to her with all their hearts.

May 22: A long time has elapsed before my return to writing. In the meantime I received a letter from Felix. He is safe and sound but far away from home. He did not report news to me but just tried to encourage me, which he seems to feel is his duty. I only wish that God may let me live until conditions improve enough for me to sell this house or leave it in reliable hands. Yesterday I also received a letter from Oettling & Co., in which they declare with great regret that they are authorized to make me payment only in the special case of my coming there myself in order to go to Germany.

It occurs to me to mention that if you should be willing to buy the vegetables I begged for, you must not buy the Frankfort dried vegetables. For I have had those Frankfort vegetables, and they are like straw. The cooking and preserving are absolutely different. I am approaching this winter with great apprehension. For if it does not rain, there will be no crop. Nor have I firewood, and it is very doubtful that it will be possible for us to get away; for at present it is positively impossible. The roads are everywhere unsafe, and the only boats setting out are Yankee boats. Father will certainly know best how things are in wartime in small places that are abandoned by one's own side and not yet taken by the enemy.

Your—Maria

❧

Corpus Christi, June 5, 1864

Dearly loved Parents,

Just a few days ago I received your letter dated January 15, and I am sorry that it contained so little good news. First I must beg, beg you repeatedly, not to try the merest approach to Kill-Mar. It is absolutely superfluous and useless, and it is even most disagreeable to me that you showed him my letter. For when I write letters to you, I just follow my impulses of the moment with no thought that strangers might be reading them. As for depriving Felix of his inheritance, Kill-Mar will certainly have his story ready. And even though 400,000 thalers is a good sum, I would not degrade myself by seeking his friendship for a million. One does not miss what one has never had. The children have grown up in mediocre conditions and are

faring very well that way. I have never regarded having much money as good fortune in itself, but a moderate quantity of it is necessary for happiness. Once more I come with the urgent prayer: be reserved and proud toward Kill-Mar to the same degree that he is, and you will not expose yourself to any insult. Your many years' experience of life must absolutely have shown you that there are people who cannot understand decency and kindheartedness. A man whose education only extends to the intellect, leaving heart and soul untouched, is like a false diamond, brilliant and radiant enough but worthless. So enough with these men!!

A few days ago I dispatched a letter to you in which I once more beg you for many things. I have claimed your help and support so much that I do so again really hesitatingly and driven only by necessity. My apprehension that the want of good articles of food, especially vegetables and nourishing fare, might bring forth cases of illness in our family has already been confirmed. For twelve days I have had swollen feet from scurvy, and I now live entirely on: goat's milk in the morning; lemonade and water for beverages during the day; and salad for my midday meal—this diet prescribed by the doctor. Otherwise I feel well, except that the swelling is painful.

You write, dear Mother, that you ended the old year and celebrated the new at Julius's and emptied many a glass in toasts to our well-being, and ask whether we too spent a merry, happy festive season. You will know the answer if you have received any of my letters. But do not feel sad about that; through sorrows we find joys. The war that has broken out between Denmark and Holstein may affect your financial circumstances so that there may be no chance of your sending me things.[60] Greet all relatives and other friends; the children send you a thousand greetings!

Your—Maria

Corpus Christi, November 2, 1864

Fondly loved Parents,

In the middle of October I received your letter from July via Felix, who was at Brownsville, which is back in the hands of the Confederates. The letter was handed to him there, and he read with astonishment that you had again made the sacrifice of sending me $100, which I regret to say I have not received. Mr. Oettling is in Europe, and his representative here assured me that they had not received any word about it from you. So be so kind as to inquire after it. Felix himself spoke to Oettling's man at Matamoros, who

was not willing to consent to the payment, even after Felix had shown him your letter referring to it. Felix goes back to the Rio Grande again tomorrow after six days here.

On August 26 I had another little daughter, who amazingly was big and fat, weighing 11½ pounds at birth! Now at two months old she weighs 17 pounds. We christened her Anna Elizabeth, and she is a charming little doll. Here in Corpus Christi everything is rather as before, except that the Yankees have not been here for some months after initially paying us a visit every fourteen days from last Christmas Eve. We are all healthy, thanks be to God, and Felix has again tendered his resignation in order to do something for his family if he can, which he could not in the last year. As to Kill-Mar and Ida, I once more beg you to ignore them totally and let not anything move you to draw nearer to them.

In this year of 1864, I have known how it feels to have to maintain a family without having the means. Though I found many sympathetic friends, who assisted me by word and deed, yet I had to sell many of my things to get by; and even so I still got into debt, so that Felix needs to do plenty of earning before we can consider ourselves free again. I had to sell my fine green silk dress and the wonderfully fine table cloth you had sent me, and likewise many other things. The green dress was as fabulous as my wedding dress, and I struggled over parting with it. Yet what is gone is gone and it is no use feeling sad about it. One thing gives me comfort: so far we have all remained happy and healthy—though Felix has been in several fights and battles on the Rio Grande, he has so far remained unwounded—and my continuing to live here has meant that so far our house has not been damaged. For the Yankees have demolished and destroyed every house that has been abandoned. There were more houses than families, and consequently they were not all occupied.

After the terrible drought, as a result of which thousands and thousands of cattle died, we have had very favorable weather and superabundant crops in Texas, and there are now shortages only in stray places where there are no farms in the immediate vicinity. Blockaders, however, prevent the usual importation of goods, and we also feel the lack of carriages and horses. Corn is back to selling for $1 a bushel. And at the moment there is an immense want of bread and fruit here at Corpus Christi.

My children are growing up at quite a pace. Mary is still shorter than I am but only by an inch; Julie is of middling height. Charley and Richard have gone to school these past three months or rather have had private

instruction from a widow, who teaches her son along with mine. I do not want to send them to the public school because of the bad company. If I have not been able to do much for my children's education, I have nonetheless always been very particular as to their companionship, for which our living at a distance from the town is extraordinarily helpful.

Our little George is a most charming and gentle boy and would certainly become a great darling of yours. Last year my boys had tonsillitis, and I thank God that they got over it so well. As soon as winter comes, my fear of this terrible disease sets in.

It is *incredible* how the desire for pleasure overrides shortages, mortal peril, and everything else. The town ladies and Yankee officers continually arrange little dances, where all of them seem to entertain themselves tremendously. Mary and Julia attended the ball at the Ziegler's on the 26th. Mr. Schübert escorted them there. Because of the little ones I cannot go anywhere. The French have now so nearly taken possession of Mexico that it will be a great blessing for that beautiful country if the rebels are unsuccessful in stirring up another round of revolution. But law and order are not, of course, what Mexican ruffians of that kind appreciate.

Charley begs for a little violin. I wrote to you before saying that he wanted a musical instrument; now he has specified that it be a fiddle. Mary is the eldest, and of course the hardest work falls to her; Julia is no less willing but is weakly. And in appreciation of Mary's joyless youth, it is always very agreeable to me if I can procure any joy for her.

Felix is about to start out, and I must close. Now farewell, greet many thousand times all brothers and sisters, relatives and friends. Once more farewell!

Your—Maria

Corpus Christi, January 17, 1865

Dearly beloved Parents,

On December 13 I received your letter dated September and at the same time one from Oettling, in which he informed me that I could draw $100 at his establishment, which I did within one hour after receiving of the letter. Many, many thanks! I am really not able to survive without your help; for Felix does very little for his family and is always on the move. He has now resigned from the army and has accepted a very good situation in the cotton trade, where they pay him $100 a month and all traveling expenses. How-

ever, he has been away three months already and has not sent news for a
month. When I wrote telling you that Felix had left his house, none of us
believed that he might return so soon. For the Yankees had occupied the
town, and of course as a Confederate, he could not come here without being
taken prisoner. I remained here to save our house. Every house abandoned
by its owner was torn down by the Yankees. Now the Yankees have gone
away again, and our soldiers have taken possession again. And probably it
will remain so for some time yet. The Yankees burn and demolish whatever
human hands can destroy, and the Confederates, with few exceptions, have
nothing to lose but their lives. So of course all that is left to them is to fight
to the last.

The shortages are terrible. Paper money is no longer worth using for
anything except taxes. I cannot feed and clothe my family for less than $3 to
$4 a day. Thus you can imagine that it is not easy to survive. Along with
this, incredibly, people are happy and cheerful, holding a little dance
somewhere or having coffee and cake almost every evening, and everyone
puts up the best possible front.

What joy it caused among the children and for me as well when such a
fine Christmas gift arrived for us from all of you. I had not at all expected
that we might still receive money, as I did not and still do not wish to draw
on you too much. I must already thank you a thousandfold for your good-
will; be assured that you are the wellspring of much, much joy.

The 18th. During the day I am so busy and often have visitors, so that I
can write only late in the evening and at night, so you must excuse my
disorderly writing. Today I heard that Mr. Oettling's goods had reached the
mouth of the Rio Grande—14 days ago—so they are by now perhaps on
their way to Corpus Christi. This morning I also got news from Felix and
$100. Indeed, the children can't wait for the crate to arrive, for Christmas
turned out poorly. Mary is now as tall as I, and Julia has also shot up but is
smaller than Mary or Charles, who will also grow very tall and who is a
great help in the house when he is out of school. Richard is solid like his
Papa and always in good cheer. George and Anna are the darlings of the
whole family and both would be a very great pleasure for you. Anna is
nearly five months old and weighs twenty pounds and is without doubt the
fairest of the children. May God keep her hale and hearty.

I sent you two letters with the Yankees and you would therefore have
received them via New York or New Orleans. The provost marshal was a
Holsteiner and acquainted with Felix's family, and he forwarded these

letters for me. But thank God that the route to Brownsville is open again and the Yankees are away from here. *Here in Texas* they proceeded gently, by order, because some renegades had indicated that Texas was largely sympathetic to the North and would compromise with them. How they could believe that when many thousands of men from Texas have fought in other states is inexplicable to me. I guess I wrote to you last autumn about the fight near Brownsville, where the Confederates overcame 125 Yankees, all very well armed, with a small number of men under the command of Col. Ford and Felix and without so much as a cannon. Fifteen Yankees fled across the Rio Grande, 35 were taken prisoner, and the rest were killed, and they captured all their horses and arms, etc.[61] But the Confederates, now on their own home turf, are fighting a strictly defensive war.

It is near midnight and I will close. Give my warmest thanks to all who took part in the sending of this crate, and as soon as I hear anything about it I shall write. The children send many thousand greetings and wish with all their hearts to be able to embrace you. Farewell! Greet all those you can and write soon to

Your—Maria

P.S. An auction of confiscated property and goods took place here, using paper money. For your diversion I'll cite some prices: an *ordinary* chest of drawers, $5,000; three chairs of the meanest sort, $150; a lamp with a glass shade, $100; and a very old, ordinary bedstead, $1,500, etc.

Corpus Christi, March 11, 1865

Beloved Parents,
I have written to you twice already this year and have not received any news from you. I thought the letter describing the death of my beloved little Anna would reach you about Christmas, and I hoped to receive an answer by last month. Postal communication has become somewhat more regular though not completely reliable. I am now to the point where I will sell all our land and invest the money so that it offers me a secure income. Felix is in Mexico and intends never to come back to Texas, and it is his wish that we go elsewhere. Our first thought was of course to go to you. Whether that is appropriate for the future of the boys, however, I doubt. Here they can undertake anything and with minimal means can secure themselves an

independent position. In Germany it is very different. Felix and I have considered this carefully and have not been able to reach a conclusion about it. All of the children have been going to school these past six weeks, and they are farther in their studies than I expected. If I took them to Germany now, they would have to begin afresh, which would undoubtedly entail difficulties with the language. It really disturbs me that I cannot arrive at definite resolution. If I went to the North, our communication would be easy, but of course it is not as if we should see each other again, which indeed is my most anxious wish.

In your last letter, dear Mother, you write that I too will soon have to think of seeing my children go away. And indeed I have thought that if I went to Germany, my children would perhaps come back to America, and this idea has been underscored by the fact that Julia has received a proposal of marriage. Though this seems rather ridiculous at her age (now almost 12), nevertheless I must say that Julia has every advantage and is highly attractive to many with her natural, simple, and yet sensible ways. The gentleman who made this proposal is an officer of the Yankee troops. Through his correspondence and his reputation in the army, he has completely convinced me that I can trust him. He is no longer a young man exactly, at nearly thirty, and is in very good financial standing. The troops have all left Corpus Christi, and that has surely been the reason for his proposal. He did his utmost to persuade me to go to St. Paul, Minnesota, where his mother lives, and not to make my home elsewhere.[62] I wrote all of this to Felix, and he is leaving it entirely to me to choose my own place, as he does not intend to reunite with us soon as far as I can tell. His position in Mexico with the Imperial Army under Gen. Tomás Mejía is excellent, and he now draws a salary of $375 a month *in gold.* But his expenses are as enormous, and very rarely can he send me any of it. Therefore it is necessary that I try to secure us an income, any income, which will surely be safe invested in federal government bonds bringing 2 cents interest per dollar or 7%. It will be at least a whole month before I can say anything definite about the sale of our lands, as I must get all the necessary papers and titles.

I should like to know whether you resolved to send us a crate via Galveston. Shipping to Galveston is no longer a problem, but getting things here from there is often slow and tedious, though the distance is small enough for a steamer to cover in a day and a half. And the Yankee troops that were formerly here are now at Galveston; some of the officers

would certainly use their influence to get it forwarded as quickly as possible. For they seem to remember with pleasure the hours they spent in our house, and since they have been stationed at Galveston, we have been amply provided with books, illustrated newspapers, music, and fashion magazines. Should you not yet have packed up anything to send, I beg instantly not to forget it all.

You can certainly imagine what all I have to do now. The children are at school the whole day, and I must do all the work alone. As long as the Yankee troops were here, their visits took up a lot of our time. Nevertheless, being on friendly terms with all of them meant we were spared much unpleasantness, and our life seems very lonely now. Mr. Schübert we seldom see these days. He has a big store and is very well-off. The truth is that Schübert had his eye on Mary, but he discovered that she does not feel that way about him. He is over 40, so that was very foolish. Mary is tops at school and is devoted to her studies with her whole soul. I have the grave of my little Anna quite nearby, and every day we take her fresh flowers.

Farewell! Many thousand greetings to brothers and sisters, friends and relatives, and please send us some more photographs. The girls wish very much to write, but they have difficulties with the German language. All the children, however, send fond kisses.

Your—Maria

Corpus Christi, April 5, 1865

Dearly loved Parents,

On March 30 we received the crate with your rich gifts. The Saturday before that I got from Mr. Noessel your letter with your dear pictures enclosed. How I long to see you face to face! I feel like rushing back to you and would love to know whether this wish will ever be fulfilled. Sixteen years is a long time and alters people's appearance immensely, whatever their age.

Now to the crate! When each of us looked at our magnificent things, it really was a feast, the likes of which we have not enjoyed for a long time, and indeed words cannot properly convey our thanks. If only you could have been here to witness the great joy. I am sorry to say that it was not unbounded, for the chest had been opened at some stage, somewhere, and six towels, a pair of boots, a little knife, and all the sheet music had been stolen, to my great dismay. Today I wrote to Mr. Oettling to find out who directed the opening of the crates at Matamoros. All other items on the list are at

hand. I have a suspicion and shall eventually tell you about it. I beg you, dear Mother, to give our deepest and most sincere thanks to all who contributed to filling the crate and adding to its contents. The children's wishes have been fulfilled beyond all their expectations. In particular, the Confederate caps for the boys are marvelous, as their Papa had one just like that. George looks most charming in his. I can scarcely say which gives me more joy, having elegant dresses or graceful things for the house. Nothing is more pleasing to me than a nicely set table, sufficient food on it to eat, and delighted faces all around! And the beans from Anna were splendid; in the sixteen years I have been here I never had a finer vegetable meal, for I think beans here are never as juicy and tender because of the excessive heat. I cannot mention all the things in detail and how they have delighted us. Words cannot express our gratitude.

The sheets of tinfoil are by no means wasted on me; we are the only people here to possess tin. Felix bought me a little box of it once before. Think your way back two thousand years and you will get some idea of the dreary position of the poor South at present. But hope for better times keeps us all going; and, for God's sake, you must not believe what the northern newspapers print about the South. If all that were true, how could the war have *lasted four years already?* But they must try to destroy sympathy with the South to further their own interests. Perhaps the North will totally break the South, for there will be little left to subdue. But make us submit voluntarily—never!

The New Year's greeting cards are more beautiful every year, and though there is nothing similar here on New Year's, they know a similar pleasure on Valentine's Day, February 14, when people get up to some fun. Easter will be in a few days. For my children this is always a coveted feast. I have already put aside more than 60 eggs but not flour for Easter baking, I am sorry to say—there is nothing here but Turkish wheat (maize/corn). It would be an eye-opener for the children to see our Easter eggs in Berlin. Yesterday Felix sent me $100 and three pictures of himself with the news that in a few days I shall receive a barrel of flour, 100 pounds of fat, a case of candles, 100 pounds of sugar, and 100 pounds of coffee. Pray God that it arrives safely, then we shall have provisions for some time. It is very difficult for a husband to provide a large family with all that is needed, considering the actual prices now. There is no post office between here and Brownsville, and Captain Patrick, who will take my letters with him, starts in 1½ hours, and I must still take them to him. Therefore excuse my hasty and careless writing.

I should like to have a recipe for a medicine that will dissolve mucus, one that I can give to the children when they suffer from angina. George might have perished if Dr. Allen had not come in the right moment. I had already given him 20 grams of balsam, and he had not vomited. Dr. Allen told me that the remedy had not dealt with the mucus at all. After this he gave me a liquid that dissolved the mucus and then provoked violent vomiting. Dr. Allen was taken prisoner by the Yankees, and they left us without a doctor.[63]

To date your kindness and rich gifts have enabled me to maintain a modicum of respectability, which is also in my character, I hope. The girls and Charley often go to parties, and of course I prefer to see them dressed decently and simply rather than to evoke the laughter of the whole community, as some here do. Charley is nine years old and 4'5" high. Richard will be four years old in October. Good, high Wellington boots are a necessity here. In winter and also at present the boys often have to go barefoot to market and school because you cannot get to town from our house without crossing deep ditches, which cannot be crossed in shoes when there is wet weather. For the last two years the boys have not always had Wellingtons. Some years ago Mr. Büsse went to town; when he returned an hour later in a severe thunderstorm, the rain water was so high that it ran into his waistcoat pocket. Mary also needs a pair of men's boots, for she must milk the cows out in the open in rain, wind, or shine, and must gather the calves to feed them, and wet feet are not a good idea. She often wears Papa's boots when it is too wet. The high grass and weeds wet her through up to above the knees. Mary is my dairymaid and housemaid, and Julia is a housemaid as well. You should know that the upper room, my bedroom, stands out and has six windows like a lantern, and the war has left me without curtains, as I had to use them for swaddling clothes, pillowcases, and sheets. Charley has the misfortune to wet the bed at times. Felix has tried everything; punishment, cold water, going to bed without supper, etc., but it kept on happening until Dr. Allen told him he would just have to tolerate it, and it would in due course disappear on its own. Dr. Allen said it was not uncommon and it recurred like a disease among many in his practice. It occurs a short time after Charley lies down, but if picked up, he cannot pass water. An English doctor told Dr. Allen of a cure involving putting on little rubber rings that would eventually cure the problem.

I have not forgotten your Christmas presents, little trifles though they be, for giving yields as much pleasure as receiving, and it would fulfill my heart's dearest wish if I could reward you all better than by words and declarations

of my deepest affection. The morsels and presents I shall send another time. It is too late now.

<div align="right">*Your—Maria*</div>

<div align="center">❧</div>

<div align="right">Corpus Christi, January 2, 1866</div>

Dear Parents,

A happy New Year to you! I duly received your dear letter of September, and since then I have waited in vain for more news from you. Yesterday a steamer arrived from Galveston, and I will try to send these lines aboard her, as regular postal communication from here is not yet available. I guess you received my last letter in which I informed you of the death of my little darling. Mary and Julia have been ill for about three months and have spent a great part of that time in bed. Julia got the dysentery so badly that for three days the doctor held out no hope of her recovering. But with God's help and the assistance of an excellent doctor she got over it. A few days after that Mary went down with a fever accompanying an abdominal complaint. Now both of them have largely recovered, though Mary is still taking medicine. This incessant fever has sorely damaged her health. Through all this deep affliction I have received neither a single letter nor any support from Felix, though he has an excellent position as chief engineer at Matamoros with a salary of $306 a month in gold. For five or six months he has not sent me a cent! I have in hand an absolute power of attorney and authority over all our property, and if ever I can manage to do so, I shall sell our house and as much land as I can. And then I shall come to you when I have sufficient means.

I had to give up my little darling. With great grief I often thought that my dear Anna might have been saved had I had a good doctor or perhaps other medicines. But so many must give up their dear ones even where good doctors and all the rest are present. Dr. Britton, who was with Anna, soon followed her. He was only 28 years old and was married to the best and most amiable lady. They had a little son, two months younger than Anna. Mrs. Britton was about to visit her parents in Virginia. On the journey the little one fell ill at the same time that her husband did here. And both of them died on the same day, November 9th, and were buried at the same time; one in Corpus Christi, the other in Virginia. The doctor had overexerted himself during the illness of Otto Noessel, who died at the end of October, and he got brain fever, which swiftly ended his life.

<div align="center">[155]</div>

The Federal troops here have been ordered away, and Corpus Christi will be rather lonely with 2,000 fewer men. The steamer by which I send this letter is taking away the last three companies, and only two companies will remain here. We have gotten along very well with the officers, and upon closer acquaintance they have done all in their power to protect us from inconveniences and the incessant thefts. We had a guard in front of the house who was under rather strict orders. Yesterday evening there was a great farewell party in which I was *forced* to take part. My refusal was absolutely rejected. You must excuse me if my letter turns out jumbled, but throughout the morning we have had farewell visits, and I have been writing in between. I have begged Captain Forte to let me know whether Kauffman and Klaener still have a business in Galveston. If you have made preparations to send us a crate, it might best go there, though there is not much traffic between here and Galveston. As long as the 10th regiment stays there I can probably get it forwarded through one of the officers, and if you prefer to send me a money order I cannot get it paid here in full. Whatever you are perhaps able to procure for us, let it be of good quality and up to date, as people always expect us to have something extra special, and through your kindness and care I have always been able to be well dressed. *Many* things that I have noted down must of course be left out, and I principally beg you not to forget food, articles of clothing, dresses, hats, gloves, galoshes, etc. And should it not be too much trouble for you, a money order can easily be cashed in New York or New Orleans and now also Galveston.

My poor children had a sad Christmas and birthdays. They did not even get a pin's worth, as I have not been able to buy them the smallest trifle, though the stores are again filled with German toys and all kinds of things. My George so begged for a little drum, but I could not fulfill his wish. The troops are already marching aboard and I must close or my letter will not go. A thousand greetings and kisses from the children. Give my love to all brothers and sisters, friends and relatives. From

Your—Maria

❧

Corpus Christi, January 26, 1866, at night

Dearly beloved Parents,

A steamer came in after sunset and sets out again tomorrow morning. I didn't want to pass up this favorable opportunity to send you an answer,

even if brief, to your letter of December 9. Above all I wish to reassure you about those unfounded apprehensions you had concerning the Federal troops. Certainly the black soldiers are a disagreeable addition.[64] Otherwise, when it comes to the officers, all have treated us with great respect. And as you will have seen from my last letter, there was even friendly intercourse. Throughout the day today we had visits from the officers, who are as sorry to leave us as we are to see them go. Tomorrow the steamer takes away the last two companies, and then everything will return to its old quiet. I greatly regret seeing Adjutant Stuart, Dr. Creagle, and Lieutenant Tiltson leave us, having been our daily visitors. The intercourse with people not born or educated in Texas makes clear the urgent necessity of giving my children a better education. I have made up my mind to quit this place and go to Germany; or, if my means are not sufficient, to the North, where the children will have good schooling. I guess we now have enough acquaintances among the Yankees not to be without assistance. Felix has sent me absolute authority to dispose of all our property. I think I would not be wise to realize all the land, as it would bring but a low price at present. I therefore wrote to Felix some time ago and am eagerly waiting for an answer and his opinion. Last week he sent me $300 but no letter. Captain Greer, the bearer of the money, told me that Felix was occupied day and night at Matamoros and indeed had no time for writing. You ask about how postal communications are faring. Up to now there has been the military mail, whereby some letters have arrived quickly. But how it will be from now on is difficult to say, because so far no arrangements have been made for civilian mail. Whatever you intend to send, I think it best to send it to Galveston. We now have several good friends there who will undoubtedly be helpful in the conveyance of the items. When we wish to leave here, considerable preparations will be needed. And our time is so limited—as we cannot get anyone to work for us washing, scrubbing, or sewing—that we have not yet made any of the almost endless preparations; especially so when we have often have had visitors, as has been the case daily in the last six months. Given the still outrageous prices of everything, I really think it foolishness to stay here longer, though the winter here has much to recommend it. We spent all of today on the terrace and indeed have not yet had five or six cool days so far this winter. Winter is all that I fear in another region. At any rate I wish that you might be able to get warm capes for the children.

Thanks be to God the children are now back on their feet, and I hope that they may remain so, as both the good doctors are now gone and there is

no good help nearby! We need many articles of new, good clothing in order not to be too old-fashioned. In this respect people are even worse here than in Berlin, and I can truly say we have never yet been so worse off than now. Since my darling Anna left me, I seem to be immune to pain and fatigue. I feel I have never been so healthy and vital. Three or four hours' sleep is all I need in twenty-four hours. This morning I went to bed at 4:00 o'clock, and it is now 1:00 o'clock and I am no more tired than when I got out of bed this morning. Greet all relatives, brothers and sisters and friends ten thousand times for me. Fare cordially well! The children are sleeping, otherwise they would send you many kisses.

<div align="right">*Your—Maria*</div>

<div align="right">Corpus Christi, July 1st, 1866</div>

Beloved Parents,

Two letters from you have already arrived here and I have not yet been able to write. Today, however, Sunday afternoon, I hope to remain undisturbed. You will of course wish to hear about the crate. It has been in Galveston since June 14, and we expect it any day. The barque *Jason* from Bremen has arrived. But the name of her captain is Thelen, and Papa wrote telling me his name was von Thülen; or have I misread it? The children are all wildly impatient to receive their presents. I thank you for the effort and great expense it causes you to manage my support and only wish you could be present when we unpack, which would repay you to some degree for all your trouble. I will not yet say a thing about the individual items, so that no misfortune befalls the crate such that we might not receive it at all.

In your last letter there was a Paris newspaper; it only confirms what I wrote to you (about the French in Mexico). Now, however, this joy has already dissipated, as Matamoros has been taken by the Liberal Party. Only 250 soldiers of the Imperial Army had remained there, and the Liberals attacked the town and took it at once.[65] Felix escaped back to Texas, where he is now at Brownsville. He has again been elected as surveyor there. Your opinion, dear Mother, is that I ought to be where Felix is. The thought is very natural, considering the situation in which you live in Germany. Here, however, it often is impossible and in many cases would be a great impediment for the husband and would cause enormous expenses under any circumstances. In the end, the Imperial troops there received no payment, and Felix has not sent me a cent since February 13, which indeed is very

hard for me. We have not yet been able to sell any of our property. So moving is precluded.

As to Julia, you absolutely misunderstood me. You mentioned that also perhaps I too might have to think of separating myself from my children, dear Mother, and I therefore wrote that this had been brought home to me *sooner* than I expected, and spoke about Lieutenant Stuart's *proposal*, but did not say at all that it was a settled affair. On the contrary, Stuart only wishes to correspond with *me* in order to remain in friendly intercourse with us, and he plans to renew his proposal after two years. Julia is 13 years old and does not think of marrying, neither Stuart nor anyone else. We regularly get letters from him, which are as interesting in composition as they are amicable.

You wish, dear Mother, that I should tell you more about the death of my beloved little Anna. She fell ill of dysentery on the night of September 25–26 [1865]. I applied such remedies as I thought would be of use and did not let up. But I saw no improvement and sent for the doctor, who gave her up from the first. She had lost too much liquid, and all her strength was spent. So she grew weaker and weaker. On the seventh day, Sunday October 1st, in the evening at 10 o'clock, she died in cramps. On October 2nd at 5 o'clock in the afternoon, she was buried in Mr. Büsse's garden. I can see her little grave from our front room, and it is well cared for by us all. I hope you received her little lock. She was the darling in our house, and there is nothing in it that does not remind us of her short existence and departure. I am not very demonstrative in my feelings, but I feel the loss no less despite that.

Julia is now playing the piano. I have had such bad luck with my piano. The frame holding the strings has broken right in the middle and has so distorted the sound produced by the keyboard that it is scarcely fit for playing. It is impossible to tune it. I should like to write a good epistle to Mr. Julius Blüthner of Leipzig if it was worth the postage. Felix bought it in 1860 at Galveston from Klaener, who had brought the pianos back from Germany for sale with the assurance that they had been built for this climate. There is nothing I miss more than my fine piano; for in its present state, it is distasteful to me. I so regret that there is no opportunity here to have Charley instructed in playing the violin; it seems to be his greatest wish. Charley, and the girls too, are eager to write you a few lines, but they cannot write German. And when they spell the words using the English grammar, the result is quite incomprehensible, and I cannot afford the time

to spell each word for them. The children cannot understand the German grammar books I have. A book similar to the Spanish one you sent me, on English and German (how to learn German), would be good. The children send you many, many greetings and thanks for the things we are expecting, to which I add mine for all those who have remembered us. Give my greetings to all brothers and sisters, friends and acquaintances ten thousand times, and write very, very soon . . . to your loving daughter

M. v. Blücher

P.S. I see a carriage coming with the crate! I must hurry to send this off so that we do not forget it in our joy. More soon.

Corpus Christi, August 25, 1866

Dear Parents,

The crate and its contents arrived here in fine condition, and it had not been opened at Galveston this time. Many, many thousand thanks for the nice things. The girls were frantic with joy over their fine things. They had not received any new garments since the receipt of the last crate, I don't think, except simple straw hats. It is impossible for me to praise every single item sufficiently, therefore I will not mention any in particular. I'll only tell you that you can scarcely imagine what a sensation the drum has caused here in the world of the young.

I can say that the things are now more welcome to me than 1,200 thalers at another time, as Felix seems to have given us up totally. In seven months he has not sent us a cent. There is no movement on the sale of our land, and you can well understand what miserable times we are going through. Schübert gives me flour, coffee, and sugar, on credit, and Büsse brings us meat. This is all we have had for seven months! Trying to get Felix onto the straight and narrow is useless, and all I can do is avoid leaving this house in order to save it for the children. Half of the property he cannot sell under any conditions. And as long as the family stays in this house, he may sell it fifty times, but nobody can take it from us. All of this is of course a great sorrow to me.

Now that the girls are so grown up as to be going to school, they must continually wash, iron, etc. And the boys of course should go to school, but I cannot raise the means. At the next session of the court I shall propose partition of the property and then see if I can do better for the children. I

expect that land prices will climb, as Corpus Christi has recently been made a port of entry, a port serving foreign ships, and of course a customs office will be opened here, which is a great advantage. A mail steamer, too, is now expected daily. And if I can just persevere until I can sell a piece of land at a good price and do what we have intended for ten years already, buy sheep, then I think I will have secured something for them. The important wool trade carried on from here is, I guess, the reason that the government is doing more for the place. Schübert has built himself a fine house. He himself attends to the businesses, and his partner lives at the sheep ranch, so that he makes double money. Mrs. Chapman, who formerly lived here, has grown rich by keeping sheep, going halves with somebody.[66] It would be so agreeable if we just had a pleasant house like our other friends, for now I am constantly in need and want. The girls are great favorites with all, and so of course we have visitors almost daily. The young ladies generally stay with us overnight, sometimes for a whole week. Though I can entertain them only poorly, they always seem to enjoy being with us. How grateful the children are to have been provided with good clothes again. For here people always dress up even when only going as far as the next house for an evening visit. Where all regard themselves as being of equal social position, only luxury can make a difference. To give you proof: General Davis presented his wife with a fan of heavy segments of mother-of-pearl, richly mounted and inlaid in gold, and ornamented with two diamonds.[67] At least the children are spared the humiliation of needing to hang back because of their garments. Next month there will be a great exposition here of the things the ladies are making for the benefit of the Presbyterian Church. All hands are diligent, and I only wish we had more time to take part in it.

The old black woman who worked for us for so long wishes to come back to me. She begged someone to tell me that she loves no one in all the world like us. If she should come, I shall perhaps not have the means to take her into service. This evening the young people will have a riding party and picnic in the moonshine. Mrs. Davis is the leader, as always. There are about six officers here, who are throwing this party for their paymaster, in celebration of his arrival yesterday bringing six months' back pay. Mr. Büsse yesterday received a letter from his sister, who gives a dreadful description of the cholera in Berlin. I hope it is not too terrible and that all of you come safely through the scare. Fear of cholera here began as early as the spring, when no one would usually have thought it a problem that soon. I have been waiting with great longing for a letter from you, for the issue of the

war in Germany seems to have the whole world holding its breath. And I too am curious about how things will work out.

Farewell and write *very soon.*

<div align="right">

Your—Maria

</div>

The children send a thousand kisses and greetings. Give my love to all those who still remember me.

<div align="right">

Your Maria

</div>

<div align="right">

Corpus Christi, October 4, 1866

</div>

Beloved Parents,

I received your dear letter of August and wanted to answer at once. But there is never any lack of interruptions to slow down my writing, especially as all the children are going to school again. They go to Hidalgo Seminary, an excellent school directed by the Catholic priest, Gannard, a Frenchman.[68] They are at lessons from 8 in the morning to 5 in the evening. Their studies are: English, Spanish, French, arithmetic, geography, history, writing, reading, drawing, etc. They all make excellent progress and are very eager to learn. Of course I have very little time for myself when I have to do all the work. The school instruction is so expensive here that if one does not have a good income, it is difficult to give a family the advantage of a good education. Yesterday I again had to pay $20½ for the coming month.

When you send another crate, Mary begs you to send her a wedding dress! One month ago Mary became engaged to Lieutenant James Downing of Boston.[69] I should have written sooner, but we wanted to wait for Felix's consent first. I had sent him a letter and he was here several days ago, and together with his consent he gave Mary the promise to do his utmost for her. There can be no thought of money or a dowry. Nor does Mr. D. expect that. Felix gave them a piece of land to settle on. Mr. D. intends to buy sheep and stay with us for several years. His parents were opposed to his staying in Texas and hoped he should come home after Nov. 1st. But as Mr. D.'s parents made up their minds to undertake a journey to England, whence they had come fifteen years before, they did not make any further objections. It seems peculiar to me not to be able to make any preparations for Mary. But it is out of the question, and Mr. D. will have to build and fit out the house as best he can. He has gone to Brazos and Brownsville to be paid off, and we expect him this week. He wanted to bring back a wedding

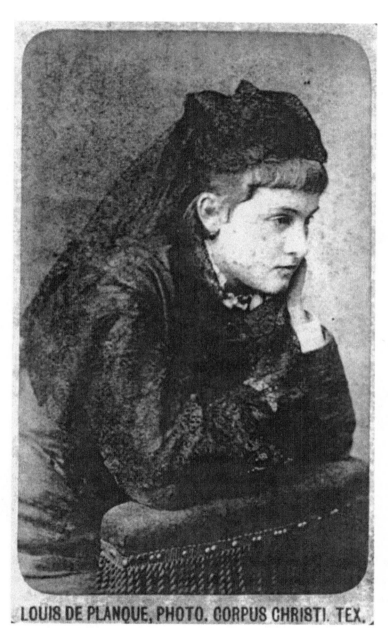

Maria (Mary) Felicia von Blücher. Charles F. H. von Blücher Family Papers, Special Collections and Archives, Mary and Jeff Bell Library, Texas A&M University–Corpus Christi.

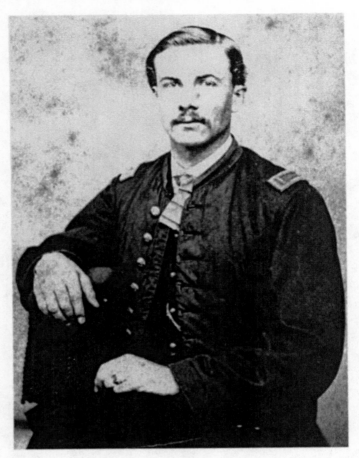

James Downing, ca. 1860s. Charles F. H. von Blücher Family Papers,
Special Collections and Archives, Mary and Jeff Bell Library,
Texas A&M University–Corpus Christi.

dress for Mary. But as I did not wish to allow that, I had to promise him to
write to you for it, so that may be here once all the rest of the arrangements
are complete. I will send more details later on. You will find it terrible that
she wants to marry so young, but I gave my consent in the conviction that
he will care for her better than her father ever did. Mary has told him that
she still wants to go to school for some time. He agrees that even after their
marriage she shall go to the seminary as long it suits her. Mr. D. is not a
handsome man but frank, plain, and very quiet in his nature. In this they are
equal. From the moment when he first saw her at a sailing party and was too

timid to say a single word to her, I guess he was resolved to win her. Since Mrs. Davis introduced him to us, he has never been away from our house for a single evening except when he was on duty. He is a man better educated in religion than any young man I knew in Germany. All my children attend Sunday school where the Bible is read and explained. On the whole there is much more done for the religious education of the youth in America than in Germany, though it does not always bring forth good fruit. Some weeks ago, Mr. D. received a certificate from Washington, D.C., in recognition of his service, conduct, and bravery during the war, and he has been promoted to brevet lieutenant. For seven months he was one of the unhappy prisoners at Andersonville, where 12,000 were starved to death. His stories of experiences there are so dreadful that I can no longer listen to them, especially when he is talking of the dying and the last hours of those unhappy men. His own health has been affected and sometimes—suddenly—he gets alarming fits. But he hopes that in time his strong constitution will overcome that. From nearly 200 lbs. his weight dropped to 95 lbs. in the seven months at Andersonville. He was sick for many months afterward. He jumped from a railway car while being transported at night and thus escaped. He now weighs 178 lbs. again. Mary is only half an inch shorter than I am, and he is more than six feet tall. If they fit as well in every other respect as in size, they have certainly been made for each other. On Dec. 4 he will be 24 years old. As far as my experience has shown in the four or five months of our acquaintance, he has a very good, extraordinarily calm disposition and is not egotistical. Selfishness is far from him, and that is a great blessing. We received a second proposition for Julia's hand from Lieutenant Tiltson, who is now in the North and must come to New Orleans on business affairs this winter and will pay us a visit on that occasion. He is one of the handsomest men I ever saw and is 2" taller than Mr. Downing and squarely built and strong. There is no need to feel sad about the possibility of her engagement to Mr. Stuart. If you knew Julia, you would know that she will not consider it. She is so independent in everything that nothing can influence her opinion, and she has a great fear of poverty to boot, so that she will be rather cautious in her choice, I hope.

Mrs. Headen, a very rich and amiable young lady, has a great interest in Mary and confessed to me that she had selected her for her own sister-in-law and that her brother's poor health had enjoined her to secrecy about it.[70] She was ready to write to New York at once for Mary's wedding dress and beg her cousins to select the accessories. She will be astonished when she

learns it will come from as far as Berlin! Her husband has now returned from New York and has brought her more than $200 worth of baby linen and a perambulator and cradle for their first child, born on September 11. I was with her for several days and nights, and we are indeed like two sisters, though she is fifteen years younger than I. Cornelia Moore, her youngest sister, is an intimate friend of Mary and Julia's.[71]

Winter is at the door, and I do not know how I shall get warm garments for the girls and myself, as I cannot make any time for sewing, and they themselves have to study throughout the evening to be prepared for school in the morning.

October 19th. On the same day that I intended to send off this letter, Mr. Downing returned from New Orleans. He did not spend an idle hour on his journey. He brought along his picture for us, two large photographs and many small ones. It gives me pleasure to have the opportunity to introduce him to you thus. In addition he brought each of the children a magnificent Bible, three big books of music and Tennyson's poems for me, and for Mary a precious, simple ring besides the Bible.[72] He is now with us in the house and will start tomorrow morning for Santa Gertrudis with Felix.[73]

It was my firm intention to write you a long letter, but Mr. Downing is already standing beside the saddled horse waiting for my letter. When I sat down to write, he begged me to give you a good description of him so that you might become as fond of him as we all are, and I am to tell you that "he will endeavor never to grieve any of us." I cannot give you the precise translation of his words, but that is as close as I can get. It is becoming difficult for me now to write German, and I am convinced that I express myself very clumsily. Yet I hope that you can understand me and can sense my close attachment to you, dear, beloved Parents.

Christmas will be upon us when you receive this, and I hope it will find you all healthy and happy, as I wish the same for us. It would be better yet if we could spend it together. Here, it will be a poor Christmas. Nevertheless, the children are looking forward to it with joy. Once more many greetings and kisses from *all* my children, my [*new*] *eldest* son included. And my most heartfelt congratulations for Father's past and your coming birthday, dearest Mother! Farewell!

Your—Maria

5

Reconstruction and Redemption: The 1870s

CORPUS CHRISTI, UNLIKE BROWNSVILLE and deep South Texas, realized no economic prosperity from the Civil War.[1] Occupied by Federal troops in 1864, ravaged by drought and unusually severe winters, and isolated from all other areas of the secessionist South by the Union naval blockade, the town lay prostrate at war's end.[2] The bleak postwar years brought even more chaos. Mexican brigands, Union renegades, unemployed Confederates, and freebooters from all over the world commenced a vicious guerrilla war against law and order. Posses of law-abiding citizens and minute companies, whose methods rivaled those of the bandits, exacerbated the anarchy. Highway robberies, murders, cattle raids, kidnappings, and general thievery set the Nueces country afire in a great burst of violence. It was not until July 1875, following Texas Ranger Captain Leander H. McNelly's legendary campaign, and Mexican President Sebastián Lerdo de Tejada's arrest of Juan N. Cortina, that the violence subsided.[3] Maria von Blücher nonchalantly described to her parents the brutal lawlessness: "Bloodshed is now so general here" that having "four or five murders a week is no longer striking. One grows accustomed to it all and ceases to get excited about events of this kind."[4]

Yet in spite of this reign of terror, the rankle of defeat in the Civil War and the rancor of Reconstruction were never as severe in Corpus Christi as in the rest of Texas.[5] Nearly half of the town's citizens had been Federal sympathizers, and a large number of Union officers had settled there after the war. Townsman

Edmund J. Davis, who in Federal blue had led the First Texas Union Cavalry, served as Reconstruction governor.[6] Corpus Christians generally were spared the corruption that marred other Reconstruction governments, partly because of the leadership of the former Union officers who became citizens. Several married into local families, including Lieutenant James Downing, who took Felix and Maria's eldest daughter Mary as his bride on November 16, 1867.[7] And on the heels of the occupying soldiers had come scores of merchants and tradesmen, who once again turned Corpus Christi into an economic frontier.[8]

Enterprising individuals quickly rebuilt the livestock industry, particularly in cattle, horses, sheep, and mules, and throughout the 1870s the town enjoyed a considerable wagon and ox cart trade in wool, hides, and skins. Prosperity and growth were ensured for the decade in 1874, when a channel allowing direct access to the Morgan Lines steamship routes was successfully dredged. And the "Car of Progress" arrived with the construction of the Corpus Christi, San Diego and Rio Grande Narrow Gauge Railroad, which would connect the town and port with the interior of South Texas, Laredo, and northern Mexico upon its completion in 1881. At last the natural geographic advantage of Corpus Christi's fine harbor could be exploited to garner the lucrative trade of Saltillo and Monterrey, which had previously gone to Matamoros and Brownsville via the Rio Grande. By 1880 population had built up to 3,257 and the town was finally progressing.[9]

Amazingly, Corpus Christi survived a series of natural disasters to achieve its growth during the late 1860s and 1870s. A hurricane, droughts, and yellow fever epidemics followed the ravages of the Civil War, taking a frightful toll and often paralyzing the town.[10] Yet despite being faced with great losses, townspeople continued to embrace the vast land of their environs and the mighty Gulf of Mexico before them. The land and the gulf had always had the potential to provide opportunity, security, dignity, and pleasure. It was this generation of Corpus Christians who would finally reap some of the fruits that for one reason or another had remained beyond the reach of their predecessors. Unfortunately, they could not conquer the old hatreds and mistrusts between Hispanic and Anglo: race relations in Corpus Christi remained tense throughout the 1870s, with little or no improvement in cultural understanding.[11]

Maria's letters from 1867 to 1879 document this pivotal period of transition in the history of Corpus Christi. At the start of this era, she was forty years old, healthy and able. She was sturdy. Moreover, she had achieved the status of full partner within her marriage, groomed by the war to do her husband's

duties as well as the always full load of domestic jobs. She was cook and house-keeper, nurse and tailor, trader and accountant. Indeed, the mantle of responsibility passed to her. She and Felix settled into a pattern of obligatory affection and indifference. His continued drinking and periodic abandonment gave her cause to scold him and preach homilies on the evil of alcohol. She came to conclude simply that "whiskey is the cause of all evil."[12]

During the late 1860s and throughout the 1870s Maria carved out an acceptable social role outside of marriage. To meet the endless worries over food and money, she took a job as a teacher, instructing students in music and languages (French, German, and Spanish). She also began playing the piano and organ at social functions and at the First Presbyterian Church. She became the delegate of the Blücher household, stepping into society again for the first time since prior to the war. She completed the job of raising her children, nursing them through various illnesses, seeing to their education and religious instruction, and guiding their development into adulthood. It is abundantly clear that she was a devoted mother and loved all her children equally, and they loved her.[13] They had supported one another through terrible times and could now look forward to the happier times that followed. How she rejoiced when daughter Mary married in 1867; when daughter Julia departed for Germany in 1869; and when sons Charles, Richard, and George began successful careers. Of her new life as the senior partner of the Blücher household she remarked: "I can really be thankful to see myself so independent."[14]

The Blüchers did partake of the general prosperity during the 1870s. In spite of his weakness for whiskey, Felix's many talents found success. His business concern, Felix A. Blücher & Co., Western Texas Land Agency, generated hefty profits—when he was sober and worked diligently.[15] He also apparently received another portion of his long-disputed inheritance.[16] Maria's independent income as a teacher now allowed a few modest luxuries: a new piano, sewing machine, washing machine, clothes and books, fine furniture, and improvements to the homestead.[17] Moreover, having invested for more than twenty-five years in land, and Maria having sacrificed greatly to preserve their holdings during the Civil War, the Blücher family finally saw their estate beginning to achieve lasting value. The building of the railroad adjacent to their land holdings increased their assets measurably. By the end of the decade, the family was free from "financial embarrassment."[18] Maria could finally look forward to a life without fear of losing "her children's property." She merely noted: "We lead quite an agreeable life."[19]

Redemption came for Maria in the summer of 1874. Early in June she boarded the steamship *Thuringia,* bound for Hamburg, Germany.[20] After twenty-five years, she was returning home to visit at last and to embrace once more her beloved parents, her daughter Julia, her brothers and sisters, relatives and friends. One can only imagine the emotions she must have felt, what she simply called the "excess of joy."[21] For ten months she was reunited with her loved ones—months of visiting and entertainment. What feelings must have been shared, what tales must have been told! The Old World still had a powerful hold on her, and she would later often contemplate returning for her last years. But her life, a life that she had built with Felix and her children, and mainly on her own, was no longer of course in Berlin. It was in the New World, in America, at Corpus Christi, Texas. Thus it was that in May, 1875, she once again bade her family farewell to return to the "thrill of a new country."[22]

Corpus Christi, January 4, 1867

Cordially loved Parents,

A happy New Year to you from all of us! Felix has now been at home again, and it seems he is earnestly endeavoring to compensate for his former negligence. But of course things progress only slowly. We live from hand to mouth. Nevertheless there are prospects that he will soon do better. The inhabitants of Corpus Christi have entreated him to accept the old office again. Mr. Büsse has not been able to fulfill his obligations in it. And if Felix succeeds in selling off his land, that would also help us a little.

I hope you received my last letter with Mr. Downing's picture. Mr. D. has remained at our house. Felix cautioned him against buying sheep in the fall, and in order not to waste his time, he undertook building houses. His father is a master mason in Boston, and he has learned the business. He carried out his work so well that he received some more commissions and will perhaps stick to this completely. He made $10 clear gain for each day of work. He sees of course how badly off we are. Mary has only three dresses besides the white ones. And as I have quite definitely declined his every offer of help, he insists very earnestly upon marrying in a few months so that he may care better for Mary. I don't think that they will stay long in Corpus Christi. Boston is too much on his mind, and every week he receives letters with invitations, etc., so that Mary also is by no means averse to going, though I tell her that she is not equipped to appear there. For I

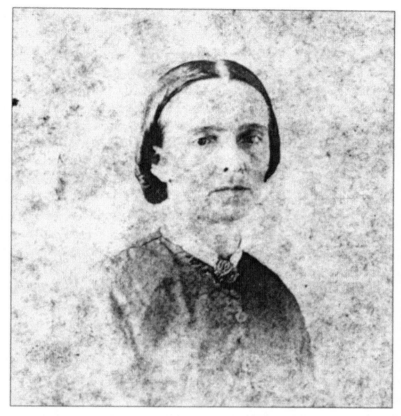

Maria Augusta Imme von Blücher, ca. 1860s. Charles F.H. von Blücher
Family Papers, Special Collections and Archives, Mary and Jeff Bell Library,
Texas A&M University–Corpus Christi.

give piano lessons to help clothe the children, and I cannot save anything for me, much less for her to procure her something. I promised her that I would beg you to send her a wedding dress and if possible another respectable dress, so that she does not leave our house in too miserable a state. Downing wished that the wedding be in May. But I told him that it would be impossible to get the dress here by then. If it is in the least troublesome to face such expenses on your income, please let me know as soon as possible so that I can see what other arrangement I can make for her.

We had a strange winter; no cold or disagreeable weather at all until the first of January, and then all of a sudden a strong north wind came, and within a few hours we had ½ a foot of snow on the ground. This weather

fortunately lasted only two days, and now it is warm enough again to have all the windows and doors open to let the warm air into the house. Many birds were frozen to death in the fierce weather, as were some men who were traveling a route where there is often no house for miles and miles. And the sheep and goats suffered greatly.

Lieutenant Wheeler and Lieutenant Downing prepared the Christmas tree for the children this year and gave them many nice gifts.[23] Mrs. Davis and Miss Peterson were with us on Christmas Eve, and the festival passed pleasantly but without further contributions from our side. How ardently I wish that I had a thousand thalers left; I should send Mary, Downing, and Julia to you for a short visit. Lieutenant D. often speaks of it having been his greatest wish for many years to visit Germany. But of course traveling costs money. Mr. Noessel and family are in Corpus Christi again. I hardly go out at all now as the days are very short and I give piano lessons in the afternoon.

We had a great fair—an exposition—that lasted three days, ending with a ball. It was to raise money to build a church. Then we had two concerts, the one to support enclosure of the churchyard and the other for a larger schoolhouse. They pressed me into service on these occasions, and I could not very well refuse. I have had to withdraw Mary and Julia from school again, but as soon as it is possible I will send them back there. Charley makes very good progress at school. Richard is not as zealous about learning and of course is much farther back. Julia practices diligently on the piano and is leaning toward teaching it. Therefore, at present I mainly want her to learn to play exercises. The eternal obstacle is that I cannot get them the sheet music they need so much in order to advance fast.

Mr. Downing has charged me with many cordial greetings for you, regretting that he cannot understand or write German so as to be able to send you some lines himself. After having begun this letter, I had to put it aside in order to give three piano lessons. Now in the evening, Felix, Mary, and Lieutenants Downing and Wheeler are playing whist, and I will try to finish it. The children are all well and send many, many greetings, as does Felix. Now fare very well! The last letter from you was dated August 18. You may imagine how many times I have sent to the post office in vain, and therefore do not make me so long again wait for an answer. Once more farewell!

Your—Maria

Monday 9th. I beg you earnestly to see to the money affair for me. Mr. Wheeler again paid a bill for us this morning, because Felix drank away the last money yesterday. You must know that he never brings money into the house. He keeps it in his office in town, buying things for us when he is in the mood, which is very rarely the case. Mr. Wheeler is a good, good friend; for I have no right to impose on him, as on Downing. Even so he is always willing to help us. He buys more garments for the children than does Felix. I am always a burden to you with money and things, but I have no other way.

Farewell! With love

Your—Maria

Corpus Christi, February 28, 1867

Cordially loved Parents,

We are all safe and sound and busy from morning to night, no longer going out at all. Mr. Downing bought a very nice place a short distance from our house, and they are hard at work there fencing it, etc. Felix got his old office back and is trying his best to get back on his feet. But it is more difficult than one might think, and we go on living poorly. I give some piano lessons, but these contribute little to meeting our expenses. Nevertheless I hope that we shall in due course regain our former circumstances, if Felix does not spend too much. I fear you were unpleasantly surprised by the contents of my last letter and the new demands made on you. But I have no prospect at all of procuring anything for Mary, and I do not know how we shall manage to pull together the wedding to good effect, as all of Felix's earnings have been used up by the family. Yet I will not lose heart. God's hand has led us through hard times and will also help us forward now, we hope.

With the exception of the snowfall, which lasted three days, we have had extraordinarily mild weather, and we are afraid that winter is perhaps yet to come. Here in the town very good photographs are taken now, and I should so much have liked to have the children photographed for you but cannot save the money. He demands $4 for ½ a dozen and $6 for one dozen pictures. If I can somehow arrange it, I shall have them taken, you may depend on it. This morning Felix began a survey for the canal that is to be dug so as to be able to bring big ships here. It is astonishing how the town is expanding. Everywhere there are new houses, and business is extraordinarily vigorous. Three steamers now run regularly between here and New Orleans. Hides, horn, wool, cotton, cattle for slaughter, and mules are exported from

here. The last steamer took 150 mules and 256 oxen to New Orleans. I mainly wanted to let you know that Corpus Christi now is a port of entry, so a crate can come here without being opened anywhere, which is a great advantage for us, especially as Felix is on friendly terms with the customs house officer, so that at least the duties would not be more than is right and proper.

Mr. Downing says I should send each of you a hearty kiss. He has just come back from a long ride. In a few hours he traveled 40 English miles. Mr. Downing's health is not very good, and I fear it will never again be completely sound. Mr. D. says you should come and see how happy he is with Mary: "like two crayfishes at high water" (as he puts it). I say you may see from this how foolish he is.

Tell brother Julius he might send Mary a wedding cake. Wouldn't everyone be thrilled to be served a wonderful tiered cake? Such a thing is viewed here as totally fantastic. And send me some baked pears in the crate. Now farewell! Greet all brothers and sisters, friends and relatives cordially. Many thousand kisses from all the children and me. Write very soon to your . . . loving daughter

—*Maria v. B.*

I do not have time to reread the letter. Excuse mistakes or words left out.

❧

Corpus Christi, May 26, 1867

Beloved Parents,
When Mary's wedding will take place we cannot yet say at all, as Felix has so little to do for the present military command that we scarcely have enough to eat, so for the moment I cannot think of getting even the least thing for Mary. Mr. Downing has put his capital into his business with Mr. Wheeler, and both of them suffered significant losses from a sudden storm. They have a brick yard and kiln on their land and had ordered from Michigan a machine that produces 2,000 bricks an hour, operated by four men and two horses. They had an immense kiln full and ready after two days of firing, when during the night before last a terrible thunderstorm burst. Their roof was partly destroyed, whereby they lost many thousands of bricks. And a mule that had cost them $100 ran away. The thunderstorm struck Schübert's house but only did some exterior damage. Then it tore the cross from the Catholic church. A ship was also struck by lightning, and one

more house, Mr. Cahill's, was struck. Last night a house was burned down in town. A young Yankee officer, retired, had been publishing a newspaper here for a short while, the *Union Record,* and of course he had many opponents; because of this they suspect that the house was set on fire. I should not wonder if it were so.

To come back to Mary's circumstances, they intend to build here close to us on our land, if they should remain here. On the plot of land they bought there is a good house, but it is very small and a good distance from the town. Downing must now make the trip four times a day. But as he has a good horse, he does not feel it unduly. Felix had promised Mary a plot of land because D. first intended to buy sheep. But Felix has dissuaded him from it, and so the land has no great value for them for now.

Dear Mother, I always read with great regret of your sufferings with your feet. That is a great affliction, and I fear that dealing with the crate disrupted your accustomed peace. And I certainly should not have made a demand of that kind unless I knew that it would be impossible for us to get Mary a reasonably respectable dress.

Accept all our united thanks for all your kindness and believe me that we should deem ourselves happy if ever we might return every favor. Downing and I often discuss the possibility that if we cannot come to Germany sooner, we shall come for your golden wedding anniversary. Three weeks ago there was examination at the Hidalgo Seminary, and Charley spoke very nicely, for the first time. He is very zealous and diligent at school. I received a letter from Lieutenant Stuart from Montana. He has had extraordinarily good earnings and is still secretary of the expedition. I hope you will not face war. A wealthy merchant in New York has bet $10,000 that in case of war the French would have Berlin by July 4. I hope he will lose his thousands.

Address my letters: Mrs. Maria A. v. Blücher, Corpus Christi, Texas. If you write Mrs. Felix A. B., the postmaster always sends them to Felix's office, which I do not like.

Farewell now! Many greetings to all friends and relatives and many kisses for yourselves. The children send a thousand greetings, Downing included.

Your loving—Maria

Corpus Christi, October 1867

Beloved Parents,

Though I wrote to you not long ago, I think it my duty to answer your last letter dated September 25 at once, as rumors of yellow fever have probably reached you, and however bad they may be they cannot be much exaggerated, as it has indeed ravaged the place terribly and is still producing desolation.[24] It has been indescribable. Our children returned at last two weeks ago, as we thought it had totally left this place—but found that this was not the case. Mr. Downing caught the fever last Tuesday, but we hope he is now out of all danger. The girls have grown during their stay at Mr. Gamble's. Mary is nearly one inch taller than I, and I fear her dress will almost be too short.

I accept your kind offer to send me $1,000 with many thousand thanks, my dear Father, if it does not prove too great a burden for you. For I would not want my comfort to cause you too great a sacrifice. By this means I should be able to send the children back to school, having had to withdraw them for lack of funds as well as of suitable clothing. They are delighted at the prospect of returning to school. Felix does not know anything about this. Some time ago Mr. Büsse told me that the United States had made an agreement with Prussia to issue payment on postal money orders, which is consoling, as the postmaster here would certainly have to pay out, and I believe one might receive compensation even if a letter were lost. I am so ill informed on financial matters that I cannot give you better advice on how to send it. Mr. Downing says that one way is as safe as the other, except that he does not recommended "Adam's Express," as he had trouble getting his money from Indianola through them, there being no A.E. agent here in Corpus Christi. During the yellow fever, when all postal communication in the South was disrupted, Downing failed to receive a letter containing $200, and these funds are undoubtedly lost to him.

There are still two months until Christmas. If it is possible to send anything to me by then, I shall be able to enroll the children in school at New Year and have some garments and shoes ready for them. I cannot describe to you how much happiness we have all have been feeling since the arrival of your letter. The attorney I had engaged died of yellow fever, and I must now take any further steps myself. Had I come home years ago, things would have been much easier for me. But the whole family would have been burdensome to you. For Felix would not have done anything for them, and in addition all our property would have slipped out of our

hands; I thought my duty to prevent that. Felix pays taxes on property worth $20,000. Though its value fluctuates, whatever it is worth will be something for them.

I would give my eye teeth to have had a picture made of my little Anna. When I have some money, I shall have a little cross installed for her. At present there is just the lawn. She lies buried in Mr. Büsse's garden close to our house. Mary has not yet been married, and I think this will perhaps take place at Christmas if possible. Mr. Downing is going to put a fence around our estate and build a cistern. Everything is in terrible decay.

Mr. Büsse had yellow fever, and I did what I could for him; since that time he has been much devoted again. I never see Mr. Schübert but know he is doing fine. There is still much space on my paper, but I must close nevertheless. Mary has been exclusively occupied with nursing Mr. Downing, and Julia and I have to see to everything else. When there is a sick person in the house there is always much to do. I shall let you know when I receive the money, how I employed it, and what advantages it brings us.

Live and fare cordially well. Many kisses and fond greetings from all, and again accept my sincerest thanks. Greet all, brothers and sisters, friends and relatives, fondly from

Your—Maria

Corpus Christi, October 31, 1867

Beloved Parents,

A few days ago I wrote to you, but since then I have ascertained that postal receipts from foreign countries do not yet operate here; the postmaster does not know anything about it, at any rate. Mr. Schübert has a rather substantial business here, and he has suggested to me that if a draft is forwarded to Cramer in New Orleans, he will make me payment here, which will be completely safe for me and will simultaneously save time. For as soon as you let me know that the money has been paid out, I can receive it from him. He would also help me invest part of it safely without Felix suspecting anything. I must mention that whether it is payable in hard or paper currency must be specified. The latter is not advisable, as in Corpus Christi paper is worth less than in the North. Mr. Schübert proposed ordering me a washing machine, which almost every family in the North and South is now using, so that we shall be spared the worst work of washing. Mr. Ziegler praises the machine immensely. I examined it today and the linen washed in

it; it really does not leave anything still needing to be washed. Such a machine presently costs about $28 in hard currency.

Today Mr. Downing has gone out for the first time, and I hope he will not have a relapse, which is always dangerous.

I write in haste in order to catch the mail. So fare cordially well, and for you, my dear Mother, we all send many, many congratulations for your birthday. May kind Heaven long spare you!

Your loving—Maria

P.S. Did you hear of the terrible hurricane in Galveston and on the Rio Grande?[25] Yellow fever is everywhere in the country. Right now someone who died a few hours ago is being buried here. Cholera has broken out in the eastern part of Texas.

~

Corpus Christi, December 8, 1867 (Sunday)

Cordially loved Parents,

Mary was married on November 16, and in consequence we have had many visitors, and we have likewise been out more than would otherwise have been the case. I should have liked to inform you of it beforehand, as you wished, dear Mother, so that you could have thought of us on that day. But a few days before, Felix declared his wish that Mary might marry on his birthday, the 15th. As that was a Friday, it was delayed until the 16th. We did not invite anybody. Mr. Büsse came as a witness. He and Lieutenant Wheeler, who is living with us again, were the only others present. You should know that here they have the dreadful custom, as I guess I have already written to tell you, that the boys from the town gather on such an occasion banging old kettles, etc., and for that expect a good treat of $1 each. We kept it all secret to avoid such shenanigans, and amazingly, we succeeded. The girls both looked very nice in their white dresses and once again send their thanks for your gifts. The flowers, too, looked lovely. It was difficult to make out which of the two girls looked better. Mr. Downing and Mary will soon write you some lines. They live in our old house, and thus we remain one family, as before. I can tell you little more about the wedding. The local judge was fetched after our supper. He spoke half a dozen words, and it was all over. As for Felix, things remain as before. Most of the time we are in need and want, and Mr. Wheeler and Mr. Downing are all the help I have. They have now built me a nice wash house with a kettle,

[178]

baker's oven, and stove for heating the irons, which is a great relief for us in getting the work done and as protection against heat and cold. Were it not for the awful poverty that the children and I suffer, we should be quite content, as Felix generally goes to bed early after coming home drunk in the evening. His room is such that he does not come into contact with anyone.

I look forward to your help at year's end. I beg you to announce Mary's marriage to all brothers and sisters, friends and relatives. If by your kindness I should receive the money before New Year, I intend to send the children to school, which will certainly do them good. Mary and the rest are all well and remember you in the greatest love. December 14th is near, and we all send our united congratulations for your future health and well-being, which we hope you may enjoy for many years yet. Fare cordially well and remember with love

Your—Maria

Corpus Christi, January 23, 1868

Cordially loved Parents,
Happy New Year above all! May you enjoy many, many more in good health. We all began it happy and content. Felix gave his word of honor that from the beginning of the new year he will no longer drink, and so far he has kept his word. If he can maintain his resolve not to get drunk, he will be able to help us emerge from the calamity into which we have plunged during his phase of drunkenness.

About five days before Christmas I received your letter with the needles. Many thanks for these; I had not a single one that size left. I intended to reply at once, but Christmas was near, and of course I had neither prepared anything nor had the prospect even of getting shoes for the children until your letter arrived. Mr. Schübert thereupon lent me enough money to buy the boys decent suits. What difference there is between the prices here and in Germany! I had to pay $7 for each suit, trousers and jacket. And they are made of simple, thin, woolen cloth. It was all I could get, just one suit for each of them. In addition I had three warm coats made so that they are better provided for than I had dared to hope they would ever be again, thanks be to God. On January 6, Julia's birthday, I received the bill from Hoffmann at New York on a house in New Orleans and at once cashed it here: $348.83 was the amount. I cannot describe my thanks; for one must be in a situation like mine to understand fully how much the arrival of the

money relieved my sorrow. I bought warm covers, and the children are going to school. This is the best way to use the money. Together we all thank you with all our hearts. Of course in Germany I should have been able to buy everything much more cheaply. But the need was so great that it was better to lose no time. You wonder at the high taxes. Yet I know that here I would not have been able to buy the things that were in the last crate for what they cost you. Indeed I should not even have been able to get such things here at all.

Last week we had two concerts and living pageants (plays) to complete the church, the one we began construction on when we held the fair last year. I must always play the piano for all the singers, and the rehearsals, which take place at the homes of the ladies on the committee, are a great pleasure for the young people. There are no more rehearsals at our place as I no longer have a piano. More to the point, I had to renounce that honor because champagne, choice edibles, and often more delicacies are very lavishly spread before one.[26] What I really wanted to tell you was that Mary and Julia appeared in their new dresses. Mary represented "America" and looked better than I ever saw her. Among her other roles, Julia was the "Daughter of the Republic," for which she drew resounding applause. I suppose that with my next letter I shall be able to send you the picture of my second (future) son-in-law. Julia has refused a very good match—in every respect—with an officer in the standing army who has an excellent salary and is moreover one of the best-looking men I have ever seen, and amiable besides. But his proposal came from thousands of miles away, and Lieutenant Wheeler, the favorite one, is here.[27] At least it is certain that no fault of importance can be found in him. He is not a nice-looking man, but one soon forgets that in closer intercourse with him. Mr. Downing and Lieutenant Wheeler will go away again as registrars the day after tomorrow, and that will probably finish their work as such. As required by their orders, in February they must go to New Orleans to make their report personally to General Hancock.[28] What they will undertake after that is still uncertain. Perhaps Mary will go along to New Orleans, where she can get a good picture of herself taken.

During the time Felix was at Matamoros, Mr. Büsse made outlays for me, and I am anxious to repay him as soon as possible. For Felix has not paid a cent of what others, such as Ziegler and Schübert, gave me in the time of need as regards provisions, cloth, indeed the urgent necessities of life. Of course this will consume much of what I have now received. But it is

nevertheless worth it to put such liabilities behind me, especially when the persons concerned never press, yet would like to get their money.

How eagerly the children wish that we might all be united. Downing would love to go to Europe. But it would be difficult for him to undertake anything as he does not have full command of the German language. Wheeler's uncle is the mayor of New Orleans, the highest civil office in the city.[29] He wishes and continually urges Wheeler to come to New Orleans so that he can give him a good position. When he goes there now to make his report, they will perhaps persuade him to stay.

At Christmas the girls made five pairs of shoes, and our patterns have been used over and over. Therefore I would beg you, dear Mother, if you have the chance, to get a nice shoe pattern from an old fashion journal and keep it for us; also a picture of the "Daughter of the Republic." For there will probably soon be another performance. Mrs. Davis wishes to arrange one, and then Julia will certainly undertake that role but, if possible, in a different dress. Such papers may be sent like a newspaper. You need *not prepay* it, for Wheeler and Downing always have postage stamps.

Once more I repeat my fondest thanks for the money.

Your—Maria

Corpus Christi, March 15, 1868

Beloved Parents,

Nothing particular has happened here except that Mr. Wheeler and Mr. Downing went to New Orleans and returned from there last Tuesday. Downing brought back for his wife a fine outfit of linen, which is always welcome. Felix is at present away from home busy with a survey. So far he has restrained himself and has not fallen back to his old evil. He seems to be very earnest about it, and perhaps he will succeed in completely changing for the better.

Julia and the three boys now go to school, and I will keep them there as long as I can pay. Julia and Mary also have piano lessons there. I have to pay $15 a month, though I pay only ½ of the fixed price, as Mr. Carpenter, the headmaster, knows our circumstances very well.[30] I am well satisfied with the progress they are making. Every two weeks there is an exhibition, for you cannot call it an examination. The pupils give performance of music, songs, and plays. The amount raised is for charitable purposes or to procure books and maps for the school reading room.

I have also had a washing machine for six weeks, and you cannot imagine anything more excellent. The washing undoubtedly takes less of a hammering than when done by hand, as it is only tumbled and squeezed. The washerwoman does nothing but turn a handle to and fro, which gets the washing done. Then there is a wringer consisting of two gutta-percha mangles, which leave the washing so well wrung out as to be almost too dry for ironing. The washerwoman can do all this in her best dress and not soil it. I can't tell you what a help that washing machine is. Washing would now almost be a pleasure were it not for the ironing.[31]

In my last missive I did not even thank Papa for his picture. It has given me much, much joy, and I wish you might always include a picture. General Hancock's aide-de-camp, Colonel Wilson, was here last week; he passed the two evenings he spent in Corpus Christi at our house and went directly from here to the steamer, as he appeared satisfied with what he saw of Corpus Christi.[32] Many rumors of mismanagement and illicit dealings have reached the ears of General Hancock, the commander of the district of Texas, and Colonel Wilson's presence was a visit that may be of great advantage to the people of Texas. For there are now worse goings-on than during the war.[33]

Sunday 22nd. It was not possible for me to finish my letter last Sunday. Felix has not yet returned. Charley has been very sick. He has always been sickly, and I have the greatest apprehension that if I cannot nurse him better, he will become consumptive. He has scarcely been able to attend school in the last week. One day he tried to attend the lessons, but the teacher soon sent him home, thinking he would faint. It is a great sorrow for me that I cannot give him the careful nursing he must have. He cannot go up twenty steps without having to lie down afterward. Downing intends to go to Boston in two months' time and wants to take Charley along there. But I should never let him from me as long as I shall be able to have him with me. He regrets incessantly that his studies are being thus interrupted. He has always had his heart and soul in them. The other day in school, speaking from memory before all the classes for thirty-three minutes, Julia gave a lecture about the American Revolution. She made no mistakes, neither hesitating nor pausing. Mr. Carpenter told me himself, as he told many others in the town, that it had astonished him.

Downing's brothers give him no peace. It is constantly: come, come! If Mary can just stand the climate, I think she will be better off in Boston than here. Downing knows only one care, that being to procure joy and com-

Richard Paul and Carl (Charles) Friedrich Harvey von Blücher, ca. late 1860s. Charles F. H. von Blücher Family Papers, Special Collections and Archives, Mary and Jeff Bell Library, Texas A&M University–Corpus Christi.

modities for Mary. Wheeler is the same or more so. Downing brought Mary two pairs of high boots and Wheeler brought Julia three pairs and one pair for me, at least nine to ten inches from the heel. One of Julia's pairs cost $12, and the girls will again begin to wear short dresses. Downing and Wheeler will probably be reappointed registrars for two to three more months. But as

the commanders continually change over and General Hancock will probably not stay in office longer than his predecessors, we can predict nothing definite.

I hope you received my last letter in which I wrote of receiving the money. It has put me miles ahead. I used it for decent garments, shirting, linen, woolen covers, and many other useful items and paid many a little debt that was troubling me, such as $50 to Schübert, $36 to Mr. Wheeler, and $26 to Mr. Downing, which they had lent me in cash when I was in need.

Julia has been engaged to Mr. Wheeler since January, and I was no less astonished than you probably are, though he told me sooner than Julia that this was his intention. But he had disguised it so carefully that none of us had any idea. Wheeler is much satisfied in Corpus Christi. He has only a sister, who is in the North. His father remarried and he and his wife moved to be with her family, so that he regards us entirely as his family. Mr. Heath, mayor of New Orleans, his wife and Wheeler's cousins welcomed Downing and Wheeler very kindly and wished Wheeler to stay with them. But of course he preferred to return.

Greet all friends and relatives cordially. Greetings and kisses for you from your

Maria and 7 grandchildren!

❧

Corpus Christi, May 24, 1868

Beloved Parents,

I fear that my long silence has already alarmed you. But Mary left for Boston last Tuesday, May 20, and for the last four weeks I really have not had a moment to spare, as I wanted to avoid having Mary to help me in the house so that she would have time to make the necessary arrangements for Downing and herself. In addition to that Felix went away on the 19th for some weeks or months, and I had my hands full getting him ready. Today, Mary is already at New Orleans, and I hope the change of scene will divert her a little and make her forget her sadness. From morning until late in the evening Mr. Wheeler works in Chapman's store, where he and Downing worked together before.[34] Mr. Wheeler bought all Mr. D.'s property in order to see if he can sell it at greater profit in due course. D. wanted absolutely to take Julia along. But I did not wish to disturb Wheeler that way; otherwise I should have let her go too if it would have given her pleasure.

At the end of April I received the rest of the money: $311.80, and once again my fondest thanks for it. I used it on many a trifle for Mary, which was a great consolation for me. Your wish that I should invest the money and that the interest should be enough to relieve me was quite right, dear Father. But when the needs in a family have grown to such a degree that everything, everything is lacking, even the most essential things, it seems best first to procure the necessary and to cover little debts and tear me and mine out of such stifling circumstances. For however great our need has been, I have never allowed Downing and Wheeler to maintain or clothe us. They have lived among us and given their share for it. It has always felt as if we were one family and it has never felt oppressive for either them or us. I have kept an exact account of what they have given us in garments for the children and in cash and have repaid them upon receipt of your money, as follows: Schübert, $50; Büsse, $18; Wheeler, $30; Downing, $36; and Mrs. Ziegler, $22. For Felix has given us almost nothing at all for 7+ years; he has drunk and wasted it all.

Downing left me materials here to fence ½ our place, and Wheeler will give me the other ½. In addition, D. has left thousands of bricks neatly stacked here; if I sell them, he told me, I can keep the money. Of course, after D. and Mary had been married, I accepted much assistance from him. Wheeler is now working in Chapman's store and only gets $50 a month. But he prefers to be content with this limited amount than go to New Orleans. He is always at home in the evening, does not smoke often, never drinks, and is an active, steady man. Strange to say, he is Felix's pet, though he is absolutely the opposite of Felix.

I am sending you pictures of the children and our family. I would entreat you to send some to Mr. Kill-Mar by local post, *without writing to him further.* What you wrote about Hermann Blücher surprised me very much, dear Mother, as I definitely thought you would abide by my request not to show my letters to *anyone in that family,* and you had also given me your promise. You know they would do all they could to disadvantage us. Now I only beg you to grant my request and *send* the pictures of Lieutenants Wheeler and Downing, Mrs. Mary D., Julia v. B., Ch. F. v. B., R. v. B, and George v. B. to Mr. Kill-Mar *(without writing)!*

I enclose the following card: "Julia A. v. Blücher & Lt. Harvey Wheeler Engaged." Please send it to all family, friends, and acquaintances, etc. Mr. Downing took along your pictures and those of the whole family, and I beg you very much to send me more *of everyone.* I shall perhaps also include my own picture in the next letter. Mr. Downing so regrets that he has not yet

received the pipes from Germany. He is a passionate smoker. I comforted him with the assurance that, if it is not too expensive, you will send them to him at: East Boston, Massachusetts, Saratoga Street, No. 137, addressed to Lt. James Downing.

Write and tell me all about relatives, friends, and acquaintances, and be assured that news is always read with the greatest interest. Many thousand greetings to Julius, Anna, the other brothers and sisters, and all relatives. Once more a thousand greetings from the children and

<div align="right">*Your—Maria*</div>

<div align="right">Corpus Christi, December 6, 1868</div>

Cordially loved Parents,
Soon another year will have passed and still we are denied being reunited. On the same day I last wrote to you, Felix nearly lost his life. He had drunk too much and had not come home for several nights. But as I had already become accustomed to that, I was not surprised or expecting anything out of the ordinary until I heard a loud crash. He had fallen out of a first-floor window during the night! He just managed to get to his feet and struggle as far as his office, where he was prostrate for two weeks, utterly broken down. However, he now seems to be fully restored, and I believe it to have had a very wholesome effect on his behavior, as he is also less brutish and rude than he has been in years. He now usually spends the evenings at home.

I receive letters from Mary and Downing every week, and they are doing fine. Mr. Wheeler, who came back a month ago after a seven-week absence, had a pleasant time with them and gives us delightful descriptions of their life in Boston and how amiable Downing's old parents are. He thinks it will be impossible for Downing ever to get away from there during the lifetime of his parents. However, with each letter I receive, Downing seems to me more determined to return to Texas soon. Mary writes that she feels the cold in Boston and that she hopes also to be in Texas again by next winter.

As regards Julia's marriage, dear Mother, you will scarcely be surprised soon. Julia told Wheeler early on that she will not marry before she is 18 years old. And what she says, she means, and he has been content with it. He has his house nicely in order and has rented it out. It gives me great satisfaction that you do not hear anything at all about Felix's family.

Christmas is near at hand, and the children are joyful only from old

habit, for they know that I cannot make any preparations at all. Felix brings in what we need to subsist but nothing more. Mr. Wheeler will probably give them some presents, and they must be content with that. Mary has also sent some things as Christmas gifts. Mr. D.'s mother sent us a case of the choicest apples, but in spite of all care, they spoiled.

Charley's health has now improved somewhat. I hope that when he grows up he will become strong and healthy. He is now nearly as tall as Julia, who is three years older. So far he has often been frail and self-absorbed. Indeed, I have much sorrow and worry about the boys, as they so often suffer from tonsillitis. About a month ago George had it so badly that Charley had to run for a doctor during the night, though I am always prepared for such cases. With each cold the attacks intensified until whooping cough set in. Now Richard, Julia, and George have all gone down with whooping cough. The first two have gotten over the worst, but Julia came down with it only last week.

Mr. Büsse is happy and content, I think. I see him seldom now as he works in town all day and only sleeps up here. For several days Felix has been complaining of very alarming fits of dizziness and giddiness, along with blood rushing to his head. The other day when writing he fell off his chair and lay senseless for a while. If only he would look after his health he might avoid further bad turns, I hope. It is so dark that I can no longer see what I am writing. The children, Mr. Wheeler included, send many sincere greetings and wish you a merry Christmas and a happy New Year! Farewell, and write soon to your

Maria

❧

Corpus Christi, January 31st, 1869

Cordially loved Parents,

Yesterday I received your dear letter dated December 4th and I hasten to answer it, though it really is difficult for me to write German and express myself in the right and proper ways. If I heard another person who grew up in Germany say as much, I should certainly find it ridiculous. Nevertheless, for me it is the sad truth. I always speak German with Julia and Charley when we are alone. But of course our conversation only deals with certain things. If I want to explain something to them more precisely and give full particulars, I do so in English, as they then understand it better.

It gladdens my heart that you are all in good health and enjoying your life in peace. May God preserve you thus for many more years yet. As for us, I have not much cause for complaint now. The children have all had whooping cough and also gave it to Felix, who had it very badly. Strangely enough, I did not catch it. Charley's health is pretty good, but his nerves are very weak. There was a Professor Hardy here, a ventriloquist and magician, who gave a really excellent performance. He ran a knife through his wrist so that half of the big knife could be seen at one side and the handle at the other side. Charley was quite captivated by all that he saw until that part, whereupon he fainted. But I hope he will get over it, as he is of a cheerful and merry disposition at all times. Felix really seems to have left off his great evil habit, drinking, and is now always at home in the evening and finds pleasure in caring for us well. He showed me in his account book that he has over $700, which monies are quite safe, from the last half year when he worked diligently.

The only inconvenience is that he cannot keep from continually reprimanding Julia and Charley with word and deed—as he says himself, he cannot bear either of them, which causes me much sadness. So often I point out to him that he should consider how other fathers treat grown daughters, but that only makes it worse. How little it takes to irritate him! I will mention to you, for instance, that at the table, in the presence of Downing and Wheeler, he said to Julia, "God damn your soul to hell," because she had forgotten to fill the mustard box. I am now convinced that Julia accepted Wheeler's proposal to secure herself a protector against such coarseness. For I am convinced that she does not feel any more for Wheeler than that she likes him because he is a respectable, neat young man. I for my part have repeatedly told Wheeler this. Yet he is content with how it is and is devoted to her with body and soul. So far she calls him "Mr. Wheeler" or "Lieutenant W." Downing most eagerly wishes Julia to come to them in Boston this spring. He shares my opinion concerning her feelings and thinks if she had an opportunity to see more of the world, she would be better able to decide for herself. But there is no hope for this at all. Felix at first promised to procure for her the necessary money, but he now thinks he has better uses for it. For I think he would not show much sympathy if she later proved to have regrets!

As for the Downings, Mary is very content and happy in Boston. Nevertheless, Downing must leave the North before next winter. His health has been in a very serious state since the latter part of autumn, and he

himself thinks that it will develop into consumption if he does not choose a warmer climate for his domicile. So at the end of this summer, all else being equal, we expect them back. Mary has at least seen a bit of the world, has been to and visited important towns, even if for only a short time; cities such as New Orleans, Washington, New York, and Boston, which is here called the center of the world because of its numerous inventions and riches and much traffic. It is still Downing's heart's desire to possess a real German, middle-sized pipe. He asks in every letter. I have told him it is not in my power to do more than beg you in each missive to send him such a one.

I sent Mary a little package with a gray poplin dress for her birthday. Felix had presented me $20, which of course I used for the children, as he almost never gives the girls anything or buys them any clothes. Since they received the last things from you, they have had nothing good. However, Wheeler has always brought good things for Julia at Christmas and on birthdays or when he has taken a journey. In the beginning that was most disagreeable for me. But once he gave me his reason for it, I put up with it. How often I wish that Julia might come to you for half a year. She is still very modest and would not be very burdensome to you. There, among relatives and acquaintances, Julia would find suitable friends. Here, she does not visit anyone except Cornelia Moore, but even that is seldom, as she lives on the other side of town.

I read with great joy and emotion of Father's jubilee, and it must have been a great satisfaction for him to see his many pains and works thus acknowledged. I did not even have an idea of all of that. You must have collected a rich assortment of memorabilia at those festivities. What kind of image of you, dear Father, is rendered in bronze? I wish indeed that I might yet see you and all of that; what a pleasure would that be!

You write of the warm winter you have had. It was just like that here. We have had nothing but rain and warm weather. It has been so favorable even through December and early January we had common white cabbage and cauliflower, fresh salads, etc., all grown in the open air. For of course hothouses are not yet known in Corpus Christi. Commerce in Corpus Christi is now flourishing, and a Hamburg firm, Edly and Kirsten, a mercantile house, made $36,000 clear profit in six months in wool, hides, horns, etc., being shipped from here. At the same time banking businesses and three new stores have opened (two in the country, one here), where one can buy from the finest goods, from velvet to pins, foods, and hardware, all in different departments (as all the big stores arrange things here), and more

elegant than I anything I ever saw in Germany. A man recently fenced off 36,000 acres or 20 leagues of land, all using the kind of cypress posts we in Germany would use for a good garden enclosure.[35] Then there are now four slaughterhouses in operation here. Every day 100 oxen and cattle are killed there; one operates only for the hides and fat, with all the meat thrown away! In due course Corpus Christi will become an important commercial center.

Mr. Büsse chugs on, his endless laziness getting him nowhere is particular. Mr. Schübert has left town for the country, where he has a wonderful store and is doing very well. I guess I have reported all the news from Corpus Christi. Greet all from Julia and me. Let me know any news concerning our acquaintances and friends. Do you ever hear from or of Bertha Müller? She was my first and best friend from childhood, and I remember her with great love. Many greetings to all brothers and sisters, friends and acquaintances. The children send greetings and kisses for you. Fare cordially well and remember me with love.

Your loving daughter, Maria A. v. Blücher

Corpus Christi, March 10, 1869

Beloved Parents,

I did not wish to let today pass without writing you some lines. Today it is twenty years since I gave up your name and left my former happy circumstances. Unfortunately, the day finds me ill if up and about; Julia in bed; Charley convalescent once more; and Richard very unwell. We all have caught violent colds with the sudden change of weather, as is so usual here. I hope we shall all soon be restored again. Yesterday Charley had to make our breakfast, which we take at 6:30—beefsteak, coffee, tea, and toast—and then, after the custom here, nothing until noon. Charley handled it all excellently.

I have to let you know the sad news that Mr. Downing, Sr., suddenly died on February 3rd. His death made a deep impression on Mary. He lay fully conscious in his final agony for twelve hours, Mary's hands in his. In the last hours he spoke only to Jim, giving his thanks to God that he was with him at such a time, and he left to Jim—though not the eldest—the regulation of his business affairs. Downing is deeply affected. He was greatly attached to his father. Felix wrote to Downing to come back as soon as he can finish the administrative matters. He misses Mary very much.

Mr. Schübert will pay his relatives in Berlin a visit in June. He is a rich man, leaves his business in secure hands, and plans to get married in Germany. Büsse asked him whether he would not take Julia along with him, as I had so often expressed the wish to send one of the children to you for a visit. He instantly agreed and offered to pay all expenses. For Felix would never give his hard-earned money for a journey for Julia or Charley, neither of whom he can bear. Julia was beside herself at the prospect of coming to you and becoming acquainted with all the relatives. I am writing to you about this in detail so that when Schübert comes, you will not suppose that I had not thought you might perhaps like to know *one* of my children. But I do not have the means to do it. For this could be the only impediment. Schübert would do everything in his power to make the journey agreeable. I can just imagine what an eye opener it would be for her to walk Unter den Linden and see the Tiergarten, your nice garden, etc., all new and an unknown delight for her.[36] She is very timid and would perhaps feel uneasy at first, but that would soon cease. Mrs. Moore, Mrs. Headen, and Mrs. Britton here all say that you would be well pleased and privileged to have her a while and consider me to be in the wrong if she does not come to you, as they really can never imagine that many people do not have money enough to be able to fulfill their dearest wishes.

My letter must go to the post! Fare cordially well and greet all brothers and sisters, relatives and acquaintances a thousand times from your loving daughter

—*M. A. v. Blücher*

Corpus Christi, April 12, 1869

Dearly beloved Parents,

In the last letter we discussed the possibility of Julia coming to you in June. We must not tell the likes of Kill-Mar of this at all. Felix feels such a hatred against the whole band, as he calls them, that he generally slips into a stream of curses just thinking about them. I beg you, never attempt an approach, whatever may happen. If I were to come to Berlin, I should not take the least notice of them.

Downing has a great deal to do in Boston, and Mary is very happy and delighted there. I also think she would much prefer to stay there. But since his father's death, Downing is still more determined to come back, to which feeling his changed business circumstances probably also contribute. Jim

had been in business in association with his father. The father always invested his portion of the profits in real estate, and Jim put his money in deposits in the bank. Now that both parties' debts must be cleared, and according to the father's last will all real estate goes to the mother, Downing has had to take his money out of the bank to cover all the obligations. And the mother has control over considerable holdings in grand buildings, houses, and land, which she can distribute at her discretion and which she will probably in large measure pass to the youngest son, who is the apple of her eye. He is closely attached to Jim and Mary, which, however, does not change anything in the matter. Jim was the father's right hand and darling, and he feels the wrong done to him in the settlement of the estate all the more.

Many thousand greetings from all the children here and your loving

—*Maria*

P.S. Dear Mother, don't you know a means for curing Charles's troubles? His whooping cough increases rather than decreasing. But he continually ails from coughing.

∿❧

Corpus Christi, May 24, 1869

Cordially loved Parents,

Some days ago we received your dear letter dated April 20, which at once decided the question of Julia's journey. As Papa writes that it would be possible for him to procure the money required, as I have quite frankly told you I am not able to do so, I understand, dear Father, that you are thus inclined to make it happen. Julia is mad with joy and works restlessly from morning until deep into the night to make the linen needed for such a long journey. Felix gave her some money for that purpose. As regards the time and length of her stay, it probably will not be possible to fix that in advance. Mr. Schübert will leave Berlin at the end of October because he fears winter might not agree with him. Mary, on the contrary, has survived the winter excellently in Boston, and I think we also need to consider how Julia will bear the autumn in Germany, which is probably worse with its rain and wind than is winter with ice and snow. If she could once spend a Christmas with you, that would be a great joy. On the other hand it would carry further costs, as she is not prepared or provided with the warm clothes needed in Germany. All of this can be sorted out much better when she gets

there. I shall certainly let her have such trifles and money as I can. But if Felix continues drinking, as he has been in the last two months, there is little hope that it will amount to much. Because of Felix's drinking I am pleased that Julia is coming to you, for she is *very sensitive,* and his behavior affects her greatly. If she stays in Berlin for a while, I will somehow at least make it possible for her to have piano, singing, and drawing instruction. She has significant artistic talent. She also has a good voice, and that would be a source of pleasure for her as long as she lives. And here in Corpus Christi the expenses for such instruction would be and are beyond my means.

In recent years we have spoken so little German at home that Julia is afraid of appearing ridiculous with her incorrect speech. She speaks English so much better. Concerning Felix's family, let me say that it is my thoroughgoing wish that she have as little to do with Kill-Mar, Ida, etc., as possible; if you are not good enough to be treated politely, your granddaughter can be still less so. Therefore, we will ignore them totally. My children have nothing to thank Kill-Mar for, so do not have any dealings with him!

Mr. Schübert is expected back here in town next week, when the time of departure and all further details will be arranged. I will then at once inform you. I hope my young nieces and cousins may kindly take charge of Julia.

It has been fortunate that Mary went to Boston. For some time she has not been in good health. The doctor who treated her said she had an inner defect, etc. I advised consulting another doctor, who after investigation declared that she had an inner tumor that had been growing for years and that would take her life if it went on growing. He promised to perform an operation from which recovery would take fourteen days but after which she could be completely restored. Mary had been recovering from the operation for eight days when last she wrote to me. I am looking forward to her next letter with great impatience. She was in very good humor and by no means depressed. As she wrote, she had excellent nursing and care, which it would never have been possible to give her locally, and who knows how long she would have suffered here without any resolution. How many people continually have bad luck that keeps them from getting ahead, so that despite all their work and diligence, they grow no richer or healthier. Mary's illness cost Downing three dollars ($3) for each visit by the doctor and use of the surgical instruments. Then about three weeks ago his tool house, where all his workers' tools are stored, was set on fire. His property was mostly insured; nevertheless, he lost much.

Wheeler now talks to Julia as little as possible. I wish she would look inside herself to decide whether she can truly bear him sufficiently to marry him. It is my opinion that only by his earlier and incessant begging and pleading did he get her to agree to the engagement. He has now been in New York on business for four weeks.

I shall close now in order to help Julia as much as possible. I shall soon write to you again. Remember me with love

Your loving—Maria v. B.

❧

Corpus Christi, June 28, 1869

Dear Parents,

Mr. Schübert and Julia started from here on June 22nd and expect to reach you by July 15. In summer the direct run from here is interrupted, and they are obliged first to go to New York. I hope you are not disappointed in your expectations about Julia. She is a little timid and reserved in the beginning but affectionate when she feels herself at home. Nor should you be astonished when she is peculiar about eating. She never was very good in that respect. So you must not see harm in it if she does not eat all that is set before her. She has her favored dishes, and I will tell you what they are: above all, tea; boiled rice; cabbage; bread and butter; roast ham; and poached eggs. I do not mention it so that you might play along; on the contrary, it is my wish that she may learn to eat all that is served. But I thought it was better if you knew her peculiarities. If you wish to give her something extra, there is nothing she likes more than raisins, almonds, biscuits, Spanish wine, and grape jelly. These are her delicacies. Here at home she never got to see much of them, but most of our acquaintances live extraordinarily well. One more thing I should like to mention: here we have things washed every week. Julia is perhaps more extravagant with linen and clothes than may be the case at your place. And I most eagerly wish to bring as little trouble and change as possible into your calm household. Therefore I propose to have her things washed elsewhere, and I have provided her with a bit of money to bear expenses of that sort without becoming a burden to you. Julia has all the documents she needs.

I should like it best if she took no notice at all of Kill-Mar, but Felix would like her to pay a visit there. And if Ida von Blücher should invite her, she is *not* to accept *even* to stay there for just a few days. Julia is accustomed to the best society here. Life is downright royal at Colonel Moore's, where

she is like a member of the family, and at General Davis's, so I know that Ida cannot impress Julia with great finery; but I have an express aversion to her company. Mr. Müller here intends to visit Germany next spring and wishes to take Charley and Richard along. It will not cost us a cent. Müller has money enough and no family; therefore, I should accept it from him without hesitation. I should still like to mention that if you are willing to give Julia a great treat, please take her to the circus. There was a company here that gave extraordinary performances. Julia was there every evening, five times, with the boys, and they have been in such raptures that they can scarcely eat or sleep. Since then our boys have put up all conceivable contrivances, and they are already getting quite good at the gymnastics involved. Just now six boys were riding in their homemade circus on bits of cane hung with red rags in place of horses bedecked in flags, and they are thrilled to be reenacting what they saw. I think Julia will feel more at home at Treptow than in Berlin, especially if she has an opportunity for taking the baths. Just tell her to make me drawings of the nicest places in the neighborhood of your house. Mr. Schübert promised her he would take her to Dresden. Of course if he issues such an invitation, he means it at his expense, and you need not hesitate to allow her to accept it. He is a rich man, and his income continues here.

I now close. I hope and wish that you may grow fond of Julia and her presence may give you pleasure. She has been a general darling here and a source of pleasure for all. Greet brothers and sisters and relatives fondly from me and tell them they must all most kindly accept Julia. Now farewell and write soon to your loving daughter,

Maria A. v. Blücher

Corpus Christi, July 26, 1869

Cordially loved Parents,

Julia will probably have arrived and be feeling at home there before this reaches your hands. Since the 18th I have imagined every minute of how your first meeting would be. Yesterday I received a letter from Mary, in which she describes her meeting with Julia. It was a great joy for me to hear that they had seen each other. Here the inquiries about Julia are endless, especially at Colonel Moore's and Mrs. Headen's, where I had to repeat about ten times what she had written to me from New York. Even old General Ruggles inquired most intimately about her, assuring me that she

had made such a deep and lasting impression upon him that after his journey through Mexico, he still had the full pleasant memory of it.[37] I wish she may acquire with you as many good and sincere friends as she left back here.

I have reflected on Julia's visit to Kill-Mar and consider myself justified in saying I think it absolutely unnecessary that she pay a visit there. Why should she expose herself to disagreeableness if she can avoid them, especially when Mr. Kill-Mar has the insolence to speak of me with disregard; I who have every right to reproach him for his falsehood and fraud. Therefore do not let them even exist for you. For from the moment Julia enters their house, inconveniences would also begin for her. Mr. Büsse knows Kill-Mar quite closely and told me much of his respectability, or lack of it.

I am looking forward with great impatience to the first letters from you and to what Julia will have to say. I promised to send her a bit of money so that she will not be a burden to you. But up to now I have not been able to do this. Felix has been away these two months and we have neither seen nor heard anything of him, which really puts me in a bind. But as I am already so accustomed to this, I do not regard it as unusual.

On June 28 we had an extraordinary rain here, as a result of which whole areas of Texas are under twelve to twenty feet of water and many lives were lost. Above Corpus Christi the Nueces River cut itself a new channel, which formed a stream 100 feet wide and of significant depth, and in which yesterday they shot an alligator that was pursuing a horse. The slaughter-houses have been cut off on the other side of the water, and the meat must be ferried over to market in boats.

Mr. Wheeler gave me such a description of Mr. Schübert's great care and kindness toward Julia that I send him through you my fondest thanks. I never doubted that she would be well cared for under his protection, otherwise I would never have entrusted him with taking her along. Mr. Wheeler writes that as long as he shall live, he will entertain the warmest wishes for Schübert's happiness and well-being. And Mary writes that Schübert persuaded Mr. Wheeler to take Julia to Central Park in New York, which was a very pleasant diversion for her.

I very much enjoy hearing about all my old acquaintances. I never lost my interest in them. I often remember all my old acquaintances and should like to hear from and of them. In my memory they all have remained the same, and I cannot think of them differently. I read a description of the grand aquarium that is being built in Berlin, and it is difficult for me to

conceptualize such a thing.[38] I hope Julia will get to see and admire it. Mr. Schübert will surely not abandon Julia right away but will take her around a little; for he does not mind spending money. Mr. Müller wishes to take both Charley and Richard to Berlin next spring. I wish he might make this come true while Julia is still there.

I still have to write four long letters today, so I now say farewell to you! I know that Julia is in better hands with you than here, so I make further mention of that. Once more farewell and let me soon hear from you.

Your loving daughter—M. A. v. Blücher

Corpus Christi, August 16, 1869

Beloved Parents,

With greatest joy I opened your dear letters yesterday and found that Julia had arrived safely, to your mutual pleasure. I have no doubt that even if Julia brings many an inconvenience into your quiet household, you will find some reward in her loving return of your kind feeling toward her. Whatever she has seen there up to now has been a pleasure and happy surprise for her, and I only hope she will not become homesick when the charm of novelty recedes.

Mary will probably return to me next month when Mr. Wheeler returns to Corpus Christi. Nevertheless, nothing has yet been fixed about the time of his departure. Downing cannot come before his father's affairs have all been settled, which will still take him some time and money. He has already paid out $1,200 in cash, and the mother is holding onto all the property. Downing has left her house, and they have been living elsewhere. Mary seems not at all in a hurry to come back. She is very comfortable there, but Downing thinks it will be too solitary for her in winter. There is not much news to be reported, as I told Julia. I forgot to tell Julia that if she has an opportunity to watch sewing machines working—hemming and felling, especially the latter, which I do not understand—she can inform herself about what causes the needles to break when bobbin and rotating hook (she understands it better) are completely aligned. I have a great love for my machine, but I have never seen such fine work done here as the shirts you sent for the boys some years ago.

I am sending this short note so as not to have to hold off until Saturday. The mail to the north goes only twice a week. I have told Julia, if she has a not unreasonable desire, not to hesitate to pronounce it; as, e.g., she likes to eat vegetables mostly with vinegar, i.e., to add it cold herself. Here it is the

custom to have casters on the table at every meal in every house, and I know she would never ask for that even if she liked it ever so much.

Many cordial greetings to all brothers and sisters and relatives, and many kisses from the children and your loving daughter

Maria

P.S. Mr. Downing always sends the sincerest greetings and messages for you. Why did you never answer his letter?

Corpus Christi, October 10, 1869, Sunday evening

Cordially loved Parents,

I have not written to you for quite a while, knowing that you are surely hearing enough from me through Julia. She is happy and content and eager to stay as long as you are willing to have this responsibility. It seems to me clear that you may sometimes long for quiet togetherness without my little harum-scarum there. How is she really getting on with the German language? She does not write anything about that. I hope she will not forget, in all her pleasure, to studying English.

I received a letter from Mr. Schübert in which he announces his departure at the beginning of October. I had not thought that he would pay such a short visit, and he had half promised me that he wanted to stay until next year. He writes that he will use all of his influence to persuade Julia to remain in Berlin. But if he had read Julia's letters, he would know that this requires no persuasion, that she is completely happy. I had hoped that Schübert would stay, and as soon as you are in Berlin, Julia should take piano and singing lessons if possible. I wanted to pay for that through Schübert as soon as I have the chance. The idea is that when I sell oxen, I will let her have the money, which would probably be sufficient to pay for a good while even if it did not appear at just the required moment. Can American paper money (currency) be sold without great loss and trouble? Julia had an infinite desire to learn to play violin. If she still wants to do so, she may learn that instead of playing the piano. That will probably appear strange to you, but for me it is no surprise. With immense trouble, she taught herself to play some little pieces. I am all the more eager that she learn some music because I believe that I have my piano playing to thank more than anything else for my and the children's position. When we came here, there were no pianos. My knowledge was far overestimated, but to

save myself from being submerged in the slavery of household work, I boldly seized the day and made an effort to get on. The first rungs on a ladder like that are shaky. But when once a foundation is laid, one moves along. Fortunately assorted calamities did not dissipate my energy but strengthened it. If I had my piano in order and wished to devote myself to giving lessons, I might make out quite well.

I have the joyous prospect that with God's help Mary will soon be with me again. I expect her in a few days. Downing will still stay in Boston for about two months, and Mary is coming with Mr. Wheeler so that I will not be so alone. Mary is now completely restored and fit and sturdy, according to Downing's description, and has enjoyed her life in Boston. She will perhaps no longer like Corpus Christi so well.

Julia wrote to tell me that you were well and kindly received at the Blüchers. If only one might know whether what they manifest is sincere. She gives glowing reports of the birthday party, of everything. How much should I like to write, but when evening comes, I am generally so tired that I cannot muster clever thoughts, and you must mostly be content with my cordial greetings. Felix has again been away for a survey. He will have had a hard time, as flooding has been widespread.

I will close now as my eyelids are drooping. Many cordial greetings to all relatives, brothers and sisters, and friends, and a thousand thanks to you and all who bestow so much good upon my Julia. Many greetings from the boys, and if they could, they would all be with you. Once more cordial thanks from your loving daughter

<div align="right">

M. A. v. Blücher

</div>

<div align="center">

Corpus Christi, November 15, 1869

</div>

Cordially loved Parents,
I have not received a letter from you in ages, though I waited with great longing. Julia seems to be so engaged that she completely forgets us. If writing is too bothersome for you, have Julia do it. First I had to wait seven weeks, and this time six weeks for a letter. She has not written at all to her sister Mary, who is attached to Julia with fondest love and weeps and feels bitterly grieved about this neglect. You are so kind and amiable to Julia that she does not miss us at all, and she can never be thankful enough to you for that. I beg you with all my heart to remind her to write, at least once every two weeks.

We received two of her pictures and are highly delighted with them, as they turned out so extraordinarily well. Everyone here admires them, adding that Julia has filled out so well. Accept my fondest thanks for the fine gifts you were kind enough to send back with Mr. Schübert. Mary sends many thousand thanks for the pipe and ring. She thinks Downing will now come even sooner, because he has so longed for the pipe, and she is very proud of her ring. Mary is so amiable and affectionate, feeling childlike joy about every gift.

Today Felix turns 50 years old, and tomorrow is Mary's wedding anniversary. Yesterday I got the three boys baptized in the Presbyterian Church after their having studied with the preacher for one month.[39] Julia ought to get herself baptized, but I do not know how she is getting along in the German language, whether she is able to understand, etc. Julia wrote to me about the visit to Kill-Mar's. I wonder whether he will continue to appear friendly. Mr. Schübert fortunately arrived here at the end of last month, and the two seem very happy together. At this stage they are still undecided as to whether they will remain in town or go to the rancho. She is an excellent piano player. I hope Julia will endeavor to get on a little at it (piano playing). It is an infinite advantage in every respect in this country to know some music.

I am as interested in all that happens in the family as if I were in Germany myself. Mary begs you to send more pictures; she has a very fine, big album and wishes to have as many pictures as she can of the whole family. What do all the relatives say about Julia? I have already given you the little news I have to report from here. Once more many thanks for your great kindness toward Julia and your kind gifts. Many, many greetings from Mary, Downing, Felix, Wheeler, the boys, and your loving daughter

Maria

Corpus Christi, January 2, 1870

Cordially loved Parents,
It was a great joy for me to hear from you once again. Above all I wish you with all my heart a happy New Year, and may kind Heaven let you live to see many more. It seems strange to me to hear that you are feeling decrepit with age, dear Father. I cannot imagine you other than hale and hearty, as I have always known you, and I hope spring renews you with fresh courage to tackle life.

Regarding what you write about Julia's travel expenses, I can only regret that they so outstripped what you expected. I know that the costs of such a journey are considerable. For we often calculated the expenses when Mr. Downing wished to take Julia to Boston, which is only seven hours by railway from New York, and $150 was the lowest option without undue inconvenience. Mr. Schübert stayed at a very shabby hotel in New York, and I know that all amusements, theater, etc., were at Mr. Wheeler's and Mr. Schübert's expense. Had there been time, I would have written to you in advance with details of the expenses of such a journey. It is too late to repent, and I beg you only not to let Julia know that this visit has far overrun the expenses expected. For she writes that she is so happy, enjoying charming rest and peace the like of which she never knew before. Felix always treated her brutally, and now he praises her to the skies, has her picture hanging above his bureau, etc. True to my design, I tried to save some money for Julia's music lessons, but in Felix's absence I have not been able to lay by anything. And now his right hand is so injured from a blow against the iron on the buggy that he has no receipts at all. He has not been able to do anything; we are in a big hole financially. I will lay by something of what Mr. Wheeler pays me per month, at least. Mary is now taking lessons and making extraordinary progress, though she has no piano here in the house and must go to town to practice. We think that Mr. Downing left Boston today and will be here by the 14th, Mary's birthday.

The Schüberts now live in Concepción, about 75 English miles from here.[40] All that I hear of her is that she likes it and is quite content. I like Mrs. Schübert very well and regret that our acquaintance was such a brief one. For she will probably not come to Corpus Christi often, as the journey is very fatiguing and tedious. I am glad that Mr. Kill-Mar liked Julia, and that she is welcomed by our friends and relatives. I am suffering with my foot again, unsure whether it is rheumatism or something else. I cannot rest it and am obliged to stay at home all the time, because I cannot put on a shoe.

Fare cordially well, kiss my Julia for me, and greet all friends and relatives from your loving daughter

—*Maria v. B.*

Corpus Christi, March 25, 1870

Beloved Parents,

Today, the 25th, when I am with you in spirit every moment, I will answer your last letter of February 22. Receiving letters from you means great joy for me. After reading Julia's letters, I always feel I would like to hear ten times more. Three quarters of a year have now passed since she left us, and it feels as if I miss her more every day, though I know that it is her good fortune to be away. For the circumstances here were very oppressive for her. She is as happy now as one can expect to be. The cold does not seem to matter to her at all. But rainy weather is what she fears. The masquerade and skating are prominent in the catalog of her pleasures. Schübert had promised that he would take her to Saxon and Switzerland.[41] But his own affairs engaged him so that he did not manage this. Mr. Schübert was with us last Sunday before his departure on Wednesday. He is radiant with happiness with his Auguste. In the whole of America he would not have been able to find such a wife. She is so content on the rancho that she did not want to come to Corpus Christi with him.

Everything is much the same with us. Felix has been at Rio Grande City on business for a month and will probably be back in a few days. Mr. Downing has a very good post as a bookkeeper in a big business here but daily expects an appointment from Governor Davis. They have always been friends, and Davis promised him a good post. Mary is diligent and mostly occupied at home with needlework for me. She misses Julia very much. Charley is now in a very good school, and the only question is how long he can stand it. From 8 o'clock in the morning until after 5 o'clock in the evening without coming home is too much. Richard and George will also begin school in a few days. Mr. Wheeler has now a government appointment at $125 a month.

Since 1 o'clock this morning I have spent every moment with you. The time difference between Berlin and Corpus Christi is something more than seven hours, and I wondered yesterday whether I would be awake when Julia's baptism took place. Downing had been out and came home at 12 o'clock. Just after that a violent thunderstorm hit, so that without effort on my part I remained awake, thinking of my little Julia. May kind Heaven bless and protect her.

That my dear Papa is now growing old makes me long more than ever to see him again, and let us hope that I will be given an opportunity to do this. It is a great joy for me that Julia fits in so well with her cousins. She writes

of all of them equally cordially, as if she feels herself among old friends. It is also a great joy for me to learn that Julia is making excellent progress playing the piano; this makes me infinitely glad. Mary takes lessons and is progressing very quickly, though we do not have a piano in the house on which she might practice, which rather impedes her learning.

Mr. and Mrs. Doddridge, friends of ours, will travel to Europe next month.[42] They are *very, very* rich and lost their only child, a boy of six or seven years, to yellow fever, and since that time they always travel in summer. At any rate they will come to see Julia, and I need not beg you to receive them as kindly as possible, as I am already sure you will. I do not know how long they will stay in Berlin. Every Thursday they have a party at their house, where old and young amuse themselves brilliantly and feast on the best fare. Julia will scarcely recognize Rachel Doddridge, as she has grown so fat.

Mary is ironing. She sends you the most cordial greetings, as also to everyone else in the house. Greet all brothers and sisters, nieces, cousins and aunts a thousand times from me and take my fondest thanks for the kindness you bestow upon Julia. Fare very well; write again soon to your

Maria

Corpus Christi, June 20, 1870

Beloved Parents,

For two months I have been waiting in vain for news from you or Julia, and this uncertainty about whether anything has happened at your end is becoming almost unbearable for me. The last letter I received from Julia was written only a few days after her confirmation, and since then I have not heard any more from her, though I write to her every Sunday. It is so wrong that she does not write to me every week or two. Today a year ago was the last Sunday she spent in Corpus Christi, and I have been preoccupied with thinking about her, and as a result I have felt more sharply disappointed over not hearing anything from her. A year has already slipped away, and we are giving up hope of seeing her again in Corpus Christi. However, nobody who knows this place and has ever been in Berlin can take it amiss. The difference is too considerable, especially for young people like Julia, who can find little here to amuse themselves. Mary feels forsaken without her and is not closely involved with anybody, though she has acquaintances enough and is very much a general favorite. Most of the young ladies here are very

frank and ill-considered in their speech and manners, and Mary is very reserved and modest.

I have taken over the music class at the school here, meaning that Mary now has to do all the household work. Felix has had no income at all in several months. Then I received this offer. I already have 16 students and earn $63 a month. It was to be $80, but school fees and my midday meals are deducted. Tuition for each child is $5 per month for three ½-hour lessons a week. I teach from 8 o'clock in the morning until 5 o'clock in the evening every Monday, Wednesday, and Friday. Assuming nothing gets in my way, I can be really grateful to see myself so independent.

As I am now away from home three whole days a week, Mary has much to do in the household, of course. If I only could get a maid, all would be well. But as it is now, the work is almost too much for Mary. However, it is the same here for many people—they cannot get help. There are so few maids in America. When new ones come, it is not long until they get married and begin their own households. Julia will tell you the circumstances of my getting a piano. It is my greatest pleasure to have music in the house again.

Mr. Downing's mother died on May 1st and left all the property to the other two sons because Downing came back to Texas. He has got along for so long without her help that he will surely do the same in the future. We are having awfully dry times here again, and everything is already suffering. I am getting on very well with my piano school, and I only wish I also could give singing lessons, in which case I should do much better yet. Mr. Wheeler still lives with us, though he has given up hope of ever seeing Julia again. He has a good salary and has built himself a nice little house and will probably recover soon enough from losing her. I do not see or hear anything from the Schüberts. They live as happily as the first couple in Paradise and seem not to be concerned with the rest of the world. When Schübert comes to town, he comes to visit us only rarely.

On the 1st of July Mr. Downing will also enter a government office, as collector of customs, with a salary of $125 a month. Mary could never have hoped for a husband more attentive to her wishes. They suit each other excellently well. I intended to leave Felix and move to town, but I could not find a suitable house for now and shall have to wait some months. Mr. Noessel died here fourteen days ago, and Mr. Littig eight days ago, both of them old friends of ours. Whiskey is the cause of all evil.

Every day I think how nice it must now be at Treptow, while here everything is parched. For several months we have not had any rain, though

in the last two days little showers have fallen. The boys are at school and will remain there until the 1st of July, at which point they start two months of vacation. I shall not take a break at my piano school but will go on instructing, all things being equal. Charley and Mary take piano lessons, the latter already playing quite well.

All the soldiers have left here again and the place is rather deserted. All indications are that war against Mexico is expected, and it almost seems that way, as all the troops have been ordered to the frontier.[43]

A month from today your wedding anniversary comes around again, and we all send fond congratulations, hoping you may enjoy many more together. On Wednesday it will be a year since Julia went away, and I am sure I shall not get through the day without sadness. Julia will perhaps scarcely remember it. I still have three more letters to write, and it is late. Therefore, adieu! Many thousand greetings to brothers and sisters, relatives and friends! The Downings and the boys send their greetings. Do not forget your loving daughter

Maria

Corpus Christi, Nueces Co., Tex., August 1st, 1870
Cordially loved parents,
Whether this letter will ever reach your hands is very uncertain, as according to the news here postal communication with Prussia has been interrupted. I was not astonished to hear from you of the impending war between France and Prussia; here people think and speak of nothing but war.[44] Everybody asks me whether Julia will come home before serious fighting breaks out. Of course I cannot answer other than to say that you will know best what needs to be done. Of course I should most like her to be here with me at such a time, as one can never foresee the outcome of a war, and it is not impossible that all communication with us will be cut off for a time; it would be very hard for me if I were in the dark for a long time about your and Julia's well-being. I know that it is cruel even to think of wanting to take Julia from all comfort, and I am sure that she herself does not think of coming back, and the longer she stays there, the less she will long for us.

And yet necessity has more than once wrung from me the wish that I might have her help. Mary has a kidney disease, and the doctor ordered her strictly not to do any hard work at all. Of course that throws everything

upon me, though I am instructing so many students. Seventeen is the number I teach now. I have not succeeded in finding a maid, though there are enough black women available here. How many German girls vainly seeking work in Berlin might find steady work here! Mr. Downing received his appointment on the Rio Grande with a yearly salary of $1,900. So Mary will probably also leave me again soon. Charley and Richard now do most of the work. Charley gets up at half-past three every morning, gets coffee ready, sets the table, serves the breakfast, and milks the cows all before we get up.

Aunt Rieben's death I regret with all my heart, as she seemed to be attached to Felix with great love. I know she did not think much good of Felix's mother and father; she told me so. As for her having promised us an inheritance but then apparently left nothing, I do not miss what I never possessed and feel no regret—although if she could have seen who most needed it, she would perhaps have made other arrangements.

Has Julia ever mentioned Mr. Wheeler to you? I guess he still hopes she will change her mind. I believe that he still feels attached to her. Do not tell her anything of him, so that she does not think we wish to persuade her in his favor. Let her do what she thinks best for her. For we can never predict who can make her happiest. Her cousin's wedding certainly made a great impression on her, and I hope she will not commit herself to someone in Berlin just so as to enjoy similar festivities herself.

Felix has returned from Austin, and we now have a music room and his office under one roof. I am writing to you in his office, and as it is evening already, I will close. I have just learned from the newspapers that all American travelers in Europe are now being advised to return home. So the war must indeed be thought imminent. The Downings and children send many greetings. Give my greetings to all brothers and sisters, relatives and friends. Give Papa my heart's fondest wishes for his birthday. Kiss my dear little Julia and remind her to write often, as under the present conditions of war, I may not receive all the letters. Fare cordially well, and write soon to your loving

Maria

Corpus Christi, Texas, August 20, 1870

Beloved Parents,

Just when I have got everything well arranged for my piano school, Mary must go away to Rio Grande City, where Mr. Downing has a good appointment as inspector of customs with a $1,900 salary, as I told you in my last letter. A colonel who used to be here in Corpus Christi has come from there and will take Mary back on Thursday. She was willing to wait two or three more months yet, if I would make Julia come back, so that she might supervise the house while I am away instructing, and she offered to pay a maid $5 a month so that Julia would not have to work so hard. I should never have resolved to write to you about it but for our friends thinking it to be unjust to Mary and myself for me to be intent only on Julia's comfort. I therefore beg you to ask Julia's opinion, and if she feels in the least awkward about it, thinking she can no longer be happy here, let her stay safely where she is, and I will see how I can get along without her.

When we first talked about this, I could not conceive of asking Julia to come back at all. I knew the change would all be too great. But listening to all the others and seeing that they are happy and content here helped me make up my mind to write. The chief thing is, if you have become so accustomed to her that you would miss her, do not say a word to her about it but keep her as long as it suits you to be together, for my going away left you lonely enough.

This does not seem to be the best time to speak of journeying in Europe, while war is raging there. On the other hand, should you decide to part with her, she may more readily find company now, as many Americans are returning. In that case she would do best to come to Galveston, which costs less and is a landing point not too far from here, and I should prepare somebody there for her arrival. I will try to get a draft for $50 on a Hamburg house to help her pay for the return journey. I guess the price to Galveston is $125 or $150, and from there I would pay her passage to Corpus Christi. I cannot well imagine that Julia will be inclined to come. Yet have I often heard that people have a soft spot for their birthplace. And if this is the case, after the initial shock she may perhaps resolve to give up her friends and pleasures there, if you are willing. Everybody asks me whether Julia will return when Mary goes away, and it was only thus that I arrived at the idea.

If this letter causes sad moments, as I can imagine it may, I am sorry to have written it. I am well aware that it touches upon Julia's whole future, and that is why it was so hard for me to write. Nevertheless, I am brought to

this by circumstances. I have been much more content since acquiring my independent income, being able now to send the children to school and to dress them well. My social position is the same and perhaps still better, because I go out more. I now play the organ for the Presbyterian Church, and if Julia should come back, I should be very glad if she could sing a little at church. Mary takes singing lessons with me and piano lessons, and I should make Julia continue too. I hope you will not think the worse of me for speaking of Julia's return and am sure you will soon resolve whether it will be very hard for her to leave you, in which case I shall be able to get along without her. Mr. Downing will perhaps have the appointment at Rio Grande City for several years, and of course I cannot demand that Mary give up Downing so long because of me, especially as she is attached to him with all her soul and it was only to help me that she did not go with him at once.

The war in Europe occupies all minds here, and everyone is anxious to settle the issue, as if our own lives depended on it. Of course we are much interested in the affair, eagerly reading all the news we can lay hands on. It arrives in the North from Europe in a few hours by telegraph and gets to Indianola from there in a few more hours by the same means. Do write and tell me which of our friends and relatives have seen active service.

Fare cordially well, and many, many greetings to the family. Many kisses for my Julia! The children all send greetings, Mary especially. Write very soon to your

Maria

Corpus Christi, Texas, November 20, 1870

Dearly beloved Mother,
I received your dear letter dated October 10 on Nov. 14, and you can well believe I sincerely enjoyed hearing from you again. Since the middle of September we have had no communication with the outside world because of the quarantine; I could not even write to you.[45] As for Julia's return home, I am sure you will have received one of my letters assuring you that I do not insist on her return but, on the contrary, wish she may stay with you as long as you are willing to keep her. I am convinced that she has many more comforts with you, though you say yours is a simple life. Mary is still here and will probably stay over the winter. Do not burden your heart about Julia's return, but enjoy life as much as you can.

We have received sad news about the war conditions. The last news telegraphed was that they will bombard Hamburg.[46] This would really be sad, and you would wind up seeing more of the war than you might wish, and I am really alarmed about that. Everybody here takes the greatest interest in the progress of the war and is anxious about the issue, though with different views and leanings about it.

Mr. Downing is still in Rio Grande City, and he is very well off financially in his present position. He thinks of remaining at it for some time and will then build a little house here and take up a different position that has been offered to him and will remain reserved for him—not, however, as well paid. Yesterday Mary paid $125 for bedroom furniture he is having sent from New York, and he is gradually getting everything shipped, and I see from this that he is earnest about remaining here. So far Felix has not gone away, and he will perhaps not get the work he was expecting, in which case he will be staying. I have 15 girls for piano instruction. Then I teach the Spanish class at school for ½ an hour each morning. You can well see from this that I have no time to myself. I never go out after coming home in the evening, so I live a very isolated and regular life. The boys are learning well at school, and I am rather satisfied with their progress. What does their Papa do during the long winter evenings? He does not go out; he must find reading for hours just too fatiguing.

Many thousand greetings to Papa, brothers and sisters, nieces, aunts, and all friends who remember me. Farewell and write soon to your loving

Maria

P.S. Charley's health and whooping cough are much better, thanks be to God, since he has been taking a medicine the doctor prepares for him.

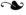

Corpus Christi, Texas, February 12, 1871

Fondly loved Parents,

Today at last, on Sunday, I have time to answer the letter I received last week. I am deeply dismayed to hear that Papa's eyes are now so weak that I scarcely can expect a letter from him. His firm, steady handwriting has always been a delightful sight for me. I hope spring will fill him with fresh strength and vitality again and that many a note from him will reach me yet.

Our winter has been extraordinarily mild up to now. Today we are astonished to find it has grown cold and rainy all of a sudden, so that all of

us crowd around the fire. I have not heard anything from Julia these past seven weeks, and I have no idea what can be causing such a long silence. We had hoped she would send us a description of how she spent Christmas. Felix has now been away from home for more than two months, and of course nobody hears from him, and I have again had to provide for all our needs. The three boys now have the demands of grown-ups but are not yet able to see to things themselves. Charley was 15 years old the day before yesterday and is taller than I. He is the best or surely one of the best pupils in the school, I guess. You can certainly imagine that I have my hands full. Every day I teach from 9 o'clock in the morning until 5:30 in the evening, with only a ½ hour for the midday meal. In that time I have dinner with the children, which I cook on a coal-oil stove. I have 18 music students three times a week; a ½ hour of Spanish and a ½ hour of French each day; and German spelling and reading twice a week. From April 1st, 1870, to January 1st I earned more than $700. But as I have to bear all the expenses alone, I did not use more than $3 or $4 for myself. Felix of course likes the arrangement very well; he travels about and amuses himself ever so well. Mary has remained with me and cannot make up her mind to leave me. But Downing will probably come driving along and take her away with him, for he is unhappy alone. He is more than willing to care for me, but what would become of the boys? As long as I can work for myself and the children, I shall do so. I am convinced that I am happier earning my keep than living on charity. Mr. Wheeler still lives at our place and will probably continue to do so as long as Mary is here. After she leaves, I shall have to shut up my house and he must find lodging somewhere else in town.

I cordially thank you for your New Year's wishes. Mr. Schübert was here last week. He grows fatter and fatter, being now nearly as broad as he is tall. He lives very happily with his wife and is as comfortable as one can be in Texas. She would like me to visit their rancho, but I cannot leave my school.

I should very much like to write you a long letter, but it is so cold in the room and so late that I must close. Greet Papa ten thousand times from me. Many greetings to all my dear brothers and sisters, relatives and friends, aunts and all cousins, and especially Julia. Fare cordially well and write as soon as it is possible to your loving daughter

M. A. v. Blücher

P.S. Be so kind as to inquire how much a good Spanish-German or Spanish-English dictionary costs.

Corpus Christi, April 22, 1871

Fondly loved Parents,

I have had your dear letter in my hands for some weeks, and I cannot describe the pleasure it gives me to receive such lovely long letters. Oh, what I wouldn't give if Papa could still write to me as before. I hope with all my heart that in spring his eyes may grow better again and his depression may lift. Perhaps the return of the troops and peace may breathe new life into him.

I often think what a comfort it would be if Julia or one of our cousins were here with me; for after my day's work I have no chance of taking a rest but must keep plugging on from morning to night. On the other hand, however, I also know that Julia would scarcely be able to be happy here again after having been in Berlin, and I will bear my yoke indefatigably as you do, dear Mother. Mary of course has quickly set up her household with Mr. Downing. She has an extremely agreeable life there and no affliction of whatever kind, though Rio Grande City is miserable.

Wheeler told me he would be writing to Julia once more. I thought of advising him not to do it, but it will be better for him to hear directly from her what she has to say. She never mentions him in her letters. He on the other hand will not give up hope. My only wish is that she not leave his question unanswered. It would be unforgivable, for he awaits her answer in anxious suspense. He wishes only that she might be his. I have no advice to give her and will support her whatever she decides. I wish I might now know her opinion and could spare him the uncertainty. He seems entirely unable to accept that they will be separated forever. In any event, do not bring this up with Julia unless she speaks to you of it herself.

As for me, I have 22 students. When one leaves, I already have others waiting to start. Charley and George are very diligent at school, and I hope that one of them will get a prize. George is small and very, very thin. I still have much to say, but it is night and I must be on the move early in the day. So a cordial farewell, and greet and kiss Papa daily for me. Greet Julia and the brothers and sisters, relatives and friends from your loving

Maria

Letterhead of Felix A. Blücher & Co., 1871. Charles F.H. von Blücher Family Papers, Special Collections and Archives, Mary and Jeff Bell Library, Texas A&M University–Corpus Christi.

Corpus Christi, June 28, 1871

Cordially loved Mother,

Receiving your dear letter some days ago was a long-awaited joy. It dampened my happiness, though, to hear that our dear Father has been ailing, and I so hope that the summer at Treptow will restore him. What would I not willingly give to be able to be with him, joining the rest of you in trying to cheer his days, and nothing could prevent me from coming but the impossibility of leaving three boys in good hands during my absence.

I think you are wrong concerning Julia, dear Mother. I do not believe that she entertains the slightest desire to return. Charley says if all she needs is an escort, he will fetch her. And as for marrying, I think she does not entertain the least wish in that direction. Mr. Wheeler's letter has not been answered as yet, and of course he takes this as an unfavorable sign and will therefore leave us today or tomorrow. He offered to sell Felix his nice little house, which stands on our land, for a very low price. Felix has had our house renovated, and it looks very good again. As for the money I sent to Julia, she will certainly have told you by now that Felix contributed the greater sum. He gave it to me to send to her. And of course I am glad to save you some expenses. But above all she *must* fulfill my wish to take singing lessons. I will always pay for this. How well she would now be able to sing if she had taken lessons these past two years. Every girl sings here. Knowing that she has a very good voice, I wish Julia to try.

You regret my position as a working person. It is true that it is rather hard not to have a moment to spare. Yet I am paid well, and it seems to have had a good influence on Felix. It is possible that I shall soon cease teaching. Felix's new land agency has already earned much money.[47] It's just that everything is so expensive here that even so, one does not save much. Yesterday was the school examination, and my hope that Charley would get a prize was dashed because of his bad eye, which caused him demerits for absences. It depends on the number of good marks. Though he was absent for a week, she who won the prize scored only one point higher: Dora Lawrence scored 14; Charles 13. George, however, earned his prize. I am sorry for Charley.

My time is so fully committed that I must close now. Mary is still at Rio Grande City, wishing herself back here. Many thousand greetings to all family members and friends, chiefly many kisses to Papa and Julia from your loving daughter and the boys

—Maria

P.S. You write of Julia's delicacy of feeling in not declaring her wishes. She learned that early and deals with it with rare resignation.

Corpus Christi, September 27, 1871

Cordially loved Parents,

I received your dear letter two weeks ago, and I can scarcely describe my joy at seeing the well-known and long-missed characters of Papa's hand again. I was so constantly anxious because of Papa's eyes that only this visible proof of his improvement could give me comfort. Day after day I have tried to find time to reply, but as yet I have found it impossible, as the days are shorter and I have lost Charley's help. He drove to Rio Grande City in our carriage to fetch Mary and I am now expecting her at any moment, but she left Charley with Mr. Downing, so that I am not much better off, as he can do much for me that Mary cannot do. Mr. Wheeler and the coachman will come along with her. Though Mr. W. no longer lives with us or has any further intercourse with us, his friendship with Downing seems to have remained unchanged. People in Germany would not be able to imagine what traveling is like here. Mary will spend perhaps four or five days and nights on her way from Rio Grande City, putting up only once at Santa Gertrudis and staying the rest of the time out in the open air, in rain or shine. Felix continues his old ways; working a little, then drinking again until the money is at an end, then he recovers for a day or two, and then he goes away again. I have a good number of girls as students, and I thank God I am able to help myself and my children. I now earn $75 per month, and from October 1st it will be $83. You must not be angry if I let Julia have part of it, dear Father. For many months last year I earned $100 a month. During the greatest heat of the summer some of the girls went away. I earned more than $1,000 last year in all, not without effort, of course, but also not entirely without pleasure. I bought a good piano for $250, and likewise a good cistern and many other things that were useful and agreeable to me. And the main thing is that I sent the children to school, except Richard, who had to undertake managing the house after Mary went away. Mary intends to help me all through the winter, provided nothing happens to call her away. After all that I have written here, you will probably find it under-standable that I am pressing so hard for Julia to develop her talents in music and singing, as it might yet be that even against her wishes, circumstances might oblige her to come back here. And it is an infinite advantage in a

place like this one to be a little gifted or to possess a cultivated talent. Where the young people continually push aside the older ones, as in Germany, singing and playing are soon over for those who are married. So far things are otherwise here; both old and young can achieve prominence this way. I have little hope that Julia will return. She has already been with you too long, and it would surely be strange if she should resolve to take such a step. Nor does she speak of it any longer, and she probably thinks of it still less.

We now have a telegraph office at Corpus Christi, and news from here might reach you in a few minutes via an Atlantic transmission.

I hope you will forgive me for writing such a short letter, as it is already going on 10 o'clock in the evening. Fare cordially well! Thanks for the letters, and do try to write again soon. Many kisses from the children and greetings for all from your loving daughter

<div align="right">*Maria v. B.*</div>

P.S. Mary has arrived and sends her greetings.

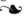

<div align="right">Corpus Christi, March 26, 1872</div>

Fondly loved Parents,

I received your dear letters with the greatest joy. Julia's state of health has greatly alarmed me, as her illness must cause you uneasiness and many an inconvenience. I hope with all my heart that spring has brought recovery to her and relief to you. If it really is a nervous disease, there is little hope that she will be fully restored. I inquired of the doctors here, and a change of surroundings was recommended as the best and most secure approach. So I expect every good when you move back to Treptow.

Julia was so charmed with her rich Christmas gifts and birthday presents that she described them all to me, which I enjoyed. Mary is impatient to have Julia with her again. Nevertheless she knows that even if you could do everything in the world for her, you would not be able to replace her present home. Downing has a good position. They live in a genteel way and continually have in their home the best company to be had in Texas. The Downings are both very popular, as is apparent not only from people's remarks but from the thousand attentions bestowed upon them. The children and Felix are well. Charley now works hard with his father, and Felix expects he will make an excellent surveyor. The only problem is that he never had an opportunity to learn drafting and will scarcely make such

excellent maps as Felix, who sometimes receives $150 or $200 for one map. We have now refenced part of our property, which is very agreeable to me. As before, I give lessons, which is a great help. We have a new light carriage and good horses, so that going home in the evening, I am spared the trouble of tedious traveling. Richard has saved some money and bought a nice little donkey for $8, giving him and George great pleasure.

As a result of the tremendous drought we had an awful cattle plague here. Half of all the cattle in Texas died. Felix told me that on the Nueces River, at every prominence where one can overlook the river, one might count more than 3,000 dead cattle. The river has now been settled up for 60 to 80 miles by acquaintances of ours. And this pile-up of corpses stretches all along the inhabited sections. How much farther it extends I cannot tell. How many millions cannot be counted. It sounds incredible, but it's true nevertheless. A man gets $2½ a day for stripping hides off dead cattle. Everyone can take what he can get. Each hide brings $5. The owners of the animals cannot get enough workers to skin their animals.[48]

I must restrict myself to this small page; but between my lessons I have already written three letters. Many greetings from Felix and the children to you, Julia, brothers and sisters, relatives and friends. Many kisses from your

—M. v. B.

Corpus Christi, June 22, 1872

Fondly loved Parents,
All day long I have tried to make time to write you. For today it is three years since Julia left us, and each year I have been very aware of that date. The drought that ruled here for months came to an end some weeks ago with a terrible thunderstorm. Nobody here had ever experienced such lightning or strokes of thunder before; six of them were indescribable, and each of them struck. For a long time the storm remained just above our house and the nearest surroundings, where it did considerable damage. One bolt of lightning hit the house in front of ours, Chapman's house, destroying part of the roof and singeing all the shrubs in their fine garden. To the right of us, at some distance, a stable was hit twice, killing a horse that had cost Dr. Karney $300. And inside his home the strike was such the doctor was benumbed for a while. He left the house at once, before breakfast the next morning. The fence separating Mr. Büsse's place from ours was thrown down, and lightning also hit our pond. Charley and I sat up the whole night

through. It began at 11 o'clock in the evening and lasted until 5 or 6 o'clock in the morning. All the violent strikes came at 4 o'clock or a little before. Yesterday at noon we had another thunderstorm, although short, and the lightning killed a man and horse. He was a traveling merchant and had come 300 miles with six laden wagons, and just as he reached the first houses of Corpus Christi he was killed. Thunderstorms have always seemed to me sinister, and now seem yet more so.

What you write, dear Mother, concerning the sale of Mr. Kill-Mar's house must be mistaken or a handwriting error. For 600,000 thalers, the sum you give, is more than half a million dollars, and that cannot be.[49] I never reckon on inheritances and in that respect cannot be disappointed. I have wished we had more wealth because of the children. Once the time when an inheritance might improve their education is behind us, I could not care less.

Included you will find a $5 note. Give Julia the benefit of it; she will certainly find use for it. Felix has done very well in business. Our house has been significantly improved, and he has himself gone to a wedding with me. Perhaps I shall go with him to Santa Gertrudis for some weeks and let Charley and Richard take charge of the house.

I was interrupted and must close. Kisses for Julia, Papa, and all the rest; a thousand for you from all and your

<div align="right">*Maria v. B.*</div>

<div align="center">Corpus Christi, October 29, 1872</div>

Fondly loved Parents,

My sincerest thanks for your congratulations on my birthday. May kind Heaven long let you enjoy all good things and remove every affliction and woe from your path. I offer Papa my greetings and best wishes for the celebration of his eightieth! What joy it gave me that Julia had such a magnificent excursion; she wrote downright enraptured. Until then she had always believed Treptow to be the nicest place she might see, and it has done her health more good than any medicine. I hope with all my heart that the winter will not dent your health, for this year the summer had much to make up for. How I should like to be with you and try to give you comfort.

The hope of Charley going to Germany next spring has come to naught with Mr. Müller's unexpected death. He was shot for $5, bequeathing his

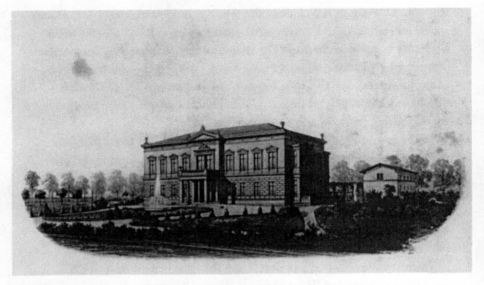

Caroline Cottage, home of George Kill-Mar, Felix A. von Blücher's stepfather, in the Tiergarten district of Berlin, ca. 1870s. Charles F. H. von Blücher Family Papers, Special Collections and Archives, Mary and Jeff Bell Library, Texas A&M University–Corpus Christi.

black housekeeper $20,000! The last time he was here, he spoke of what he would give our children because we took him in when he fell out with his wife. He was giving Mary a town lot worth about $500. He intended to take Charles to Europe and send him to school there for two years at his own expense. Death has cut off all of it. He met his end at the very place that had belonged to Felix when Müller first began to lay the foundations of his property and wealth.[50] Murder and bloodshed are now so general here that we do not venture to go out even for a picnic, not 1½ miles from Corpus Christi. All the scum from Mexico knocks about on this side of the Rio Grande. Mary will probably return to Corpus Christi. Downing expects to be selected as a representative to the legislature. Then he would go to Austin during the session, and Mary would come to me and occupy her elegantly furnished little house on our land. Downing bought her a new sewing machine with ten additional features, costing $150. He paid us a visit some weeks ago. I did not recognize him as he has become so fat. He weighs more than 200 lbs. Charley weighs 157 and Mary 152, and I weigh only 127. They have all outgrown me.

Dear Mother, write to me soon and greet all dear relatives and friends cordially from me. A thousand kisses for you and Julia from us all and especially from your loving

Maria

Corpus Christi, December 29, 1872

Fondly loved Mother,

This is the only bit of paper in the house, so for this time I must restrict myself to it. Christmas has happily passed and the New Year draws near. I wish we might begin it together and live near each other in peace. You astonished me with the change of prices in Germany. Did Carl not make arrangements to compensate you at all for the immensely increased value of the house? It must indeed have doubled in value, and if all expenses have risen in proportion, the income should likewise do so. I am really indifferent concerning Kill-Mar's riches. I am not young enough to hope for better times or think of justice. By now all such promises from him have ended for us as empty words.

Julia's letter is still quite filled with her journey to Teplitz.[51] I believe that she intends to remain unmarried. All her friends have been married, while she rejected the best proposals. So she must indeed intend to devote herself to her books alone.[52]

Felix has had the interior of our house refinished, and that makes it more comfortable for us. Charley is back in school, as are Richard and George. The Downings did not come for Christmas as I had hoped.

Every day I remember our dear Papa. How grievous it must be for him to have his sight gradually fading. Distress is everywhere! Greet him a thousand times from me and tell him that I feel this affliction with him, wishing I might be with him. Greetings and kisses for all of you as well from your loving

Maria

Corpus Christi, March 10, 1873

Beloved Parents,

I made up my mind today, on my wedding anniversary, to address a few lines to you. Two weeks ago, after a long wait, I received a letter from Julia. She gave me a description of her Christmas and birthday presents. I had

hoped to see Mary here for the holidays. I had to give up this hope as Downing resolved to stay in Rio Grande City. Before this reaches your hands, it will be spring and you will have the prospect of seeing your pretty Treptow soon. As long as you have gotten through the winter, then I do not fear for your health as much. Throughout the winter we had bad weather—stormy, misty, cold, and for a change, rain. Now everything is magnificent and green. In spite of this, the cattle are sick and are dying by the thousands. We, thanks be to God, are hale and hearty. My friends put on such a festive time for me today that I should like to celebrate my silver wedding anniversary next year in your home and together with you. I wish so myself with all my heart. If I am to see Julia again, I shall indeed have to come to her, as she does not think of returning to Corpus Christi. I do not blame her for that.

I have so little time left for writing. I am always occupied from morning until deep into the night. For Felix's vice is constantly increasing, as is always the case with drinkers. We now have free schools like in the North, which means savings. I should like to get some silver teaspoons, as these things are much more expensive here than in Germany, at least I think so. Mrs. Doddridge had a nice silver cake cutter sent from Philadelphia and paid $15 for it. This seems to me too much. And a set of oil and vinegar casters for $175; a single tablespoon for $30. These are very high prices. I still have only one or two silver teaspoons to my name.

Farewell, kiss my Julia for me, and remember your loving

Maria

P.S. Please tell Julia that I sent her a book, *Shakespeare's Works,* and a piece of schottische dance music.

Corpus Christi, April 27, 1873

Fondly loved Parents,
Having just a few moments to myself, I know I cannot make better use of them than to write to you. I duly received your long, dear letters, beloved Mother, and I see from them with great regret that your feet now cause you greater trouble than before when we all hoped that Teplitz might have cured you, at least for a time. I hope Treptow will bring you and Papa good health. We all feel a little ill: colds. Unusually late in the season, we had very cold north winds, which probably are the cause. Mary is impatient for me to

come and visit them. If I can somehow arrange it, I will pay her a visit this summer. The Downings are happy and content—living "in high style" is more like it. General Sheridan and his staff and the minister of war have been in Rio Grande City, where they had big festivities.[53] Mary has grown very stout, so everyone tells me. When I go to visit them, Mary intends to come back with me, which of course would be very agreeable to me.

Charley has now made up his mind to study medicine. If Felix fulfills his promise and can give him $1,500 during the three-year period of study, he will have learned a decent profession. Concerning my former proposal to send Charley to brother Julius, I probably judged the matter from the local standpoint. Willing as the Americans may be to impose upon each other, on the other hand one finds them so helpful, especially in families. It seemed natural to me that Julius would be prepared to regard Charley as a son, as his only child is well provided for and cannot render helpful assistance in his business. I expected this all the more as I have always understood that Julius is very rich, and several years ago he assured me that he would do some-thing to offer me lasting advantage. For my part, I need little, but for the children I will of course secure as many advantages as possible. I hope that Charley may prove worthy at his profession and thus secure his own future.

I have caught such a cold that I can scarcely recognize the letters. Fare fondly well, kiss my Julia, and many greetings for all the other family members and friends. Greetings from all here! Write soon to your loving daughter

<div align="right">*M. A. v. Blücher*</div>

P.S. Greetings to Hermann Blücher's family. Last night I dreamed Julia had returned!

<div align="right">Corpus Christi, September 7, 1873</div>

Cordially loved Parents,

You have surely wondered about my long silence. For two months I have been firmly resolved to write every Sunday, but each time I was prevented from it. Sunday afternoon is the only time I have free. My acquaintances know that, and so they generally choose that time for their visits, all the more so as Mary was here. For four weeks I did not feel at all well and was obliged to give up teaching. My neck and lungs were affected too much. Now, thanks be to God, I am much better again, and I played again at church today for the first time.

On Monday, September 1st, Mary left me alone once more after having hoped in vain to see a letter from Julia while here. She gave up expecting to receive even *one* herself a long time ago, though she and Downing always still write. I cannot grasp what has changed her like this. In a few years she will surely no longer write a word to us and will scarcely remember us. When I consider how closely united the girls were before and how affectionate and devoted Mary is in every respect—no week passes without my receiving a letter from her—I cannot begin to imagine how Julia changed so quickly. I sent her books and bought more for her here but do not know whether they arrived or not.

We are all greatly alarmed about the cholera said to be raging so badly in Berlin. Of course we are all the more anxious to know whether you are all in good health. Under such circumstances it is a great comfort to receive letters. Thanks be to God we have not had any disease in Corpus Christi, and our family is in good health.

I have not heard anything at all here about the Vienna Exposition.[54] Many of our acquaintances have traveled there, but no one has yet returned. Did any of them pay you their respects? Several asked permission, but whether they will make use of it is doubtful. You will certainly have heard from the girls about my excursion to Santa Gertrudis. I amused myself extraordinarily well.[55]

Like Julia, I have had diversions. Just now I received a note with an invitation to drive to the "Grand Tournament." Fine prizes will be given to the best gentleman and lady riders who wish to try their luck. This is something new here. We have had bullfights, menageries, the circus, ventriloquists, etc., and all kinds of amusements that we formerly knew only by name.

A thousand kisses for you from us all and for Julia! Greetings for brothers and sisters and all nieces and nephews and all friends who remember us. I no longer hear anything from brother Julius at all!

Your loving daughter—M. A. v. Blücher

Corpus Christi, November 9, 1873

Cordially loved Parents,
Your last letter, written on my birthday, I received a short time afterward, and I was glad that you beloved ones were all safe and sound. What would you say to celebrating my next birthday together? I am firmly resolved to

pay you a visit next year. Mary and George will come along with me. We want to leave here at the end of April and stay until fall, if nothing happens to destroy our plan. Mr. Downing thinks I should go and will do all he can so that Mary can accompany me. I think $500 will cover the round trip for George and me. Charley and Richard must see how to get along with Felix. Charley would give much to come, but that will not be possible.

I fear Julia will not be pleased by the news, because she may well think that we would like to take her back with us. But that has not entered my mind. If you are content to keep her and she herself is happy, she is better off with you. Mrs. Noessel wishes most anxiously to go along with us in order to visit Sophie, so that we are four (4) already. As for George, I could not see leaving him at home. For a fortnight I have been doubtful about whether to write of this or not, as something could so easily come up to prevent it, in which case we alone would have to bear the disappointment. This is the reason I did not answer your dear letter at once. Nevertheless, I have resolved to let you know of my plan. I thought it would be something for Papa to chat about and reflect on in the winter. If you fear that the change and trouble will perhaps bother him more than delighting him in his old age, dear Mother, then you had better not speak of it. Of course we wish to disturb your quiet household as little as possible while still being close by.

I can well imagine that Julius' attacks of illness fill you with great alarm. Doesn't it perhaps come from his heart? You know you had similar fits, chest complaints, and fainting episodes afterward. If it becomes difficult for you to write, dear Mother, let Julia do it for you. Julia seems quite taken with the idea of having talent as an author and with the opportunity that such a profession offers for pleasant travels. I advised her to translate books and other literary works. Perhaps she can satisfy her love for writing that way. She writes very nice German letters to me.

Our railway works will begin this week. Felix has been appointed engineer. Tomorrow they will set out from here in order to survey the route and pinpoint destinations. Charley will go with them as he knows how to handle the surveying instruments as well as Felix.[56]

I must tell you the sad news that the Wheelers lost their little son to croup. He is altogether depressed. The baby was just thirteen months old when he died. My heart bleeds for them. He was a cheerful, nice little baby. The Wheelers lived completely for their child. He built a nice house a mile

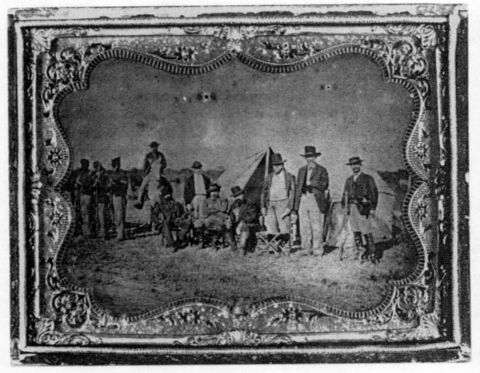

Felix A. von Blücher Surveying Party with Soldiers Present, South Texas,
ca. early 1870s. Felix von Blücher standing in front of tent. Charles F. H. von Blücher
Family Papers, Special Collections and Archives, Mary and Jeff Bell Library,
Texas A&M University–Corpus Christi.

from the shore, as the sea breeze was too strong for the baby. He drives
home from his office at 3 o'clock and then nobody sees or disturbs them
until the next morning.[57]

I must close now with a thousand fond greetings to Papa, Julia, all the
cousins, brothers and sisters, and all friends from former times. Mary and
the boys send their greetings. Many congratulations for your imminent
birthday. I hope this comes in time to offer them to you from

Your loving daughter—M. A. v. B.

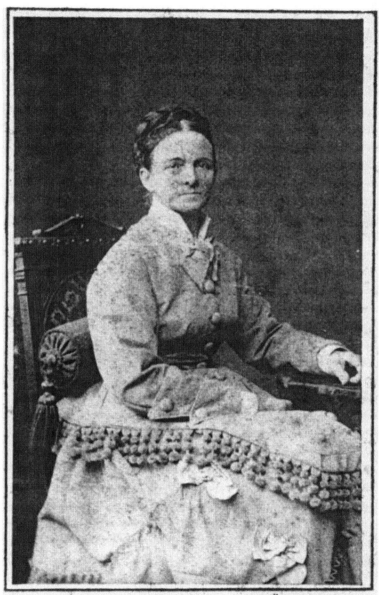

TH.PRÜMM, BERLIN

Maria Augusta Imme von Blücher, ca. 1874–1875. Charles F.H. von Blücher Family Papers, Special Collections and Archives, Mary and Jeff Bell Library, Texas A&M University–Corpus Christi.

Corpus Christi, February 18, 1874

Dear beloved Mother,

I address my letter to you not because it contains some special secret but because you alone write to me. Nevertheless my letters are meant for Papa as well as for you. I received your last dear letter, of January 8, at the end of the same month, but am sorry not to have heard a word from Julia this year. At other times she always wrote to me instantly after her birthday and told me about the Christmas festivities and the presents she received. This year I did not hear about any of that.

The railway work is in progress and when Felix, Charley, and Richard return, I shall set out on my journey. Probably Charley will come instead of George, as I should like to see whether he can study there. For Charley has Felix's talent and memory but has not had the chance to develop these.

Now it is my wish above all other things to cause as few inconveniences and changes in your accustomed situation as possible. Therefore I thought, if it would be more agreeable, I should rent a little apartment of two or three rooms for a while. How long I can stay cannot well be fixed in advance, as it depends entirely on how they will get on at home here during my absence. In summer of course I shall go and stay in Treptow; only do not displace your dear tenants, with whom you have enjoyed such friendly relations; it would spoil much of my joy. Mrs. Savage, the wife of the chief engineer on the railway, will leave Corpus Christi the day after tomorrow to receive her inheritance in Berlin and to take her daughter, Aliza, to school. This daughter is from her first marriage and is indeed an amiable, vivid and charming little woman. Mrs. Savage has been married again for just a year to one of the most excellent men, four or five years younger than she is. And she thinks it better to send Aliza under severe control, as Papa would totally pamper and coddle her. Mrs. Savage intends to pay you a visit. It is her wish to know you. She will start out at the same time as this letter. At first sight, she is an intimidating woman of distinguished appearance. You will find her very cordial and amicable. I chiefly wish Julia to be on friendly terms with her.[58] I have been to her house in the evening several times a week, but I have *never* hosted her at our house. My time is so occupied that I really could not undertake it, and I should not like her to believe it to be a family fault to offer so little hospitality. I should very much have liked to come with her, but Felix wished me to wait until they come back from the survey. I expect to start from here at the beginning of May or at the end of April. Mrs. Savage also intends to rent some furnished rooms in order to spend

some time agreeably in Berlin. Her father was Mr. Scheibler; he must have been a very rich man. She brings a little gift for Julia, which will probably be agreeable to her. She is very clever and you will all probably like her a lot. I hope Julia will become good friends with her.

It is still not yet fixed whether Mary can come with me or not. I wish Felix would just give her the necessary money for it, but he is not thinking of that. He promised me $1,000 if I go with Charley. For George I would have to pay the passage of a grown-up, and therefore we thought it better to give Charley the opportunity.

Friends have already urgently invited me to their homes, begged me to visit acquaintances in Galveston, and given me addresses in New Orleans to arrange comforts for the passage. I have no idea when the Schüberts will go to Germany, but I guess very soon. It is late, and I will close my letter. I hope you will have a pleasant time with Mrs. Savage. I shall give her some lines for Julia; she begged me for them.

Now all fare cordially well until we meet again. Many greetings for brothers and sisters and friends. Kisses from the children for Grandpapa and Grandmama and Julia, from your loving daughter

M. A. von Blücher

P.S. It occurs to me that you wanted to hear about Wheeler. I wrote at that time how two years ago he married one Miss McCambell, a nice little goose!

❧

Corpus Christi, April 4, 1874

Fondly loved Mother,

Right on March 10 I received your dear letter and cordial congratulations from Papa, and I regret only that Julia did not remember us. A letter for George and a postcard came at the same time, but no word of congratulation for my silver wedding anniversary. I had no celebration at all; everyone was away from home except George, and so the day passed quietly. Mrs. Doddridge had sent to Philadelphia for a mustard spoon, a sugar spoon, and some salt spoons, all richly worked and richly engraved with monograms; and Philip Fullerton presented me with a silver thimble. George made me a present of two thalers and was very sad that I did not accept them. Late in the evening I received the silver wreath with congratulations that you, dear Mother, placed in it. Cordial thanks for it. Felix is not yet back with Charley

and Richard and will perhaps still stay away three more weeks. Due to their absence, I cannot yet say with certainty when I shall leave. The weather has been so bad that they are not advancing too fast with the railway survey.

Mrs. Savage will probably have reached you now, when I am writing this, and I only hope that you will like her as well as I do. I wrote about this to Julia. Her husband is an excellent and also influential man, who worships this woman.[59] In this regard I hope Carl is not like Edward with his "family only" idea. There are many nice people outside the family.

I now expect the Downings daily. He has given up his position in Rio Grande City and has got a similar one here, which is more agreeable to me but I think less so for the Downings. At Rio Grande City they were so popular and the center of society, and here we lead a more retiring life, though we should not lack society if we sought it more.

I wrote to you some time ago that Mr. Wheeler has already been married for two years. He lost his first son, and now they have a little daughter. I see them very seldom, as they keep to themselves and do not take part in any amusements. She is such a strange creature; no man can bear her. She is young and looks quite nice, but her mood changes from day to day.

Today is Easter Sunday. I dyed three dozen eggs and hid them for George and our Mexican boy. That was the extent of our celebration. I heard that the Schüberts went to Germany but could not find out when. He has sold out and quit his rancho, and that is all I know. I never see Mr. Büsse; he sticks to common, low company where he seems clever and is regarded as an oracle. I guess he lives from hand to mouth as always, without ambition.

Tell Julia that her revered Lieutenant Tilston is a rich man and happily married. I received a long letter from him in which he described his whole wedding and grand tour. He remembers Julia with great warmth and friendship.[60]

We are having magnificent weather here; all is green and in blossom. I think we have never had a year when vegetables were as splendid as this year. One wagon after another comes driving up in the morning.

Now farewell until we meet again and kiss Papa fondly from me, but pull Julia's ears and remember

Your—M. v. B.

P.S. $5 enclosed for Julia!

Steamship *Thuringia*
Sunday morning, June 28, 1874

Beloved Parents,

Just now we saw the first land, and according to all calculation we may arrive at Hamburg on Tuesday night or early Wednesday. I hope to meet Julius or surely Julia there and soon after that embrace you, whereupon you may hear everything about my journey. I write this only to inform you about our happy passage so far. With love

Your—Maria

❧

Berlin, February 3, 1875

My dear Felix,

The letters you have sent me probably all being lost, I find myself obliged to write even without hearing from you, though a husband's actions certainly ought to determine how a wife behaves. The children always write to me diligently. You may certainly imagine that the news of Mary's cough and the smallpox epidemic made me very sad. Yet I can do nothing but hope and wish that they all get over it well.

In my last letter I told you that Hermann had been transferred to Koblenz.[61] We were at the station for his departure and they made us promise to visit them there, which would be very pleasant if it did not entail expenses. They long for Berlin, though it is so beautiful there. Hermann is too vigorous to be pensioned and has the prospect of becoming a packing yard inspector in Berlin—i.e., to be here again at the end of the year.

Papa Kill-Mar, Baron of K., I met at your aunt's. His amiable conversation would make everyone believe him to be the most excellent man. Over a convivial glass of red wine he told me about the disagreeable affair (see the enclosed newspaper clipping!) and explained it thoroughly. He also told me at once that it did not surprise him that I did not visit. Of course I shall now also go there one of these days. He spoke much of the sale of Birken-wäldchen, the fabulous price it brought, etc., etc. Old Mr. Bernhard, whom you probably remember, told me intimate details of Kill-Mar's financial affairs. The grandparents, Hermann and his wife, and even Kill-Mar wish to write to you—begged me for your address. Julius, Anna, and Julia send a thousand greetings. Julia is my close companion, giving me much pleasure. Edward is said to have earned 60,000 thalers. I wish I had just 100 of them

so as to be able to bring along something for everyone at home. So, until I see you again!

Your—Maria

❧

New Orleans, May 5, 1875

Dear Parents,

Yesterday evening at 9 o'clock we arrived here after a long but very agreeable passage. From Le Havre we had very high waves and headwinds for five days, but no storm. We stayed one day in Havana, from where I had promised to write you. But by all accounts the letter would have arrived later than one sent via New York. That is why I did not do it. Because of low water, a ship was stuck in the pass at the mouth of the Mississippi River, where we lay for five and a half days before we could get through. But as we had fellow travelers who were good company, and an excellent violinist, we spent our time very well. Extraordinary food. We had beef, mutton, pork, ham, geese, pigeons, etc., in abundance; the finest vegetables, even the Teschen turnips; and magnificent fresh and preserved fruits.

Out at the pass I received a telegraphic message from home. The hotel servant and carriage had been ordered for me and stood ready upon the arrival of the steamer. Early the day after tomorrow, at 7 o'clock, I shall go on to Corpus Christi. Here everything is already in fullest splendor and bloom, the orange trees laden with fruit. Living in the finest place can be as fine as traveling. But my journey is now coming to an end. This morning I amused myself by examining my things. A lady at customs searched us ladies quite thoroughly, including the hems of petticoats, loose outer garments, etc. Yet she was not able to find the three watches. My trunks were only unlocked and closed again; it was probably too hot for the old, very nice gentleman to do more in the New Orleans sun on the wharf, where the crates and trunks all are examined in the open air.

From Le Havre to Havana we had a family with five servants on board. The gentleman is possessed of $40,000,000. Strangely, however, they are less favored by nature. The father has consumption; the mother has an incurable disease and is anyway half crazy. The eldest daughter looked just as if she were Chinese and had only one eye. The only son is stupid; the second daughter is very beautiful but stammers; and the youngest is utterly ape-faced.[62]

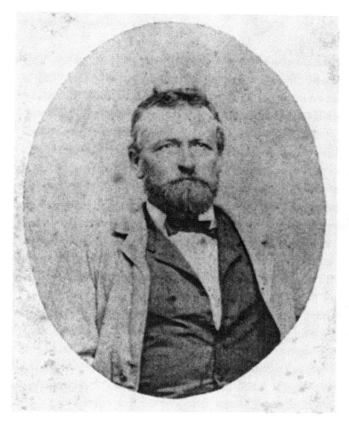

Felix A. von Blücher, ca. 1875. Charles F. H. von Blücher Family Papers, Special Collections and Archives, Mary and Jeff Bell Library, Texas A&M University–Corpus Christi.

I am safe and sound, thanks be to God, and hoping that you, too, are well and that our Papa also has recovered fully. I am very tired, as last night I did not sleep much. Greet all brothers and sisters a thousand times and also all my dear lady and gentleman friends! More from Corpus Christi! With love

Your M. v. B

P.S. Julia will hear tomorrow.

Corpus Christi, June 1st, 1875

Beloved Parents,
You have surely been astonished not yet to have received any word about my
arrival here. But you can probably well imagine that in the first days I had
no peace at all for writing. First, I had visits from morning until evening. I
had not yet been home for an hour when they began. Thus it went on day
after day, so that it was hardly possible for me to get my things unpacked.
The children were radiant with happiness about the things brought along
and send a thousand cordial thanks for the items you sent. They all feel they
received just what they wanted. Everything has arrived in good condition,
nothing damaged. I am missing only some trifles that must have been left
behind during repacking. Had I known that the trunks would be so little
examined at New Orleans, I should have brought along still much more,
chiefly in garments. I did some buying at New Orleans, for enormous prices
of course. From New Orleans I reported to you that we had had a long
passage—31 days—but at the same time a very agreeable voyage. I have
gained so much weight that nobody recognized me. Upon my arrival at
Corpus Christi I was met by Felix, who arrived right on the day when the
steamer was expected. Mary has not yet recovered fully, and I fear she will
never become quite healthy, as the doctor told me that she had had very
serious hemorrhages from the lungs with her chest infection. She must pay
much attention and will take a little journey to recover.

They did up the house very nicely for my arrival: made two rooms out of
one large one, painted everything with white oil paint, and procured fine
furniture for my bedroom and parlor; they fitted up a new dining room and
kitchen, so that now I have my house furnished very agreeably. Eight nice
rooms and a kitchen.

The railway works are proceeding vigorously; the station is or will be
close to the edge of our land. A bridge has already been built beside our
house, which suits us well.

Monday, June 7th. A long pause in my letter—visitors still come daily
and claim my free time. Above all I must try to express to all my thanks for
the objects brought along. I cannot begin to tell you how much joy these
have caused. We were invited to two weddings, but attended only one,
where Mary introduced her blue dress and I my black one.

Mary has a nice garden, and so has Charley. On my arrival my room had
fine rose bouquets that were renewed every day. They even have the beauti-
ful yellow rose, and *green* and *black* roses—at least sixteen different kinds—

which they ordered from Philadelphia: six bushes for $2, delivered. I should like to have the instructions for *"painting the floors."* I thought I had it but only find noted down "painting for polishing."

George is thrilled with his gun but fears the percussion caps will run short. So if the opportunity arises, I beg you to add some more.

Mr. Büsse intends to come to Berlin. I have seen him only once and found him much changed. From people who know him I hear that he is a little crazy and rather weak in the head. I should not wonder, for he has always been distinctly odd.

Felix intends to go to Germany next year. Had I stayed longer, he would probably have come to meet me. I found my parrots and canaries safe and sound, and I forgot to bring back the little bathing tubs. I could not find porcelain bowls for parrots in Berlin, which I regret. I also forgot to get bone china bowls and fish plates and miss them daily. Some of my things got lost or were ruined during Mary's illness, which, however, was unavoidable.

Felix departed again the day before yesterday and will probably not return home soon. He has much to do on the Rio Grande. Charley and Richard have found employment with the railway at $75 and $40 per month, and food, of course. Charley wishes to begin a sheep rancho, a good business if one has capital. Today we again sold a piece of land with payment on account.[63] In August it will be fully paid off. The buyer, who already has more of our land, brought me some wool from his sheep. I include here a little sample of Texas wool for you. I am not an expert but think it to be of good quality.

I think of you about a hundred times a day and wonder how you will endure Berlin in the heat, having sold the summer house at Treptow. We have fine clean air that allows us scarcely to feel the heat. The other day I weighed myself and I weigh 152 lbs . So you surely can conclude from this that I have not been melting away since returning from Germany. The fox skin is a great embellishment for my room. I do not have it lying on the floor but over a nice rocking chair, with the head hanging down the back, which looks very nice. I took a snakeskin to Berlin, left it with the furrier on Jerusalem Street, and forgot to go and fetch it. They wanted to make a collar out of it.

I thought Julia would write to me, as I wrote to her from Le Havre. I hope to have time to write her a few lines tomorrow. I also sent her something from France, which she will receive in due course. I have not yet

written to anyone else in Germany, as I first have to pay all the return visits here before I can take a pause and get around to that. Richard is now as tall as Charley; he has grown much in the last year. So has George, but that is not as evident.

Now fare right well. Do send me a lock of your hair in the next letter. Many thousand greetings to all friends, too many to name! Also, many thousand thanks and greetings from Felix and the children! From your loving daughter

<div style="text-align:right">M. v. B</div>

❧

<div style="text-align:right">Corpus Christi, August 17, 1875</div>

Beloved Parents,

Today I have at last succeeded in finding a spare moment to address a few lines to you, chiefly to offer you my congratulations together with the united felicitations of the children, dear Father, for your 84th birthday. We all wish you good health and good spirits and the fulfillment of your every wish. I hope you have rallied this summer so that you can face the winter calmly and without fear.

I received Mother's dear letter some days ago, and I see that you are in Berlin in spite of the sun's scorching heat. That would almost be too hard even for me to stand. Julia wrote to say that you had paid a visit to Königsee and that it is as beautiful as paradise there.[64] It has always been my wish for you to have such a little retreat, and I have not yet given up the idea of achieving my aim if Felix can sell his land. I should have written to my friends in Germany long ago, but I cannot find the time. Incredible as this may seem, it is so. At 7:00 o'clock in the morning Richard must be in his office, and of course he must have his breakfast, warm rolls, beefsteak, and coffee, before 7 o'clock. At 12 o'clock lunch for him and at half past two for the rest of them. These different meals require much time. But it cannot be helped, and as I do not permit Mary to do anything in the kitchen, I thus have my hands full. From 5 o'clock in the evening we generally have visitors. Downing began this practice, and we have kept it up. At the same time I have to do my sewing.

Texas and Mexico are now in a more deadly feud than ever, and we expect war or murder and bloodshed. Companies of volunteers have already been formed here, and the government has provided arms. An encounter has already taken place.[65]

Mary's state of health remains unchanged. She must keep part of her back exposed to ease the ache in her lungs. She coughs less and looks well and strong. The doctors only fear fall and winter. They are of the opinion that she has an inherited disposition for consumption and was born with it. But I don't know from whom this dreadful inheritance might come. Their home is finished now, and it really is a charming little place. Their bathroom is near the bedroom, and a pipe leads from a cistern into the bath, and similarly a pipe has been installed to drain the water away. It is provided with a shower bath and various other gadgets.

The greatest inconvenience here is that there is now only one school, the Catholic one, largely frequented by Mexican children. Most people send their children to the North for instruction, which, however, is rather expensive. I propose to lease out our house in the near future; using that income I will come to Germany with George and send him to school there. In a smaller German town it will not be as expensive as in Berlin. Felix now has his office hundreds of miles from here and comes home once every twelve months for eight days. Charley and Richard are both grown up and must seek their living as well as they can. Of course if I go to Germany I shall miss Mary very much. Nevertheless, something must be done. George is thirteen years old and is intellectually gifted, and it is a sin and a shame to let him grow up here. He is radiant with happiness with the rifle you sent him. He shoots daily at a target and is always the best shot in his crowd. Yesterday, he shot eight jackrabbits in short order.

Last night, thanks be to God, we had the first rain after more months of drought. My paper is at an end. With many thousand thanks and greetings to brothers and sisters, nieces, nephews, and friends, and chiefly to you, from us all. I kiss you cordially. Greetings for Julia!

Your—Maria

Corpus Christi, October 12, 1875

Cordially loved Mother,

Corpus Christi has changed so much for the worse after the storm last year that I no longer feel comfortable here, and the acquaintances of recent years are not like the friends of our youth. We lead quite an agreeable life but are always surrounded by dangers, which in the end is not agreeable.[66] Mary's state of health seems to be improving to some degree. She has gained eight pounds in the last three months, which is probably a good sign. Nevertheless,

she is never free from the pain in her lungs. The boys are safe and sound. I expect Felix; he should arrive today. But the day and evening have passed and so he will probably turn up tomorrow.

You will probably have heard and read of the terrible storms here on the Gulf Coast. Indianola and Matagorda have been totally destroyed.[67] Corpus Christi got off rather lightly. A stronger storm has been predicted for the 15th–18th, with the worst to come in November. Construction of the railroad is proceeding. Locomotives and railcars are already here in the machine house. The station is being built on a part of our land, and as soon as it becomes operational, I intend to lease out our house and live in Germany, as the hot climate here is not much to my liking. I felt fine in the cold in Germany.

I received a letter from Julia from England; she seems indeed to have found her journey diverting, and I hope that it may have a favorable influence on her health. We also celebrated the day of your golden wedding anniversary here; please tell Julia to send me a detailed description, to gather her thoughts and recall the events of the day in detail. I have not yet written directly to all those who contributed so much to making my stay in Berlin pleasant for me. I can scarcely find the time to answer the letters I receive and read with pleasure. How awfully long the summer must have been for you alone in the city. How often I imagined what Papa must have endured there. I regret with all my heart that you two are not in good health, hoping fervently to receive better news soon. Kiss Papa heartily in my name; greet Julia and tell her I miss her very much and that every day we talk a dozen times of her. A thousand greetings to brothers and sisters, relatives and friends, and as many from us all to you. Remember with love your

Maria

Corpus Christi, Texas, November 18, 1875

Beloved Mother,
December 14 is approaching and I must hasten to offer our congratulations. I wish you health and well-being with all my heart. May all affliction keep its distance and may you spend many a year yet in peace and quiet. I shall be with you in spirit every moment of the day. The memory of your last birthday will be the guide for my thoughts.

Felix was at home four weeks and has now gone again away to Mexico. Charley has been away for a week already and will not come home before Christmas. He is accompanying Major Hollub as an engineer and surveyor.[68]

This arrangement is advantageous for both of them. Charley does most of the surveying and sends in the calculations. Major H. makes out the maps and the necessary documents. He manages their affairs here in Corpus Christi. Richard is still at the newspaper; George will probably follow Charley as an engineer.

You will see from this letter how difficult it has become for me to express myself correctly in German. But I cannot help myself; it is now the most difficult task for me to write a letter in German. This is the reason I do not get on with it, as I cannot express myself as I should like; hence I delay writing and replying. I regret this with all my heart, as it is the greatest pleasure for me to hear from everyone. How is our good old Papa doing? I hope his eye ailment has been alleviated, so that it is at least endurable. Julia certainly had a nice journey. You can imagine that I rejoiced much at it. I know how agreeable it is to take an excursion. And it seems she too was wonderfully amused. Charley made her a fine Christmas present, which I hope has reached her in good order. I am sorry not to be able to send her anything else, as I did not save much to send. I still have to pay a debt to brother Carl, which I hope to do in a few weeks. Felix has assigned money from a land sale to me. The man has paid $100 on his account but has not been in Corpus Christi since then to pay off his debt. The sale of the wool has begun, and I hope soon to salute him and *his* wool here!

Now, dear Mother, fare cordially well! Many thousand greetings and kisses from the children for you. Kiss Papa from me, and greet all dear friends and relatives and also Julia a thousand times from

Your—Maria

Corpus Christi, January 16, 1876

Cordially loved Parents,

At last I have a little more peace in the house and some time to send you some lines. It really is a blessing that Papa has found relief from his terrible pains in the eyes. I hope he is feeling fit and well. If you had weather at Christmas as nice as we had here, Father would not feel the winter at all. Just consider—Mary sent me the finest rose bouquets at Christmas, and now the yuccas are also in bloom. We have yet to have a cold day and only once this winter have we had a fire in the fireplace. Mary also has fine violets blooming in her garden. Perhaps I missed an opportunity, but I am sure I did not see roses in Berlin as fine as they are here.

Last evening the registered letters from Julia arrived, and we say a thousand cordial thanks. All is wonderful and gives us double joy in that it comes from home. I am glad that Kill-Mar remembered Julia. He certainly would have done that sooner if she had made an approach; better late than never!

Yesterday I had my house so full of people that I scarcely had time to sit down. Then I had to make preparations for Richard and George, who both went on a surveying trip with Major Hollub and will be away a month. George has now also been roped into the work. Charley is now a nineteen-year-old man, although he looks starved and older. He and Major Hollub did very good business last year and the prospects are good. They have won the contract for the county roads as far as 60 miles from Corpus Christi, and Major Hollub has the contract as architect for a new county court-house; on this, too, he is giving Charley a share. Hollub's health is not very good, and he cannot manage a long survey as well as Charley can. Therefore the latter does most of the work that involves being away, and Hollub superintends the town work, documentation, and drawings.

Now dear Parents, fare cordially well, give my greetings to my brothers and sisters many times and also to the nieces and everyone. (Many greetings from the children! Major Hollub dried the enclosed rose for Julia.) Remember with love

Your—Maria

~&

Corpus Christi, April 11, 1876

Beloved Mother,

I fear you must have doubted whether you would ever receive a reply from me to your dear letter. In recent months I have relived each day of the previous year over and over, just wishing still to be with you. I do not like it here at all any longer. I felt more at home among my old friends in Germany. There is constant coming and going here, and one does not like such a restless life as one grows older.

Felix has been in Zapata, and he likes it better there than at home. A great wonder has happened, however: he wrote to Kill-Mar. I was so astonished that I really did not know what to say. And Kill-Mar and Ida will certainly feel likewise.

Some days ago Mary received a letter from Julia, which she enjoyed very much and will answer very soon. As we had such a mild winter, Mary's

health has been very much better, and I hope she will soon be able to forget all illness. I consider Dr. Spohn the best doctor in the world.[69] He still has her under his care.

I can report little news to you from here. Having four or five murders a week is no longer striking. For the past three nights, 20 men have been patrolling on foot, as 30 very suspicious characters are roaming about here. Also, there is now a dancing teacher here. The young men in town take their six-shooters and pistols to the dances. Julia will certainly read about it in the newspapers. One grows accustomed to it all and ceases to get excited about events of this kind.

Charley was away for six weeks and returned just a few days ago. In the entire time he spent only two nights under a roof. The rest of the time he was in the open air, in storm and wind. Richard and Jim will start out on Saturday, and thus it goes continually. I have grown very tired of it.

I am not writing much as Julia has been keeping me informed of events in the family. Fare very cordially well, and kiss Papa from me. The children greet and kiss you a thousand times. Write and remember

Your—Maria

&

Summer 1876

Beloved Parents,

I fear not being in time this year with my congratulations for September 12. Nevertheless, the many congratulations from here are no less cordial and tender. We all wish you good health and many more happy years. As always, we shall remember the day here, thus being together in spirit.

This year it has really been impossibly hot. In New York up to 40 to 70 people a day were dying of heatstroke; it is said to be awful there. Here it is somewhat endurable as the fresh sea breezes keep the air cooler. We go bathing in the sea at 4 or 5 o'clock in the morning, refreshing ourselves for the entire day.

We are all fit and well here, thanks be to God, except Mary, who has never quite recovered and been well. Sunbathing does her good. Where is Julia? I have not heard anything from her for some time. I do not know what is the matter with me; I have lost all inclination for writing. Indeed, there are so few points of contact here, so little news, to enliven a letter. Not much happens here, and the little that does is not of interest.

On July 4, we had grand festivities here, a supper for about 1,400 persons,

and everything present in abundance.[70] At 12 noon 100 shots were to be fired from three cannons. At the 10th shot a young man, Jim's most intimate friend, had his arm shot off! Of course they did not continue. Ten minutes after the accident he already lay bandaged up after the amputation, quiet in his bed. At 2 o'clock he wrote with his left hand that he did not want to interrupt the celebration. When the processions passed his house, he shouted a cordial hurrah! He was ill only about two weeks; after that, he resumed his work at the inland revenue office.

I close with this. Charley is going to town and will take this letter along. A thousand greetings from all! With love

<div style="text-align:right;">*Your—Maria*</div>

<div style="text-align:right;">Corpus Christi, November 16, 1876</div>

My dear Mother,
I wish with all my heart that this may yet reach you by December 14 and finds you healthy and happy. We all send you many thousand congratulations and wish you many, many returns of the day. Yesterday I received a letter from Julia, and today I sent her a few lines. I really have so little time left for writing, otherwise I never should make you wait so long. How is Papa doing? How is his eye trouble? We are all well, thanks be to God.

Charley and Richard have been away for six weeks surveying land, and they returned only a few days ago. It is a hard existence. But if you have no capital in hand here, you must go to work. Charley expects to make $200 profit from this trip as soon as he gets paid. Of course there is never much left of the clothing they take along on these excursions. As I make their clothes myself, I have my hands full. Having three boys and no woman's hands for help is rather difficult. Mary has recovered well and weighs 156 pounds again. I think she will get over her weakness of the lungs fully, if she just takes care of herself.

We have had an extended drought here in Corpus Christi and vicinity. Since last winter we have not had a decent rain that lasted longer than a few hours. Again the drought has been terrible; there has never been one here to equal it. All the ponds and wells have dried up, and the fields and pastures are totally scorched. The cattle die by the thousands at the empty pools, and deer 30 to 90 come into town before sunrise searching for water. New wells are incessantly being dug, but thousands and thousands of cows and horses,

whose masters live God knows where, roam the neighborhood daily, desperately thirsty. For three days I hardly opened my door at all in order not to see the misery. We turned our horses loose to search for better food, which they find outside our pasture, and 64 have disappeared. Felix and Charley will round them up after four weeks' absence. Because of the bad weather, our crops and everything else at the rancho have not turned out as well as last year.

About the inheritance affair, I can only inform you that Felix sent Kill-Mar the required papers as long ago as last March or early April, but so far neither answer nor money nor anything has arrived. Felix does not seem to be troubled by that, so I am still less so.

Now, dear Mother, I must close. Charley sends a thousand greetings and kisses for your birthday and hopes soon to be able to give you something better. With cordial greetings for Father, Julia, brothers and sisters, and friends, I remain

Your—Maria

Corpus Christi, December 18, 1876

Cordially loved Mother,

On December 13 I received the sad news of the death of our beloved Father. Though it was not quite unexpected, after Julia's last letter to Mary, it still hit me hard. How thankful am I to have been able to see him after our long separation. You had devoted yourself to him so completely that you must certainly miss him every moment. You did not tell me the date of his death; I can only gather that he died about the beginning of November. I had hoped with all my heart that he might live long enough for us to render his life a little easier, as he probably did not get all the appreciation he deserved.

Richard and Jim Downing are on a journey to Laredo and will not be with us this Christmas. We shall not have a Christmas tree, for the first time, I guess. I have not congratulated Julia on her birthday and beg you to do it belatedly on my behalf. Today is Julius's birthday. All day I thought of it, wondering whether you two were together or not. How I wish I might be with you.

The projected railway is now in operation, and each day the railcars go a little farther, which makes our property much more valuable, and perhaps I can sell part of it to advantage.

Now farewell, very well, dear Mother. Do not let the bitter blow that has hit us all break your spirit. Mary, Charley, and George send many greetings. And greet all, chiefly Julia, a thousand times from

<div align="right">

Your—Maria

</div>

<div align="right">

Corpus Christi, Summer 1877

</div>

Cordially loved Mother,
I duly received your last dear letter, containing the chain, and I thank you cordially for both. I will wear the chain in memory of our dear good Father, and I will not be parted from it as long as I live. You can scarcely reproach me more than I do myself over my sparse letter writing. I do not know how it happens, but it has never been so difficult for me to find time for it as now; for I am always occupied from 5 o'clock in the morning until the night. And my eyes are so bad that even with good spectacles I can barely read and write by lamplight. We are all healthy, going on in our quiet way as ever. Murder and homicide are a daily occurrence here, and one at least ceases to be astonished about it. As for Julia, she has not written anything at all to me of the journey you mentioned to Normandy, and I find it very natural that she did not wish to be separated from you for so long. I am sorry if it causes you disquiet. In matters concerning Julia, I never try to influence her but let her decide as she goes along.

I guess my garden is also to blame for my writing much less now, as I like to spend every free moment I can spare on improving it where I can. It is such a nuisance that the rain is erratic and insufficient. The vegetation approaches being wonderful. But lack of rain renders it impossible to grow many fine plants. Nearly two months ago we began enjoying our grape crop, the finest blue grapes, as sweet as sugar. And my sour cucumbers and pickles are also not to be sneezed at. My castor-oil trees are over 20 feet high and their foliage so widespreading and dense that it covers 10 feet of fence. And some branches hang over the fence, covering it on the other side. The leaves are about four feet across, some even more.

Do not take it amiss that my scribbling is so untidy, but I have had nearly twenty interruptions, and then I wind up writing in a hurry. How often I think that if only I had a skilled German girl as a maid, what a great help that would be to me. The Mexicans are too uncivilized to do much good.

Dear Mother, can you possibly procure for me a little package of pepper-

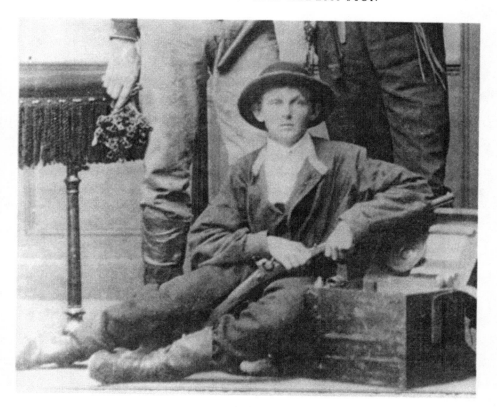

George Anton von Blücher, ca. 1876. Charles F. H. von Blücher Family Papers, Special Collections and Archives, Mary and Jeff Bell Library, Texas A&M University–Corpus Christi.

mint seeds? I so much like to have it with tea, and here we cannot get good peppermint. Elderberry and chamomile I have in my garden, but not the right kind of peppermint.

I wish you might make an agreement for Carl to rent you a different place to live, without a third floor and nearer to our relatives and friends. It would really be so much more agreeable in the summer. Now, dear Mother, I must close with many greetings for Julia, relatives, and friends. Mary and the boys send a thousand greetings. Once again, farewell! Your loving daughter

Maria

Corpus Christi, November 3, 1877

Dearly beloved Mother,

Yesterday, on the anniversary of our beloved Father's death, I wanted to write you, but it was not possible for me. As we have no servants for the moment, every instant of mine is taken up. I was with you in spirit, however. As happens so often, because I am alone a lot and I enjoy being quiet and alone, my thoughts always wander back to you.

Charley and Richard have become young men and are at their jobs all day long.[71] Charley has now established himself independently, and I hope he may get on well. We have therefore tightened our belts a little so that he discharge his obligations honorably. Felix is scarcely accountable for his actions, as he uses up what he earns. Don't mention this to Julia. She takes things of that kind to heart more than is necessary. For one grows accustomed to such circumstances and scarcely gives them a further thought. From afar, it looks worse than it is.

It always gives me great pleasure to receive letters from home. But as I am now so careless about answering, I of course rarely hear anything. But God knows, I cannot sit down and write as before; at times it is quite impossible for me, and I certainly have sometimes been guilty of neglect, which did not used to be the case.

Now, dear Mother, farewell, and greet Julia and all relatives and friends who remember me. Take a thousand greetings from us all

Your—Maria

&

Corpus Christi, March 18, 1878

Beloved Mother,

In the middle of February I received your dear letter. On Charley's behalf I thank you cordially for the good wishes; I passed them on to him. He has been at Laredo with Felix on a survey. I seldom write about Felix as there is nothing special to tell. You know how careless he is about writing. Thus I rarely hear from him except when it is essential for him to write. You wrote last year asking me to have legal authority drawn up for Julia. According to your wish I had such a document drawn up by an attorney and then sent it to Felix for his *personal* signature, which is necessary in such a case. The document lay at a post office for months, and only now has it come back to my hands. I must still have my signature notarized; then I shall send you the papers.

This year we did not have a winter at all with the exception of four or five days before Christmas, when it was disagreeable and rainy, but not cold enough to have a fire in the house. Mary always has a warm, cozy room where we sit in the evening. We have had the finest weather you can imagine for the garden: rain—enough for a change—and enough sunshine and warmth to make everything grow, all year round. Mary's roses might gain honors at any exposition. Six weeks ago we planted callas, and now Mary's are already in fine bloom. My sumac and wisteria are shooting forth wonderfully, and I hope both will flourish for my joy and satisfaction. If you could have even a little garden, it would surely give you much pleasure. My garden is the reason that I write so seldom now. I spend much time on it when I ought perhaps to be doing other things. But I feel much better after my work there, and therefore I will not give it up.

Felix sent me some money again, and I enclose $5 for you. You have surely done as much for me, and I have always wanted to be able to send you an occasional trifle. Do not spend it on Julia; I shall also send her something.

Fare cordially well, and greet all dears from me fondly! And stay dear

<div align="right">Your—Maria</div>

<div align="center">❧</div>

<div align="right">Corpus Christi, July 14, 1878</div>

Beloved Mother,

I hope you and Julia have returned to Berlin from your journey fresh and sound. If you had as much rain and heat as we have had here, you cannot have been out of doors much. But, on the other hand, it is great compensation that everything is so magnificently green and fresh. This season has been the wettest and dreariest in many, many years. Only in the first years of my stay here was it like this. You can see everything growing. My erigeron trees are indeed wonderfully beautiful, and I often think what pleasure it would have given Father if only he could have seen them.

Charley arrived from Laredo some days ago quite unexpectedly. Only three weeks ago he had returned there, and as the journey is very arduous, it is not undertaken lightly. Felix had been rather ill some time ago; he had a hemorrhage. It fortunately happened at Laredo, where he had an excellent doctor and Charles to help him. He is now fully recovered and is living at Santa Gertrudis. Julia knows the family. He will stay there six months. The rest of us are all well, thanks be to God. George is running the machinery at

the ice works.[72] His entire mind is directed toward the machinery. He has immensely difficult work, especially when he is on night shifts for weeks at a time and has only five hours out of twenty-four for sleeping! But he makes no complaints as he wants to learn this branch of trade. It is marvelous to get fresh ice every day. Butter, milk, etc., keep so much better. Since the building of the railroad, there have been many improvements that contribute greatly to residents' convenience here. Although the railroad is not yet connected to a major line, there is already enormous traffic in goods and freight, as it is already useful for people not to have to take oxen and mules to town but to be able to bring in their goods on the railroad.

Dear Mother, enclosed are $2 and a little sample of silk. Mrs. Noessel begs Julia to procure for her more of this type of silk. I should like to beg you to send me a little package of forget-me-not seeds as soon as possible. I must close now. Greet all friends and relatives a thousand times. With fond love

Your—Maria

Corpus Christi, November 6, 1878

Beloved Mother,
Your cordial, fine present arrived here right on my birthday, and that was a great surprise. I thank you a thousand times for the congratulations and the fine gift. You must not take it amiss that I did not write at once, but a few days after my birthday I went out into the country, where I stayed for several weeks of relaxation and diversion. Mrs. Meuly and her daughter Mary had invited me to travel with them to their rancho, which is situated in one of the nicest places around here. Mary is the young girl Charley has selected for his future partner in life. You know it is not the custom here to have a public engagement or to make an announcement when such a connection is tacitly recognized in the family. His prospects are not so scintillating now as to suggest a speedy marriage. The terrible yellow fever, which has ravaged the South as never before, has of course affected all business. Otherwise Charley would probably have remained at Laredo, where his business relations were very favorable in the beginning. Now he has again been employed here at the post office. Mary is a pretty girl; I have known her from her earliest childhood. The mother is very well-to-do; the father is dead. Julia knows the sisters well, the eldest of whom was married some months ago.[73]

I had hoped to be able to include a birthday present for you, but because of the quarantine a bill of exchange that was due on October 23 has not yet been paid to me. I wish and hope most anxiously that it will be possible for me to make good on it at Christmas. Quarantine is still urgently necessary. More than one hundred people are still taken ill daily at New Orleans, and more than four thousand have already died there. It is awful to read the reports. Whole towns have nearly died out. Few have been spared, and hundreds who hurried to New Orleans for assistance have lost their lives.[74]

Any time I have a little time, and in the evenings, Mary reads to me. I cannot see well in the evening for writing or reading, in spite of spectacles and good light; in the daytime it gets better. Do not forget to write me. How has the winter been? I am always anxious about Julia's health. From her letters, she has apparently found the winter easy. Nevertheless I do not believe it. It is so sad for young people to be sick and in ill health. I still want to try to write a few lines to Julia, so I close.

A thousand congratulations for December 14.

Your—Maria

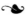

Corpus Christi, February 8, 1879

Dear Mother,

I have just received your dear lines from Charley, and I would be glad you all are safe and sound were it not for the fact that the sad news of Felix's sudden death—by apoplexy of the lungs—arrived at the same time. It was so unexpected that it makes me feel quite strange. I am so het up that I feel like running several miles. A Mr. McClane, who has been Felix's companion these past five years, was with him.[75] He died on February 6 in the evening, and this morning he was laid to rest until Jim and Charley can transport his body here. They will start on Monday, and they will arrive in a week, whereupon the burial will take place.

Charley has just got over a serious illness, diphtheria. This is a terribly ravaging illness in the North. Whole families are carried off, and sulfur with glycerin, stirred to a thickish consistency, is an unfailing means. All the newspapers in America and England are full of it. I write this as you will perhaps be able to save a life with it: take a teaspoonful three or four times a day, according to age; use it to paint the throat with a brush, but do not put the brush in the flask; and dab the nostrils with a sponge. It is a harmless remedy.

J. VAN RONZELEN BERLIN

Julia Augusta von Blücher, ca. 1880. Charles F. H. von Blücher Family
Papers, Special Collections and Archives, Mary and Jeff Bell Library,
Texas A&M University–Corpus Christi.

Dear Mother, I will not write more now. Fare cordially well and tell Julius and brothers and sisters, relatives, and friends the sad news for me! Yours with love

M. A. v. Blücher

6

*It was such a new world, reaching to the far horizon
without break of tree or chimney stack; just sky and grass and grass
and sky. The hush was so loud. The heavens seemed nearer than ever
before and awe and beauty and mystery over all.*
—*Lydia Murphy Toothaker, 1859*

ON FEBRUARY 8, 1879, Maria learned of her husband Felix's death two days earlier at Henry E. Woodhouse's ranch, Tresquillas, in Cameron County. Since returning from Germany in 1875, she had rarely seen Felix, who worked and lived during those years in Laredo and Zapata and with Captain King at Santa Gertrudis. Indeed, she had seen her husband only once, for eight days, in the previous year. His death, she wrote, "was so unexpected that it makes me feel quite strange. I am so het up that I feel like running several miles."[1]

Now a widow at fifty-one, Maria again faced uncertainty. Fortunately, she was healthy and able, and she had long since established a life for herself and children independent of her husband's vicissitudes. This proved fortuitous, for without Felix's professional income, his estate was insolvent. Beginning with his arrival in 1849, Felix had long speculated in land, buying, selling, bartering, and trading thousands of acres all across South Texas as well as

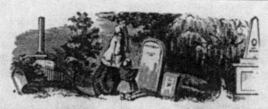

FUNERAL NOTICE.

DIED, February 6th, 1879,

FELIX A. BLUCHER,

Aged 59 years, 2 months and 21 days; a native of Poglow, Meklenburg Schwerin, Germany.

Friends and acquaintances of the family are invited to attend the Funeral, TO-MORROW, Feb. 23d, 1879, at half-past two o'clock, P. M., from the residence of the deceased.

CORPUS CHRISTI, TEXAS, February 22d, 1879.

Funeral Notice of Felix A. von Blücher, 1879. Charles F. H. von Blücher Family Papers, Special Collections and Archives, Mary and Jeff Bell Library, Texas A&M University–Corpus Christi.

town lots in Corpus Christi, Nuecestown, San Patricio, San Diego, and Beeville.[2] At one point he owned thirty thousand acres and several ranches. Yet he never achieved financial independence or commercial success in the livestock industry, which he continually bemoaned, and he blamed this on his lack of capital; in fairness, he had indeed been cheated out of a sizable inheritance by his mother and stepfather.[3] Although he achieved a measure of prosperity for Maria and his children in the 1870s through a number of land sales, he was nevertheless dependent on the income from his professional services.[4] Maria of course had a different perspective: Felix was "too disorganized to draw profit from his property, and at the same time too indifferent about cultivating closeness with his family and making them happy."[5]

[251]

Maria served as executor of the estate—Felix had died intestate—and she learned the painful details of their financial situation. Assets included 5,658 acres of ranch lands in Bee and Live Oak counties and the eight-acre homestead in Corpus Christi, together valued at $8,274. Liabilities, however, tripled that amount, as much of the land (4,428 acres on Medio Creek in Bee County) was encumbered by back taxes and litigation. After six years of attempting and failing to meet her obligations, Maria was discharged as executor, and the probate court ruled the estate insolvent in 1885. As a widow with minor children, she was allowed to keep her Corpus Christi homestead and the Live Oak County ranch of 1,230 acres on the west bank of the Nueces River, which she leased out annually for $500.[6] This, along with her income from teaching music and the love and support of her children, allowed Maria to live comfortably in her final years.

On top of Felix's death in 1879, Maria suffered another great loss that year when her beloved mother passed away in Berlin at the age of 74. Now her parents, on whom she had depended and to whom she had been truly devoted, were gone. Her grief was tempered, however, when daughter Julia returned home to Corpus Christi from Berlin the following year, bringing with her all of Maria's letters to her parents. Maria undoubtedly found solace reviewing thirty years of correspondence, what she termed "written conversations," with parents she had loved deeply.

Surrounded by her now grown children, Maria lived out the last of her years in tranquility and calm at her beloved homestead, known locally as "Blücherville," on the bluff in Corpus Christi. She continued to teach music, enjoyed her garden and pets, and delighted as she always had in the beauty and bounty of the bay and chaparral. On September 28, 1893, after a month of illness, she died at her home on a sunny afternoon. Her obituary in the *Corpus Christi Caller* reported:

> It is with genuine sorrow that we are called on this morning to note the death of Mrs. Maria Augusta von Blücher, which occurred at her home in this city yesterday afternoon at 2:45 o'clock. About a month ago Mrs. Blücher was taken ill and since then she has gradually grown weaker until at last death came to her relief and freed her spirit from its bond of clay. Her death was as peaceful as the setting of a summer's sun and she seemed only to have dropped into a gentle slumber, so quiet was the end.
>
> Mrs. Blücher was 66 years and 3 days old at the time of her death and was a native of Berlin, Prussia. She came to Corpus Christi as a bride in

1849, her husband, Felix A. von Blücher, being many years afterward sur-
veyor of Nueces County. Mrs. Blücher was a lady of rare musical talent and
taught music up to the time she was taken ill. It was claimed for her just
before she died that she had educated more pupils in music than any other
music teacher in the state.

Mrs. Blücher was a widow at the time of her death, her husband having
preceded her to the grave several years ago. Five children survive her: Mr.
Chas. Blücher, our present county surveyor; Mr. Richard Blücher, who re-
sides in a western county; and Mr. Geo. Blücher, Mrs. Jas. Downing and
Miss Julia Blücher of this city. Mrs. Blücher was a woman of many noble
traits and character and was always a friend to the distressed and needy. A
residence of 44 years in Corpus Christi had made her one of our oldest
pioneers, and by her death another link in the chain which bound the Cor-
pus of the far past to the Corpus of the present is broken.[7]

The history of the American frontier reveals a pattern of ongoing transfor-
mations. Across South Texas, the coastal plain was plowed into fertile fields,
the tough brush was hewn into family jacales and cabins, and the endless
stretches of prairie grass were fenced into rich pastures. In the course of chang-
ing the land, the people of the frontier themselves changed and grew. They
became the architects not only of jacales and cabins but of towns and new
societies. In a span of just fifty years, Corpus Christi grew from a remote
smugglers' outpost and army camp into a vibrant agricultural center and port,
connected to the world by railroad, telegraph line, and steamship.[8]

Felix and Maria von Blücher's lives as revealed in this remarkable body of
correspondence stand as a testament to this frontier experience. The land titles,
surveys, plats, and maps Felix created in his thirty-four-year career as sur-
veyor, land agent, and lawyer are a tangible legacy vital not only to the histori-
cal record but to any current transaction involving land in South Texas. Maria's
life, representative of the experience of all immigrant and pioneer women,
provides us with a less tangible but equally important legacy. She gave her
youth, health, courage, and the very best of her life to the development of a
large and strong family with roots deep in both the New and Old worlds. It
was the New World, however, that Maria chose for her life's work, rejecting
the offers and pleas of her parents to return to Germany where she would
have fared much more comfortably. Instead, she came to embrace the Ameri-
can identification of life with progress, growth, and freedom. She left be-
hind crowded, preempted Germany—where control by government and the

Died,

In Corpus Christi, Texas, Sept. 28th, 1893, at 3:45 p. m.,

Maria Augusta von Blücher,

A Native of Berlin, Prussia, aged 66 years and 3 days.

———————

The funeral will take place to-day, at 4 o'clock p. m., from the family residence on the Bluff.

Friends and acquaintances are respectfully invited to attend.

———————

Corpus Christi, September 29, 1893.

Funeral Notice of Maria Augusta von Blücher, 1893. Charles F. H. von Blücher Family Papers, Special Collections and Archives, Mary and Jeff Bell Library, Texas A&M University–Corpus Christi.

aristocracy was total and where life was dictated by the past—to live in "the day after tomorrow."[9] She thought time and time again of her children, and she depended on her own faith and a willing suspension of disbelief, holding to the resolve that tomorrow would bring opportunity and growth. The result was a family that has made significant contributions to Corpus Christi and

South Texas and continues to do so. The strength of Maria von Blücher's individualism, her faith, and her determination reshaped the family's life, often at immeasurable cost and in the face of obstacles that stagger anyone considering them now. This is the intangible legacy of Maria's life and an important part of our common heritage.

Notes

PREFACE

1. Maria von Blücher to Beloved Parents, June 13, 1849, Blücher Family Papers, Special Collections and Archives, Mary and Jeff Bell Library, Texas A&M University-Corpus Christi, hereinafter cited as Blücher Family Papers.
2. Maria von Blücher to My Dear Parents, July 14, 1849, Blücher Family Papers.
3. "Mrs. Maria A. von Blücher," *Corpus Christi Caller,* September 29, 1893.
4. Bill Walraven, *Corpus Christi: The History of a Texas Seaport* (Woodland Hills, Calif.: Windsor Publishing, Inc., 1982), 27–76; Eugenia R. Briscoe, *City by the Sea: A History of Corpus Christi, Texas, 1519–1875* (New York: Vantage Press, 1985), 44–89.
5. Julia von Blücher (1853–1937) traveled to Berlin in 1869 and lived with her maternal grandparents until 1880, when she returned to Corpus Christi. Mary Downing to Julia von Blücher, October 28, 1880, Blücher Family Papers. For a biographical sketch of Julia von Blücher, see *Corpus Christi Caller,* June 26, 1937.
6. Marie von Blücher to Dr. Ernst Nolda, September 19, 1952; April 2, 1953; Willy Witzel to Marie von Blücher, May 2, 1953, Blücher Family Papers. For a biographical sketch of Marie Marguerite von Blücher (1890–1986) see *Corpus Christi Caller-Times,* February 20, 1986.
7. See, for example, Maria von Blücher to Beloved Parents, April 10, 1849, and August 22, 1859, Blücher Family Papers.
8. Three important books that greatly influenced my understanding of Maria's life as a pioneer woman, and from which I drew heavily, are Joanna L. Stratton, *Pioneer Women: Voices from the Kansas Frontier* (New York: Simon and Schuster, 1981); Sandra L. Myers, *Westering Women and the Frontier Experience, 1800–1915* (Albuquerque: University of New Mexico Press, 1982); and Evelyn M. Carrington, ed., *Women in Early Texas* (Austin: Jenkins Publishing Company, 1975).
9. Stratton, *Pioneer Women,* 17–27, 267.
10. See among others Gilbert G. Benjamin, *The Germans in Texas* (Austin: Jenkins Publishing Company, 1974); Terry G. Jordan, *German Seed in Texas Soil* (Austin: University of Texas Press, 1966); and Glen E. Lich, *The German Texans* (San Antonio: Institute of Texan Cultures, 1981).
11. Jerry Thompson, *A Wild and Vivid Land: An Illustrated History of the South Texas Border* (Austin: Texas State Historical Association, 1997), 1–2, 117–61.
12. T. R. Fehrenbach, *Lone Star: A History of Texas and the Texans* (New York: Macmillan, 1968), ix–55.
13. James L. Haley, *Texas: From the Frontier to Spindletop* (New York: St. Martin's Press, 1985), ix–x.

14. *Corpus Christi Caller*, September 29, 1893. Maria's experience mirrors that of many pioneer women. See Stratton, *Pioneer Women*, 17–27.
15. *Corpus Christi Caller*, September 29, 1893. Franz Liszt (1811–86), Hungarian composer and the greatest piano virtuoso of his time, revolutionized the technique of piano playing and invented the "piano recital" as it is known today. Alan Walker, *Liszt* (London: Faber and Faber, 1971).
16. *Corpus Christi Caller*, September 29, 1893. Her obituary stated that "she had educated more pupils in music than any other music teacher in the state."
17. Maria von Blücher to Beloved Parents, August 17, 1875; Maria von Blücher to My Dear Mother, November 3, 1877, Blücher Family Papers.
18. Three documentary volumes strongly influenced how I approached the daunting task of editing: Paul Lack, ed., *The Diary of William Fairfax Gray: From Virginia to Texas, 1835–1837* (Dallas: Southern Methodist University, 1997); Theodore Rosengarten, ed., *Tombes: Portrait of a Cotton Planter, with the Journal of Thomas B. Chaplin 1822–1890* (New York: William Morrow, 1986); and Robert H. Ferrell, ed., *Dear Bess: The Letters from Harry to Bess Truman, 1910–1959* (New York: W. W. Norton, 1983).
19. Fernand Braudel, *The Structures of Everyday Life* (New York: Harper and Row, 1979), 32.

CHAPTER I. PRUSSIA

1. For a detailed history of Prussia, the land on the southeastern coast of the Baltic Sea, see Hajo Holborn, *A History of Modern Germany, 1648–1945*, 3 vols. (Princeton, N.J.: Princeton University Press, 1969), 3:45–202. Frederick William IV (1795–1861) ruled Prussia from 1840 to 1861, a period of social unrest and demands for German unity. A true conservative, he was a fervent believer in a God-given medieval kingship. He opposed suffrage and championed government by the predominantly aristocratic large landowners and the retention of the monarchical character of the Prussian army and bureaucracy. Historians have characterized his reign as "more ineffectual than calamitous, for Prussia's spirit of traditional loyalty to the crown and its deep class divisions helped to preserve his monarchy." E. Lewalter, *Friedrich Wilhelm IV* (Berlin: Gustav Kiepenheuer, 1938), 12.
2. Holborn, *History of Germany*, 3:45–202. For a brilliant analysis of population changes in Europe during this period, see Braudel, *Structures of Everyday Life*, 479–558.
3. Alexandra Richie, *Faust's Metropolis: A History of Berlin* (New York: Carroll and Graf, 1998), 124–52.
4. Carl Friedrich Imme (1792–1876) was the proprietor of what was described as a "large brass goods manufacturing establishment, making such items as lamps, chandeliers and similar goods." He was first married to Marie Luise Schröder (d. 1823), which union produced two children: Amalie (1817–83) and Carl, Jr. (1819–99). In 1825 he took as his second wife Marie Auguste Kroll (1805–79). This marriage also produced two children: Julius (1826–?) and the subject of this work, Maria (1827–93). Friedrich Wigger, *Geschichte der Familie von Blücher*, 2 vols. (Schwerin: Stillersche Hofbüchhandling, 1870–79), 2:187–200. This massive genealogy was discovered by Ernst Nolda, one of the translators of Maria's letters, in

the Mecklenburg State Library at Schwerin. See Ernst Nolda to Marie von Blücher, September 18, 1953, Blücher Family Papers. As to Maria's mother owning and managing rental property, see Maria von Blücher to Dearly loved Mother, February 18, 1874, Blücher Family Papers.

5. Maria von Blücher to Cordially loved Parents, September 29, 1850; October 20, 1853, Blücher Family Papers. The 630-acre Tiergarten park is recognized as one of the world's finest urban parks. During Maria's lifetime, the Tiergarten district was home to Berlin's diplomatic quarter and contained some of the city's greatest cultural institutions, including the Berlin Zoo and the Zoological Gardens. Richie, Faust's Metropolis, 124–52.

6. For Maria's interest in German politics, see among others Maria von Blücher to Beloved Parents, January 24, 1851; November 2, 1851; and June 24, 1854, Blücher Family Papers.

7. Charles F. H. von Blücher, "My Mother," typescript dated October 20, 1935, Blücher Family Papers; "Mrs. Maria A. von Blücher," Corpus Christi Caller, September 29, 1893.

8. Wigger, Familie von Blücher, 2:187–90. For the Immes' guarded acceptance of Felix, see Maria von Blücher to Beloved Parents, July 2, 1849, Blücher Family Papers.

9. Wigger, Familie von Blücher, 2:187–90.

10. Maria von Blücher to Beloved Parents, July 2, 1849; October 20, 1849; September 27, 1850; February 22, 1854, Blücher Family Papers.

11. Karl Wilhelm Freiherr von Humboldt (1767–1835), language scholar, philosopher, and diplomat, became in 1809 Prussia's minister of education and established in that year the university that today bears his name. The university was a center for liberal and radical thinkers who openly challenged Prussian authority. Richie, Faust's Metropolis, 124–52.

12. "Major F. A. Blücher," Corpus Christi Daily Gazette, February 14, 1879. General George C. Meade, who met Felix during the Mexican War, wrote in his journal that "Count Blücher was the editor of a paper (radical) in Berlin, and owing to some articles that met with the disapprobation of the King, he was obliged to fly the country." George Meade, The Life and Letters of General George Gordon Meade (New York: Charles Scribner's Sons, 1913), 105. Also see Maria von Blücher to Beloved Parents, July 2, 1849, Blücher Family Papers.

13. Felix A. von Blücher to C. F. Imme, February 15, 1848, Blücher Family Papers. For a biographical sketch of Prince Carl of Solms-Braunfels and history of his founding of New Braunfels, see Ron Tyler et al., eds., New Handbook of Texas, 6 vols. (Austin: Texas State Historical Association, 1996), 5:1141–42. For Meusebach's treaty with the Comanche Indians, see Tyler et al., eds., New Handbook of Texas, 4:650–51. A copy of the original treaty, drafted, penned, and illustrated by Felix von Blücher, is in the Texas State Archives.

14. Felix A. von Blücher to C. F. Imme, February 15, 1848, Blücher Family Papers.

15. Walraven, Corpus Christi, 10–17. For a biographical sketch of Henry Lawrence Kinney (1818–62), see Tyler et al., eds., New Handbook of Texas, 3:1117.

16. Receipt from the Court Marshal's Office of His Royal Highness, the Prince of Prussia, Berlin, February 13, 1849, Blücher Family Papers. William I (1797–1888) became prince of Prussia and heir presumptive in 1840 on the accession of his childless elder brother, Frederick William IV. During the revolutions of 1848 his

advocacy of force to crush the liberals and radicals earned him the sobriquet "Prince of Grapeshot." It must have been an interesting meeting between such a conservative royalist as William and a young radical like Felix. William I went on to become king of Prussia in 1861 and the first German emperor in 1871. Erich Marcks, *Kaiser Wilhelm I* (Berlin: C. A. Starke, 1897).

17. Maria von Blücher to Dear Mother, March 19, 1849; April 1, 1849; April 10, 1849, Blücher Family Papers.

18. Maria von Blücher to Dear beloved Mother, April 10, 1849, Blücher Family Papers.

19. Founded and chartered by the Saxon duke Henry the Lion in 1160, Schwerin is located on the southwestern shore of the Schweriner See (lake) and was long the historic capital of the duchy of Mecklenburg.

20. Felix's sister mentioned here was Marie (1821–?), who was married to Dr. Franz Wentzlaff, an educator. Wigger, *Familie von Blücher*, 2:189.

21. Coming from a wealthy Berlin household, Maria's Prussian sensibilities and class prejudices are clearly shown in this statement degrading Mecklenburg servants.

22. Dresden, founded in 1216 and the historic capital of Saxony, lies in the Elbe River basin, southeast of Leipzig. The city was known as "Florence on the Elbe" and was numbered among the world's most beautiful cities, noted for its architecture and art treasures. Maria must have visited the city, for here she compares Schwerin with it.

23. The National Assembly of the German Confederation was meeting at the historic ducal palace in Schwerin. It is indicative of Maria's interest in politics that she would take time from her honeymoon to attend the debates of the National Assembly. These were bitter disputes over the form that national unification should assume.

24. Located in the lowlands of the Mecklenburg plain and on the shore of the Schweriner See (lake), Schwerin has mild winters, late springs, cool summers, high humidity, and frequent fog. As Maria indicates, the weather is often cool and damp.

25. This is the anniversary of the outbreak of rioting in Berlin that helped spark the Revolution of 1848.

26. These was Maria's sister-in-law and her husband, Marie and Franz Wentzlaff.

27. Hamburg, the largest port in Germany, lies on a promontory between the Alster and Elbe rivers with access to the North Sea. Founded in A.D. 825, it is one of Germany's most historic cities and viable economic centers. In 1849 when Maria arrived seeking departure to America, Hamburg was a thriving port city of 130,000 with extensive trade.

28. Maria's brother Julius and his wife Anna.

29. Felix's aunt, Christine von Rieben, apparently helped to raise young Felix after his parents' divorce. She was extremely fond of him and welcomed Maria into the Blücher family with open arms. Christine von Rieben to C. F. Imme, April 21, 1849; August 22, 1849, Blücher Family Papers. Güstrow, on the Nebel River south of Rostock, was a significant agricultural market and commercial center from the time it was chartered in 1228.

30. Teschow was the castle and seat of Ernst Anton Wilhelm von Blücher (1793–1863), one of Felix's many uncles. It was located between Teterow and Waren and contained some of the finest agricultural lands in Mecklenburg. See Adelige

Haüser A. Band IV, *Genealogisches Handbuch Des Adels* (Görlitz: C. A. Starke, 1960), 30.

31. For details of this family dispute, see Christine von Rieben to C. F. Imme, August 22, 1849, Blücher Family Papers.

32. Felix's uncle, Ernst Anton Wilhelm von Blücher (1793-1863), his second wife, Auguste von Dewitz (1813-99), and her younger sister. Band, *Genealogisches Handbuch*, 30.

33. The young men were Felix's cousins, Gustav Hans Karl Friedrich von Blücher (1822-92) and Ernst Karl Theodor von Blücher (1824-87). Band, *Genealogisches Handbuch*, 32. Halle, founded in A.D. 806, is located on the Saale River just northwest of Leipzig in central Germany.

34. Sukow, the ancestral castle of Felix's line of von Blüchers, was located in the vicinity of Waren and was apparently built by Helmuth Hartwig von Blücher (1745-1817) and Georg Ludwig Ernst von Blücher (1767-1828). Band, *Genealogisches Handbuch*, 21.

35. Poggelow was lost to Felix's parents' creditors in 1828. For details on this mismanagement, see Christine von Rieben to C. F. Imme, August 22, 1849, Blücher Family Papers.

36. See Band, *Genealogisches Handbuch*, 12-37, for an outline of this large and at times complicated and confusing genealogy.

37. Felix's mother Karoline von Hertel married her husband George Kill-Mar, on April 7, 1839, after a scandalous affair. Kill-Mar was a wealthy real estate developer who owned the estate Birkenwäldchen (Birchforest), located in the Tiergarten district of Berlin. He later sold this estate and developed the lands into one of Berlin's most fashionable neighborhoods. Part of the land was also incorporated into the city's famous Zoological Gardens. Wigger, *Familie von Blücher*, 2:187-89.

38. Felix's two youngest brothers, Friedrich Theodor (1825-39) and Lebrecht (1832-40), were said to have been "mistreated to death by the stepfather Kill-Mar." Wigger, *Familie von Blücher*, 2:189.

39. Büsse and Schünke were carpenters who accompanied Felix and Maria to Corpus Christi to help them build their new home. Frederick Büsse would remain loyal to the family his entire life, although at times he was troublesome for Maria in her household. According to her son Charles, Büsse "was a highly educated man, a graduate architect and builder, who contributed a great amount of pleasure and general entertainment to our family. He was always jovial and full of fun. . . . We children called him 'Uncle Büsse' and he died at about 70 years of age after a long and interesting life spent as a neighbor of ours." Charles F. H. von Blücher, "Uncle Büsse," typescript dated September 15, 1929, Blücher Family Papers.

40. Bremen is a port city on the lower Elbe, where hundreds of thousands of Germans departed for the United States. Le Havre is a city and port in northern France on the English channel.

CHAPTER 2. PASSAGE TO A NEW LAND: AMERICA

1. Maria von Blücher to Beloved Parents, July 2, 1849, Blücher Family Papers.
2. Maria von Blücher to Beloved Parents, June 13, 1849, Blücher Family Papers.
3. Ibid.

4. Ibid.

5. Lyle Saxon, *Fabulous New Orleans* (New Orleans: R. L. Crager, 1950), 92–98.

6. Saxon, *New Orleans*, 249.

7. Ibid., 247.

8. Ibid., 247–52.

9. Maria von Blücher to Beloved Parents, June 13, 1849, Blücher Family Papers.

10. Maria von Blücher to Beloved Parents, June 13, 1849; July 2, 1849, Blücher Family Papers.

11. Maria von Blücher to My Dear Parents, July 14, 1849, Blücher Family Papers.

12. Ibid.

13. Walraven, *Corpus Christi*, 27–46; Briscoe, *City by the Sea*, 45–78; Tyler et al., eds., *New Handbook of Texas*, 3:1117.

14. Briscoe, *City by the Sea*, 120–28.

15. Walraven, *Corpus Christi*, 44. See also Anne Dodson, "Pioneers in South Texas Found Life Difficult, Bloody," in *Corpus Christi Caller-Times*, January 23, 1983, p. 39.

16. Walraven, *Corpus Christi*, 44. For an excellent analysis of this livestock economy, see Val W. Lehmann, *Forgotten Legions: Sheep in the Rio Grande Plain of Texas* (El Paso: Texas Western Press, 1969), 112–13.

17. Briscoe, *City by the Sea*, 77.

18. Maria von Blücher to My Dear Parents, July 14, 1849; October 30, 1849; November 29, 1849, Blücher Family Papers.

19. As earlier indicated, Dresden was the beautiful and historic capital of Saxony. The city was the scene of several riots during the revolutionary activity of 1848–49.

20. Here, Maria is clearly worried about the safety of her parents in revolutionary Berlin.

21. Maria's initial observations and comments on the American landscape mirror those of most foreigners during this era. For an excellent introductory anthology including representative selections from foreign travelers, see Oscar Handlin, ed., *This Was America* (Cambridge, Mass.: Harvard University Press, 1949).

22. Maria's description of the Americans, their dress, character, language, and industriousness is remarkably similar to those by other foreign travelers during this period. Like her, many foreign observers commented with amazement on how much Americans ate and on the abundance of food. See Handlin, *This Was America*, 39–77.

23. Wittenberg, chartered in 1293, is located southwest of Berlin on the Elbe River. Its university, made famous by Martin Luther and Philipp Melanchthon, was founded by the elector Frederick the Wise in 1502. The Reformation started in Wittenberg on October 31, 1517, when Luther nailed his famous Ninety-five Theses to the wooden doors of the castle Church of All Saints. Prince Paul, from the House of Witten, was a celebrated world traveler and naturalist associated with Wittenberg University.

24. Herr von Winterfeldt could not be further identified.

25. The California Gold Rush of 1849 was in full swing when Maria wrote this letter. New Orleans was a major stopover for all going west, by either land or sea, providing supplies and stores for the long journey ahead.

26. For a biographical sketch of Captain Frederick Hughes, Mexican War veteran and early land surveyor for Nueces County, see Frank Wagner, "Research Papers," typescript in Local History Collection, Corpus Christi Public Library, hereinafter cited as Wagner, "Research Papers," Corpus Christi Public Library.

27. Nueces County Deed Records, Book E, 98, microfilm copy, South Texas Archives, Texas A&M University–Kingsville, hereinafter cited as Nueces County Deed Records. A morgen is a German measurement of land approximately 62 percent of an American acre. This property was described as 640 acres on the Nueces River "twelve miles from San Patricio."

28. This is the first mention of an inheritance dispute involving Felix, his mother, and his stepfather. The dispute played a major role in the von Blüchers' lives and would shape Felix and Maria's life in the New World. Details are in Christine von Rieben to C. F. Imme, August 22, 1849, Blücher Family Papers.

29. From the German word *Erdferkel*, a nocturnal African burrowing mammal with a thickset body, large snout, and donkeylike ears. This apparently was Maria's first view of African slaves, and her Prussian superiority and sensibilities are obvious.

30. The first four were Maria's brothers and sisters, the latter two her niece and nephew.

31. Pauline and Bertha Schmidt were Maria's close girlfriends in Berlin.

32. Maria spelled the name Ohlers throughout her correspondence, although the historical documents record it as Ohler. For a biographical sketch of Edward and Matilda Ohler, see Wagner, "Research Papers," Corpus Christi Public Library. Edward Ohler was among the wealthiest citizens in Corpus Christi, with an estate of thirty thousand dollars. National Archives Microfilm: Seventh Census of the United States, 1850, Texas, Nueces County, 140, hereinafter cited as 1850 Census with appropriate county and page number.

33. Maria at first thought highly of Matilda Ohler but later came to view her as a woman of low morals and as greedy. After 1855 the Ohlers divided their time between Corpus Christi and Indianola, where they had another warehouse and import/export business.

34. The Ohler home was located at what is today the corner of North Broadway and Antelope. It stood until 1937, when it was torn down and replaced with a United States Post Office.

35. Nueces County Deeds, Book D, 514.

36. Maria's son Charles later described the property: "My father located in the present Blücher place in Corpus Christi, buying an eight acre tract which had been previously owned by one Hiram Riggs and used by Riggs as a small farm. The southeast corner of the tract was sold to 'Uncle Büsse.' Riggs had, according to the deed, only six acres, but the survey laid off eight. Riggs had improved the place considerably, having placed on it a couple of wells and a high brush fence surrounding the whole place, and some very good buildings, stables and pens, and a drainage ditch around most of the place. It had at the time of my father's advent, however, only one small house in which father and mother lived and used as their living room and parlor. It being a very small affair, most of their furniture, including mother's piano, was kept under a tree, and their kitchen was established under a large hackberry tree and also a nearby mesquite tree. A spacious table for kitchen work was built surrounding the trunk of the hackberry tree which was very convenient. Soon afterwards, as father's income permitted, he built another small house and an addition to the first house." Charles F. H. von Blücher, "Early Days," typescript dated July 28, 1929, and "The Old Mesquite Tree," typescript dated February 12, 1933, Blücher Family Papers.

37. Dramatic changes were taking place in South Texas with the construction of several

military posts to protect the frontier. Maria here is probably referring to the construction of Fort Merrill on the south bank of the Nueces River in present Live Oak County.

38. Settled in 1804 by Juan José de la Garza Montemayor of Camargo, Mexico, the Casa Blanca grant consisted of twenty-two thousand acres on the Nueces River, approximately twenty miles upstream from Corpus Christi.

39. Channel catfish *(Ictalurus punctatus)* remain an important sport and commercial catch to this day in the Nueces River and Corpus Christi Bay.

40. This would later be named Nuecestown; see Walraven, *Corpus Christi,* 27–41.

41. This was the tract bought from Hiram Riggs.

42. Maria's daughter Julia brought back from Berlin in 1880 an oil painting of this dog by Gustav Richter, who had been a dear friend of Maria's during her "Belle of Berlin" years. The dog was named Stint and was Maria's absolute pride and joy. Note of Julia von Blücher dated December 8, 1929, typescript, Blücher Family Papers.

43. The needle gun, a breechloader with cylinder bolt, was invented in 1832 by Nikolaus Dreyse and manufactured at Thüringen, Germany. The weapon was adopted as standard issue by the Prussian army in 1841 and was valued for its accuracy and rapid firing capabilities.

44. This is the first indication of trouble in Maria and Felix's marriage. Maria's later letters indicate that Felix had a violent temper that was made worse by drinking. Here, he must have spoken harshly to her for the first time.

45. Hungary's reform revolution of 1848 was crushed just a year later when Russia invaded and defeated the liberals on August 13, 1849, delivering the country back to Vienna and the Habsburgs. Savage reprisals followed, and the country was again dismembered and subjected to an absolutist and extortionate rule exercised from Vienna through a foreign bureaucracy.

CHAPTER 3. EARLY CORPUS CHRISTI: THE 1850S

1. Walraven, *Corpus Christi,* 27–47; Briscoe, *City by the Sea,* 44–89; Tyler et al., eds., *New Handbook of Texas,* 3:1117. For an insightful analysis of these boom and bust cycles on the South Texas frontier, see Milo Kearney and Anthony Knopp, *Boom and Bust: The Historical Cycles of Matamoros and Brownsville* (Austin: Eakin Press, 1991).

2. Walraven, *Corpus Christi,* 27–46; Briscoe, *City by the Sea,* 44–89; Tyler et al., eds., *New Handbook of Texas,* 3:1117. The agents Kinney hired in Europe were empowered to offer each family of prospective emigrants upon their arrival at Corpus Christi "10 cows on shares for 10 years; 100 acres of land for $1.00 an acre; 1 yoke of oxen and 1 horse—all to be paid for at the end of 10 years."

3. Walter Prescott Webb, *The Texas Rangers: A Century of Frontier Defense* (New York: Doubleday, 1935), 143. The patrol was under the command of Captain Gideon K. "Legs" Lewis (d. 1855); see Tyler et al., eds., *New Handbook of Texas,* 4:202.

4. Walraven, *Corpus Christi,* 27–46; Briscoe, *City by the Sea,* 86–99.

5. Briscoe, *City by the Sea,* 136–71. For an insightful analysis of racial relations, see David Montejano, *Anglos and Mexicans in the Making of Texas, 1836–1986* (Austin: University of Texas Press, 1987), 75–99.

6. See, among others, Maria von Blücher to Fondly loved Parents, November 24, 1854; and Felix von Blücher to Beloved Parents, April 25, 1857, Blücher Family Papers.

7. Maria von Blücher to Dear Parents, January 24, 1855, Blücher Family Papers.

8. Maria von Blücher to Fondly loved Parents, April 3, 1855, Blücher Family Papers.

9. See among others Maria von Blücher to Dearly loved Parents, November 29, 1854, and February 20, 1859, Blücher Family Papers.

10. Maria von Blücher to Dear Parents, November 24, 1854, Blücher Family Papers.

11. Maria von Blücher to Cordially loved Parents, November 6, 1858; February 20, 1859, Blücher Family Papers.

12. Maria von Blücher to Cordially loved Parents, November 1, 1856, Blücher Family Papers.

13. Maria von Blücher to Cordially loved Parents, February 22, 1856; January 24, 1857; December 29, 1859, Blücher Family Papers.

14. Felix von Blücher to Dear Parents, April 25, 1857; Maria von Blücher to Cordially loved Parents, November 6, 1858, Blücher Family Papers.

15. Maria von Blücher to Dear beloved Parents, August 22, 1859, Blücher Family Papers.

16. See among others Maria von Blücher to Dear Parents, July 2, 1849; June 26, 1850; and May 1, 1852, Blücher Family Papers.

17. Maria von Blücher to Cordially loved Parents, February 20, 1850; May 1, 1852, Blücher Family Papers.

18. See among others Maria von Blücher to Cordially loved Parents, July 18, 1857; December 11, 1857; and August 5, 1858, Blücher Family Papers.

19. Maria von Blücher to Dear Parents, December 14, 1853, Blücher Family Papers. Alexandre Dumas (1802–70) was one of the most popular French authors of the nineteenth century. He gained a great reputation first as a dramatist and then as a historical novelist, especially for such works as *The Count of Monte Cristo* and *The Three Musketeers*. He exploited the vogue for historical fiction that had been inaugurated by Sir Walter Scott and introduced to France by Victor Hugo.

20. Maria von Blücher to Dear beloved Parents, February 20, 1859, Blücher Family Papers.

21. Maria von Blücher to My Dear Mother, May 29, 1855; June 2, 1855; and November 1855, Blücher Family Papers.

22. See among others Maria von Blücher to Beloved Parents, March 8, 1857, and February 20, 1859, Blücher Family Papers.

23. Maria von Blücher to Dear Parents, October 26, 1851, Blücher Family Papers. Maria's son Charles later reflected that "[Mother] raised a family of five children; disciplining them according to the German method, which proved quite a success. I recollect that there was no sparing of the rod, which sometimes took the form of a raw-hide whip, that inflicted never-to-be-forgotten lessons." Charles F. H. von Blücher, "My Mother," typescript dated October 20, 1935, Blücher Family Papers.

24. For a biographical sketch of Georg Noessel, proprietor of the Corpus Christi Hotel, see Wagner, "Research Papers," Corpus Christi Public Library. The Noessels became close friends with Felix and Maria.

25. For a biographical sketch of Margaret Rahm Meuly (1829–1912), see Charles F. H. von Blücher, "Conrad Meuly and Meuly Genealogy," typescript, Blücher Family Papers. The Meuly family traveled on the same ship from New Orleans to Corpus

Christi as did Maria and Felix upon their arrival in 1849. The families would be close friends thereafter; Maria's son Charles married a daughter of Conrad and Margaret Meuly in 1880.

26. Felix's brother, Hermann Ludwig Karl von Blücher (1824–81), had a brilliant military career in the Prussian army and seems to have been the only sibling of whom Felix remained fond. Wigger, *Familie von Blücher*, 2:187–89.

27. During this period, Kiowas, Comanches, and Lipan Apaches often ravaged the Texas frontier, particularly in the upper Nueces Valley. See Robert M. Utley, *The Indian Frontier of the American West, 1846–1890* (Albuquerque: University of New Mexico Press, 1984), 55–56.

28. The tiger Maria writes of was probably a large mountain lion *(Felis concolor)*. Known by different names in different places, mountain lions are variously called cougars, pumas, panthers, and catamounts. Up to five feet long, with gray to tawny fur and a black-tipped tail, these furtive predators roamed throughout the South Texas chaparral during the nineteenth century. The vast desert and brush country also supported jaguars *(Felis onca)*, jaguarundis *(Felis yagouaroundi)*, and bobcats *(Lynx rufus)*.

29. Sisters Bertha and Pauline Schmidt had been Maria's closest friends.

30. In 1850 Kinney had married Mary B. Herbert, a widow with several children. The marriage was doomed from the start and the two later divorced. Maria, however, later became good friends with Mrs. Kinney, in spite of her "low descent."

31. Mauricia Arocha Belden, a native of Matamoros, Mexico, was the wife of Frederick Belden (1809–67), a prominent merchant and trader. For a biographical sketch of the Beldens, see Wagner, "Research Papers," Corpus Christi Public Library.

32. For a biographical sketch of Henry A. Gilpin (1808–95), see Wagner, "Research Papers," Corpus Christi Library.

33. Felix would continue his entire life to bemoan his lost inheritance.

34. Trakehner is an East Prussian breed of horse famed for its versatility, serving equally well for riding, light labor, and carriage.

35. Cholera represents any of several diseases of humans and domestic animals marked by severe gastrointestinal symptoms characterized by griping diarrhea and sometimes vomiting. In overcrowded nineteenth-century Berlin, epidemics of cholera swept the city annually, with devastating results. See Braudel, *Structures of Everyday Life*, 81–89.

36. Maria here laments having missed her parents' twenty-fifth wedding anniversary. In Germany, this milestone was a celebrated event. "This was when Grandfather Imme was in the heyday of his active life. They gathered all the children and grandchildren together on this occasion, except for Maria, who was away in Texas." See "Miscellaneous Notes from Aunt Julia," typescript dated January 10, 1932, Blücher Family Papers.

37. Frederick William IV, king of Prussia, was in the throes of crushing the liberal rebellion and reestablishing autocratic royal order in 1850. See Holborn, *History of Germany*.

38. This scarcity of finished products on the South Texas frontier and Maria's long "laundry lists" of goods requested from Germany fill many of her letters to her parents during this period.

39. Without a surname, the Mexican Domingo could not be positively identified, for there are numerous men of that name in the 1850 census.

40. Maria's original letter in German contains a copy of Felix's sketch.

41. Holborn, *History of Germany.*

42. Maria's growing interest in American politics reflects the mantra that "all politics is local." For an excellent discussion of pioneer women in politics, see Stratton, *Pioneer Women,* 253–67.

43. Smallpox was one of the world's most dreaded plagues. A virus, it arises from human contact with another case of the disease. Smallpox was especially devastating to Native Americans. After Englishman Edward Jenner discovered a vaccination in 1796, and the procedure spread rapidly around the world, the death rate from smallpox plunged.

44. As earlier indicated, Maria's use of discipline in child rearing is described in Charles F. H. von Blücher, "My Mother," typescript dated October 20, 1935, Blücher Family Papers.

45. This again was probably a mountain lion.

46. For a biographical sketch of John Peter Schätzell (1776–1854), see Tyler et al., eds., *New Handbook of Texas,* 5:914.

47. One of Berlin's many exceptional art museums in the Tiergarten district; it was destroyed by fire. Richie, *Faust's Metropolis,* 136.

48. Maria is referring to London's great world fair of 1851.

49. Here, Maria and Felix's liberal politics are clearly expressed. This is the only letter in which Maria identifies her father as a royalist; her other letters indicate that he was more of a moderate.

50. This filibuster was a fiasco, the mercenaries getting no farther than Mustang Island, where they rioted while awaiting transport to Cuba and were finally dispersed by Texas Rangers. See Wagner, "Research Papers," Corpus Christi Public Library.

51. This event was Kinney's infamous Lone Star Fair of 1852, which led to his financial collapse. See Walraven, *Corpus Christi,* 27–47.

52. As earlier noted, Mrs. Kinney would later become Maria's friend.

53. For the history of German immigration to Texas, see Benjamin, *Germans in Texas;* Jordan, *German Seed;* and Lich, *German Texans.*

54. Mieze, as Maria uses this term of affection for baby Mary, is from the German word *miezekaetzchen,* meaning "little pussy cat."

55. See Hortense Warner Ward, "It Was Texas' First State Fair," *Houston Chronicle Magazine,* April 27, 1952, p. 22.

56. These officials had all been followers of the liberal and revolutionary party headed by Count Kossuth in Hungary in 1848. They obviously fled the country after the rebellion was crushed by the intervention of the Russian army in 1849. As earlier indicated, Hungary was then dismembered and ruled by a foreign bureaucracy.

57. This is an interesting comment revealing that Maria had no qualms about owning slaves, indicative of her later ardent support of the South during the Civil War. Yet her son Charles later recalled that "my father and mother abhorred slavery." See Charles F. H. von Blücher, "Civil War Times," typescript dated October 20, 1935, Blücher Family Papers.

58. Major General Persifor F. Smith (1798–1858), commander of the Department of

Texas, relocated the army's headquarters from San Antonio to Corpus Christi in 1852, supposedly because he favored the seaside climate and the local oysters. See Wagner, "Research Papers," Corpus Christi Public Library.

59. Nueces County Deed Records, Book E, 148.

60. The German word *Meisbock* can be literally translated as "wretched goat." It is used, however, as a name for a child who is in a sulky, foul mood. Maria seems to have meant that Doña Carmel might help her care for her difficult toddler once the new baby arrived.

61. Seyler, obviously an acquaintance of the Imme family in Berlin, could not be further identified. He quickly irritated Maria, who had little good to say about him.

62. Yellow fever, caused by a virus, is transmitted among susceptible hosts by several species of mosquitos. For more than two hundred years, it was one of the great plagues of the world. The tropical and subtropical regions of the Americas were subjected to devastating epidemics, and serious outbreaks occurred as far north as Boston. During Maria's lifetime, epidemics repeatedly swept over the southern United States, decimating populations, paralyzing industry and trade, and holding the people of the South in a state of perpetual dread. Maria's letters reflect the terror that the disease produced in the nineteenth century. The last outbreak in the United States occurred in 1905, when New Orleans and other ports of the South were invaded.

63. Nueces County Deed Records, Book E, 148.

64. Dr. Henschel was the Imme family doctor in Berlin.

65. Corpus Christi's early medical needs were served almost entirely by military doctors assigned to the Department of Texas. For an insightful look at how these army doctors were valued by outpost communities like Corpus Christi, see Caleb Coker (ed.), *The News from Brownsville: Helen Chapman's Letters from the Texas Military Frontier, 1848–1852* (Austin: Texas State Historical Association, 1992), 345.

66. For an excellent discussion of this race riot, see Briscoe, *City by the Sea*, 289–93.

67. This riot is indicative of the racial tensions that existed between Tejanos (Mexican Texans) and their Anglo counterparts. See Thompson, *A Wild and Vivid Land*, 51–82.

68. Mrs. Kinney and her mother, Mrs. Webb, shortly thereafter moved to Galveston, where Mrs. Kinney then divorced her husband. Tyler et al., eds., *New Handbook of Texas*, 3:1117.

69. Frank Abbe could not be further identified and no extant newspaper account of this tragedy was found.

70. For a biographical sketch of Cecilio Balerio (1796–1868), also known as Ceilio Valero, see Wagner, "Research Papers," Corpus Christi Public Library.

71. The yellow fever epidemic of 1854 devastated Corpus Christi, killing by some accounts one-fourth of the town's population. See Christopher Long, "Corpus Christi," in Tyler et al., eds., *New Handbook of Texas*, 2:332–33.

72. This is Maria's older brother, Carl Frederick (1819–99), who succeeded his father in the brass business.

73. Nicholas I (1796–1855), emperor of Russia since 1825, died in St. Petersburg on March 2, 1855, at the height of the Crimean War. That conflict lasted from October, 1853, to February, 1856, and was fought mainly on the Crimean Peninsula between the Russians and the British, French, and Ottoman Turkish.

74. Neither this story nor the identity of the miracle doctor was discovered.

75. For biographies of Major William Warren Chapman and his wife Helen, see Coker, ed., *News from Brownsville.*

76. Maria was in error here, for there is no record of this rumored marriage. See Tyler et al., eds., *New Handbook of Texas,* 3:1117.

77. In September, 1854, the British, French, and Ottoman Turks landed troops in Russian Crimea, on the north shore of the Black Sea, and began a year-long siege of the Russian fortress of Sevastopol. After a series of major battles, the Russians blew up the forts, sank their ships, and evacuated Sevastopol. Apparently Felix's brother, Hermann, had left the Prussian army to join the English in the fight. Wigger, *Familie von Blücher,* 2:187–89.

78. For a biographical sketch of Hamilton Prioleau Bee (1822–97), see Tyler et al., eds., *New Handbook of Texas,* 1:458.

79. Alvaro Pérez, a native of Mexico, was a successful tailor in early Corpus Christi; 1860 Census, Nueces County, 281.

80. These are Spanish terms for godfather, godmother, godson, and goddaughter.

81. These Spanish terms reference the godparents in relation to the parents of the godson or goddaughter.

82. Possibly Michael Müller, 60, carpenter and stockman; 1860 Census, Nueces County, 281. Felix and Maria's son Charles identified this ranch as being "about 6½ miles west of Corpus Christi on land known as Blücher Prairie, which extended from *Guajolote* or Turkey Creek, where my father had a ranch, northerly into the flats on the south side of Nueces Bay. Father's ranch was a small place of about 150 acres, the rest of the land being open country at that time and used by everyone in common for grazing. It was covered with a fine growth of native grasses which at the proper season of the year yielded a quantity of excellent hay. Many deer, cattle, and horses grazed on this fine range. Father attempted to develop this ranch throughout the 1850s; he having a few huts for his Mexican workers and a well of good water. About 1859 the Indians raided and destroyed the place, and in consequence he abandoned and sold it afterwards." Charles F. H. von Blücher, "Blücher Prairie," typescript dated March 31, 1935, Blücher Family Papers.

83. For an overview of this contentious litigation, see Tyler et al., eds., *New Handbook of Texas,* 5:914.

84. After just three years the army abandoned its post and depot at Corpus Christi for removal to San Antonio. The removal was completed in March, 1857, when forty-three wagons departed with the quartermaster stores. All army warehouses and buildings were sold at auction, with the purchasers given until the last day of the month to remove their property from government land.

85. Nueces County Deed Records, Book G, 440–41, 511–12, 513.

86. In spite of a messy divorce, failure to pay creditors, and a disastrous filibuster to Nicaragua, Kinney was given a hero's reception when he returned to the town he founded. See Tyler et al., eds., *New Handbook of Texas,* 3:1117.

87. For a biographical sketch of Charles Lovenskiold (1822–75), who became Felix's attorney and business partner, see Tyler et al., eds., *New Handbook of Texas,* 4:307.

88. In late 1858 and throughout 1859, the entire Texas frontier, from the Red River to El Paso to the mouth of the Rio Grande, suffered attacks by raiding Indians. See Utley, *Indian Frontier,* 55–56.

89. The sewing machine, invented in France in 1841, was the first widely distributed mechanical home appliance and an important industrial machine. The French

version was widely improved upon in 1846 by Americans Elias Howe of Spencer, Massachusetts, Walter Hunt of New York, and Issac Merrit Singer of New York and Boston. By 1860, more than 110,000 sewing machines had been sold in the United States alone. The firm of Wheeler and Wilson was headquartered in Bridgeport, Connecticut, and was one of the nation's largest manufacturers.

90. For a detailed analysis of what became known as the Cortina War, see Jerry Thompson, ed., *Juan N. Cortina and the Texas-Mexico Frontier, 1859–1877* (El Paso: Texas Western Press, 1994).

CHAPTER 4. CIVIL WAR

1. Kearney and Knopp, *Boom and Bust*, 73–88; Thompson, *A Wild and Vivid Land*, 70–90. For the Cortina War, see Thompson, ed., *Juan N. Cortina*, 11–12.
2. For biographical sketches of these influential leaders of the Lower Rio Grande Valley, see Tyler et al., eds., *New Handbook of Texas*, 4:363–64; 5:414; and 6:102, 1128, 1134–35.
3. For a biographical sketch of Richard King (1824–85) and his influence on the economic development of South Texas, see Bruce S. Cheeseman, "Richard King: Pioneering Market Capitalism on the Frontier," in *Ranching in South Texas: A Symposium*, ed. Joe S. Graham (Kingsville: Texas A&M University–Kingsville, 1994), 86–91. For a biographical sketch of Mifflin Kenedy (1818–95), King's lifelong friend and business mentor, see Tyler et al., eds., *New Handbook of Texas*, 3:1064–65. According to his obituary, Felix von Blücher was "engaged [for most of his career] to attend to business for Capt. R. King, who, together with Capt. M. Kenedy, he always esteemed as his nearest and dearest friends." *Corpus Christi Daily Gazette*, February 14, 1879.
4. Maria von Blücher to Cordially loved Parents, May 11, 1861, Blücher Family Papers.
5. Maria von Blücher to Cordially loved Parents, December 26, 1860, Blücher Family Papers.
6. Maria von Blücher to Dearly beloved Parents, October 5, 1862, Blücher Family Papers.
7. Maria von Blücher to Cordially loved Parents, May 26, 1860; February 19, 1861, Blücher Family Papers.
8. Maria von Blücher to Cordially loved Parents, February 19, 1861; May 11, 1861; October 5, 1862, Blücher Family Papers.
9. Thompson, *A Wild and Vivid Land*, 91; Walraven, *Corpus Christi*, 47–56.
10. Maria von Blücher to Dear beloved parents, July 10, 1863; October 29, 1863; April 5, 1865, Blücher Family Papers.
11. Maria von Blücher to Dear beloved Parents, October 29, 1863, Blücher Family Papers; "Major F. A. Blücher," *Corpus Christi Daily Gazette*, February 14, 1879.
12. Maria von Blücher to Dearly beloved Parents, October 5, 1862, Blücher Family Papers. Also, for the role of the corps of engineers in coastal defense, see Alwyn Barr, "Texas Coastal Defense, 1861–1865," in *Lone Star Blue and Gray: Essays on Texas in the Civil War*, ed. Ralph A. Wooster (Austin: Texas State Historical Association, 1996).
13. Maria von Blücher to Dearly beloved Parents, October 5, 1862, Blücher Family

Papers; Norman C. Delaney. "Battle of Corpus Christi," in Tyler et al., eds., *New Handbook of Texas*, 2:330–31.

14. Tyler et al., eds., *New Handbook of Texas*, 2:330–31.

15. Maria von Blücher to Cordially loved Parents, May 10, 1864, Blücher Family Papers.

16. Richard V. Francaviglia, *From Sail to Steam: Four Centuries of Texas Maritime History, 1500–1900* (Austin: University of Texas Press, 1998), 189–220; Bruce S. Cheeseman, "'Let us have 500 good determined Texans': Richard King's Account of the Union Invasion of South Texas, November 12, 1863, to January 20, 1864," *Southwestern Historical Quarterly* 101 (July, 1997), 76–95. On January 30, 1864, King wrote to Confederate authorities: "The grass is as bad as it gets here. I am now busily engaged gathering my horse stock, and trying to save a few of my mares and colts. I know not where to drive them, as there is no grass east of the Nueces. We are in fact in a starving condition."

17. Maria von Blücher to Fondly loved Parents, March 16, 1864, Blücher Family Papers.

18. Maria von Blücher to Dearly loved Parents, October 29, 1863; January 17, 1865; March 11, 1865, Blücher Family Papers.

19. Ibid. For Rip Ford's redemption of South Texas back to Confederate rule, see John S. Ford, *Rip Ford's Texas*, ed. Stephen B. Oates (Austin: University of Texas Press, 1963).

20. Maria von Blücher to Loved Parents, July 1, 1866, Blücher Family Papers.

21. Maria von Blücher to Dear beloved Parents, October 29, 1863, Blücher Family Papers.

22. Ibid.

23. Maria von Blücher to Cordially loved Parents, May 10, 1864, Blücher Family Papers.

24. Maria von Blücher to Fondly loved Parents, November 2, 1864, Blücher Family Papers.

25. Felix's joining the French Imperial Army in Mexico earned him considerable praise in the Paris press. See "Major F. A. Blücher," *Corpus Christi Daily Gazette*, February 14, 1879. For a biographical sketch of General Mejía, see Tyler et al., eds., *New Handbook of Texas*, 4:889–900.

26. Maria von Blücher to Dear Parents, January 2, 1866, Blücher Family Papers.

27. Maria von Blücher to Cordially loved Parents, January 4, 1867; February 28, 1867, Blücher Family Papers.

28. Maria von Blücher to Beloved Parents, May 26, 1867, Blücher Family Papers.

29. The curriculum of nineteenth-century art academies centered around drawing. The student drew from the drawings of professors, then from casts, and finally from life. This was a popular art text in Germany.

30. Mary Littig, thirty-five, was a native of Wales and wife of merchant J. W. Littig, fifty-five, a native of Maryland, who had mercantile stores in Nuecestown and Corpus Christi with goods valued at five thousand dollars. 1870 Census, Nueces County, 308.

31. Ibid. The Littig home in Nuecestown was described as being "twelve miles from Corpus Christi."

32. This children's book could not be identified.

33. No extant copy of a newspaper account of the misadventures of the *Fortuna* was found.

34. This early photograph of Corpus Christi also was not discovered. It would be a rare find, possibly the earliest known photograph of the town.

35. For a detailed biographical sketch of Richard Schübert, who befriended Maria and was of great assistance to her and her family, see Charles F. H. von Blücher, "Mr. Richard Schübert," typescript dated October 1, 1929, Blücher Family Papers. For the importance of sheep raising in the emerging economy of South Texas, see Paul H. Carlson, "Sheep Ranching," in Tyler et al., eds., *New Handbook of Texas*, 5:1006–1007.

36. The outbreak of the Civil War brought renewed Indian attacks all across the Texas frontier. See David Paul Smith, *Frontier Defense in the Civil War: Texas' Rangers and Rebels* (College Station: Texas A&M University Press, 1992), 17–89.

37. The Blücher family friend Poly could not be further identified.

38. On the Union blockade and its effects on Texas, see Francaviglia, *From Sail to Steam*, and Cheeseman, "'Let us have 500.'"

39. The best accounts of Corpus Christi during the Civil War are found in Briscoe, *City by the Sea*, and Delaney, "Battle of Corpus Christi."

40. Ibid.

41. For a biographical sketch of the slave Phyllis, see Charles F. H. von Blücher, "Civil War Times," typescript dated October 20, 1935, Blücher Family Papers.

42. Two outstanding histories of the general Civil War in South Texas are James W. Daddysman, *The Matamoros Trade: Confederate Commerce, Diplomacy, and Intrigue* (Newark: University of Delaware Press, 1986), and James A. Irby, *Backdoor at Bagdad: The Civil War on the Rio Grande* (El Paso: Texas Western Press, 1977).

43. See Delaney, "Battle of Corpus Christi."

44. Ibid. John Ireland (1827–96) later served as governor of Texas; see Tyler et al., eds., *New Handbook of Texas*, 3:867. Capt. Herman Wilkie commanded a unit of eighty-seven men as part of Major Alford M. Hobby's Eighth Texas Infantry based in Corpus Christi. For a biographical sketch of Hobby, see Tyler et al., eds., *New Handbook of Texas*, 3:637.

45. The firm of Droage, Oettling & Co. had operations throughout the Rio Grande Valley, exporting Confederate cotton to Europe and importing munitions, medical supplies, clothing, and shoes. See Robert Delaney, "Matamoros, Port for Texas during the Civil War," *Southwestern Historical Quarterly* 58 (April, 1955), 473–80.

46. Ibid.

47. See Lester N. Fitzhugh, "Saluria, Fort Esperanza, and Military Operations on the Texas Coast, 1861–1864," *Southwestern Historical Quarterly* 61 (July, 1957), 66–100.

48. For the commercial activities of Confederate quartermaster Charles Russell, see Ronnie C. Tyler, "Cotton on the Border, 1861–1865," *Southwestern Historical Quarterly* 73 (April, 1970), 465–77, and L. Tuffly Ellis, "Maritime Commerce on the Far Western Gulf, 1861–1865," *Southwestern Historical Quarterly* 77 (October, 1973), 167–226.

49. By late 1863 over ninety ships were observed at the mouth of the Rio Grande waiting to take on Confederate cotton. See Tom Lea, *The King Ranch* (Boston: Little Brown, 1957), 1:192.

50. For a detailed account of the importance of this cotton trade and the Union invasion to destroy it, see Cheeseman, "'Let us have 500.'"

51. Here of course Maria was in error, as Vicksburg, Mississippi, fell to Union forces on July 4, 1863, and the Confederates never recaptured New Orleans after the city fell to the North in 1862.

52. Felix's clerk, Taylor, whom Maria describes in such detail, could not be further identified.

53. The Confederate authorities conscripted planters' slaves and exempt military men to aid in both the construction of coastal fortifications and the movement of cotton to the Rio Grande. This government conscription caused howls of protest from both impressed citizens and private operators. See Barr, "Texas Coastal Defense."

54. See Caroline Lee Hentz, *The Planter's Northern Bride* (1854; reprint, with an introduction by Rhoda Coleman Ellison, Chapel Hill: University of North Carolina Press, 1970).

55. For a moving description of the want of foodstuffs Maria faced during these trying times, see her son's paper, Charles F. H. von Blücher, "Recollections of Civil War Days," typescript dated April 20, 1935, Blücher Family Papers. "During the war we used ground acorns for coffee, and all vegetables like potatoes or onions were very scarce. To get some kind of vegetables, we went through both the Confederate and Union commissary departments, who used to throw away and condemn what little vegetables they had if not in absolutely good condition. These condemned food stuffs were carted out and dumped in the arroyo, which was running all the time. They were dumped in the water, which washed them clean of all soil, and the rotten parts were washed away. We and others would go at least every week and gather them to help out with the problem of feeding a large family during these hard times."

56. South Texas suffered through a severe drought in 1863–64. Rip Ford reported in early 1864 that one could not "imagine how desolate, barren, and desert-like this country is; not a spear of grass, nor a green shrub, with nothing but moving clouds of sand to be seen on these once green prairies." See Cheeseman, "'Let us have 500,'" 92, 52n, 55n.

57. For an important new work on the subject of Union destruction of private property, see Mark Grimsley, *The Hard Hand of War: Union Military Policy toward Southern Civilians, 1861–1865* (Cambridge, U.K.: Cambridge University Press, 1995).

58. Jacob Ziegler, sixty, and his wife Margaret, fifty-three, were natives of the German province of Rhineland and managed a hotel in Corpus Christi. 1870 Census, Nueces County, 16.

59. Mrs. Frost could not be further identified.

60. Prussia under the leadership of Otto von Bismark attacked Denmark in 1864, gaining control of the Danish duchies of Schleswig and Holstein on the pretext of oppressed German nationality. The British and the French could not agree on joint action and left Denmark to a crushing defeat at the hands of the superior Prussian military.

61. Maria is apparently describing the Battle of Las Rucias, which took place on June 25, 1864. Felix was commended by Rip Ford for "gallantry in action." Ford later spoke highly of Felix, who served Ford as chief of staff: Felix A. Blücher was "a valuable man to the Cavalry of the West." Ford, *Rip Ford's Texas*, 350.

62. The Union officer was a Lieutenant Stuart, who could not be further identified with certainty.

63. Dr. Allen could not be further identified.

64. Corpus Christi was occupied by black troops from the Thirty-sixth U.S. Infantry.

65. For a concise history of the battles between the Juarista Liberal Army of Mexico and the French Imperial Army, see Thompson, *A Wild and Vivid Land*, 117. Felix was lucky to escape, for if captured he would certainly have been executed along with Maximilian and General Mejía.

66. See Coker, ed., *News from Brownsville*, 328. Mrs. Chapman was raising sheep with James Bryden on a portion of Richard King's Santa Gertrudis ranch, which later led to a lawsuit in the late 1870s.

67. For a biographical sketch of Edmund Jackson Davis (1827–83), see Tyler et al., eds., *New Handbook of Texas*, 2:526–527.

68. For an excellent sketch of early education in Corpus Christi, see Charles F. H. von Blücher, "The Early Schools of Corpus Christi," typescript dated July 19, 1930, Blücher Family Papers. He described the Hidalgo Seminary as "a Catholic school for boys with a department for girls, conducted by the nuns. This school was held in an old concrete building belonging to an old Spanish family named Pérez. This school had for the boys several teachers at different times."

69. For a biographical sketch of James Downing (1842–91), see *Corpus Christi Caller*, May 2, 1891, and Charles F. H. von Blücher, "Uncle Jim," typescript dated November 8, 1930, Blücher Family Papers.

70. Merchant William Headen, thirty-two, and his wife Margaret, twenty-eight, were natives of Ireland who became prominent business and civic leaders in Corpus Christi. Their holdings were valued at sixty-five thousand dollars in the 1870 census, making them one of the city's richest couples. For biographical sketches of the Headens, see Frank Wagner, "Research Papers," Corpus Christi Public Library.

71. Cornelia Moore was the daughter of civic leader John Marks Davenport Moore (1811–92), who headed the dredging company attempting to establish a deepwater port. See Tyler et al., eds., *New Handbook of Texas*, 4:822.

72. Alfred Tennyson (1809–92), poet laureate of England, was regarded as the chief representative of the Victorian age of poetry. He was a particular favorite of Maria and her daughters.

73. The headquarters of the King Ranch, also known as Rancho de Santa Gertrudis, are located along Santa Gertrudis Creek in Kleberg County, approximately forty-five miles southwest of Corpus Christi. Established in 1853 by Richard King, the ranch became one of the most famous in the history of the American West. Lea, *King Ranch*, 1:129–31.

CHAPTER 5. RECONSTRUCTION AND REDEMPTION: THE 1870S

1. Walraven, *Corpus Christi*, 47–56; Thompson, *A Wild and Vivid Land*, 91–130. For the Lower Rio Grande Valley's economic good fortune as a result of the war, see Daddysman, *Matamoros Trade*, and Irby, *Backdoor at Bagdad*.

2. Maria von Blücher to Dearly beloved Parents, April 5, 1865; January 2, 1866, Blücher Family Papers. See also Walraven, *Corpus Christi*, 47–56, and Thompson, *A Wild and Vivid Land*, 110–30.

3. Walraven, *Corpus Christi*, 47–76; Thompson, *A Wild and Vivid Land*, 117–30. For a biographical sketch of Captain Leander McNelly, see Tyler et al., eds., *New*

NOTES TO PAGES 167–72

Handbook of Texas, 4:228. For Cortina's role in this violence, see Thompson (ed.), *Juan N. Cortina*, 11–34.

4. Maria von Blücher to Fondly loved Parents, October 29, 1872; April 11, 1876, Blücher Family Papers.
5. Walraven, *Corpus Christi*, 47–76.
6. For a biographical sketch of Edmund Jackson Davis (1827–83), see Tyler et al., eds., *New Handbook of Texas*, 2:526–27; for Davis's Civil War career, see Jerry D. Thompson, *Mexican Texans in the Union Army* (El Paso: Texas Western Press, 1986), 10–23.
7. Walraven, *Corpus Christi*, 47–76; Maria von Blücher to Cordially loved Parents, December 8, 1867, Blücher Family Papers. For a biographical sketch of James Downing (1842–91), see *Corpus Christi Caller*, May 2, 1891. Mr. and Mrs. Downing remained childless.
8. Walraven, *Corpus Christi*, 62–76; see also Bruce S. Cheeseman, *Perfectly Exhausted with Pleasure: The 1881 King-Kenedy Excursion Train to Laredo* (Austin: Book Club of Texas, 1992), 9–30.
9. Walraven, *Corpus Christi*, 61–73; Cheeseman, *Perfectly Exhausted*, 9–30.
10. Walraven, *Corpus Christi*, 62–76
11. Walraven, *Corpus Christi*, 62–76; Montejano, *Anglos and Mexicans*, 75–99.
12. Maria von Blücher to Cordially loved Parents, December 6, 1868; June 20, 1870, Blücher Family Papers.
13. Charles F. H. von Blücher, "My Mother," typescript dated October 20, 1935, Blücher Family Papers.
14. Maria von Blücher to Beloved Parents, June 20, 1870, Blücher Family Papers.
15. Maria von Blücher to Beloved Parents, March 26, 1872, Blücher Family Papers.
16. Maria von Blücher to My dear Mother, November 16, 1876, Blücher Family Papers.
17. Maria von Blücher to Cordially loved Parents, September 27, 1871, Blücher Family Papers.
18. Maria von Blücher to Beloved Parents, June 1, 1875; October 12, 1875, Blücher Family Papers.
19. Maria von Blücher to Beloved Parents, October 1867; October 12, 1875, Blücher Family Papers.
20. Maria von Blücher to Beloved Parents, June 28, 1874, Blücher Family Papers.
21. Maria von Blücher to My Dear Felix, February 3, 1875, Blücher Family Papers.
22. Ibid.
23. Lieutenants James Downing and Elijah Harvey Wheeler both came to Corpus Christi with the occupation forces of the Thirty-sixth U.S. Infantry. They had fought side by side for the duration of the war, rising through the ranks of the First Massachusetts Heavy Artillery. Their war records were valiant: they participated in the engagements at Fredericksburg, Spottssylvania, North Anna River, Tolopotomy, Shady Grove, and Petersburg and in the surrender of Robert E. Lee at Appomattox. *Corpus Christi Caller*, September 29, 1893. Maria's son Charles later wrote: "While it may seem strange that our family, as many other families did, entertained and made pleasure for these Union officers, their conduct and general bearing were so agreeable to the people that the animosities of war were forgotten. We ourselves, as no doubt others did, received many favors at the hands of the Federal officers. Provisions being exceedingly scarce at the time, these officers

provided us liberally with many things that could not be had otherwise in the shape of provisions. The friendships formed at that time were very pleasant and lasted a long time. My mother corresponded with several of the ex-officers scattered throughout the North for many years after. Mr. Elijah Harvey Wheeler was a lieutenant in the same company with Uncle Jim Downing and they were close chums. My name 'Harvey' was given me for Mr. Wheeler." Charles F. H. von Blücher, "Uncle Jim," typescript dated November 8, 1930, Blücher Family Papers.

24. Again, yellow fever decimated Corpus Christi; see Walraven, *Corpus Christi,* 62–76. See also Charles F. H. von Blücher, "The Yellow Fever Epidemic in Corpus Christi," typescript dated January 4, 1932, Blücher Family Papers.

25. On October 6–7, 1867, a strong hurricane roared in from the Gulf of Mexico and ripped through Brownsville and Matamoros, causing immense damage to both towns. Lea, *King Ranch,* 1:250–51.

26. This was a major fund-raiser for the building of the First Presbyterian Church of Corpus Christi, which would become the house of worship of Maria and her family. In 1960, Maria's descendants donated an organ to the church "dedicated to the glory and worship of God and in loving memory of Maria A. von Blücher." *Antenna* 2, no. 4 (October 1960).

27. Maria's younger daughter, Julia, was now entertaining two marriage proposals from Union officers; she would eventually deny both.

28. Wheeler and Downing were working in the reconstruction government, registering adults to vote. For a biographical sketch of General Winfield Scott Hancock (1824–66), see Tyler et al., eds., *New Handbook of Texas,* 3:439.

29. Reconstruction in New Orleans, unlike in Corpus Christi, was bitter and filled with corruption; see Saxon, *New Orleans,* 255–59.

30. Charles F. H. von Blücher, "The Early Schools of Corpus Christi," typescript dated July 19, 1931, Blücher Family Papers. "The school of Mr. J. B. Carpenter was in the Chapman residence and was a flourishing school attended by most of the big boys and girls and some of the small ones of Corpus Christi. It had a very good curriculum. Mrs. Carpenter gave music lessons at the school. The school was run in a very rampant and undisciplined manner. Mr. Carpenter was an accomplished scholar, a cultured man with a splendid education, a fine orator and elocutionist (oh how he could recite *The Raven!*)."

31. Maria's joy over her new washing machine mirrors that of other pioneer women; for an insightful look at how such inventions lessened the daily burdens of domestic work, see Stratton, *Pioneer Women,* 57–76.

32. For a brief understanding of politics and government in Texas at this time, see Carl H. Moneyhon, "Reconstruction," in Tyler et al., eds., *New Handbook of Texas,* 5:474–81.

33. The most detailed discussion of Reconstruction in Corpus Christi can be found in Briscoe, *City by the Sea,* 389–444.

34. For a biographical sketch of William Blair Chapman, see Coker, ed., *News from Brownsville,* 345.

35. In 1868, Mifflin Kenedy began fencing Rancho los Laureles, just south of Corpus Christi. This was the first large enclosure of land west of the Mississippi River in the history of the American West. Tyler et al., eds., *New Handbook of Texas,* 3:1064–65.

36. Berlin was recognized in the nineteenth century as one of the world's most beautiful cities; see Richie, *Faust's Metropolis*, 124–55.

37. For a biographical sketch of General George David Ruggles, see *The National Cyclopaedia of American Biography*, 12:559.

38. The Berlin Aquarium opened in 1870 and earned marvel at the time as the world's largest collection of aquatic exhibits. Richie, *Faust's Metropolis*, 222.

39. *Antenna* 2, no. 4 (October 1960), provides a history of the Blücher family's relationship with the First Presbyterian Church.

40. Concepción is located in southeast Duval County and in the 1870s was the center of Texas' sheep industry. Tyler et al., eds., *New Handbook of Texas*, 2:255.

41. Maria here clearly means Saxon and Switzerland. The Saxon duchies were made up of several states in the Thuringian region of east-central Germany.

42. For a biographical sketch of Perry Doddridge (1832–1902), Corpus Christi businessman and civic leader, see *Corpus Christi Caller*, June 12, 1902.

43. For a concise history of relations with Mexico during this period, see Thompson, *A Wild and Vivid Land*, 117–39.

44. The Franco-Prussian War began in July, 1870, and resulted in a total Prussian victory. The war remained confined to France and Prussia (or rather Germany, since the southern German states joined Prussia). Peace was restored by the Treaty of Frankfurt in May, 1871, which rewarded Prussia with a large indemnity and the provinces of Alsace and Lorraine.

45. Corpus Christi had been under strict quarantine because of another outbreak of yellow fever.

46. The telegraphic messages were incorrect, as France never threatened Hamburg.

47. In March, 1871, Felix entered into business with lawyers Charles Lovenskiold and John S. McCambell in a firm called Felix A. Blücher and Company, Western Texas Land Agency.

48. A good description of the effects of this drought on livestock operations can be found in Lea, *King Ranch*, 1:299–303.

49. Felix's stepfather, George Kill-Mar, had indeed made an enormous amount of money with the sale and development of the estate Birkenwäldchen. Wigger, *Familie von Blücher*, 2:187–89.

50. No extant newspaper account of this murder was located. During the 1870s all of South Texas suffered a general breakdown in law and order. Highway robberies, murders, kidnappings, and general thievery were rampant. Thompson, *A Wild and Vivid Land*, 117–29.

51. Teplitz is located on a rocky spur below the Erzgebirge mountains in Czechoslovakia. It was famous for its radioactive springs. Believing that gunshot wounds could be remedied by these waters, Prussian, Austrian, and Saxon authorities maintained spa establishments for disabled men there in the nineteenth century.

52. Maria's observation here turned out to be quite true; Julia remained unmarried and independent until her death on June 25, 1937.

53. For a biographical sketch of General Philip H. Sheridan (1831–88), see Tyler et al., eds., *New Handbook of Texas*, 5:1018–19.

54. Vienna, Austria, hosted a world's fair in 1873. The city skyline is still dominated by its giant Ferris wheel in the Prater.

55. Richard and Henrietta King were well known for their hospitality. Maria's lack of description of her visit to Santa Gertrudis is disappointing, for it would have been one of the very few contemporary descriptions of the King Ranch during the 1870s. Lea, *King Ranch,* 1:310–47.

56. For a history of the building of this railroad, see Cheeseman, *Perfectly Exhausted.* For a detailed contemporary account and description of this survey, see Charles F. H. von Blücher, "Early Plans for a Railroad to Laredo," typescript dated September 17, 1931, Blücher Family Papers.

57. Lieutenant Elijah Harvey Wheeler had remained in Corpus Christi after the Civil War, taking a room at first with Maria and her family. After losing in his attempt to win Maria's daughter Julia's hand in marriage, he married the daughter of Felix's business partner, lawyer John S. McCampbell. He and Maria, however, remained close friends. 1870 Census, Nueces County, 28.

58. Anna Josephine Schubie was described as "a beautiful and wealthy Prussian widow," who had worked at the German Embassy in Washington, D.C. She was reported to be a favorite conversational companion of President Abraham Lincoln. In 1873 she married Colonel Richard Henry Savage at the embassy. *New York Times,* October 12, 1903.

59. Colonel Richard Henry Savage, soldier, author, traveler, and engineer, was born in Utica, New York on June 12, 1846, and grew up in San Francisco, California. Having graduated from West Point in 1868, he served as federal commissioner to Texas in 1872–73, investigating the cattle wars and general lawlessness in South Texas. He met Richard King during this investigation and later helped to build the railroad to Laredo. Afterward, Savage spent his time traveling around the world, engaged in geographical and engineering studies. A voluminous writer, he authored thirty volumes of prose and poetry, including a fictional account of Richard King and the building of the railroad to Laredo, titled *For Life and Love: A Story of the Rio Grande* (London: George Routledge and Sons, 1894). *New York Times,* October 12, 1903.

60. Lieutenant Tilston was one of the unsuccessful suitors for Julia's hand and one of the former Union officers with whom Maria corresponded.

61. Koblenz is located in western Germany at the confluence of the Rhine and Mosel rivers. A Roman town founded in 9 B.C., it has a strategic location that made it an important military post. The Ehrenbreitstein fortress and castle, first built in the eleventh century, was blown up by the French in 1801 after a four-year siege; it was later rebuilt (1816–32) into one of the strongest fortresses in Europe. Hermann von Blücher had apparently accepted a military assignment there.

62. This gentleman and family could not be identified. Again, Maria's prejudice and Prussian sensibilities are obvious here.

63. Felix was actively selling and trading land during this period; see, among others, Nueces County Deed Records, Book H, 300–301, 347–48; Book I, 193, 314, 319–20, 329–400; Book K, 1–2; Book L, 183; and Book M, 20.

64. Königsee is located on Bartholomaussee in Bavaria in southeastern Germany, high in the German Alps. Situated in a deep valley surrounded by sheer limestone mountains rising to 8,200 feet, the town is one of the most picturesque in all the Alps.

65. Maria is referring here to the now famous campaign waged against banditry by Captain Leander H. McNelly of the Texas Rangers, who with measured brutality "cleaned up the Nueces Strip" in 1875. Lea, *King Ranch,* 1:275–95.

66. Strong hurricanes struck the Texas Gulf Coast in both 1874 and 1875; see Charles F. H. von Blücher, "1875 Hurricane," typescript dated September 5, 1932, Blücher Family Papers.

67. Ibid.

68. For a biographical sketch of Major Hollub, see Charles F. H. von Blücher, "Major Hollub," typescript dated January 4, 1932, Blücher Family Papers.

69. For a biographical sketch of Dr. Arthur Edward Spohn (1845–1913), see Tyler et al., eds., *New Handbook of Texas*, 6:32.

70. The centennial of the Declaration of Independence in 1876 was widely celebrated across the nation, including with a world's fair in Philadelphia. Every community in America held festivities.

71. Maria's son Richard built and occupied a home located next to that of his older brother Charles. He worked at various occupations until he died in 1926.

72. Maria's son George would go on to a successful career in the emerging ice and refrigeration industry.

73. See Utley, *Indian Frontier*.

74. Once again, New Orleans and the Gulf Coast were ravaged by yellow fever. Saxon, *New Orleans*, 256–59.

75. For a biographical sketch of John McClane, former sheriff of Nueces County, see Frank Wagner, "Research Papers," Corpus Christi Public Library; see also "Major F. A. Blücher," *Corpus Christi Daily Gazette*, February 14, 1879.

CHAPTER 6. EPILOGUE

1. Maria von Blücher to Dear Mother, February 8, 1879, Blücher Family Papers.

2. See, among others, Nueces County Deed Records, Book D, 514, 537, 622; Book E, 52, 98, 148, 183, 488, 613, 622; Book F, 394–98; Book G, 314, 440–41, 511–12, 533; Book H, 300–301, 347–48; Book I, 193, 314, 319–20, 329, 399–400; Book K, 1–2; Book L, 183; and Book M, 20.

3. For example, see among others Felix von Blücher to Beloved Parents, April 25, 1857, Blücher Family Papers.

4. For land sales, see among others Nueces County Deeds, Book G, 441; Book I, 329, 399–40; Book L, 183; and, Book M, 20.

5. Maria von Blücher to Cordially loved Parents, March 8, 1860, Blücher Family Papers.

6. Nueces County Probate Court Minutes, Book E, 176–82; Book F, 6–8.

7. "Mrs. Maria A. von Blücher," *Corpus Christi Caller*, September 29, 1893.

8. Walraven, *Corpus Christi*, 27–76.

9. For an excellent discussion of the immigrant experience reflective of Maria's decision to remain in America and not return to Germany, see Daniel J. Boorstin, *The Americans: The National Experience* (New York: Random House and Vintage Books, 1965), 49–274.

Index

Photos and illustrations are indicated with **bold** typeface.
MvB is an abbreviation for Maria von Blücher and FvB is an
abbreviation for Felix von Blücher.

LaVergne, TN USA
02 January 2010
210696LV00003B/6/P